WIN
JER

MW00452493

To Jay,
without whose love and support this book never would
have been started, much less completed.

Winds over Jerusalem

The Story of Rae Landy, Pioneer Nurse of Hadassah

DEBBI PERKUL

To Jane —
Thanks for your support
Happy reading !
DWM

VALLENTINE MITCHELL
LONDON • PORTLAND, OR

First published in 2017 by Vallentine Mitchell

Catalyst House,
720 Centennial Court,
Centennial Park, Elstree WD6 3SY, UK

920 NE 58th Avenue, Suite 300
Portland, Oregon,
97213-3786 USA

www.vmbooks.com

British Library Cataloguing in Publication Data:
An entry can be found on request

ISBN 978 1 910383 42 1 (paper)
ISBN 978 1 910383 43 8 (Ebook)

Library of Congress Cataloging in Publication Data
An entry can be found on request

Printed by Edwards Brothers Malloy, Ann Arbor, MI

Contents

Acknowledgements vii
List of Images ix
Introduction xi

PART I

Chapter One The Beginning 3
Chapter Two Journey to Jerusalem 19
Chapter Three First Impressions of an Ancient City 31
Chapter Four Reality Sets in 40
Chapter Five The Scourge of Jerusalem 52

PART II

Chapter Six Winter 71
Chapter Seven Visitors 81
Chapter Eight The Challenges of Summer 93
Chapter Nine War comes to Jerusalem 109
Chapter Ten The USS *North Carolina* 125

PART III

Chapter Eleven Alone 147
Chapter Twelve The Plague 165
Chapter Thirteen The *Vulcan* 172
Chapter Fourteen Called Home 181

Epilogue 196
Notes 211
Bibliography 227
Index 235

Acknowledgements

There are many special people who made the writing of this book possible. I am deeply grateful for all their help and support. First, mom and dad, I love you so much. You are always there for me, no matter how crazy my ideas are. Marilyn Perkul, mom, was the one who introduced me to Rae and told me all Rae's stories, sparking my imagination and passion for her from the beginning. Sam Perkul, dad, spent hours on Sunday mornings patiently translating old Hebrew newspapers for me, while I furiously took notes.

Valentina Shimizu, through her sensitivity and insight, lit the fire that made me actually begin writing this story, realizing the dream which I never thought was achievable.

Miriam, Diane, and Louis Rosenblum generously shared photos and documents about Rae that their wonderful mother and wife, Evelyn Rosenblum, had left for them.

Abigail Jacobson so generously answered emails and took my phone calls to share her expert knowledge with me, even though she doesn't know me. The archive librarians at the Center for Jewish History, Boni Jo Koelliker and Susan Woodland, gave me invaluable information and insight about the Hadassah archives.

My very special first readers gave me invaluable insight and suggestions to improve my writing. Michael Bloom and David Mitchell –thank you for taking the time out of your very busy schedules to read my first drafts. David Baden and Wendy Wasman, my dear friends –the time you took to read the early work and, most importantly, listen to me as I worked through this writing process is so appreciated. I love you guys.

This work could never have been completed without the dedication of Evelyn Rosenblum (z'l) who carefully preserved Rae's legacy for the world and brought Rae to life for me through hours of interviews, sharing her own childhood memories of growing up with Aunt Rae.

To all my long-distance family: Judy (z'l), Scott, Jenny, Jase, Polly – what would I have done without your encouraging words and wishes? I love you all so much.

Danny and Jared, my sweet, wonderful boys, who lost me for a few months as I worked every waking hour and every spare moment on this project –I love that you supported me through this and I am so proud of you. I promise that I am back.

And finally, Jay, my partner and the love of my life, who stood next to me through this long journey, pushing me and making me be my best. I never could have done this without you.

List of Images

1. Rae on the *Franconia* with traveling companions; courtesy of Diane Rosenblum.
2. Portrait of Rae as a young woman; courtesy of Diane Rosenblum.
3. Rae with the class of the Mt Sinai Hospital Training School, Cleveland, Ohio, *c.* 1902. Rae is in the back row, fifth from the left; courtesy of Diane Rosenblum.
4. Inside Jaffa Gate, Library of Congress, Prints & Photographs Division, [LC-B2- 4450-4].
5. Rose Kaplan and Rachel Landy in front of Nurses Settlement. Ben-Dov, Ya'akov – photographer, Jerusalem, 1913; Record Group 18, Photographs, Hadassah Medical Organization Series, Hadassah Archives, American Jewish Historical Society, New York, NY and Boston MA. Digital ID 251745.
6. Rae (Rachel) Landy, Eva Leon and Rose Kaplan at Nurses Settlement. Ben-Dov, Ya'akov – photographer, Jerusalem, 1913; Record Group 18, Photographs, Hadassah Medical Organization Series, Hadassah Archives, American Jewish Historical Society, New York, NY and Boston, MA. Digital ID 251743.
7. A group of [illegible] women and children. Confinement case of four days standing. I found outside her house talking to neighbors. Rose Kaplan – photographer; Record Group 18, Group Portraits Series, Personal snapshots, Rose Kaplan-004, Photographs Series, Hadassah Archives, American Jewish Historical Society, New York, NY and Boston MA. Digital ID 262391.
8. Nurses' Settlement, Hadassah. Miss Kaplan in the foreground. Ben-Dov, Ya'akov – photographer, *c.* 1913; Record Group 18, Photographs, Hadassah Medical Organization Series, Hadassah Archives, American Jewish Historical Society, New York, NY and Boston MA. Digital ID 251747.
9. Eva Leon visits clinic as doctor examines a child's eye (Rae Landy and Dr Ticho center background). Ben-Dov, Ya'akov – photographer, *c.* 1913; Record Group 18, Photographs, Hadassah Medical Organization Series, Hadassah Archives, American Jewish

Historical Society, New York, NY and Boston MA. Digital ID 251751.

10 Nurse Rose Kaplan with members of local population, *c.* 1913–1915; Record Group 18, Photographs Hadassah Medical Organization Series, Hadassah Archives, American Jewish Historical Society, New York, NY and Boston MA. Digital ID 256542.

11. Arrival of French pilot Marc Bonnier and mechanic Joseph Barnier in a Nieuport airplane, the first aviators to fly into Jerusalem. Library of Congress, Prints & Photographs Division, [LC-M32-50063-x].

12. Two beggar women on their rounds, Jerusalem. Rose Kaplan – photographer, undated; Record Group 18, Group Portraits Series, Personal snapshots, Rose Kaplan-002, Photographs Series Personal Snapshots Subseries Rose Kaplan, Hadassah Archives, American Jewish Historical Society, New York, NY and Boston MA. Digital ID 262387.

13. Woman with children, Jerusalem. Rose Kaplan – photographer, undated; Record Group 18, Group Portraits Series, Personal snapshots, Rose Kaplan-003 Photographs Series, Personal Snapshots Subseries Rose Kaplan, Hadassah Archives, American Jewish Historical Society, New York, NY and Boston MA. Digital ID 262389.

14. Turk mili. [military] WWI. Street scene, Jaffa Gate. Library of Congress, Prints & Photographs Division, [LC-DIG-matpc-11594].

15. Miss Kaplan, Jerusalem, *c.* 1913; Record Group 18, Photographs Hadassah Medical Organization Series, Hadassah Archives, American Jewish Historical Society, New York, NY and Boston MA. Digital ID 251749.

16. Camel train in Jerusalem near Jaffa Gate. Incorrect data provided by the Bain News Service on the negative: 'Camel train passing thru Constantinople'. Library of Congress, Prints & Photographs Division, [LC-B2- 2549-2].

17. Evelyn Rosenblum visiting Rae Landy's grave at Arlington Cemetery in 1965. Photo courtesy Louis Rosenblum.

Introduction

Hadassah, Hadassah, Hadassah! You have been running through my mind every minute of the day and have been in my dreams every night.

Rae Landy, 1937

As a voracious reader growing up in suburban Cleveland, I was always drawn to books about girls who had adventures. I read everything I could get my hands on so I could disappear into the worlds of those courageous heroines. A complaint I often expressed was that my life was boring and nothing exciting ever happened to me. To stop my complaining, my mother often told me stories of my famous great-great-great aunt, Rae Landy, one of the first two nurses sent to Jerusalem by Hadassah in 1913. From the first moment my mother told me about this mysterious aunt, I felt a deep connection with her adventurous spirit, her rebellious nature and her exciting life.

Ten years ago I had the pleasure and privilege to write my master's thesis about this intrepid woman. I dug into the archives of the Western Reserve Historical Society in Cleveland and conducted lengthy interviews with Rae's niece, my distant cousin, the dear Evelyn Rosenblum (z'l). Evelyn spent a great deal of her childhood with Rae and had a close relationship with her. She spent hours telling me stories about Aunt Rae and generously shared photos and artifacts with me. I always felt Rae's life story would make a fantastic book and, over the years, I scoured the internet to find a book about her but no one had ever written one. Finally, I decided that, if I wanted the world to discover this strong, brave woman who accomplished such amazing things and took great risks, I would have to write the story myself.

It has taken a very long time to come to fruition. Since I wrote my thesis, the internet has exploded with digitized material that has made research so convenient. Each day that I wrote, I also looked for more material, and each day I found another nugget of information I wanted to add.

Yet, while I found so much archival material, I have very few of Rae's own words and thoughts. Unfortunately, while she kept a journal during the time she was in Jerusalem, she destroyed it before she left, an action she always regretted. I also regret it, as it compelled me to piece together her story from many different sources, sometimes getting only one detail or sentence from an artifact or a photo. At other times I stumbled upon a gem that included a new story about Rae that I had not seen anywhere else.

There are still many gaps in information about what daily life was like for Rae in Jerusalem. For these gaps, I used facts about what was going on at the time, who lived there and who came to visit. I used information about what others said they saw and then extrapolated, assuming that Rae must have seen those things too, being in the same place at the same time. If everyone in Jerusalem experienced or witnessed an event, then Rae must also have. Rae wrote, 'We met every visitor that came to Jerusalem.' And I took those words to heart. There were many prominent tourists visiting Palestine in the pre-War months, and so I have Rae meeting many of them.

Rae was one of the rare women of the early twentieth century who forged her own path through life. She was a very strong-willed, compassionate woman who had a great thirst for adventure, but the motives that drove her to make her decisions are undocumented.

Unlike most women of her generation, Rae never married, and while women remained single for a number of reasons in those days, we don't know what Rae's exact reasons were. She may have been like Jane Addams and Lillian Wald, who are known to have had intimate long-term relationships with other women. She may have had an experience like Henrietta Szold, who had her heart broken by the man she loved. We can, however, determine through Rae's choices that she was like many women in nursing at that time, who viewed their profession as a calling and dedicated all their energy to a higher mission, channeling their passion into their careers. Rae may simply have decided that having a husband would interfere with her sense of purpose in healing the sick in the most trying conditions. Whatever her situation, it is easy to presume that Rae felt a great deal of pressure from her very traditional family to marry, which may have played a part in leading her to travel to a very far-off land.

There is no known record of whether Rae had any romantic loves, but in Jerusalem she found a small community of women like her: strong, independent, single women, who were leaders, dedicated to serving the Jewish people. She formed close relationships with these women and felt a great kinship with them as they worked with a common sense of purpose. It was through the friendship and camaraderie of this tight-knit community of expatriates that Rae most likely received the affirmation she needed to realize she could live life the way she chose, not stymied by the mores of the larger society.

And what about her feelings regarding what she experienced and saw? In some instances, Rae talked about her feelings and thoughts, but often she was silent. However, feelings and emotions are universal and so when something happened that was joyful, that's how I had Rae experience it. And if something was devastating, Rae was devastated also.

The information we have about Rae and her nursing partner Rose Kaplan primarily comes from extracts of their letters that Hadassah published in monthly news bulletins for their members across the country. We don't have any complete letters, as those were lost or destroyed. Rae also gave two extensive speeches about her time in Jerusalem, one in 1937 and one in 1945. The Western Reserve Historical Society and the American Jewish Historical Society archives have copies of those speeches, as well as her notes from them. Those documents contain additional rich information about her experiences. And finally, especially in Cleveland, Jewish newspapers published many articles about Rae and also about the conditions in Jerusalem during the War. But there is still so much missing, so much we don't know.

All of the world events and personalities portrayed in this book are real and documented. Every one of Rae's achievements in Palestine is true. However, I used my imagination to fill in holes where there were no details. When and how often she did certain things is unknown. Whom she had dinner with and whom she talked to on a daily basis we don't know. When Rae met the many leaders and famous people in Palestine, we don't always have the full picture about these interactions. For these occasions, I used the facts I could find and extrapolated and used my discretion to create those stories. For example, Rae wrote in her notes she had met 'Ruppin and the Thons'. It is documented elsewhere that Arthur Ruppin made it a practice to meet every newcomer to Jaffa. With these two facts, I created a scene in which they all met and had dinner. Rae wrote one sentence revealing that she had visited Petach Tikvah and Rehovot. We don't know how long she

was there for and what she did there, so, using a variety of other sources and eyewitness accounts, I re-created her sight-seeing journey and shared what Rae would have seen and experienced.

This book is a work of love, a memorial to a great woman who never had children, who has no direct descendants to remember her, to say *kaddish* for her, to mourn her and to celebrate her life. Rae is buried in Arlington cemetery, a tribute to her years of selfless service as a nurse in the US Army, which she joined soon after her arrival back in the United States. But unfortunately, most of the world has no idea who she is. It is my hope that this book will serve as a way to recognize at least one chapter of her life, and document her great work and spirit.

* * * * * * * *

Rae Landy was born in either Sirvintai or Wilkomir, Lithuania on 27 June 1885. The two towns are about twenty-five kilometers apart, but sources conflict about in which of the two places she was actually born. Rae immigrated with her entire family to Cleveland, Ohio, in 1890. Like so many other Jews of this era, the Landys, who promptly changed their name from Landsman, came to America to escape persecution and make a better life for themselves.

Always restless and looking for new challenges, Rae defied social convention. She first demonstrated her independent nature when she entered medical school –something which was almost unheard of for women at that time. When her family couldn't pay for her to complete her training, she switched to nursing and was in the first graduating class of the Jewish Women's Hospital in Cleveland, which later became Mt Sinai Hospital. A couple of years after graduating, she moved to New York to work at the newly opened Harlem Hospital. There she quickly rose to assistant superintendent of nursing. And yet, that was not enough for Rae.

When the newly established Daughters of Zion (Hadassah) advertised for a nurse to travel to Palestine to set up a district nursing system, Rae jumped at the opportunity for a new adventure. She spent two and a half years in Jerusalem, witnessing the conflict and changes during an historic time period, before she was compelled to return home to America.

PART I

1913

In which Rae is selected to go to Jerusalem:

'Hadassah Chapter, Daughters of Zion, of New York, of which Miss Henrietta Szold is president, has achieved a notable success in starting a movement to provide Palestine with a system of district nursing. Two nurses are now on their way to Palestine.'[1]

Chapter One

The Beginning

18 January 1913

Rae Landy had to pinch herself as she shivered in the frigid January air. The shrill sound of seagulls and crude shouts of dock workers surrounded her as she stepped up the gangplank of the RMS *Franconia*. Her hazel eyes sparkled and watered from the icy gusts blowing up from the open sea. Tendrils of hair escaped from her carefully made-up bun and whipped out from under her wool hat and into her face. Rotting fish and burning oil wafted around her, and she wrinkled her nose at the unfamiliar rancid smell. She heard a shout and looked up at the deck of the ship. Her traveling companions, whom she had met only a couple times in the past few days, were waving to her, welcoming her aboard. Her pace quickened as she made her way up to the ship more confidently.

The *Franconia* rose above her, towering over the harbor, teeming with men and women who were about to embark on the long journey to Constantinople, Alexandria and then finally on to Jaffa. Such foreign sounding names, ones she had only read about in her school books, would now become part of her world. It was hard to imagine that just ten days ago she was living a quiet, ordinary life; as quiet as one could live in bustling Manhattan, and now she was boarding this majestic ship about to leave for Palestine to set up a nursing program with virtual strangers, on whom she was going to have to rely for the next couple of years.

Just two weeks ago she was working as assistant superintendent of nurses at Harlem Hospital, socializing with friends after work and attending meetings to discuss new ideas on Zionism. It was then that she had learned that a Zionist women's organization was searching for an adventurous nurse to travel to Palestine to set up a district nursing

system in Jerusalem. And now, only a few short days later and after a whirlwind of activity, she was on her way to that near-mythical land of Palestine to take part in the creation of a Jewish homeland.

As Rae stood on the deck and gazed around her, she realized that the last time she had been on a ship was when her parents brought her and her brothers and sisters to America from Lithuania. Since she had been only five years old then, she didn't remember much about the trip. But this first-class, luxury voyage she would remember forever.

Rae heard her name called again and she looked up. Two well-appointed women stood in front of her, wearing long wool coats to protect themselves against the windy January weather. Eva Leon and Rose Kaplan smiled and took her by the hand, leading her to the two others in their traveling party who were standing among a small cluster of people on the upper deck. Mr and Mrs Nathan Straus both smiled when they saw her. Mr Straus shook her hand vigorously and Lina Straus gave her a warm hug. Mr Straus then directed Rae to follow Miss Kaplan and Miss Leon to her cabin to stow her bags. He requested that the ladies return as soon as possible. He gestured towards the small group of people that was standing around him and explained that they were from the *New York Times* and were going to take some photographs for an article that would appear in the paper.

Rae was astonished by this announcement. *The New York Times?* She had realized that she was about to embark on a grand adventure but she had thought about it only in personal terms, what it meant to her and her family; now she was beginning to understand that this was more than just about her. She began to feel nervous for another reason. She realized she was being handed a responsibility that the whole world would be watching. She took a deep breath and traipsed after the two women, carrying her valise along the promenade and through the entranceway of the ship.

A wide mahogany staircase with a wrought iron banister led down to their first class stateroom. Rae was wide-eyed, marveling at the vastness of the ship. It was unbelievable that a structure this size could stay afloat. It seemed as if the ship could carry a small city. They walked down a blue- and white-tiled corridor and stopped in front of Rae's cabin. She opened the door and peered in. Again she was amazed at the luxury of the accommodation. She was thrilled that this spacious cabin was going to be hers and hers alone for the next three weeks. She walked around the room, running her hands over the single bed, wardrobe and dresser. She was surprised to see there was a bathroom right in the cabin. The room was well heated, which was a comfort

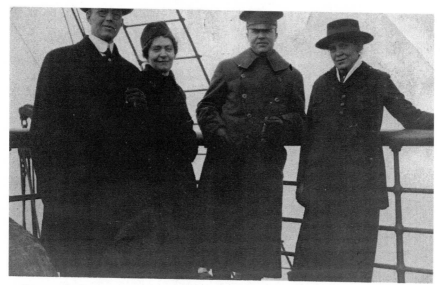

Rae on the *Franconia* with traveling companions; courtesy of Diane Rosenblum.

after the cold of the upper deck.[2] She sat down on the thick mattress and bounced a little. With a deep sigh, she exclaimed that she might never want to leave this room. The Strauses certainly had not spared any expense for this trip. Their generosity and desire for the women to travel comfortably was an unexpected surprise.

After quickly unpacking her belongings in the cabin, the three women returned to the upper deck where the reporters were anxiously waiting for them. They quickly posed for photographs and answered the reporters' many questions about where they were going and what they would be doing.[3] As the ship's horn blared, the reporters packed up their gear and wished them well. The traveling party gathered with the rest of the passengers at the rails of the deck and waved good-bye to those who had come to send them off. Rae later wrote, I 'felt rather sick at heart wondering just what I was setting out for. I'm leaving my family and friends. My only consolation is that I was going to be in Palestine and work for my own people.'[4]

* * * * * * * * * * *

The previous two weeks had been something of a blur. Rae's adventure had begun when she saw a notice at the hospital calling for two Jewish

nurses to travel to Palestine and establish a district nursing system in
Jerusalem. The announcement had caught her eye but she had only
given it a fleeting thought. When she went to her weekly Zionist study
group meeting, however, in the midst of the conversation about
Zionism, she remembered the flyer and mentioned it to the group.

The Zionist organization she belonged to was not the first she had
attended. It had taken her a while to find a group with whose members
she felt comfortable. It was hard for Rae to find women she felt at ease
with, women who weren't preoccupied with talk of marriage and
children, always looking for a man who might propose. In New York
City, at that time, she was lucky, though – there were many groups to
choose from. Between 1898 and 1914, there were 125 Zionist societies
of which 90 lasted only one or two years.[5]

These study groups were concerned with issues of Jewish identity
and support for a Jewish homeland. The writings of the pioneer Zionist
leaders coupled with the news of pogroms in Russia and the deluge of
Russian refugees pouring into the port of New York had sparked great
excitement throughout the city. Women, especially, were involved in
forming these groups.[6]

Many women like Rae joined study groups to learn about Palestine
and the situation of Jewish communities throughout Europe. It was out
of these women's societies of Harlem that the nucleus of the national
women's Zionist organizations was created.[7] The women learned about
Leon Pinsker, who had written a pamphlet in 1882 championing the idea
of 'auto-emancipation,' arguing that the Jews were foreigners in every
country in which they lived and the only way they could ever be free of
the hatred of those around them would be if they had their own country.
They learned about Theodor Herzl, considered the father of Political
Zionism, who wrote a book in 1896 called 'The Jewish State' advocating
for Jews from around the world to create a Jewish State in Palestine.

On the evening when Rae remembered the flyer, the women had
been discussing the merits of the arguments put forth by some of these
prominent Zionist leaders. Which was a more effective strategy for
establishing a Jewish homeland? Was it better to go to the powerful
governments of Europe and ask for permission to build a homeland, as
advocated and worked for by Leon Pinsker and Theodor Herzl? Or
should Jews simply go to Palestine without permission from anyone,
purchase land and build the country themselves, with their own hands,
as A.D. Gordon espoused? The women debated furiously about the
merits of both strategies. When the discussion reached a fever pitch
and the women grew a little too heated the leader ended the discussion

for the evening and the women began to chat as they did at the end of every meeting.

As Rae mentioned the notice she had seen about the opportunity to travel to Palestine, she realized the flyer was speaking directly to her. Why, after all, would she even mention it if it wasn't? It was clear that the group which was looking for nurses –Daughters of Zion, Hadassah Chapter –was very different from her own group. It had been formed only the previous year, in 1912, and was led by a woman named Henrietta Szold. Daughters of Zion was quite ambitious. They met and talked but, crucially, they also took action. They had actually raised funds to send their two nurses to Palestine. This was truly extraordinary!

As Rae discussed the news with her friends and articulated her feelings about it, it seemed ridiculous that she might consider abruptly giving up everything she had in New York to travel to a backwards place to attempt something that no one had done before. But, as she talked, she slowly began to realize that this was what she had been searching for. She tried to maintain her composure and not to show the excitement that was building up inside her as the women all exclaimed that this opportunity was meant for Rae. They pointed out to her that she fit the profile for the position perfectly.

They were right, Rae thought. These ladies had really begun to know her. At first she had been a quiet observer at the meetings, learning about Zionist ideas and hearing the other women's opinions. But more recently, as she had become more familiar with the theories and had heard the women sharing what they had learned, she had felt a gnawing need to act. She had begun to ask questions about what the women could actually do. She commented on the excessive talk and the lack of action within the group. While no one in the group shared her desire to actually do something other than talk, they recognized her restlessness. As they now listened to Rae talking about the project, they understood this was something she had been waiting for. As an accomplished nurse, she was made for the job.[8]

As Rae considered the opportunity she felt more and more strongly that it was the ideal time in her life to begin thinking about a new situation. She had been appointed assistant superintendent of nursing at Harlem Hospital just a few months earlier. She had been hired as a staff nurse at the new 150-bed Harlem Hospital when it had opened in 1907[9] and, since then, she had been promoted twice, to nurse manager and then, just a few months before, to assistant superintendent.[10]

Over the previous five years, despite the promotions and challenge of her job, she felt that her life had settled into a mundane routine and,

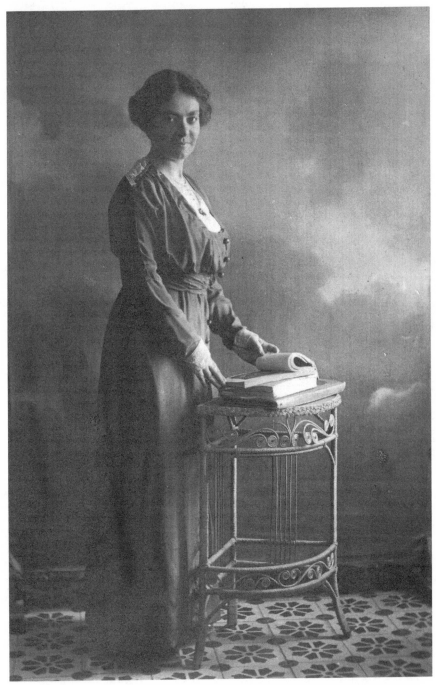

Portrait of Rae as a young woman; courtesy of Diane Rosenblum.

again, just as she had in her home town of Cleveland, she felt a noose tightening around her neck. She felt suffocated by the routine of her days. She yearned to find a new challenge. Even the social life and the politics swirling around her did not provide a sufficient outlet for her energy and sense of needing more. The constant gnawing desire to take on a unique challenge in her life, to live with a sense of anticipation of every day as a brand new adventure was something that she had experienced since she was a child.

She had thought that moving to New York would quell that feeling and bring her some joy and it had, at first. The year 1913 was an exciting time to be in Manhattan. The city was bustling with new immigrants. The Jewish community had grown exponentially over the previous few years and vibrant neighborhoods flourished all over the city. The Jewish population of New York was over 1.5 million strong. Harlem, where Rae worked and lived, was fast becoming one of the major centers of the Jewish community. Rae had soon discovered that Harlem was the place to be. Streams of Jewish immigrants were moving to the neighborhood and it was becoming known as the 'second ghetto'; second, that is, to the Lower East Side.

These Jewish immigrants were very active, both politically and culturally,[11] creating a hotbed of socialism, union activity and the beginnings of American Zionism.[12] Rae had thrived in this environment, attending meetings and often participating in political discussions. But while she now felt at home in this vibrant city and loved her work at Harlem Hospital, she was ready for a new challenge.

Life had just grown a little more complicated since a doctor at the hospital had mistaken their close friendship for love and had asked her to marry him.[13] She had been surprised at the proposal, unaware that she had sent any sort of amorous signals, but she had no intention of marrying. She felt puzzled. Couldn't he see that she was not the marrying type? She had other things to do with her life; the idea of settling down and giving up her career to cook and clean his house did not interest her. She had ambitions and dreams. As gently as she could she had rebuffed his proposal and made him promise to remain friends. She now had to see his hurt face every day. Maybe this opportunity to travel to Palestine would be a convenient way to extract herself from an awkward situation. After much thought, she concluded that she was ready for this new adventure. And so, with great anticipation, Rae applied for the job.

On Wednesday 8 January 1913, in preparation for her interview, Rae put on her best suit and checked the mirror several times to make sure that not a hair was out of place. She walked briskly through the crowded streets of New York until she arrived at Henrietta Szold's home. As she walked up the steps of the non-descript brownstone building her heart was pounding. She knocked on the door. She took some deep breaths to calm herself as she waited. Now that she had decided this job was for her, she desperately yearned to be selected. What could she say to convince her interviewers that she was the person they had been searching for? She wiped her moist hands on her wool coat just as the door opened. There in front of her was Henrietta Szold herself, the founder of Daughters of Zion, Hadassah Chapter.

Miss Szold was about fifty-three years old with a plain face and strong, piercing eyes. She was the executive secretary of the Jewish Publication Society, which published many highly regarded books about Jewish history and Jewish life in America. She was also the secretary of the Federation of American Zionists. In both organizations, she was the only woman on the executive committees. She was known in New York as one of the most influential Jewish women of her time.

In 1909, Miss Szold had traveled to Palestine with her mother. It was then that she realized that the future of the Jewish people depended on the creation of a homeland in Palestine. But she also saw the deep poverty and need in the land. Her mother had encouraged her to take action to alleviate some of the poverty and disease they encountered. When she returned to the United States she became consumed with finding a way to make a difference in Palestine. The founding of this new Daughters of Zion organization was her way of making Palestine ready to become the Jewish homeland.

Miss Szold politely greeted Rae and invited her in. As she was led into the parlor she saw an older couple seated on a sofa. They rose as she entered and shook her hand. They introduced themselves as Nathan and Lina Straus, the benefactors of this venture.

During the course of the interview, Rae learned that the women of Daughters of Zion, Hadassah Chapter were committed to action. They believed that women could do more than talk about Zionism; they could play a very important role in helping the pioneers who were building a homeland for the Jewish people. Miss Szold talked about her trip to Palestine in 1909 and how the misery and poverty she saw there inspired her to come home and convince her friends in her Zionist study group to form a new group that would be committed to action to alleviate the situation in Palestine.

Just the previous year, in February 1912, the organization had been formed with thirty charter members and they had elected Miss Szold to be president. The group decided to concentrate on providing health services to the people of Palestine and adopted a motto, 'the healing of the daughter of my people'. Both Miss Szold and the Strauses shared anecdotes of what they had witnessed in Palestine during their respective trips.

The Strauses had only recently returned from their journey in 1912. They elaborated on their sentiments about the heartbreaking poverty of the Jewish people, the malnutrition and disease they found in Jerusalem and the need for maternity care. Miss Szold then explained that the goal of Hadassah would be to set up a nurses' settlement and district home-nursing system in Jerusalem. They envisioned an institute of public health servicing people in the poor neighborhoods of the city. It was their hope that sending nurses to Jerusalem to set up a district nursing system would be a rallying cry for the Jewish women in America. Adopting this cause was a way they could tangibly help their people.

Mr Straus, who was a co-owner of both the famous Macy's and Abraham & Straus department stores, among other successful ventures, related that, while he had been financially successful in business, the work he was most proud of and passionate about was children's health and nutrition, particularly in the area of milk pasteurization. He described his mission to fight against unsanitary contaminated milk that was killing so many children in New York and in cities across the country. He told Rae about his crusade to have the government mandate that all milk be pasteurized so that children wouldn't die needlessly.

He explained how he had built upon his expertise in milk pasteurization and nutrition to open a soup kitchen in Jerusalem, feeding the most needy in the city. Now he wanted to fund the establishment of a district nursing system that could add a new level of service in Jerusalem. That would be only the beginning, however. The district nursing system could then expand across Palestine to other cities and the new Jewish colonies, where people were suffering from malaria and typhoid fever.

The Strauses and Miss Szold had become connected when Miss Szold had read a notice in a Jewish newspaper that Mr and Mrs Straus were planning to return to Palestine in January 1913. She decided that it would be a good idea to inform Mrs Straus about the ambitions and goals of Daughters of Zion, Hadassah Chapter to send nurses to

Palestine. She had a friend who knew Mrs Straus and a meeting was arranged. The result of this meeting was Mr Straus's offer to finance the traveling expenses and four months' salary for one nurse. The agreement was that Hadassah would finance the rest of the year's salary.[14] The women of Hadassah had eagerly accepted the proposal. Through donations from other generous Zionists, Miss Szold was able to secure enough funding to send one nurse for an entire year.

Then, Miss Szold explained, she cabled Eva Leon, another founder of Hadassah, who was in Chicago sharing tales of her recent trip to Palestine. She directed Miss Leon to solicit funding for a second nurse. With her gift of oration, Miss Leon was able to convince the Chicagoans, some of them even non-Zionists, to fund a second nurse. They raised two thousand dollars annually for five years to ensure that two nurses would be able to have a sustained opportunity to set up their settlement house in Jerusalem.[15] And now they were searching for the two women who could carry out the mission.

With each additional detail Rae became more and more elated. This was exactly what she wanted to do. The system of district nursing was familiar to Rae. She knew very well about Lillian Wald, who had set up a district nursing system in New York City. District nursing had been established in several large cities in the US as a way to serve the poor, not simply by tackling disease and promoting health but by addressing the challenges of poverty itself. By creating a system of self-reliance, the poor citizens of the city could learn to take care of themselves. The settlement house provided services not just related to home health and hygiene but also for vocational training, education and recreation for children. In the early 1900s, visiting nurse services were established in many communities across the United States and Jewish nurses played a big part in this social welfare movement.[16] Miss Szold had carefully studied the work of Lillian Wald and felt that this model would be a perfect fit to serve the poor of Jerusalem.

During the course of the interview, Miss Szold asked Rae why she believed she was suitable for this very unique assignment. Rae was well prepared for this question. She related the events that had led her to this meeting.

Rae had become a nurse through a circuitous route that began when she had spent several months in the hospital as a young girl. She had run into the street without looking and had been hit by a fire truck. Her injuries had forced her to stay in the hospital for many months to recuperate and it was there that she had learned English. She greatly admired the nurses and doctors who took care of her and had taken

the time to teach her to speak the language of her new country. When she was finally released from the hospital, able to speak fluent English in addition to her first language, Yiddish, she had a dream of becoming a doctor.

After completing high school, she convinced her father to send her to medical school. In those days it had been almost unheard of for a woman to be a doctor. She was proud to have been accepted to the Cleveland College of Physicians and Surgeons and began studying medicine with very high hopes.[17]

Unfortunately, the cost of medical school had been too great for her family and, at the end of the first year, she had to withdraw. While she was greatly disappointed, she soon found nursing school to be an adequate substitute and outlet for her curiosity and avid appetite for learning. She completed her studies in 1904 at the newly founded Jewish Women's Hospital in Cleveland. For her first job, Rae worked as an operating room nurse for Dr George Crile, medical pioneer and founder of the Cleveland Clinic. She also served on several of his private cases.[18]

When Dr Crile recognized her leadership qualities, integrity and character, she was quickly promoted to head nurse. As Rae's siblings began to marry and have children her parents started to ask her when

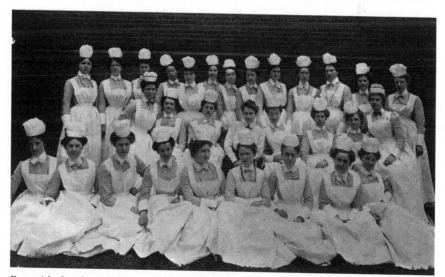

Rae with the class of the Mt Sinai Hospital Training School, Cleveland, Ohio, *c.* 1902. Rae is in the back row, fifth from the left; courtesy of Diane Rosenblum.

she would do the same. Rae had other ideas. She craved something more, something that would fill her soul and she spent many hours explaining to her family that she felt she needed to concentrate on her career.

In 1907, when she learned that a new hospital was being opened in New York City, she considered this the opportunity she had been waiting for. She sent an inquiry for employment and soon received an offer to join the staff of the new Harlem Hospital on Lenox Avenue in Manhattan.[19] Her family was devastated when she announced that she would be leaving Cleveland. She argued with them that this was the right move for her and that, even if she stayed in Cleveland, she was not about to get married. She had bigger things to do in her life. She finally convinced them to let her go, sad in the acknowledgement that this daughter of theirs had always gone her own way.

Rae quickly became acclimated to her new place of employment at Harlem Hospital. She was impressed by the spacious rooms and corridors and thrilled with the overall cleanliness of the new hospital.[20] She made friends easily with the other nurses and cared for her patients with great skill. As in Cleveland, within a year of being at Harlem Hospital, at the age of twenty-four, she was promoted to head nurse. Four years later she became assistant superintendent.

Rae explained to the Strauses and Miss Szold that she often wondered, as she contemplated her career, what it was about her that others saw and recognized as her potential for more. She looked at her colleagues, women who were very satisfied working with the patients and being staff nurses. She suspected that her desire to push herself and her determination to accomplish tasks with quality and integrity were the traits that people recognized. But whatever it was, she was very grateful for the opportunities that she had been given and she always made sure she did an excellent job, in whatever role she worked.

As Rae shared her history, she observed that her interviewers were glancing at each other with knowing smiles. She perceived from her interviewers' words and the way they were talking that they were considering her as a serious candidate. They nodded their heads enthusiastically as she expressed her interest in the ideas of Zionism and her longing to do more, especially for her own people.

Then came the most difficult part of the interview –Miss Szold revealed that the stipulation for the position was that she had to be ready to set sail with Nathan and Lina Straus on 18 January, only ten days from then.

On being offered the job, Rae was astonished when Miss Szold added a condition: she needed permission from her parents before they would let her go. Rae was indignant, protesting that she was twenty-eight years old and lived independently and that she had been on her own for years. Certainly she wouldn't need her parents' permission. But the group was adamant that her parents not only be aware that she was embarking on this journey but that she had their blessing.

Mr Straus inquired if she really wanted to take on the assignment. Could she make this commitment, settle her affairs, take a train to Cleveland to secure permission from her parents and be ready to set sail with them in ten days?

Rae seriously contemplated the absurd request they were making. She would have to race to settle her affairs in New York, ending five years of her life there, finding someone to take her apartment, resigning from her job and telling all her friends what she was going to be doing. Then she would have to rush to Cleveland and dash back – all this in only ten days. She looked at Miss Szold and the Strauses to see if they were serious. They, in turn, looked back at her, as solemn as she had seen them during the entire meeting. After a few minutes of thought, Rae swallowed her pride and agreed to their conditions. Of course she could, she thought to herself – anything to set sail to Palestine as one of the two nurses!

Rae learned that she was one of twenty-one applicants.[21] If she were unable to be ready in that short amount of time or had second thoughts about accepting the challenge there were other nurses who could take her place. Rae assured them that she would be prepared to travel in ten days. The meeting concluded. Rae shook hands with the three benefactors and hurriedly left to prepare her letter of resignation.

The next morning, when she submitted her resignation, her boss and colleagues looked at her in disbelief. They couldn't comprehend how she could be uprooting her life like this, not only because she was heading to an unknown land where people were living in dire poverty, but also because she was doing it all so hastily. She hadn't been known to her colleagues and friends in New York as an impetuous person but this certainly appeared to be foolhardy act. They cautioned her to think carefully before making a final decision.

Rae reflected that while Daughters of Zion had raised the money and said it would support her for two years in this endeavor, it was a brand new organization. Who knew if it would stand by its word? Who knew if it would even exist after a year? She had certainly seen similar groups disappear without another thought being given to them. What

if she ended up stuck in Palestine without any money or means of support? What would she do then? On the other hand, she was traveling with the famous Nathan and Lina Straus. They were certainly people of reputation and means. Mr Straus was one of the most influential people in America. They wouldn't leave her stranded. The more Rae thought about it, the more confident she was that this was for her. She was convinced that accepting this position was the right thing to do.

<p style="text-align:center">* * * * * * * *</p>

Rae sat on the train heading to Cleveland. As it rumbled swiftly along the tracks, Rae planned what she needed to say to her parents to convince them that this was the right step to take on her life's journey.

When she had left Cleveland five years before for the opportunity at the new hospital, she had worked hard to explain to her parents her need for a different kind of challenge. Life in Cleveland did not satisfy her. While they did not understand, in the end, they had acquiesced when they saw that Rae would not change her mind. Now she was going to have to explain to them that even life in New York had not been enough to satisfy her.

When Rae had arrived in New York she had been expecting an adventure – and it was at first. While Cleveland was a bustling city, brimming with new immigrants, factories and the buzz of people making money, New York was a different kind of city. It was full of miles and miles of buildings and skyscrapers and crowds of people that never ended. Now Rae sought further fulfillment, further exhilaration in her work.

Rae surprised her parents when she arrived at their Woodland Avenue home on the East Side of Cleveland. Woodland was still the heart of the Jewish community and many Jewish-owned stores were located there. Her family lived in a shabby building where her father had his Hebrew bookstore on the ground floor; her parents and youngest sister lived in the apartment above. At first they were thrilled to see Rae, embracing her tightly. But when they heard the reason for her trip home to Cleveland, they were dismayed.

Rae's father, Jacob Landy, was adamantly opposed to the idea. Rae was taken aback. Her father was a good-natured man who often sang while he worked. He didn't raise his voice very often and was more likely to leave her mother to deal with disciplining the children, preferring to remain calm himself. He was a sofer, a scribe of Jewish

letters, and a devoted Talmud scholar. He had opened this bookstore so he could earn more money to support his large family. He did not understand his daughter's desires and her impetuousness. It was hard for him to reconcile her unconventional decisions with his own outlook on life.

Her mother agreed more readily to Rae embarking on the journey to Palestine. How could she not? She was the one who had taken her children door-to-door collecting dimes from their neighbors in order to support the establishment of a home for the Jewish elderly, later known as Menorah Park. She was among a group of women in Cleveland who was building a system of self-reliance in the Jewish community. Rae reminded her mother that, as a child, she would walk the streets with her every Friday, carrying a basket and collecting food from other families and businesses to make up packages to give to poor families for Shabbat.[22] Rae asked her mother how she could deny her this opportunity when all she wanted was to take care of her own community.

Rae's father pointed out that, to his knowledge, no one went to Palestine unless they were ready to die and wanted to be buried on the Mount of Olives. He didn't believe in Zionism, especially if it meant his daughter leaving the United States. He went on, exclaiming that he and her mother had brought Rae to America so she could have a better life than the one they could have in Lithuania. They had brought the family here, risking everything. And now she wanted to leave this wonderful country?

And it was true. Her parents had sacrificed their whole lives, arriving in Cleveland with nothing; they had spent a lifetime working hard to support her and her siblings. They were part of the wave of Jewish immigrants who had fled Russia and neighboring countries to escape the pogroms. These anti-Jewish riots had terrorized Jewish communities all over Russia and Lithuania causing thousands to leave for America. In America, they were free to observe their religion without fear of persecution; with hard work and the freedom that America had offered, the Landy family had prospered.

Rae's parents had paid for her education to be a nurse and were so proud of her – twenty-eight years old and already assistant superintendent of nurses for a big hospital in New York City. How much more could she want from life? Deep down they still wished that she would marry and even now, after years of asking and begging and finding matches for her, they held out hope that she would find someone to love. While she certainly had a respectable job as a nurse,

this time it was clear that Rae was not going to settle down and be relegated to a peaceful life of predictability.

Rae knew there was only one way to soften her father. She began to cry.[23] He hated tears. Through her sobs, she appealed to his sense of needing to help those less fortunate, especially those living in Palestine. By appealing to their value of Tikkun Olam, making the world a better place, her parents finally understood that they were the ones who had built the foundation for Rae's aspirations and longing to do this type of work. In the end, they sighed: yes, she could go. But, they implored her, for G-d's sake, please be careful.

On the train back to New York, Rae was jubilant and giddy with excitement. She had done it; she was ready to go. Thoughts swirled around her brain as she tried mentally to organize all the things she would need to do before she set out on her journey. Once back at her flat in New York, she quickly packed her trunks, sub-let her apartment and said a tearful goodbye to all her colleagues and friends.

Two nights before they sailed, Rae went back to Miss Szold's apartment for a farewell party. Rose Kaplan, the other nurse who had been hired, greeted her at the door. Rae had met Rose a few days earlier at a second meeting with Miss Szold and the Strauses. Rae was flattered that, in addition to some board members of Hadassah, her former boss, the superintendent of nursing of Harlem Hospital, had come to bid her farewell.[24] The evening flew by quickly, and now, only two weeks after she had first heard about the opportunity, she was boarding the RMS *Franconia* for Palestine.

Chapter Two

Journey to Jerusalem

At dinner that first night, in the luxurious mahogany-paneled dining room of the *Franconia*, the traveling party began to get better acquainted. Rose Kaplan had been the first nurse to be chosen for the mission. Rose, who was in her late forties, was a short, stocky woman who dressed conservatively. She had a plain face and a rather pointy nose. She spoke softly but authoritatively. Rae learned that Rose had been working at Mt Sinai Hospital in New York City before applying for this mission. She also was unmarried and was eagerly anticipating the work they would be doing in Jerusalem. Rose had immigrated to America from Petrograd, Russia, when she was twenty-five years old, escaping from the pogroms and persecution.

Rae wondered why, after experiencing the hardship of life in Russia and then the freedom and security of America, Rose would be so anxious to leave the US. She wondered why she wouldn't be relieved to live in a place without fear and establish herself there. Maybe she, like Rae, burned with a desire for something more in life.

Rose shared her life story; once she had arrived in the United States, she had entered nursing school and driven to make something of herself so as not to be relegated to a life of hardship and drudgery in one of the many garment factories in New York with its back-breaking work and soul-draining life. She related her experience of being a nurse during the Spanish-American War in 1898 and being sent to the Philippines. There she had cared for the hundreds of soldiers who were ill from malaria and yellow fever. She was devoted to nursing those who had great need. Yes, Rae thought to herself, Rose was a kindred spirit. She was sure they would get along.

Rae turned to Eva Leon, their chaperone. Eva was the woman whom Miss Szold had told Rae about, who had raised the money for

the second nurse from her contacts in Chicago. Rae expressed her
gratitude to Eva for her fundraising efforts and Eva glowingly waved
off the thanks, saying it was just part of what she did. She enjoyed the
praise and the feeling that she was a major contributor to this venture.
She spent a great deal of time explaining to Rose and Rae that she had
been retained by Mr and Mrs Straus as the chaperone for the two
women in order to help them get established in Jerusalem. Because she
had been born in Syria and had lived for years in Jerusalem, her
familiarity with Jerusalem would be an asset in getting the nurses
established. She had been in Palestine just the previous year and had
cared for the people at the Straus Soup Kitchen. Also, she said, in
addition to French, English, German and Italian, she spoke Arabic and
Spanish.[25]

Eva certainly did not lack self-confidence, Rae mused. She thought
that Eva appeared to be 'like the Rock of Gibraltar',[26] steady and sure,
confident about the welcome they would find in Jerusalem and the
success of their work. Rae was relieved that someone in their group
was familiar with their destination and would help them to acclimate
to life in Jerusalem. With Eva as their anchor, the adventure felt a little
safer. It was thrilling to be with these two very strong women who, like
Rae, had chosen to live their lives very differently.

Soon it was Rae's turn to share. She recounted her full name –
Rachel Diane Landy, though no one ever called her Rachel. She had
been born in 1885 in a small town in Lithuania to Jacob and Eva
Trotsky Landsman, the fourth of seven children. Her father, one of
eleven brothers from Kovno, Lithuania, was a *sofer* (scribe of Jewish
writings). In 1890, when he learned that a *sofer* was needed in
Cleveland, Ohio, he set off for America with his wife, Eva, and his five
children. In Cleveland, two more children were born.

Rae was particularly proud to share the story of her brothers'
enterprising spirit in helping the family earn a few extra pennies.
Throughout her childhood, Rae had accompanied her two older
brothers going door-to-door selling a piece of stationery and an
envelope for a penny. They would also offer to write letters back to
Europe for the customers because they knew both English and Yiddish.
Her family really struggled in those days, as did many immigrant
families who lived in the Woodland area of Cleveland. However,
despite their poverty, her family was very close. Rae had fond memories
of her childhood, following her big brothers in their enterprising
endeavors and accompanying her mother as she collected money for
the Jewish old-age home.[27]

Mr Straus took out a piece of paper from his pocket and read to them the article that would be appearing in the *New York Times:* 'The two nurses would devote themselves to the needs of women and children, organize the work of midwives, train helpers and probationers, organize and conduct mother' circles and give illustrated health talks in schools and homes of the new Jewish colonies in Palestine.'[28]

Then Mr Straus showed them the *The Maccabaean Magazine*, the journal of the Federation of American Zionists.

> The present object is to organize a thorough system of district nursing throughout the towns and colonies of Palestine, beginning with Jerusalem. The first two nurses will co-operate with the Health Bureau established by Mr Straus. This is a work that is most essential in the present state of development in Palestine, and Hadassah deserves great credit for realizing it. It is a work in which all humanitarians, Zionists or not, ought to participate.[29]

It was clear from these two articles that they were going to be observed by the entire Jewish community in America as they embarked on their work. Rae reflected that they had to make sure they were successful.[30]

The journey to Palestine on the *Franconia* was very pleasant. Mr Straus told them that the ship was one of the best on the Atlantic. Rae was amazed to learn that it could hold three hundred first-class passengers. There were many amenities for them, including a gymnasium, which was the first of its kind on an ocean liner.[31]

Rae and Rose passed the days enjoying Mr and Mrs Straus' company and becoming better acquainted with one another. They explored every inch of the ship, marveling at its accommodations and size. After walking the broad, covered promenades lining the ship, they often retired to one of the sun-drenched lounges, sitting on cushioned chairs and settees, drinking coffee and snacking on nuts and fruit. In the evenings, the electric lights would flicker on, bathing the rooms in a warm yellow glow. They enjoyed exquisite dinners, starting with the fanciest hors d'oeuvres Rae had ever seen. Some evenings they ate turtle, while on others they were served cauliflower soup. They feasted on succulent lamb and beef ribs, mashed potatoes and vegetables, topped off with desserts of French tarts, ice cream and wafers.[32] At each evening meal they were serenaded by musicians who were seated in the upper balconies of the dining room, playing the latest songs by Irving Berlin and Al Jolson. After dinner, they

remained at their table, watching the guests whirl around on the special dance floor.

As Rae became better acquainted with her traveling partners, she grew to admire and respect both Miss Leon and Rose. Unlike Rae, Rose declared that she was not a Zionist and wasn't political in any sense. She was doing this job because of her determination to help her people but her motivation had nothing to do with building a Jewish homeland. Rae realized that, despite their political differences, Rose's dedication to helping the Jewish people and her sense of adventure and need for excitement made her a perfect partner.[33]

She also reflected that, between Eva's accomplishments in Palestine and all her worldliness, and Rose's war adventures, she would have to work hard to contribute something unique to this high-achieving group. Rae was determined not only to keep up with her two companions but to excel in her contribution.

One day, about halfway through the trip, Rae happened upon Mr Straus sitting in the smoking lounge. He appeared deep in thought and didn't even notice her for a moment. As she continued to walk through the room, careful not to disturb him, he started, awakening from his reverie. He looked at her. Rubbing his eyes and smiling weakly, he motioned for her to sit in the chair next to him. She did as she was asked and Mr Straus began to talk. He told a story that brought Rae to tears. Mr Straus' brother, Isidore, and his dear wife had perished the year before in the Titanic disaster. Mr Straus himself had been scheduled to be on that ship but, at the last moment, he and Mrs Straus had decided to remain in Europe and take a detour to Palestine. When he learned that not only had his brother perished but that he had gallantly given up a seat in a lifeboat he was heartbroken. His brother's wife, a survivor told him, had refused to get in the lifeboat, insisting on staying with her husband; she had perished alongside him.

From that moment on, Mr Straus said bleakly, he had been seriously contemplating giving up on all of his business ventures and devoting the rest of his life to philanthropy and helping those less fortunate than him.[34] Rae welled up with emotion at his story. She swallowed hard, wiped her eyes and patted Mr Straus on the shoulder. She had admired Mr Straus very much but had not understood his motives so clearly before. She vowed to make him proud and feel that his investment in her and Rose would be a valuable and useful one.

As they grew nearer to their final destination, the Strauses informed the ladies they would not be continuing on with them to Palestine. They wanted to stay in Alexandria and direct their work from Egypt. They

reassured the nurses that Miss Leon would take very good care of them and that they had cabled their contacts in both Jaffa and Jerusalem to be expecting their arrival.

On Sunday 2 February, the ship reached Naples, Italy,[35] where the party spent the day touring around the city. When the ship reached Alexandria, they took a train down to Cairo and Giza where, with trepidation, they mounted camels and rode to see the pyramids.[36]It was a thrill to see the ancient monuments and an experience Rae knew she would never forget. After their camel adventure, the party returned to Alexandria. The Strauses accompanied the women to the port to see them off on the final leg of their journey. They made sure Eva had all their letters of introduction to the people in Jerusalem who would help them in their endeavors and ensured they had the packets of money that would allow them to get started. After all these weeks of traveling together, the small party had come to know each other quite well and all of the women had grown very attached to the Strauses. The women said a tearful goodbye to their generous benefactors and reluctantly boarded the ship without them. Eva, Rae and Rose were now on their own for their journey to Jaffa and then on to Jerusalem.[37]

The *Franconia* arrived in Jaffa on 8 February 1913. As they drew closer to the shore, Rae scanned the horizon for the port. Much to her surprise, Jaffa had no harbor; the ship anchored a great distance from the shore. To both her horror and amusement, she discovered that, in order to get to land, they had to disembark from the ship into little rowboats that were steered by local Arabs. She waited in line with Miss Kaplan for their turn, watching those in front of them as they were helped into the boats. She became more apprehensive as their turn approached, wondering again what was in store for her on this undertaking.

As she was lowered into one of the boats, she panicked at the thought of being dashed on the rocks, never even having set foot in the Holy Land and once she settled safely into the skiff, her skirts damp and rumpled, she became nervous that her trunks would not reach shore. The Arab men rowing the boats were yelling at each other, appearing to be in some sort of argument. Their clothing was ragged, tattered and worn, their manner rough and intimidating. Their yelling prevented them from rowing together and Rae doubted her safety – even feared for her life. Huge, jagged rocks protruded from the sea and

the boat seemed to be heading straight towards them. At the last moment, amidst a great deal of shouting and gesticulating by the leader, crisis was averted and the small rowboat landed safely at the docks.

Rae looked down. She saw that she and Rose had gripped hands and were holding onto each other for dear life. She looked up and caught Rose's eye. Rose also looked quite shaken by the experience but when she saw Rae looking at her she managed a smile. Rae smiled in return, trying to calm her breathing. Eva, sitting across from them in the rowboat, looked unperturbed. Clearly, she had taken this journey from ship to shore before.

The day they landed was a beautiful Saturday morning. Unlike the gray, wintry skies they had left in New York, the sun was shining brightly and the sky was a deep, almost purplish blue. Getting out of the boat, Miss Leon commented on the weather: 'It is a sign of good luck.'[38]

Rae was amazed at the sights around her. Palestine of 1913 was part of the Ottoman Empire. The city of Jaffa, where the women entered, was teeming not only with Arabs and Jews but also Turks and others from all over the world. The people were dressed in so many different types of clothing it was impossible to know where they were from. While there were so many curious things to see, the first impression Rae had of Jaffa was the foul smell. As they walked up the road from the docks, she noticed its source. Sewage was running through the middle of the street. Flies were everywhere. To avoid walking in the putrid waste, they had to walk on the side of the road, lifting their skirts, dodging the holes and navigating the rough cobblestones.

And such poverty! Beggars lined the road, both men and women, most of them with children by their sides, all of them dressed in rags. Rae was shocked by the mass of humanity before her. Flies were settling on them with impunity. The people were so worn out from life, their bodies so worn down, their eyes caked with disease, they did not even bother to brush the flies away. She noticed that many of the people were blind, their eyes looking out through an opaque white film. Rae was appalled at the garbage that lay every where, at the sewage flowing down the streets, at the devastating conditions she saw in front of her. Certainly New York had poverty and beggars and filth, but never had Rae seen a sight such as this. Eva remarked that what they were seeing was going to be a common sight to them.

As they turned onto the main street, they noticed that this avenue was paved and relatively free of holes. Fine houses lined the road and storekeepers stood and watched them as they progressed up the street.

At that moment they heard a shout and looked ahead. From a doorway up the hill, a well-dressed European gentleman was waving his hand. It was Arthur Ruppin, the director of the Palestine Office of the Zionist Organization, who was reputed to greet all newcomers to Jaffa. A German lawyer who had come to Jaffa in 1908 to live his Zionist dream, Ruppin lived on this main street, Butrus Street, where the Palestine Office of the Zionist Organization was also located.[39]

Mr Ruppin greeted them jovially, welcoming them to his city. Eva was acquainted with him from her last visit to Palestine and greeted him warmly in return. She introduced the two nurses to him and told him of their mission. Mr Ruppin insisted on meeting them for dinner once they were settled in.[40] The women readily agreed and soon parted, promising to meet up in just a few hours.

As they continued on to their hotel, they noticed that, while the main street was lined with well-appointed Arab-style houses and shops that were run by both Arabs and Jews, the side streets were lined with nothing but ramshackle houses that were in great disrepair. They noted the stark contrast between the two types of street. Eva warned them that they would only drink bottled water here in Jaffa and eat only cooked vegetables and fruit. Nothing raw could be eaten, except the famous Jaffa oranges and almonds as they had a thick rind and shells that could be removed.

Since it was *Shabbat* and they couldn't travel by train to Jerusalem, the ladies settled into their hotel room and then spent the remainder of the day walking around Jaffa. Rae and Rose were moved to hear people speaking Hebrew. 'Never had I heard anything so musical as "Shabbat Shalom" when I heard it for the first time that day',[41] Rae would later reflect in her notes.

That evening they went down to dinner, meeting Mr Ruppin, Dr Yaakov Thon and his wife, Sarah. Dr Thon worked with Mr Ruppin as the deputy of the Palestine Office of the Zionist Organization. The Palestine Office had been set up in 1908 to represent the interests of the Zionist Organization, later known as the World Zionist Organization. The mission of the Zionist Organization was to establish a Jewish homeland in Palestine; it had been started in 1897 by Theodor Herzl at the First Zionist Congress in Basle, Switzerland. Mr Ruppin and Dr Thon's job was to purchase land in Palestine for Jewish agricultural communities and other Jewish settlements. During the Ottoman period, the land was primarily owned by Turks who lived abroad and were often quite willing to sell to the Jewish organization for a nice profit.

The women were delighted and impressed to learn that Sarah Thon was an accomplished professional in her own right. She was a famous educator who had established schools for girls all around Palestine, including in Tiberias, Jerusalem and Tzfat. In these schools, girls learned the craft of lace-making, enabling them to sell their handiwork to help support their families. They also learned Hebrew, which Mrs Thon was convinced was to be the language of the new Jewish homeland. Her girls had gained a reputation across the country for their cleanliness and meticulousness in both their appearance and their handicraft. However, Mrs Thon was outspoken about the role of women in the new Jewish homeland, criticizing the new immigrants from Europe who chose to dress like men, cut their hair and work in the fields alongside the men. She believed that women had a special role which included looking clean and neat and wearing dresses.

The women also learned that Mr Ruppin's wife had tragically passed away only a few months previously due to complications during childbirth. Mr Ruppin told them about his late wife in a heartbreaking tone. Shulamit Ruppin had been a professional musician who had started music schools in both Jaffa and Jerusalem in 1910.[42] She had been so proud to bring the music and culture of Europe to the Jews of Palestine so they could retain their love of the arts and teach it to the next generation. Mr Ruppin was devastated about the loss of his wife and his voice broke while talking about her.

After a few moments of respectful silence, Mr Ruppin cleared his throat and changed the subject. He explained to the women the current situation in Jaffa, giving them details of what they were seeing and answering many of their questions.

> We Jews live scattered among the Arabs in the center of town or close together on the northern outskirts in two predominantly Jewish quarters, Neveh Shalom and Neveh Tzedek. [You will see that] the two Jewish quarters, as well as the Arab part of the town [are] dirty and [certainly you have noticed] how neglected the streets and houses look. This is typical of small oriental towns. The reason there is so much rubbish in the streets and a stench throughout the city is because the drainage here is so terrible. There is no running water and the water from the wells is sometimes contaminated. [You are quite fortunate to have arrived in the winter,] as in the summer we often have typhoid epidemics. And the blind people you saw in the streets? Trachoma. It's everywhere in this land.[43]

Arthur Ruppin was a prominent leader who worked hard to make his vision a reality. He realized that Jewish labor and Jewish institutions were the key to making the country a Jewish homeland. In fact, just a few weeks previously, Dr Ruppin had presented a letter to the Jewish Congress in Vienna outlining a grandiose proposal for purchasing land all over Palestine until the Jews owned the majority of it.[44] The Labor Zionists believed that Jews could not depend on other governments to take care of them. They argued that the world's governments were not interested in helping the Jews establish a homeland. They needed to build one on their own, with their own hands. The women listened to Ruppin's oration, absorbing it all for future discussion.

Ruppin had made arrangements for the ladies to visit Tel Aviv, the first all-Jewish city, the next day. He explained to them that Tel Aviv reflected Theodor Herzl's dream of building a Jewish homeland and that the city embodied all that Herzl had dreamed of. The small party finally finished up their meal and the nurses retired to their rooms, exhausted by their very eventful day.

Early the next morning, Sunday, they traveled by carriage for the twenty minute ride to Tel Aviv. On the way, the women stopped in at the school Sarah Thon had founded, where they visited with the girls who were learning to sew lace.[45] They were very impressed by the girls' cleanliness and diligence, remembering what Mrs Thon had told them the previous evening about the poverty these girls lived in.[46] Continuing on to Tel Aviv, they saw several omnibuses. The women learned that the busses were running now between Tel Aviv and Jaffa every ten minutes, making Tel Aviv very accessible to the growing Jewish community.

The women were relieved to see that, juxtaposed to the poverty and unsanitary conditions they saw in Jaffa, the new Jewish city of Tel Aviv, which had been established only a few years earlier, in 1909, was filled with gleaming buildings emerging from the sand. Only around one square kilometer in size, the streets were laid out in straight rows, the boulevards wide and tree-lined. The streets even had lights lining them. The houses were magnificent, with balconies overlooking the streets. They were made of concrete and capped with red tiled roofs. The windows were framed with shutters and many overlooked the sea.[47] Each house was surrounded by beautiful, lush gardens. And this was just the beginning. The women learned of the plans to build a city hall, a hospital and other institutions that would make this a true Jewish city, not just a suburb of Jaffa.

Rose and Rae breathed in the fresh sea air and felt a sense of relief to know that their experience in Jaffa did not reflect the entire country.

They learned that over a thousand Jewish people lived in the city so far and that the city had been founded only four years before. Tel Aviv was an entirely Jewish city, the symbol for the homeland of the Jewish people.

As they continued their ride, Rae and Rose saw signs over some of the buildings. They saw the Office of the Odessa Committee, where the Jewish community did business with the Turkish government, and several schools.[48] Rose expressed the depth of her emotions about how she felt in this Jewish city. Despite her declarations that she was not a Zionist, she was overwhelmed with pride and gratitude that the Jews were building this great city. Rae admitted that she also felt overwhelmed with emotion at being in a completely Jewish environment.

After the driving tour, they walked through the streets of Tel Aviv and were greeted by all the people that they passed. When the citizens of Tel Aviv heard what the nurses were going to be doing, their polite greetings turned to warm wishes and enthusiasm; time and again they told the nurses how much their services were needed in Jerusalem. They walked to the end of the great boulevard and then turned to look at a new view of the small village. They saw a wide, clean avenue lined with gleaming houses. People were walking on the sidewalks, away from the carriage traffic, on their way to their business or their homes. The women were awestruck by the beauty of Tel Aviv. They saw hope for the Jewish people in this city and couldn't wait to write home and tell their families and friends about what they were witnessing. Rose later wrote, 'You will understand what one's feelings might be, knowing the condition of the Russian Jew as I knew it–not allowed to live in one place and to breathe in another, to see a prosperous little town well-ordered and managed by Jews...'[49]

The Herzliya Gymnasia was a beautiful building that stood at the head of Tel Aviv's main boulevard, Herzl Street, and was the pride of the community. The school held more than seven hundred pupils, both boys and girls, not only from Tel Aviv and Jaffa but from all over the world. Jewish parents were sending their children there to get a first class education in the new Jewish city.[50] Rose especially appreciated seeing the school. She knew from her own experience in Russia that it was not easy to get an education if you were Jewish, as many schools barred admission of Jewish children. She marveled at the audacity and courage of the Jewish parents in Russia who were sending their children to this very far away place so that they could get an education free of persecution and discrimination. Rose wrote, 'To think that there is a

gymnasium where pupils are accepted without heartaches and nervous strain seems wonderful, having seen as I did last summer the misery parents and children have to endure as a pupil in a Russian high school.'[51]

The women were impressed by the neatly dressed children, lining up for their recess, exiting from their classes in the most orderly manner, grabbing gardening tools and marching to the school garden, singing while they hoed the ground and pulled the weeds. They were treated to an exhibition of physical fitness that characterized the vision of the new Jew. No longer was the Jew relegated to a life of misery and poverty, being seen as weak and ineffectual, and subject to the whims of an often hostile government and local population. This new Jew was strong and brave and self-sufficient. The children cheered each other on as the boys showed off their skills on the vaulting horse and the horizontal bars, turning somersaults and leaping into the air, landing with a flourish, showing off for the ladies and their fellow classmates. Then it was the girls' turn. They danced in straight lines and perfect circles, their white skirts and neatly made-up hair bobbing in time with the music. It was all quite spectacular. After the demonstration, the children lined up again in perfect queues and walked back to their classrooms.[52]

Inside the school, the women witnessed class upon class of students studying intently. It was remarkable to hear the children reciting their lessons in Hebrew. All of a sudden, in one of the classrooms, Rae and Eva realized that Rose was nowhere to be found. Rae looked around and found her standing behind the door of one of the classrooms. Rose was weeping. 'What's wrong? What happened?' Rae implored.

Rose spoke through her tears, 'I'm so overcome with joy at seeing these classrooms filled with Jewish children. Look at them. They are so happy and serene–in a Jewish land, getting their education in peace, without fear of persecution, learning Hebrew songs.'[53] Rae realized that the hardships Rose had endured during her childhood and young adulthood in Russia were still very raw. She saw that Rose had had to put up a fierce struggle for her education and peace of mind. 'I guess it brought back memories of her school days', she later wrote. Miss Leon put her hand on Rose's shoulder and Rose continued to cry, 'Oh! It is so beautiful!' [54]

Rae was beginning to understand the passion and pride that the citizens of Tel Aviv felt in the development of this tiny city. With the persecution of Jews that was occurring throughout Europe and Asia, the Jews needed a homeland, a place where they could send their

children to school without discrimination and a place where they could live without fear of pogroms and harassment.

For their final stop of the day, the women walked to the Shulamit music school, the school Mrs Ruppin had founded, where they were treated to a concert by the students.[55] They learned that the music school students and faculty performed concerts throughout the year to bring the beauty of music and culture to the people of Tel Aviv and Jaffa. Mrs Ruppin had been passionate about bringing that culture to this new city. She knew that music had been a big part of the lives of the new immigrants from European cities and that they truly missed the culture of those cities. She believed that the music schools' concerts raised the morale of the people and made Palestine 'more civilized'.[56]

The past two days had been quite overwhelming. The women's hosts had filled their heads with thoughts of purchasing land for Jewish colonies and farms worked by Jewish labor, about building Jewish cities and bringing culture and education to the new Jewish settlements. They were told to keep their eyes open as they traveled to Jerusalem and they would see examples of Jews building their own homeland, tilling their own soil and being dependent only on themselves for their livelihoods. They would see several Jewish colonies and villages and the progress they'd made in turning desolate land into a Jewish utopia.

Reluctant to leave their new friends but with excited anticipation about finally completing their long journey, Rae and Rose climbed aboard the train that would take them to Jerusalem.

Chapter Three

First Impressions of an Ancient City

The train to Jerusalem was a narrow gauge railway which was filled with tourists and pilgrims making their way to the Holy City. It took more than three and a half hours to climb through the hills leading up to Jerusalem. As Rae looked out the window, the train appeared to be moving in slow motion. They moved steadily past large areas of arid land. Occasionally, they passed small Arab villages, whose houses were made from stones and mud. While they were still in the plains region, a flat land across which they could see miles around, they were able to view the Jewish colonies of Rishon L'Tzion and Mikveh Israel.

At Mikveh Israel, they were able to glimpse the agricultural school operated by the Alliance Israelite Universelle (AIU), a French foundation. They saw rows of grapes in the vineyards and orchards of oranges where the trees stood straight and tall. They noticed the stark contrast between the greenery of the vineyards and orchards compared with the dusty brown fields and desolate land surrounding it. In the villages they noted that the dirt roads were muddy and churned up from the hooves of camels, donkeys and wagon wheels. In the summer these trails were surely dusty. They noticed, as the train approached the outskirts of Jerusalem, that the houses were built of native stone.[57]

Finally, after almost four long hours, just as the women began to feel they would never arrive, the train puffed into the Jerusalem station. At the sound of the train's whistle, the women grabbed their valises and hurried to the carriage exit. They jostled each other as each clamored to be the first one off the train to step on to the holy soil of Jerusalem. Rae couldn't help chattering: 'Jerusalem at last! I have never had such a thrill.'[58]

Rabbi Stephen Wise, a prominent Zionist leader whom Rae was soon to meet, also traveled to Jerusalem in 1913 and had a similar reaction upon his approach to the ancient city. 'I wonder whether any thrill quite equals that which comes to one who has long dreamed of Palestine, as the train begins to make the ascent from Jaffa to Jerusalem...Every approach to the Holy City has a fascination and glory of its own...But none quite matches the climb from the west as one catches the first gleam of the Golden City.'[59]

As the three women stepped off the train, they saw that their arrival had indeed been expected, just as Nathan Straus had assured them it would be. A small group of people was assembled to meet them. When the crowd saw the ladies, they set up a cheer. '*Shalom! Bruchim ha'ba'im*, they shouted. 'Welcome to Jerusalem!' Rae relaxed. This is what she had been waiting for all her life: this feeling of being home; being welcomed by her people to the Promised Land. She looked around and saw a beautiful, ancient city. It was towards evening and the sun was setting on Mount Zion. She had never seen such a beautiful sight. The fading light was reflecting off the white stones of the building and the sky was filled with orange and violet streaks. It was quite overwhelming and spectacularly dreamlike. She felt calm, with an overwhelming sense of belonging, in spite of being so far from her family.[60] She wished for a moment that her father could be there standing next to her. She knew he also would feel overwhelmed at this sight. She felt a momentary pang of homesickness and a surge of tears sprang to her eyes. She quickly wiped them away and looked again at the people at the station who were watching her and Rose expectantly.

Eva knew everyone in their welcoming party and was eager to see her friends again. She gave an especially hearty greeting to Dr Isaac Levy, the manager of the Anglo-Palestine Bank. She took the hand of the nurses and introduced them to each person. 'Please meet Hadassah Kaplan and Hadassah Landy', she said. The women were greeted warmly, with gratitude expressed by each person in the welcoming committee for the work on which they were about to embark. The nurses and Miss Leon then said the *shehechiyanu* prayer, thanking G-d for bringing them to this moment. The group of friends responded with a fervent 'Amen'. 'You hear that, girls?' Eva whispered, 'That "amen" was so profound that I know Jerusalem is glad that Jewish women [have] come to do Jewish work in this ancient city.'[61]

As there were no automobiles in Jerusalem (and only one in the entire country), the traveling party and the welcoming committee climbed into horse-drawn carriages and proceeded through the city.

Rae and Rose looked around with open curiosity. The city was bustling with people, dressed in almost as many styles as there were people. It was a truly international city. By the middle of the nineteenth century, Jerusalem had a majority population of Jews and, by 1913, there was a large, new Jerusalem outside the Old City walls with pleasant new suburbs and neighborhoods. By 1900, Yemin Moshe and the German Colony had been established and, by the end of the 1910s, there were nearly twice as many people living outside the city walls as inside. Jaffa Road, the main street of the city, was lined with consulates, hotels and shops. The streets were filled with Western tourists, Christian pilgrims and Zionists. Beautiful, elaborate houses were being built in the new neighborhoods, and all the European powers, including France, England, Russia and Germany had a large presence in the city.

By 1913, there were an estimated 50,000 Jews living in Jerusalem out of a population of about 100,000, of which about 20 per cent were Christian, and about 30 per cent Muslim.[62] Looking more closely, Rae noticed the filth of the city. She saw neighborhoods in which the homes were fabricated entirely out of Standard Oil tins. Just like in Jaffa, people were dressed in rags, beggars on each corner. Children, wasting away from starvation, their eyes empty and vacant, were being dragged along by harried women. Blind people lined the streets, crowded into the narrow alleyways. As distressing as this was, Rae remembered this scene from when she had landed in Jaffa and realized the country suffered from poverty and illness on every corner. She wondered if she and Rose, with even the best of intentions, would be able to make any kind of difference here.

That first evening in Jerusalem the women were the guests of honor at a lavish dinner hosted by the Levys. Dr Levy provided the nurses and Miss Leon with more information about the situation in Jerusalem. He described the deep poverty in the city. Jews were coming to Palestine from all over the world, from Poland, Hungary, Germany, Russia and countries all over the Middle East. Some of these people were real Zionists who wanted to help build a Jewish homeland but, in Jerusalem, many people, including those who had been there for years and even generations, had come there for a different reason. They used a system of charity known as *Halukah* that was set up long ago to support pious Jews who came to Jerusalem to study Torah. The scholars' communities back in Europe and across Asia sent money to Jerusalem to support the men and their families. Over time, people had come to abuse the system, not working, feeling entitled to charitable

handouts and not contributing anything productive to the local economy. The result of this showed itself on the streets of the city.

The nurses learned that the issue of accepting *Halukah* was very complicated. There were many calls within the new Zionist immigrant groups and from Jews abroad to stop this giving of charity. However, if the Jewish communities stopped sending the money, the situation would be even worse. There were just no jobs in Jerusalem. There was no manufacturing and no other way for the people to earn a living. If they didn't receive the money from their communities back home, the poverty and disease would be even greater than it was now.

Dr Levy continued. The system of *Halukah* was creating a class of men who believed it was their G-d-given right to not earn a living for their families. They believed their job was to study Torah, and yet so many didn't even do that. They had become totally dependent on this charity from the many years of support from their fellow countrymen abroad. 'The institution of Haluka, though beautiful in its origins and though in many cases it still serves a noble end... often degenerated in more subsidizing of those who should have been economically productive.'[63]

However, there were some positive changes taking place. The art institution of Bezalel that was established in 1906 by Boris Schatz, together with Sarah Thon, was teaching its students to make rugs and ornamental goods from metal and was proving to be a very productive way for people to support their families. Many immigrants from Yemen were finding work there. They found that they were well-suited for this occupation, due to a strong history of metalwork in Yemen. The Yemenites had built a reputation as being 'a patient, hard-working branch of our race'.[64]

This discussion then led to the next, about the importance of self-sufficiency as the answer to the problem of the Jews. The ideas of A.D. Gordon, a prominent Zionist thinker, to build a Jewish homeland through the labor and hard work of the Jewish people had been gaining popularity in recent years.

After dinner, as the group walked up Jaffa Road to their hotel, they marveled at the many different types of people and languages they heard. They were amused when some passing Arabs called out, 'I love my wife but I like you, kid.' Rose remarked that the men must have been to the United States recently, as they knew the latest slang words.[65]

Late that night, as Rae lay in bed listening to Rose breathing deeply in her sleep in the bed next to hers, she reflected on the incredible day. Just this morning she had been in the new suburb of Tel Aviv and then

on a train, admiring the beauty of the Jewish colonies, the green trees and groves of oranges, thinking about the ingenuity of her people in making a dusty barren land bloom like that. It was evident by looking at the contrast with the neighboring Arab villages with their stone and mud houses and dusty fields and flocks of skinny goats that it had taken a great deal of energy and resourcefulness by the Jews to make those orange groves bloom.

And now here she was in Jerusalem. Again she marveled as she recalled seeing Jerusalem for the first time, the ancient city emerging from behind the hills as the train made its final ascent into the city. 'I can't explain it', she thought to herself as she mentally crafted a letter she would write later. 'You can only feel that kind of a sensation. I feel at peace with the whole world and am so happy. I feel at home, even though I am far away from my immediate family.' She wondered how Rose was feeling. She realized that she hadn't spoken much to her that evening. She 'was too busy with her own thoughts and feelings.'[66]

At dinner that night her hosts had waxed lyrical: 'Jerusalem has a charm like no other place we have seen before or since. Its beauty is breath-taking, majesty is in its hills, and its story speaks to us who thought of its great past and dreamed of its future. Delicious pastels of rose and violet and blue color its sunrise and sunset skies.'[67] It took some time for these jumbled thoughts to settle down, but Rae finally drifted off to sleep.

When Rae awoke the next morning, she had to pinch herself to believe it was real, that she was actually in the city whose name was spoken at every Passover, at every *Rosh Hashanah*, at every *Shabbat* –THE Jerusalem, which her own father dreamed of seeing one day and where he wanted to be buried. And here she was, about to embark on the work for which she had been preparing her whole lifetime. Rae shook Rose awake and they quickly washed and went down to breakfast.

Eva was waiting for them to begin their day. After a quick breakfast of tomatoes, cucumbers, olives and some crusty bread, they hired a wagon to take them to the Anglo-Palestine bank, the financial institution of the Zionist Organization, where Dr Levy was the manager. The bank had been founded in 1903 specifically to finance the projects of the Zionists in building a homeland in Palestine. The bank would be the conduit from which the nurses would receive their money and counsel from Daughters of Zion, Hadassah, back in New York.

On the way to the bank, the women looked around, wide-eyed, seeing everything for the first time in daylight. As they walked, they tried to memorize the blocks lined with shops: stationers, druggists, clothing and dry goods stores, book sellers and linen merchants, and dealers in building materials, olive wood, souvenirs and, of course, Jewish religious articles. They glimpsed the offices of insurance brokers

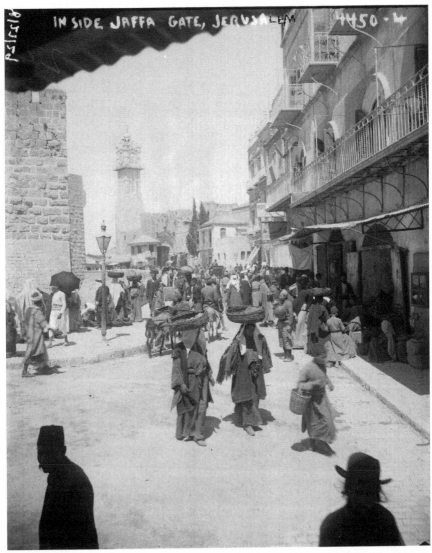

'Inside Jaffa Gate', Library of Congress, Prints & Photographs Division, [LC-B2- 4450-4].

and several private banks.[68] Merchants were shouting, women were bargaining and children were running and shouting through all the streets and alleyways.

At the Anglo-Palestine bank they were greeted with much enthusiasm by Dr Levy. The nurses were presented with contracts that spelled out how they were to withdraw the money both for the running of the settlement house and the supplies they would need, but also for their salaries. They read the contracts carefully and saw that everything Nathan Straus and Henrietta Szold had told them was included. They both signed without hesitation. After a great deal of hand-shaking with Dr Levy, the women left the bank, excited to get started.

Their next stop was the Straus Soup Kitchen which was in the Old City, not far from the Wailing Wall. They had been expecting to meet Dr Bruenn, the head of the Straus Health Bureau, who was supposed to be supervising their work, but learned that he had gone to Tiberias to help treat a cholera outbreak.[69] Instead, they received a tour of the institution from a worker in the Soup Kitchen. He explained that the Soup Kitchen fed 300 people daily, all funded by Mr Straus. Each person received a bowl of soup and a piece of bread and, on *Shabbat*, thirty-nine portions of fish and meat were also provided.[70] The women saw two separate dining rooms, one for men and the other for women. Both were very clean and neat, filled with long tables and benches where the most needy in Jerusalem were fed each day. The women were incredibly impressed with the generosity and foresight of Mr Straus. The philanthropist was so committed to improving the lot for the people living in Jerusalem.

Finally, the women were ready to see the building that would be the settlement house. They wound their way through the narrow alleys of the Old City, reaching an area just outside a neighborhood called Mea Shearim. Mea Shearim had been established in 1874 and was made up of stone homes framing courtyards with a wall encircling the settlement. It had originally been established to alleviate some of the crowding inside the Old City walls but now this neighborhood was also very crowded and dirty. People were packed into the streets, going to and from the markets, selling their wares and carrying their purchases.

They turned the corner onto a side street and the din magically dissipated. They finally stopped in front of a white stone wall that encircled a stone, two-story house. Inside the gate of the wall was a courtyard. The courtyard contained a garden and a beautiful lemon tree which shaded the yard and provided a refreshing aromatic scent. Several rain barrels stood near the doorway. Once inside the courtyard,

the sounds of the street completely disappeared and a feeling of peace was felt by all three women. They sighed with relief. The hustle and bustle of the neighborhood that had caused them unknowingly to tense up was now gone.

The women opened the door to the house and stepped inside a large entrance hall. Leading from the hall were four rooms –one larger room they immediately designated as the sitting area –and three smaller rooms, perfect for each woman to have her own bedroom. They then walked into a tiny kitchen and discovered a small bathroom adjoining it.[71] They were very pleased with the condition of the building and agreed that it had a great deal of promise as a functional and comfortable place for them to live and a center for their work as they set up their nursing system.

While the Strauses had provided them with the funding to furnish the house, they learned that there was no place in the city to purchase ready-made furniture. The women would need to design their furniture and contract with carpenters to construct what they needed.[72]

That evening, the women enjoyed a simple dinner cooked on the primus stove and ate by the light of the kerosene lamps they had purchased. It had been something of a shock to discover there was no electricity in Jerusalem and, as the sun set, the city was plunged into a deep darkness, lit only by the light of the moon. Rae remarked on how the lack of modern technology would affect their work and lifestyle. It would be an adjustment to live not only without electricity but also without running water, without telephones and without automobiles. In addition, they didn't even have a real bathtub; they had to purchase a folding rubber one that was quite clumsy to set up.[73]

As they finished up their dinner, Eva reviewed the situation they would face as they began their work. Maternal health would be their top priority. Because of the lack of Jewish maternity hospitals, the Jewish women of Jerusalem had been left with no choice but to receive care and deliver their babies at home or at missionary hospitals, where they were subject to proselytizing and sometimes persuaded to have their babies baptized. Consequently, the women of Jerusalem were very suspicious of anyone who offered health care to them. Many of the poor people of Jerusalem had come from backward countries and they often subscribed to superstition and home remedies that had no basis in science. Most often the mothers chose to deliver their babies at home rather than subject themselves to the missionary hospitals.[74] Since most people lived in unsanitary conditions, mortality rates were extremely high for both mothers and babies. Women in labor, who were at the

highest risk, could be brought to Shaare Tzedek hospital but the nurses had learned from Miss Szold that there were not enough beds to fill the needs of the Jewish population.

Eva explained about the prevalence of rain barrels in all the neighborhoods. They were indicative of another major problem in Jerusalem: the lack of water. The main reason the entire city was so filthy and polluted with waste was because of the challenges of living with an inadequate water supply. The city depended upon rain that fell between October and May. Once summer arrived, not a drop of water fell. Even through the winters, there was often insufficient rainfall to sustain the citizens of the city.

What did the people of Jerusalem do to catch the rain? Cisterns were dug throughout the city to collect each precious drop. The rain barrels weren't just an ornament or luxury. The people of Jerusalem stored rainwater in barrels anywhere they could, on rooftops, in alleys and in courtyards. However, if there was a year in which not much rain fell, the entire city was in peril. Then, water had to be brought in from outside the city and water sellers offered Jerusalemites goatskin pouches of water at the exorbitant price of around twelve cents per two gallons. There was a small reservoir outside the walls of the city, called Solomon's Pools, and that was the city's only reserve.[75] It was no wonder that most of the homes in Jerusalem, not to mention the people, were very dirty and untidy. They simply couldn't afford to keep themselves and their homes clean. Water was a luxury.

That second night the three women slept in their new home. Having no furniture, they made do with bundles of blankets on the floor. They were so tired from the excitement of their day that not one of them struggled to sleep through the night.

Chapter Four

Reality Sets In

Early the next morning, the women were awakened by the sound of the call to prayer from the *muezzins* singing out from the minarets of the many mosques and the ringing of the bells from the many churches nearby. They moved quickly to dress and eat as they were eager to begin their first day. Eva had reminded them again the previous evening that since a little more than half the population of Jerusalem was Jewish there were plenty of women to reach out to. And, while their primary duty was to the Jewish population, they were directed not to discriminate in any way against any other population that may need their help. Both Muslim and Christian women could also avail themselves of the nurses' services. It was said that the Christian missionaries were so eager to convert the Jewish women that they often favored treating the Jews, while neglecting their own people.[76]

The three women walked through the streets of the Old City that morning, stopping people and introducing themselves. They explained, in a mix of the languages spoken by all three, what they were going to be doing. The mothers and pregnant women they spoke with were confused at first; they had never been approached in this manner, being offered maternity care with nothing expected in return. They were suspicious of the nurses and often walked away quickly, dragging their dirty, ragged children behind them.[77]

As they walked through the city, Rae was aware of everything around her. From the open doors she smelled the deep sweetness of baking bread. The gardens in each courtyard emitted a fragrant perfume of almond and lemon tree blossoms. The storefronts were laden with barrels of deep brown dates, tan figs, purple eggplants and orange, red and brown spices. Shouts of vendors bargaining with their customers rang through the streets and the braying of donkeys and the

sharp crack of whips cut through the air. The sacks of spices in front of the open windows of the shops were filled with the smells of saffron, cumin and cinnamon.

The people they saw were so interesting, their dress so different, a kaleidoscope of countries of origin and religious beliefs; Jews, Christians and Muslims all shared the roads. The languages they heard were many, as each colonial power was represented in the population: British, French, Turkish, German and American. The people even walked down the streets differently; the Turks and Germans with so much confidence, in an arrogant manner, hardly noticing the masses around them, while the poor Jews and Arabs moved quickly, skirting the center of the streets to stay out of the way of the steady stream of donkeys and camels that were laden with goods being carried to the markets.

As the day wore on, the women again heard the Arab call to prayer from the minarets and the sounds of the bells from the many denominations of churches spread throughout the city. They passed by open windows where the sound of Jewish boys studying Talmud and praying crept through the air. Women carried baskets of produce and bread on their heads, balanced skillfully as they made their way home after bargaining in the bazaars or *shuks*. Men and young boys walked purposefully, whether Christian, Muslim or Jew, on their way to prayer, oblivious to the ancient walls and towers from bygone eras that surrounded them.[78]

That evening the women gathered around their make-shift table for dinner. They discussed all they had seen and heard that day. Rose pointed out that, in order to get to their homes, the women and children were disappearing into narrow alleyways and dark doorways. Those doorways appeared so dark and dingy from the street, they couldn't imagine what the insides of their homes were like.

They noticed that everyone looked at them with real suspicion and fear in their eyes. They realized they would need to make some sort of practical plan to gain the women's trust quickly. They would only be able to help them when the women of the city realized that the nurses didn't have an ulterior motive and that they were there to help make their families healthier. Eva reminded them that it was just the first day of their outreach efforts. The women would need to be patient and tolerant of the people's suspicions and continue to take the time to get to know them.

After that first discouraging day, the women took a step back and spent the following weeks preparing their settlement house to receive

patients. One evening, Rae wrote a letter to her friends at Lakeside Hospital in Cleveland, the hospital where she had had her first nursing job.

> Miss Kaplan and I are doing district nursing in Jerusalem. It is a very new thing in Jerusalem and we are having some difficulty in becoming established but I am sure things will adjust themselves in the end. We rented part of a house and not being able to get ready made furniture we are having everything made. I am sure the work is going to be very interesting. There is a great field here and plenty to do. The conditions are perfectly distressing. I never imagined people could be so poor and miserable.[79]

The women had a big celebration when their newly constructed furniture arrived, admiring the simple yet quality craftsmanship. And, on 23 March 1913, they opened their settlement house to great

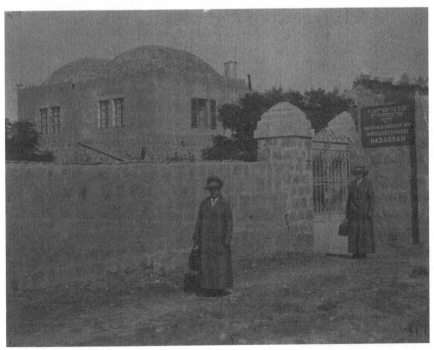

Rose Kaplan and Rachel Landy in front of Nurses Settlement. Ben-Dov, Ya'akov – photographer, Jerusalem, 1913; Record Group 18, Photographs, Hadassah Medical Organization Series, Hadassah Archives, American Jewish Historical Society, New York, NY and Boston MA.Digital ID 251745.

fanfare.[80] They hung a sign outside the gate announcing the establishment of their enterprise. 'American Daughters of Zion, Nurses Settlement, Hadassah' the sign proclaimed in Hebrew and English. They even hired a photographer who posed the three women standing under the sign. The photo was sent to New York so that the Daughters of Zion could see what they had accomplished.

The date of the opening had been chosen with care. It was *Purim*, the festival of celebration of the story of Esther, or Hadassah in Hebrew, and it was fitting that the opening should coincide with the anniversary of Hadassah's heroism in saving the Jewish people from Haman. Also, Eva gleefully suggested, it would be a great day to have a *Purim* party for the children. On one of their daily tours around the city, a child had shown them an invitation to a *Purim* party that a Christian missionary had circulated. By timing the opening of the settlement house with a *Purim* party and inviting the children in the neighborhood, they could begin to build a trusting relationship with the parents and gain the goodwill of the community.[81]

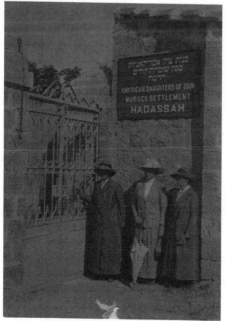

Rae (Rachel) Landy, Eva Leon and Rose Kaplan at Nurses Settlement. Ben-Dov, Ya'akov – photographer, Jerusalem, 1913; Record Group 18, Photographs, Hadassah Medical Organization Series, Hadassah Archives, American Jewish Historical Society, New York, NY and Boston, MA. Digital ID 251743.

In addition to a formal opening of the settlement house, they also went out for a short while each day to meet people and to introduce themselves to shopkeepers, vendors and even the 'establishment' in Jerusalem. They spent each evening discussing what they had seen and learned about the people they had encountered that day. Every day they discovered new nationalities of people represented in the city. They met the leaders of the great colonial powers and of the institutions, hospitals and schools. They mulled over the crushing poverty and disease they saw and the lack of nutritious food available to the poorest residents of Jerusalem.

A plan was slowly devised. They had understood that they would be working under the supervision of Dr Bruenn of the Straus Health Bureau but, since he was still not in Jerusalem, the nurses began to plan on their own with the counsel of Eva. They decided that they would tend to the women's most basic needs first and then, when the women began to trust them, the nurses would convince them to accept help with health care, primarily of course in the area of maternal well-being. They decided that they would make an initial investment in food and clothing for the women and their children. Taking care of those needs would allow them to prove to the women that they wanted to help, and by providing them with the nutrition they and their children needed, they would gain the women's trust.

With that plan in mind, Rae and Rose began to provide milk and food to the women they saw on the streets. When they saw a baby, they gave the mother clothing for the infant. They went door-to-door distributing fresh milk and vegetables. They approached Dr Segal, the chief obstetrician and head of the Rothschild Hospital, to ask if they could engage him to oversee their maternity services. He readily agreed to their proposal and immediately began to supervise and counsel the nurses in that work.

The leaders of the various communities living in Jerusalem, as well as their first patients, began telling neighbors about the nurses and soon women began inviting them into their homes. Children began to stop them on the street, pulling them to the homes of women about to give birth. Through word-of-mouth, the news of their work spread through the alleyways of the Old City and into the crowded courtyards of Mea Shearim.

While the nurses had limited funds, they were prodigious in stretching every *lira*, bargaining in the markets for the best and freshest food. The linens and layettes they used were, for the most part, improvised, rather crudely made and very sparingly distributed when

dire necessity warranted. The suspicion that they were working on behalf of the missionaries lingered for a while but their deeds soon spoke for themselves and the suspicions evaporated. The nurses realized that the fact that neither spoke the varied languages of their patients, which included Hebrew, Arabic or Ladino depending on their origins, was a handicap to their work. But they discovered that they could always locate a kindly neighbor who would readily interpret for them.[82] They were always happy when they had patients who spoke Yiddish, as that was a language they were both fluent in.

One evening, exhausted after another long day, they returned home to the settlement to see a few children waiting outside the gate. They begged the nurses to come to their home to help their mother deliver her baby. Rae wanted to cry she was so tired. She had so looked forward to resting and gathering strength for the next day. Sighing heavily, the nurses turned around and followed the children to help their mother. Later that night, as they lay in their beds, they could barely speak they were so exhausted. Rae moaned that her feet hurt badly from walking around the city all day. Rose replied that it was time to implement the next stage of their plan.

It was clear that there was so much work to do in delivering babies that the two of them were not enough to make a difference. Their outreach efforts had resulted in an abundance of work. They just wouldn't be able to keep up the pace needed to take care of everyone. They realized the wisdom of the district nursing system and saw that a great deal of the work they were doing could, instead, be done by trained midwives.

First thing the next morning they went to Dr Segal who, in no time, recruited three trained midwives for them.The nurses quickly set up a maternity care system.[83] Rae and Rose found that the services of the midwives were a lifesaver. They proved to be excellent in their work, improvising with whatever materials they had on hand, doing their work efficiently in the most trying conditions. Their dedication and unflagging energy were an inspiration to the nurses, who redoubled their own efforts to continue their work.[84]

Dr Segal recommended a triage system of obstetric care. They divided the city into sections and each midwife was assigned to one of the sections. At the end of every day, the midwives reported back to the nurses about their patients. If there was any patient who needed additional care, one of the nurses would visit and investigate. If a nurse saw that the patient needed even more aid, she would send for Dr Segal who would come immediately.[85]

As they were invited into the homes of the women, they were unprepared for what they saw. They were shocked at the conditions in which the poor people of Jerusalem lived. The women they visited were almost all poor and hungry; the homes often had no bedding, no water and no heating. The saving grace was that these hovels were on the ground floor and, for most of the year, people could easily be out of doors. Superstitions regarding health practices were rife and treatment by charms and amulets was often more acceptable than modern science and a physician. Nursing care in the home was given by the women in the family, according to the instructions of the wizened old women and men 'and the lore which had been passed on from generation to generation.'[86]

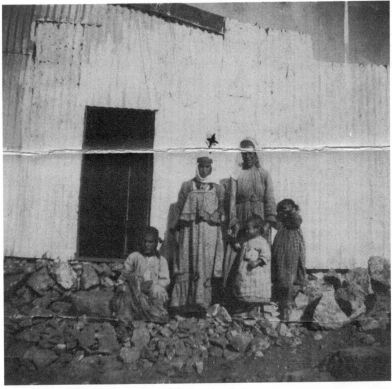

A group of [illegible] women and children. Confinement case of four days standing. I found outside her house talking to neighbors . Rose Kaplan – photographer; Record Group 18, Group Portraits Series, Personal snapshots, Rose Kaplan-004, Photographs Series, Hadassah Archives, American Jewish Historical Society, New York, NY and Boston MA. Digital ID 262391.

Unexpected situations arose from time to time. The streets and alleyways of Jerusalem were very confusing to navigate and the nurses often got lost looking for a patient's home. If the nurse was on her own and got lost, she could laugh at herself and choose whether or not to tell the others but if she were trying to guide the others or, even worse, Dr Segal, it was sometimes quite embarrassing.[87]

The women realized that the settlement house was not sufficient to care for patients who came to seek treatment. More space was needed. After talking to Eva, who spoke to Dr Levy, a new room was purchased and outfitted with furniture and supplies. This room became the school where they would set up their midwife training and eventually their 'little mother' classes.[88] They went to the homes of a few of their patients asking the mothers if their teenage daughters would be interested in earning some money to help support their families by working as midwives. They immediately recruited three girls between the ages of fourteen and sixteen. These girls soon joined the experienced midwives, all working under the close supervision of the nurses.

As soon as the maternity care system was set up and running smoothly, the nurses began to care for patients who were sick. However, much of their nursing care consisted of hygiene, nourishment, medicine and a referral for a physician's visit.[89]

Rae would never forget their first non-maternity patient. She was led to the patient's home by a young lady who was quite distraught about her sick sister. They navigated the narrow, winding alleys and Rae tried to memorize where she was going so she wouldn't get lost on the way back. As she walked through the doorway of the patient's home, she was immediately struck by the overpowering stench of unwashed humans. Murky light seeped in through the doorway and through the slats of the closed shutters which covered the room's only two windows located high up near the ceiling. The windows were tightly shut and the room had no air circulation whatsoever. Rae found it hard to breathe. Squinting, she slowly made out the forms of bodies in the shadows around the room.

As her eyes adjusted to the gloom, Rae saw that the one room was actually partitioned off by sheets, creating several smaller rooms. The young woman who had brought her there pulled on her arm, pointing across the room. Rae's eyes followed the pointed finger and saw that, in the corner, taking up much of the room, was a low bed with several people in it. A man and a woman were huddled around a bundle of blankets which, upon closer inspection, was actually a girl of about

twelve years old. To her astonishment, in addition to the patient and
her parents, there was an Arab charcoal stove in the bed with them.
They were desperately trying to keep themselves and the sick child
warm. Rae walked slowly across the room, stepping around shadowy
masses of humanity. Mentally, she counted about eight other people in
the darkened, chilly room, lying on the floor, all staring at her as she
navigated around them.

Rae examined the young girl and determined that she was sick with
typhus. She told the sister to take the patient to the hospital and
explained that she would be unable to take care of her at home. The
hospital would give her the proper care she needed.

The sister spoke quickly to her parents in a language Rae did not
understand. Their reaction needed no translation. They threw their
arms around the small child and the mother began wailing. A high
pitched cry of almost primal sorrow filled the room. The father shook
his head vehemently: no.

Rae spoke to the young woman, urging her to explain to her parents
that if the child didn't go to the hospital she could die. The young
woman replied that her twenty-five-year-old sister had just died in the
hospital the previous month. The family no longer trusted the care they
would receive there.

Rae sighed. Her experience in nursing had been in hospitals, caring
for patients who were already there. She didn't have experience in
convincing people why they needed to be in a hospital. She wasn't
prepared for this. How was she going to explain to people that had
suffered such tragedy that hospitals didn't kill people? Well, that would
have to come with time. For now she had to concentrate on the matter
at hand.

She sent the young woman for some water, heated it up on the stove
by which the entire family was getting warm and cleaned the sick girl
as best she could. She then brought the sister back to the settlement
house and gave her some milk, bread and a few vegetables. With
instructions on how to create a mush that the sick girl could eat, she
sent the woman on her way and said she'd be back to visit the next
day.[90]

That evening, the two nurses were quiet. They each felt
discouraged but didn't want to admit it to the other. Rae was filled
with anxiety as she contemplated the possibility that they would not
be successful in their mission. She had not experienced much failure
in her life and had certainly never given up in despair before. She did
not want to admit defeat out loud. She felt a tension between her and

Rose as they mulled over the events of the day. Finally, she knew they needed to talk.

The next day, Rae and Rose went for a walk together, alone without Miss Leon. They found a quiet path near the Bezalel School and sat down on two stones. They were silent for a moment relishing the tranquility. They heard the birds chirping and the wind blowing through the leaves on the trees. They heard the distant bleating of some sheep. It was hard to realize that, despite the human misery they were encountering, the beauty of the natural world around them continued to exist. Then they had a heart-to-heart conversation.

They talked about their experiences and realized that they were both having the same feelings. They felt so helpless and incompetent to deal with their situation. There was just so much to be done, so many people in distress and so little on hand to work with. They realized that setting up the district nursing system, a project that had seemed so simple while talking about it back in New York, was turning out to be overwhelming in practice. Daughters of Zion, Hadassah expected them to do this work, but with just the two of them how could they possibly succeed? This city was so desolate and filled with misery. They were both despondent.

When they finished their discussion, they breathed sighs of relief. Having shared their worries and feelings they understood they shared these burdens and now felt empowered to continue their work. They agreed that, from here on out, they would rely more on each other and speak frankly about their situation and their feelings so they wouldn't feel so isolated in their challenging circumstances. They knew they were kindred spirits and could trust each other. They looked around and saw a beautiful blue sky and perfect weather and realized that they had the strength in them to persevere.[91] They stood up, brushed the dust off their skirts and hugged each other. Then they slowly meandered down the path back to their home, feeling a great relief from the pressure they had each placed on themselves.

After mornings spent visiting patients, the nurses would arrive home for lunch. They would then open the dispensary and clinic, examining the patients who lined up outside the gate of the settlement house. In the late afternoons the nurses went out again to see more patients and then came home to dispense medications once more. They continued their practice of distributing milk, food and clothing to their patients, making sure the pregnant women were getting the right nutrition and ensuring the newborn infants had adequate clothing.[92] They ended each evening with a light supper, eaten while discussing the events of the day.

Nurses' Settlement, Hadassah. Miss Kaplan in the foreground. Ben-Dov, Ya'akov – photographer, c. 1913; Record Group 18, Photographs, Hadassah Medical Organization Series, Hadassah Archives, American Jewish Historical Society, New York, NY and Boston MA. Digital ID 251747.

The nurses realized that they were ready for the third phase of their program, their 'little mothers' classes. Many young girls of Jerusalem were already taking care of younger siblings. With a bit of training in hygiene and home-making, the girls could bring their new-found knowledge into their homes and help create more healthy environments. At the training school, the girls learned basic hygiene and nutrition. They were also taught basic nursing skills and how to keep patients clean and fed, which would greatly decrease their recovery time.

With classes in full swing, the nurses found that their focus had shifted a great deal. At first they had spent all their days going through the streets and into the houses to help the women deliver their babies and attend to the sick. Just a few weeks later, they were supervising the new midwives and teaching the younger girls how to care for their family members and neighbors who were sick, making sure that the patients were cleaned properly and were given the right foods. Of course, they still visited patients, taking on the people they could treat at home and sending the very sick to the hospital.

After a while, Rae realized that their work had changed from being overwhelming and seemingly impossible to a real joy. She saw that the services they were providing were greatly appreciated by their patients.

In their spare moments, they filled small paper bags with tea and rice and had them ready to distribute to their patients. They decided how much they should give each person in order to make their supplies last. They engaged a milkman named Joseph to bring milk to their patients in need. They soon discovered that Joseph was a unique character. He was always looking for more business and invariably came to tell them about some emaciated man or woman who needed milk so he could increase his number of customers through them. But Joseph was unhappy. When the women asked him how many children he had, he told them sadly that he had only one child and three girls, as though girls were not children. Joseph's attitude towards his daughters was a common perception amongst the men of Jerusalem at the time and one the nurses encountered every day.[93] As they carried on their work with mothers and children, they had to reconcile themselves to the fact that they could not change the attitudes of the men, but could empower the women and girls by educating them about health and hygiene, and teaching the girls practical skills in the 'little mothers' classes. And so they did this with enthusiasm and gusto.

Chapter Five

The Scourge of Jerusalem

One night, the nurses and Miss Leon had *Shabbat* dinner with the headmistress of the famous Evelina de Rothschild School. They knew that Miss Annie Landau was one of the most respected and admired women in Jerusalem and they were very eager to meet her. She had revolutionized girls' education, teaching lessons in Hebrew and English to some of the poorest girls in Jerusalem. The school also made hygiene and domestic skills a top priority.

There were many different schools in Jerusalem, each run by a different nationality and taught in different languages. Besides the Evelina de Rothschild School, there were the German Hilfsverein Schools, French Alliance schools and many *yeshivas* and *Talmud Torahs*, religious schools for Jewish boys.

Miss Landau's Evelina de Rothschild School was different in that it taught according to the philosophy of self-sufficiency and civic engagement. Miss Landau was strong in her beliefs and worked hard to educate the girls and their families about medicine and hygiene as weapons against disease, rather than the amulets and superstitions with which the girls arrived at the school. The nurses felt an immediate kinship with Miss Landau. They felt that their own mission was similar. They also wanted to promote self-reliance for the Jews of Jerusalem so they would no longer depend on the *Halukah* system or the charity of those abroad. In their short time in Jerusalem they had realized that all they had been told about the *Halukah* system was true. The religious people's reliance on charity had contributed to the lack of a thriving economy and the inability of many to earn an honest living. The people of Jerusalem lacked hope and aspiration. This had a huge impact on the culture and health of its citizens.

Miss Landau expressed concern about the number of hours the nurses were working. She had become known in Jerusalem as

the hostess of the best and most interesting parties. She cautioned the nurses about working so hard without taking the time to rest and socialize. She advised the women that she would be inviting them all to lunch and to dinner and that they MUST accept the invitations.[94] After the nurses agreed, the women spent the rest of the evening talking about everything from politics and art to gossip about the elite of Jerusalem.

So began another important part of Rae's and Rose's lives in Jerusalem. 'Our social life was delightful. We saw everybody that came on a visit to Jerusalem', wrote Rae. They also spent every *Shabbat* dinner with Dr and Mrs Levy.[95]

One week at *Shabbat* lunch, Rae, Rose and Eva met Dr Avraham Ticho, the renowned ophthalmologist from Vienna, and his wife, the artist Anna Ticho. They learned that Dr Ticho was sent to Jerusalem in 1912 by the Frankfurt-based Zionist organization, LeMa'an Tzion, to open an eye clinic.

Dr Ticho explained the work he was doing in Jerusalem fighting against trachoma. Trachoma had blinded an entire generation of children. It was rampant in the cities, especially in Jerusalem. It spread very easily, as hygiene was so poor and ignorance about the disease and how it was spread was almost universal. He explained that trachoma is an infection in the eyes that causes the inner surface of the eyelid to scar and roughen and turn in on itself. The roughening and the eyelashes then rub against the eyeball leading to the breakdown of the cornea, causing pain and blindness.

The bacteria that causes the disease is spread by both direct and indirect contact with an affected person's eyes or nose. Flies flit from one person to the next, landing on their faces and picking up the bacteria. Rae and Rose acknowledged seeing children with multiple flies sitting in and around their eyes and mothers too apathetic to brush them away.[96]

Dr Ticho continued:

> The crowded living conditions, poor sanitation and shortage of clean water, the exact conditions that exist in Jerusalem, are the perfect environment for this disease to spread. And children spread the disease more often than adults as they touch each other when they play at school and in the streets.
>
> You'll see, as summer is quickly approaching, that in spite of the great heat of the summer, the windows and doors are kept shut, the water is scarce, and washing an infrequent luxury. A

mother uses her apron to wipe the eyes of all her children or if there be a handkerchief, it is common property.[97]

Rae and Rose noted that, of course, they had been painfully aware of the many blind people in both Jaffa and Jerusalem. It was so distressing to them and they often spoke about their desire to do something about it but hadn't been sure what help they could give. They were continuously astonished and appalled at the large number of blind children begging in the streets. As they engaged in their maternity work, they were constantly being confronted by blind patients of all ages asking them for help. What was most heart-breaking were the questions of the children when small gifts were brought to their homes. 'What color is the toy?' they would ask. 'What does the doll look like?' They learned to anticipate the questions of the children and, as they handed over a small gift, they would say, 'This is red' or 'This is blue.' They realized that these poor children faced a lifetime of poverty and disease.[98]

'Almost a third of the people in this city has trachoma, leaving a countless number of blind. It's known as the scourge of Jerusalem', Dr Ticho said. He went on explaining his idea about how the nurses could help. What if they took on trachoma work, in addition to their maternity work? There was so much to be done and he had a great need of assistance, even helping to catch trachoma early on before the disease progressed to the point where people came to LeMa'an Tzion for treatment. If they set up stations where the children were, in the schools, he believed they could make real progress in combating this disease.

The nurses agreed eagerly, thinking that, if they could be of help in purging trachoma from Jerusalem, they would really feel that they had had an impact. They set up a time to meet the next day in order to iron out the details and to find out how they could best help Dr Ticho. They felt that a campaign against trachoma among the school children would be a good beginning in eradicating the disease; this was something they could manage. They spent the rest of the afternoon visiting with Anna Ticho, viewing her latest works and admiring her artistry. Mrs Ticho spoke about her love of art that was now only a hobby at this point in her life because of the support she was giving to her husband in his practice.

The next day, after their morning rounds, they went to the LeMa'an Tzion Eye Clinic. Dr Ticho showed them around the clinic and explained how they did their work.

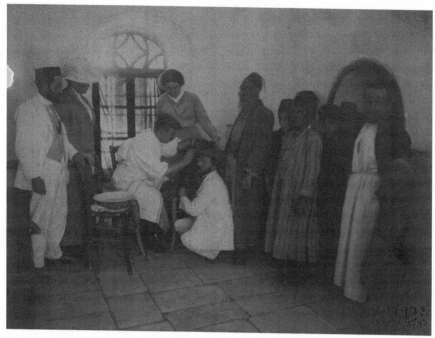

Eva Leon visits clinic as doctor examines a child's eye (Rae Landy and Dr Ticho center background). Ben-Dov, Ya'akov – photographer, c. 1913; Record Group 18, Photographs, Hadassah Medical Organization Series, Hadassah Archives, American Jewish Historical Society, New York, NY and Boston MA. Digital ID 251751.

After the tour, they all sat in the consulting office to make a plan. Dr Ticho explained that in the Jewish schools in Jerusalem there were about 9,000 students. These 9,000 students were together every day, spreading the disease by their close and direct contact. Rae and Rose shuddered at the thought of the dirty children touching their faces and their eyes while they were playing in the yard then touching each other as they played tag or wrestled on the ground.

The women were excited about the idea of setting up eye treatment centers in the schools. While they were there, they could also teach the children about hygiene. Rose pointed out that the children would be much more receptive to the nurses' advice and instructions than their parents, and then the children could go home and teach their parents.

Dr Tichon showed the nurses how to examine the children's eyes and to identify the different stages of the disease. He wrote a letter of introduction to the heads of several of the prominent schools so the nurses could present the idea of the school-based clinics, and he

suggested they start at the school they already knew – that of their friend Miss Annie Landau.

The next day, the nurses went to the Evelina de Rothschild School to have lunch with Miss Landau. After finishing lunch, they took a tour of the school and Miss Landau showed them the room where they could set up. She gave them linen and other odds and ends to make the room feel like a real clinic.

The nurses attacked the trachoma campaign with a vengeance. The next few days were spent going to the other schools in the city and introducing themselves. They were greeted warmly at each school and made to feel not only welcome but very much needed. One challenge that the nurses faced was with language. In each school the children were taught in different languages: Yiddish, German, Arabic and French. Of these, the nurses could only speak Yiddish. However, they managed to get along. Children were taught hygiene and nutrition using Yiddish-speaking children as translators. The Evelina de Rothschild School used English as the teaching language, so that became one of Rae's favorite schools, as she could communicate with the children most easily there. It didn't hurt that she and Miss Landau had become fast friends.

The nurses trained the students in their nursing program to examine the children's eyes and they divided up the schools amongst them. Soon 6,000 children were being examined daily. The nurses also treated patients at Dr Ticho's clinic and visited the hospitals to introduce themselves and become acquainted with the citizens of Jerusalem. Within only a couple months they all felt that they had hit their stride and would experience great success.

It took some organization, but soon 9,000 school children in Jerusalem were being examined on a regular basis. Eva wrote to New York about this critical new work that had not been anticipated when the nurses set out. She was assured that the work would be funded and they should continue with their efforts. With the proper treatment and improved hygiene amongst the children, their eyes started to improve.The nurses were quite surprised by the positive results and felt that this work was their most gratifying so far.

While the nurses worked in the schools, they told the children about the nursing services they could offer to their families and they quickly won the children's hearts. They told them the importance of getting competent medical help if someone in their family was sick. They made such an impression on the students that soon lines of people stood outside the settlement house waiting for them each day.

As the women set up their clinics, they had some difficulty distinguishing the different stages of the disease and remembering which children were at which stage. They soon resolved this problem by giving the children different colored cards according to the degree of their infection. With the colored cards they could quickly identify what stage of the disease they were treating and remember which child had received which type of treatment.[99]

Each morning, Rae woke up early and arrived at the Evelina de Rothschild School by seven o'clock, eager to begin her work. One morning, to her delight, many children were already standing in line outside her office waiting for their daily treatment. As she approached the door the children began whispering and nudging each other. They started giggling as she looked at them questioningly. Finally one of the smaller girls stepped out of line and pulled from behind her back a small bouquet of flowers. Then a second girl showed a flower she had hidden behind her back and then a third girl did the same. When Rae asked the girls where they had gotten the flowers, the girls continued to giggle until finally the oldest girls sheepishly confessed that they had taken the flowers off their teacher's desk. They felt that Hadassah Landy deserved the flowers more than their teacher. Rae worked hard to look stern as she told them they needed to return the flowers to the poor teacher who was probably wondering what had become of her bouquet. She held back her smile until she turned her back to the girls to unlock the door. She loved these children and was so glad that they loved her too.[100]

She began examining the children's eyes and was astonished to find that many of the girls did not need to return for treatment; the medicine had worked. When she told the girls they did not need to return they groaned and begged her to allow them to keep coming so they could visit her. One of them even offered her brother's hand in marriage, saying she would love Rae to be her sister. Rae felt flattered and expressed her delight to the girl but inside she cringed. While there was no need to take this offer seriously, in the longer term she needed to come up with some good answers about why she was not going to marry. Rae felt her chest tighten with emotion as she looked at the line of students. She loved her time with these girls and so looked forward to going to the schools and talking to them. They were so eager and happy to be with her. Visiting the schools was by far the best part of her day.[101]

Rae later wrote about this work:

I feel that my service in Jerusalem with the school children, knowing that I helped to cure them of trachoma, was the happiest

time of my life. We lost no time going from one school to the other striving to adhere to the schedule so that our treatments would not interfere too much with the children's studies. Everything went along in co-ordination and with satisfaction. We thought our maternity problems solved and we were making wonderful progress with the trachoma campaign. There could not have been two happier beings than the two Hadassah nurses in Jerusalem. Our work filled our lives and we were content.[102]

* * * * * * * *

In April 1913, on *Erev Pesach* (Passover Evening), the nurses were thrilled to welcome the famous Zionist leader Rabbi Stephen Wise and his wife to Jerusalem. Rabbi Wise was a Reform rabbi who had left his congregation in Portland, Oregon to found a synagogue in New York called the Free Synagogue. The Free Synagogue billed itself as a democratic institution in which the rabbi was not bound by the board of trustees, who were usually the wealthiest men in the community and usually quite conservative in politics. In the Free Synagogue, Rabbi Wise could pursue his passions for social justice and Zionism. He was spending most of his time working for the Zionist cause, trying to convince more people in the American Reform movement that they should support Zionist ideology.

The nurses and Miss Leon spent Passover *seder* with the Wises. As they recited the words in the Hagaddah, relating the story of the Hebrew slaves journeying through the desert for forty years to reach the land where this small gathering now sat together, Rae felt a thrill. With the words '*B'shana Ha Ba'ah B'Yerushalayim*' Next Year in Jerusalem! that she had pronounced every year of her life, she almost cried with tears of happiness in acknowledgement that she was now in Jerusalem. 'You know what it means to be in Jerusalem on Pesach?'[103] she later wrote.

During the *seder*, Rabbi Wise praised the nurses for the great work they were doing. He was amazed that in just a couple months they had done so much. He was especially impressed with the trachoma work they had begun. 'The most appalling thing about our visit [has been] to find the great number of sight-dimmed and the blind. Even the few unconfined lepers, despite their hideous scars, [have not been] as mournful a sight as the blind, young and old. Happily, Hadassah [is having] a real part in eliminating, if not yet entirely overcoming, the blight of blindness.'[104] Mrs Wise added her own admiration. She had

helped set up a district nursing system in Portland, Oregon,[105]so she was quite aware of the challenges of the work.

The next day there was a giant celebration in the city center to welcome *Pesach*. Rose and Rae joined the thousands of Jerusalemites to watch a parade in celebration of *Pesach* and spring. Lines of children representing all the different schools marched proudly past the spectators, poking each other, pointing and waving when they saw their own families. Then came an orchestra, displaying its banner showing it to be from Rishon LeZion, playing lively music and encouraging the crowd to clap and dance. And finally, the onlookers were entertained by the athletes of the Maccabi sports club who flexed their muscles and rode horses in double lines through the parade route.

The crowd grew a little too exuberant and, towards the end, the parade disintegrated as droves of young men and children joined in, making it impossible to distinguish the crowd from those marching.

After the parade, people pushed their way through the crushing crowds to the streets where exhibits had been set up. They admired all the displays of goods that were laid out, including tables loaded with honey that had been poured into decorative bottles, green and red cabbage, fresh eggs and cheese, garlic and bright orange carrots, all grown in the Jewish colonies. They sampled the wine that was made at the Carmel Mizrachi winery of Rishon LeZion, which had been founded by Baron de Rothschild. Eating fresh almonds and sweet cookies, they made their way down the street where they watched teams of children playing games and participating in sports competitions. They all laughed and clapped with excitement. Finally, exhausted and caked in the dust that the large crowds had kicked up, they decided to call it a day, standing on the street corner exclaiming about the great time they had had, saying their final goodbyes and going their separate ways.[106] All in all, it was a great *Pesach* holiday, filled with joy at the sight of the progress of the Jewish community in Palestine.

The women had learned at the *seder* that one of Rabbi Wise's friends, Miss Jane Addams, founder of the district nursing system in Chicago and the settlement home known as Hull House, was going to be in Jerusalem any day. The nurses knew that Miss Addams was just as famous and accomplished as Lillian Wald whose district nursing system in New York was so highly regarded. As soon as they heard that Miss Addams had arrived, they sent an invitation to her to visit their settlement house. The nurses were very excited and honored to show Miss Addams their work. As they gave her a tour of the settlement house and walked her around some of the neighborhoods where they

worked, they were gratified to hear her words of praise. Miss Addams
noted that, in spite of the short time the school had been operating,
she was astonished to find such cleanliness and order existing among
the girls in the household school.[107] The nurses were gratified that they
had made a noticeable difference in such a short time.

* * * * * * * *

After Miss Addams' visit, the days in Jerusalem gradually grew warm
and then hot as summer set in. Luckily, at night there was relief from
the heat, when the hills provided a cool breeze that lowered the stifling
temperatures. As they visited more and more patients in their homes,
they continued to be appalled at their living conditions. In one letter
back home, Rose wrote:

> Many patients suffer from malnutrition. Beds are quilts on stone
> floors or a board on tin cans. It is difficult to keep clean sheets on
> the beds because the patients think they are too good for everyday
> use and take them off when we leave and put them back on when
> they thought we would next be coming. We found that before
> getting medical care most of our patients are usually in immediate
> need of nourishment. The homes of our patients, with very rare
> exception, consist of one room, housing often six and more
> members of a family. If there is a bed, most of them or as many as
> can get in sleep on it. If one of the family is ill, it does not make
> any difference, they all sleep together anyway, unless someone
> insists upon the contrary, and then it is doubtful if it is done.[108]

Rae sighed as she contemplated their situation. This work was
draining. The poverty was overwhelming and the need was much
greater than she and Rose could handle on their own. They would
need additional help if they were going to make the situation in
Jerusalem any better.

On 1 June, a new ophthalmologist arrived in Jerusalem. Dr Arieh
Feigenbaum had been appointed head of Nathan Straus' Health
Bureau's trachoma division.[109] Born in Lemberg, Austria, Dr
Feigenbaum had trained in ophthalmology in Vienna and was drawn
to Jerusalem to begin his practice. While his expertise was sorely
needed, a competitive discord arose between him and Dr Ticho.[110]

* * * * * * * *

Now that summer had arrived, the nurses were seeing more and more cases of malaria. At first they didn't understand what they were seeing. Malaria usually strikes in areas with lakes and swamps but geographically Jerusalem was the opposite. There was no water anywhere. Then they learned from the doctors that it was the lack of running water that was actually causing the outbreak of the disease. All the cisterns around the city, which contained the rainwater that fell in the winter, held standing water that was a breeding ground for the malaria-carrying mosquitos. If the people covered the cisterns the water became rancid and useless for drinking so they were left open, allowing the mosquitoes to settle. There had recently been an introduction of some netting that could be draped over the cisterns in order to keep out the mosquitos but the poor, uneducated people of Jerusalem did not understand its importance and ignored the advice on how to use the material.[111]

One day a young woman came to the settlement house asking the nurses to visit her father. He had been very sick for the past three days and, though she had tried to take care of him, his health had declined and she didn't know what else to do. Rae volunteered to take the case. She followed the young woman through the streets and into the alleys, winding down the cobblestone walks, picking her way through the increasingly dirty roads. After a walk of about twenty minutes, they entered a doorway off a narrow alley and walked down a dark flight of stairs into a basement. Upon entering, Rae saw that the home consisted of one large room in which eight family members lived. The room was dark and it took a while for Rae's eyes to adjust after the brightness outside. The patient was on the floor lying on a sack filled with straw. He couldn't stop coughing and hacking. Rae listened to his heart and lungs and realized the man had pneumonia. She gave instructions to the daughter to have him brought to Shaare Zedek Hospital.[112] There was no objection to her orders and the daughter readily agreed. Rae was surprised. This was a stark contrast from the first patient she had seen in April, only three months before. Rae was relieved to see that, in the short time she and Rose had been working, they were gaining the trust of the families.

On her way home, Rae found herself humming. She made her way through the maze of alleys in the Old City, side stepping the small piles of refuse that lined the streets. She noticed that she was navigating the roads and alleyways almost without thinking about it. She smiled to herself as she realized that she knew where she was going now – the city was becoming more familiar. She felt a deep satisfaction knowing

that the people were open now about accepting her instructions. Just the fact that there had been no wailing or protesting about going to the hospital was a huge step in the right direction.

The nurses had become a familiar sight on the streets of Jerusalem. They were greeted by young and old, male and female; shouts of '*Shalom* Hadassah Landy and Hadassah Kaplan' were heard wherever they went.[113] 'Despite the hard work and the difficult living conditions, the nurses were unfailingly happy, optimistic and proud of the important work that they were doing.'[114]

In August they received a copy of a report that Henrietta Szold had presented in June to the Sixteenth Annual Convention of the Federation of American Zionists in Cincinnati Ohio:

> Our work in Palestine has gone on apace. The two nurses sent there have rented a little house and are doing work among the Yemenite and other Jews. They are learning Hebrew in order that they may be able to talk with all elements of the population. They have examined the eyes of 5,000 Jewish children who are afflicted with trachoma. They go from school to school rendering assistance to the physician in the more serious cases and attending of their own accord those children whose eyes require ordinary treatment. Our motto is 'The healing of the daughter of my people' and I appeal to those societies, to those communities in which the Jewish women have not taken up Zionist or Palestinian work to pledge themselves to carry on this work.'[115]

Rae and Rose felt proud when they read those words. To think that their work was being recognized and spoken of in such glowing terms to all the Jews in America! It seemed so odd that the daily work they were doing, that was both grinding them down as well as giving them such hope and inspiration, was receiving this kind of publicity across the ocean. It was a funny thing that the day-to-day routine they had established, that truly had become routine, was being reported at the highest level of Zionist leadership. They certainly didn't feel that they were doing anything spectacular. They were doing what they were hired to do and trying to fulfill their mission.

Rae and Rose were particularly excited about their 'little mother school' which had proved to be a huge success. In the household school, the girls were taught to keep their rooms tidy, how to wash and iron clothes, how to sew and how to cook. Rae attempted to teach the girls in Hebrew but the girls often made fun of her stumbling words and

mispronunciations. Finally giving up, she hired one of the graduates of the program to teach the girls. Classes went more smoothly after that. The girls made dresses, which they proudly wore to class as soon as they were complete.

Rose had arranged a tour of an area the nurses had often passed by but had not yet ventured into. 'Tin Quarter', located outside the Old City, was named for the material that was used to construct the houses – pieces of board covered with small pieces of tin collected from refuse piles which included old tin Standard Oil cans. Their tour guide was a teacher from the Laemmel School who had encouraged Rose to visit so that she could see the needs of the area.

Rose, Rae and Eva met the teacher outside the Jaffa Gate and they walked the short distance to the Quarter. Immediately, the women covered their faces with their handkerchiefs as the smell of raw sewage running through the narrow alley overwhelmed them. The streets between the makeshift board and tin houses were about three feet wide and were more like gutters as all the impure water was emptied into them.

They picked their way carefully over the waste and garbage littering the walkway, looking at the so-called houses. The women learned that the settlement was inhabited mostly by Persian Jews who had fled their country because of persecution. While Persian Jews had been migrating

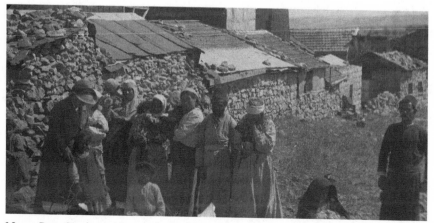

Nurse Rose Kaplan with members of local population, c. 1913–1915; Record Group 18, Photographs Hadassah Medical Organization Series, Hadassah Archives, American Jewish Historical Society, New York, NY and Boston MA. Digital ID 256542.

to Palestine over the past twenty-five years, in the past five years their numbers had increased dramatically.

They looked inside the homes and saw that most consisted of one room, sometimes two. The rooms were dark and constructed very close together, resembling chicken coops more than human dwellings. Very few of them had beds or chairs. People sat and slept on the floors. Rae cringed as she looked in, feeling a sense of despair as she imagined the inhabitants' endless days of suffering. She was repulsed by the odor and she shuddered to think about the diseases that must be prevalent here.

As they made their way gingerly through the streets, a man approached them. He told Miss Leon about a destitute family who lived in the area whose mother had given birth six days ago. Rae and Rose agreed to see the woman immediately. As they followed the man, he told them that the husband supported his wife and two, now three, children by carrying bundles, earning only five francs a week. When they arrived at the home, they ducked into the low doorway and waited for a moment, as they always had to, for their eyes to become accustomed to the dark. They saw one good-sized, fairly clean room that was used as a dining room, bedroom and living room. A tiny corner outside the home was used for the kitchen.

The patient was in bed with the baby. The woman started to speak in a foreign language that the nurses couldn't understand. The man who had brought them there interpreted what she was saying. She was distraught as she explained that they were very poor and didn't have enough to eat. She couldn't feed her family and milk was a luxury. How was she going to sustain her new baby? The nurses looked her over and examined the baby and the other two children and saw that the main thing they needed was food.

They took the patient's older son with them and went to the nearest market and found a milkman. They bought some food and milk and sent it all back with the little boy.[116] As when they had treated the poor patients in the other areas of Jerusalem, they fretted that what they gave the family was completely insufficient to sustain them beyond a couple days, much less solve the problem of their poverty.

During clinic hours the next day, Rae treated a young boy of about twelve years old who had trachoma. A man accompanying the boy told Rae that the boy's mother had been taken to Ezrat Nashim Asylum for the Insane as she had not been of sound mind for some time. There were other children at home who were all now in the care of the father, who taught in a *Cheder* and earned just enough for food. A ten-year-old daughter was keeping house now for the entire family.

The following day, during her rounds to patients' homes, Rae went to this family's home to see if there was something more she could do to help. As she entered the home, she was shocked to see the condition of the one-room living quarters. It was clear that even when the mother was home, she had not been in the right frame of mind to care for her home or her children. The floor was filthy, with dirt and mud covering every inch. Waste and dirty clothing, utensils, plates and old rags were piled everywhere. The stench of feces and unwashed bodies filled the air. Rae went back outside, closed her eyes, took a couple deep breaths and then returned to the room.

The children began to cry when they saw her, clearly in need of attention and care. As soon as Rae saw the condition of the neglected children, with their dirty bodies and lice-filled hair, she again backed out of the house and ran home to get the help of Miss Leon. These children could not stay in the home without their mother as their father was clearly incapable of caring for them properly.

Eva arranged for the children to be taken in by an orphan asylum; however, when she arrived with the children, the administrators refused to take them in. They insisted that the nurses take care of them first, cleaning them up and getting rid of their lice so they wouldn't infect the rest of the children. When Eva returned to the settlement home with the children, she told the nurses what they would need to do before the children could be accepted into the asylum. Rae took another look at the children and realized she could not treat them at the settlement house and she made arrangements for them to be taken in by the hospital to get the care and treatment they needed.[117]

That evening the women discussed the enormity of their work once again. They needed more hands, more nurses, in order to do what they had been charged with. They had begun to get the feeling that Miss Szold was feeling the same way. There had been letters from her in which she asked them what more they could do and how many other nurses would they need for the work. The nurses encouraged Miss Szold to continue her work in finding additional funds to send another nurse or two.

During the late summer, Eva Leon was busy working on her final project. Mr Straus had entrusted her with a very sacred mission. The previous year, when Mr Straus had been in Jerusalem, he had been deeply distressed by the condition of the walkway and stairs leading to

the Wailing Wall. He was actually horrified that the Jewish people, ascending to their holiest site to pray, were walking through total filth. During their journey to Palestine, Mr Straus had charged Miss Leon with seeing if she could get the walkway cleaned and maintained so the Jews could approach their holy site on a clean and pleasant walkway.

When Eva petitioned the mayor of Jerusalem, Hassan Al Husaini, to maintain the walkway, he complained that the city just couldn't afford the cost of keeping this area clean. But Miss Leon was ready for this argument and respectfully explained to him that she had a solution to this problem. As soon as the mayor heard that Mr Straus was prepared to pay for the cost of the upkeep of the stairs and walkway, he immediately agreed to the arrangement. Soon after, street cleaners were hired and the walkway was cleaned three times a day.[118]

In July, Rae learned that Nathan Straus was about to invest in a new venture in Jerusalem. He was going to open up a factory in order to employ some people in the city. He realized that the deep poverty in Jerusalem would never be alleviated unless people had jobs. Despite the important service the Straus Soup Kitchen was providing, it was not addressing the cause of the need to provide food. Even when people tired of the *Halukah* system, of accepting charity from Jews living abroad, and wanted to earn a living, there were just no jobs to be had in the city. So Mr Straus sent a cable to Dr Levy telling him of the impending opening of the workhouse and asking him to serve as its manager.[119]

In September, Dr Levy publicly announced that, through the generous funding of Nathan Straus, he was going to establish two small factories. There would be a button factory and a souvenir factory that would produce goods targeted at the many tourists who flocked to the city each month. Each souvenir and curiosity would be carved from mother-of-pearl, wood, black stones from the Dead Sea, red stones from Jerusalem, silver and ivory.

Soon, a train arrived from Jaffa carrying the heavy machinery needed to manufacture the goods. Unfortunately, the engineers discovered that the machines were designed to run on engine oil and petroleum, both of which were in very short supply in the city. In response, a method was devised to drive the machines by foot. After a bit of ingenious engineering, the factories opened and about eighty men and twenty-five women were given jobs manufacturing the goods.[120] Dr Levy was thrilled to manage the workrooms as it promoted the continued building of self-sufficiency within the Jewish community.[121]

One evening in late August, as the women sat down to their light

supper, Eva surprised Rae and Rose with some upsetting news – she would soon be returning to New York. The heat of the day was dissipating in the cool breeze that the hills offered up to the city. The sound of mourning doves was echoing against the white stone walls of the buildings and the shouts of children playing in the street rang from a distance. Rose and Rae dropped their forks with a clatter and looked at Eva in surprise. Rae felt a momentary feeling of panic at the thought of their team breaking up. They had known that Eva was only with them to help establish their work and that she had not been hired by Hadassah to do the nursing, but over the past eight months she had become an integral part of their operation. They had depended heavily on her counsel, her friendship and her knowledge of both the city and its people. For a moment there was complete silence as they contemplated what life would be like in Jerusalem without Eva and how they would manage without her authoritative and comforting presence.

Eva reassured them that they would be fine without her. In those eight months they had met so many people who were helping them in their work. They had gained the people's respect as hard-working, innovative nurses and had brought true progress to Jerusalem. Eva now had other work to do. She was taking it upon herself to get the message back to Hadassah about the great progress the nurses were making and how important it was that they send additional help. It was critical that the Jewish community know what living conditions were like in Jerusalem and how and why they should help. With additional people and resources, their work could be expanded. They knew that, as much as they were doing and as well as they were doing it, there were only two of them, and it would take an army of nurses to continue to build the district nursing system and staff it adequately. They had had such high idealistic dreams of how they would set up a district nursing system throughout all of Palestine and now the reality of the task had set in. They needed so much more assistance.

The nurses realized that, of course, Eva was right. They had accomplished so much in such a short time but they had reached their capacity in terms of what they could do to build up a nursing system. More help would enable them to realize Hadassah's plan.

The Hadassah leaders in New York were very pleased with the nurses' work; however, they felt that they had been side-tracked from their primary mission. The nurses had received letters from Miss Szold expressing her frustration that they had not accomplished as much as she had expected. She felt they were spending too much of their time

and effort on treating individual patients and not enough on developing and administering a system of services. Miss Szold was raising money through the Hadassah chapters all over the United States to send a third nurse to Palestine and she was hoping that an additional nurse would enable them to move her plan forward. While she did not express these sentiments publicly, she shared them with her colleagues in New York and the nurses.[122]

The next couple of weeks were filled with a great deal of tears and sentiment as the two nurses reluctantly helped Eva pack up her belongings. They gave her packages for their families that she would mail when she got to New York and letters to Miss Szold, expressing their gratitude for her continued support. The reality of Eva's imminent departure hit home when they saw her filled trunks.

On the day of Eva's departure, the women lingered over breakfast, reminiscing about their experiences one last time. They marveled again at their first-class voyage to Palestine, comparing the luxury of their accommodation on the *Franconia* and those carefree weeks with the hard-scrabble life they were living in Jerusalem. They laughed until they cried as they recalled the frightening, rocky journey from the ship to the docks in Jaffa. And they spoke about their joys and disappointments of the past eight months, as they realized how much they had grown to love and care for each other.

Too soon, the carriage arrived to take them to the train station. As the driver hoisted the trunks into the carriage, the midwives and several students arrived to say their final goodbyes. Eva was moved to tears as the little girls presented her with handkerchiefs and aprons they had sewn especially for her journey. The girls were so proud to show their teacher their handiwork. After hugging all the girls, Eva wiped her eyes and climbed aboard the carriage, turning to look one last time at the settlement house. The women rode in silence to the train station, each immersed in her private thoughts. Rae looked at Rose, realizing that it was going to be just the two of them now. She felt anxious that they would be on their own; however, she knew that Eva had prepared them well for this day. The people of the city had embraced them and they had learned how to navigate the many different cultures of the city.

At the station, the trunks were unloaded and put on the train. Rose and Rae each hugged Eva goodbye and then she boarded the train. The nurses waved until the train pulled out of the station and then turned to go back home. After eight months of hard work in Palestine, Eva Leon set sail on the steamship *Auguste Victoria*.[123]

PART II

1914

In which Jerusalem becomes home:
'The nurses were like an oasis in the desert in their clean trim
uniforms. They were angels of mercy in the doing and teaching,
bringing help to the needy sick and instructing the family in the
home care.'[124]

Chapter Six

Winter

It was the end of January and exactly a year since the two nurses had started out on their journey to Palestine. In some ways, it felt like they had been here in Jerusalem forever. The streets of the city now felt like home. They navigated easily through the crowded neighborhoods, traipsing through the stone streets in their white uniforms with the blazing blue Star of David on their sleeves. They worked hard and were often exhausted at the end of the day, but they were seeing results from their efforts, especially with the children in the schools.

For their maternity work, the nurses had divided up the neighborhoods, with Rose taking the 'Tin Quarter' and Rae treating the women in the crowded neighborhood of Meah Shearim. Although they were acutely aware of all the women in the city they weren't able to reach, Rae felt transformed by her work and the impact she was making on the lives of the women they were able to help. She was at peace with herself in a way she never had been before.

Winter had settled in and the cold weather had seeped into everyone's bones. Jerusalem's stone buildings which had offered relief from the heat during the long hot summer now only magnified the cold, as the stones were chilled through and the windowless rooms of Rose and Rae's patients did not let in any sunlight that might warm their occupants.

Rae shivered as the damp air penetrated her cloak, sending chills through her body. The one overpowering feeling she'd had since the first rains had arrived right around the holiday of *Sukkot* was of uncomfortable cold. Of course, the actual temperatures of the Jerusalem winters were not even close to the freezing cold in Cleveland and New York, but there it was possible to warm up by going indoors and enjoying the relief that the coal-fed furnaces brought. In Jerusalem

there was no such thing and people used the heat of kerosene or charcoal stoves in a feeble attempt to ward off the winter chill. Whether outdoors or in, the low temperatures seemed more pronounced and pervaded Rae's thoughts. When visiting patients in their hovels, the wind of Jerusalem's winter whistled in through the doors, swept up under her skirts and grabbed hold and squeezed her lungs. Rae and Rose now put on layers of clothes which they kept on all day long whether they were inside or out, but there was just no way to escape the discomfort. At night, they went to bed beneath freezing blankets, waiting for their body heat to warm their chilly sheets. They would wake up warm but dreading having to emerge from such comfort.

Some time in January, the nurses received a telegram announcing that Rose Jacobs, one of the founding leaders of Hadassah, was coming to visit Jerusalem. She had recently married and she and her husband were using their honeymoon as an excuse to see how things were progressing in Palestine. They were set to arrive in early February, sailing on the S.S. *Caronia*.

Rae and Rose were excited to welcome their guests, and for the next couple of weeks they were busier than ever, readying the settlement house. They looked at their house with fresh eyes, seeing it as visitors from the United States would. They dusted every corner and scrubbed every inch. They even engaged their young students to help with the preparations. But despite how clean the settlement house was, they still saw the dirt and refuse in the alleyways and the waste running through the streets. They wondered if Mrs Jacobs would be able to make a positive report on their progress despite what the surrounding neighborhoods looked like.

Rae paused in her cleaning and sat down for a few minutes. She pondered how much things had changed for her over this past year. The idealism and grand plans she had had upon arriving in the city had been tempered by the reality she faced every day. And yet, her enthusiasm for the work hadn't waned one bit. If anything, she was more excited, even after a year, by the possibilities that arose each week. The initial discouragement she and Rose had felt had all but disappeared as they set new expectations about what they could accomplish. She wondered how she could translate her feelings into words to make Mrs Jacobs understand how transformative this experience was for her.

However absorbing the nursing work was, however, Palestine was a dynamic place where exciting things were occurring all the time. Rae's

thoughts turned to the happenings of the past months. There were two events, in particular, which had been causing quite a stir.

A long-simmering language war had flared up among the Jews in Palestine, centering on the language of instruction in schools. At stake were the core tenets of the Jewish homeland they were building. Was the language of the Jewish homeland going to be Hebrew, the ancient ancestral language, which united Jews who came to Palestine from all over the world? Or would it be better to adopt a language that the rest of the world spoke, perhaps German or English or French, so that Jews would be regarded as citizens of the world? Whichever language was chosen had to be taught to the children in schools.

Currently, there were Jewish schools in Palestine where French was the first language, while other schools taught the children in English, German or Hebrew. Now the teachers were demanding that all the children be taught in Hebrew. Hebrew should be the unifying language of the Jewish people, they argued, no matter what country they had come from. All through the preceding year there had been discussions and debates about this issue.

The situation came to a head when news was received that the language of instruction at the new Polytechnic University in Haifa was going to be German. Upon hearing this, teachers and students across the country had rebelled by storming out of their classrooms and marching in the streets in protest. What an uproar this had caused! The case for the German language had been bolstered by the views of several Muslim newspapers which argued that if the classes were taught in Hebrew then the Polytechnic University would be a school for Jews only. The Hebrew press argued vociferously that, in fact, Hebrew was more likely to include Arabic speakers, as Arabic was closer to Hebrew than any European language. It was argued that the use of Hebrew as the language of instruction would show the Arabs that the Jews were closely related to them and were not 'an alien people.'[125]

On 10 December 1913, a dramatic showdown had occurred right in Jerusalem, involving one of the schools in which the nurses worked. At the center of the events was their friend, Vera Pinczower, the headmistress of the German administered Hilfsverein school called Laemmel. The teachers of the school had petitioned the Hilfsverein administrators to allow them to add hours of instruction in Hebrew. For fear that the school was dropping German as the language of instruction, Mr Ephraim Cohn, the director of the Hilfsverein schools, the Consul of Germany and three policemen unexpectedly arrived at

the school that day, entered the classrooms and forced the teachers to stop teaching immediately and leave the building.

Miss Pinczower told the story to the press. 'Imagine my astonishment', she exclaimed, 'when in the middle of the morning, the officials, accompanied by the police, entered my office and demanded that the teachers be forced out'. When the officials entered one teacher's classroom and demanded that he leave, he said a 'few words of farewell' to the students. Miss Pinczower reported, 'Mr Cohn immediately grabbed the teacher by the collar and attempted to push him out of the classroom.' This was all done in front of the girls of the school who were all 'terrified and wept'. The girls were afraid of the police and refused to leave the school. They were 'shocked to see the teachers they loved driven away by armed force'.[126]

Mr Cohn had the right to feel threatened. All across the country, teachers and students were abandoning the classrooms of the German-speaking Hilfsverein schools and starting brand new Zionist, Hebrew-speaking schools. Miss Pinczower herself started a Hebrew language school right after she was summarily dismissed from Laemmel School, and immediately enrolled 200 girls.[127] There was talk that Arthur Ruppin was going to be organizing the education system for the Jews in order to alleviate some of the chaos that was taking place.[128]

Now, with the pressure of the walkouts and demonstrations, the Hilfsverein was considering conceding defeat and it looked like Hebrew was going to be the main language of instruction in the Haifa Polytechnic University.[129] There were great celebrations among the Zionists who felt that an important battle had been won for the future of the new Jewish homeland.

The second event that had occurred in December had also been very exciting, although the implications for the Jewish homeland were far less significant. The first airplanes had landed in Palestine! On 26 December, a telegram had arrived in Jerusalem stating that a plane from France – on its way from Paris to Cairo – was going to be stopping in Mikveh Israel, a prospering agricultural colony outside Jaffa. The pilot, Jules Vedrines, was trying to win 500,000 francs as the first person to make this journey. He would land, rest a bit and then quickly fly on to Cairo to claim his prize.

In honor of the momentous event, the Jaffa-Jerusalem railroad scheduled special trains to take crowds of people from Jerusalem to Mikveh Israel to the landing strip that had been hastily prepared. Rae and Rose joined the rest of Jerusalem who had rushed to the train

station to take the journey to see the airplane and witness this historic event.

At Mikveh Israel there was a crowd of thousands who had come from all over Palestine –by train, in carriages, on horseback and on foot – to witness the airplane land. Most of the people had never seen an airplane before and they were beside themselves with excitement. At the field, a band was warming up and people were making signs to welcome the pilot.

The crowd waited and waited, growing impatient as the scheduled time of Monsieur Vedrines' arrival came and went without any sign of him. After a couple hours, a man on horseback appeared informing the people that, unfortunately, Monsieur Vedrines would not be arriving that day. He had run into some winds that had forced him to land on the beach in Jaffa and one of the wheels of the plane had broken off in the sand.

The crowd groaned with disappointment but the young messenger reassured them that the plane would be arriving the next day after the wheel was repaired. With that news, the crowd slowly dispersed, making their way back home just in time for dinner, many planning the return trip the next day.

The next morning the crowd returned to Mikveh Israel and waited with great anticipation for the arrival of the pilot. Finally, in the distance, a speck appeared over the horizon. A great shout went out as someone spotted it. As the speck grew larger and more people saw it, the cheering grew until the entire crowd erupted with jubilation. The plane flew over the spectators, tipped its wing, circled the field and made a graceful landing. As it touched down, some of the crowd ran towards it to get a closer look at the flying machine and its hero pilot. The pilot climbed down and greeted the waiting people, shaking hands with the children and all those who had run out to meet him. There were official speeches made by the French Consul and some Ottoman leaders. All in all, it had been a wonderful adventure and a diversion from everyone's exhausting daily routine.

Only a few days later, on 31 December, another plane, piloted by Monsieur Vedrines' competitors, landed in Jerusalem near the train station. In contrast to Monsieur Vedrines' arrival, the mayor of Jerusalem received news that this plane was arriving only half an hour before it was due to land. A very hasty welcome party was pulled together to greet the pilots and, that night, a reception was held in honor of the two aviators. In the paper the next day it was reported, 'Jerusalem – which has no water supply system, no electrical light, not

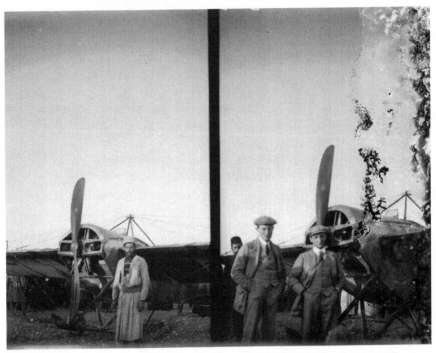

Arrival of French pilot Marc Bonnier and mechanic Joseph Barnier in a Nieuport airplane, the first aviators to fly into Jerusalem. Library of Congress, Prints & Photographs Division, [LC-M32- 50063-x].

even gas light – nothing which is modern, that Jerusalem now has its own airplane.' [130]

Rae smiled to herself as she remembered these events. It was exhilarating to think about the past year and all that had happened. Life in Jerusalem was never dull and there seemed to be a new adventure waiting for her and Rose each day.

Since Eva had left and the two nurses were on their own, they had had to rely on their new friendships and acquaintances to endure the challenges of helping those who lived in the extreme conditions of poverty. It was such a contrast for them; during the day they would treat their patients who lived in crushing destitution, witnessing their hardships and trying to alleviate their burdens and cure their diseases, and then in the evenings and on *Shabbat* they would visit and dine with their relatively wealthy compatriots, none of whom were native to Jerusalem but who came from countries as far away as England, France, Russia, Germany and, of course, the United States.

These Jews were part of the New *Yishuv*, or new settlement of Jews, arriving in Palestine with the common Zionist ideal of establishing a national Jewish homeland. The members of the New *Yishuv* were dedicated to creating a better life for themselves than they had had in Europe where they had faced a great deal of religious and economic persecution. The beauty was that, despite the many countries from which they had come, in the end they were all Jewish and they felt a great sense of camaraderie.

Their dinner parties and social gatherings were filled with talk and gossip about the latest events around the world and in Palestine regarding Zionist activities. It reminded Rae of the study groups back in New York. The big difference, however, was that these people were taking action to make their dreams come true. It was a heady time in the country, exactly what Rae had been searching for all those years in Cleveland and New York.

Rae was particularly drawn to the women who were most like her; women who had chosen a different path through life and poured their passions into their careers. Vera Pinczower was a prime example, a strong woman who had the gall to stand up to the German authorities and the determination to start her own school. Annie Landau, who had become known as a socialite, hosting parties and holding court for the diplomats and Jerusalem elite, had transformed the Evelina de Rothschild School into a model of excellent education for the girls of Jerusalem and was widely respected by Jews, Muslims and Christians. Rae was amazed to see how these women had found a way to fulfill their lives without taking a traditional route of marriage and children and she realized that there were other women who longed for the same independence and freedom as she did. She and Rose spent a great deal of time with these women, spending hours talking and sharing ideas about what was happening around them.

This was truly an extraordinary time in history. Tens of thousands of Jews from Eastern Europe had been pouring into the country over the preceding few years. They were escaping persecution and the anti-Semitism they faced in their native countries and were looking for a better life. But, unlike the millions that were going to America, these Jews were filled with an ideal that Jews could only be free and safe if they had their own country and ruled themselves. These Zionists were dedicated to building their own homeland with sweat and hard work.

At first, the nurses had only listened as the dinner guests argued vociferously about the merits of purchasing land for new colonies and adopting Hebrew as the main language of the Jews of Palestine. Was

Arthur Ruppin doing the right thing in purchasing land? Was A.D. Gordon's ideology of Jewish labor really the key to a successful state? Could Jews from around the world, who spoke different languages and had different histories and cultures put aside their differences and unite to create a new Jewish homeland here in Palestine? After 2,000 years wandering, being expelled from country after country and being persecuted because of their religion, beliefs and customs, could it happen?

If one looked at the determination of the thousands of new pioneers, or *chalutzim*, and the work they were doing in bringing the land back to life with their rich agriculture and the beautiful new Jewish city of Tel Aviv, it appeared that this dream could come true.

Not everyone agreed, though. Around this time an article was published in the *Jewish Review and Observer* in Cleveland, Ohio questioning the rationality of Zionism.

> The Zionist ideal...we fear, will never be realized. Where is the Jewish nation? Is it not a mere figure of speech?... There is something infinitely pathetic in the Zionist ideal; it is so hopelessly 'out of joint' with the times we live in. For the modern Jew has come to learn through much suffering, bitter persecution and painful experience, that it is left to him to work out his own salvation...[131]

This point of view was diametrically opposed to that of those living in Palestine who were working so hard to establish agricultural settlements and promote Jewish self-sufficiency. The people who immigrated to Palestine were dedicating their entire lives to building their dreams.

Although Rose professed that she was not a Zionist, she had been utterly amazed at the sight of the Jewish agricultural settlements. In contrast to her very vivid and painful memories of growing up in Russia, the orange groves and the Jewish farmers were a continual topic of conversation for her. She often shared with others the wonder she felt when she had seen the Jewish laborers tending the fields. The difference was stark between the Jews in Russia, who were merchants and craftsmen, pushed to the margins of society, eking out a living in a hostile country with no connection to the land, and here in Palestine, where the Jewish farmers were tanned and fit and strong.

While cultivating the land, these Russian Zionists were building a connection in their innermost spirit to their ancestral homeland. In a very short amount of time they had made enormous progress. The land

was yielding to their hard work; groves of trees were producing oranges, vineyards were filled with the sweetest grapes and fields of wheat were ground into flour for the entire country.

With this new-found knowledge and her own experiences in the work with her patients, Rae now felt quite comfortable sharing her own thoughts on Jewish self-sufficiency. Most of the women Rae and Rose served were part of the 'Old *Yishuv*', whose husbands and fathers had primarily come to Jerusalem to study Torah and fulfill their religious beliefs. Some people came for the sole purpose of dying there, so they could be buried in the Holy City. This was the group that relied on charity from their communities of origin who regularly sent money to sustain them and their families. These were the people that lived out their lives in dire poverty, the patients of the Hadassah nurses.

Rose wrote about these conditions in a letter to the women gathering for the annual convention of the American Nurses' Association that was to be held in St Louis that April:

> Miss Landy and I, nurses for the Daughters of Zion of America, send greetings from Jerusalem to our friends at the convention to be held in St Louis. We greatly appreciate the interest you have taken in the work of the Daughters of Zion and consequently in our work in the Holy Land...The poverty among the Jews in Jerusalem can perhaps be equaled nowhere else. It is especially severe among the Jews who have recently emigrated from Persia and among the Yemenites or Arabian Jews who are coming to Palestine in large numbers owing to persecution. Frequently these poor emigrants lack all necessaries of life. Their homes usually consist of one room housing a family of from two to ten members. These cabins are often built out of tin taken from discarded Standard Oil cans. Beds and chairs are seldom to be found. The people sleep on straw mats on the floor. If there happens to be a bed, as many of the family as the bed can hold get into it. I have often come into homes of our patients during the Winter to find visitors in bed with the patients for it was warmer there than on a mat on the floor. Under the conditions described above it can easily be imagined how difficult it is to nurse a very sick person in a poor home in Jerusalem.[132]

Rae sighed as she thought about the challenges facing them. It was clear that self-sufficiency and independence was the future of the Jewish people. But to look at the people of the Old *Yishuv* and the lack of

motivation amongst the men to earn a living by working, they had a long way to go.

Rae enjoyed her quiet moments sitting and reflecting on the recent events and how much she had learned. She mused about how it was all so interesting and how grateful she was to be living in Jerusalem at this time. Her attention now turned back to the matter at hand. It was time to continue getting ready for the Jacobs' visit. She rose from her seat where she had been resting and turned back to continue preparing the house.

Chapter Seven

Visitors

When the train pulled into the station, Rae and Rose stood on the platform, craning their necks to find the Jacobs. And there they were, anxiously looking out of the window. They waved wildly when they saw each other. All the nurses' nervous anticipation disappeared as they saw Mrs Jacobs looking excited and happy to meet them.

As the couple descended from the train, the nurses greeted them with formal handshakes and introduced themselves. While the porters collected their valises and trunks, they led the Jacobs to the waiting carriages. Once stowed safely inside the carriage, Mrs Jacobs chatted excitedly about their journey and adventures. All the way to the hotel, the visitors looked around with astonishment as they witnessed the holy city for the first time. Rae and Rose also looked around, seeing things through the eyes of the new arrivals. Rose Jacobs later reflected on her first impressions of Jerusalem and on what she saw that day, writing about the 'magic of the light reflecting off the stone buildings and walls, the pink and purple colors, the weight of the history of the Jewish people heavy all around them, shown on every Jerusalem stone, reflected in the walls of the Old City.'[133]

The Jacobs stayed at the Grand New Hotel, which was located right inside the Jaffa Gate, in front of the Citadel, or Tower of David, the busiest part of the city. Along the street leading to the hotel and adjoining it was a long line of small shops selling antiques and souvenirs. The ground floor of the hotel also had a gift shop, selling souvenirs, antiquities, jewelry and other trinkets a visitor would want to purchase to remember his visit to Jerusalem.

When newly built, the Grand New Hotel had been a wonderful place with its round arched windows and decorative molding. It was always touted as one of the three main hotels at which visitors to

Jerusalem should stay. While tourists still stayed there, over the years it had grown somewhat shabby and rundown. The Greek Orthodox Church, which owned the building, had not updated it since it had been built in 1884, so it lacked many amenities that other new hotels now included. Mrs Jacobs remarked, while checking into the hotel, 'I see that the Grand New Hotel is neither grand, nor new.'[134]

The couple perked up, however, when they discovered that there were some prominent Americans also staying there. Rabbi and Mrs Stephen Wise and Mr and Mrs Julius Rosenwald were also visiting Jerusalem. Mr Rosenwald was head of Sears, Roebuck and Company, one of the richest Jews in the United States and a great philanthropist. Although Mr Rosenwald's primary area of giving was to the American black community, for whom he was building schools primarily in the South, he had recently become interested in Jewish and Zionist causes as well, mostly due to his meeting with Aaron Aaronsohn.

Mr Aaronsohn was an agronomist and botanist who had discovered a strain of wheat in Palestine that had been proved to be an original species. He had been on a tour in the United States in 1909, meeting with prominent Jewish leaders and philanthropists to raise money for his agricultural research, and had convinced Mr Rosenwald to come to Palestine to see the work he was doing at his agricultural station at Atlit, located near Haifa. Mr Rosenwald had been intrigued with Aaronsohn's discovery and finally decided to make the trip that winter of 1914.

Arthur Ruppin later told this story: at the same time that the Rosenwalds had arrived, Baron Edmond de Rothschild, head of the Rothschild banking dynasty of France and great benefactor of the Jews of Palestine, was also there visiting after a long absence. He arrived in his yacht which he anchored off the coast of Jaffa. During his stay, he met often with Mr Ruppin to talk about the work he was doing with land purchase and setting up farming communities.

When Mr Rosenwald arrived in Jaffa, he sent a message to Arthur Ruppin to come and meet with him in order to learn about his work but Mr Ruppin was offended by the 'summons' from the American millionaire. In the end, Ruppin relented and agreed to a meeting as he didn't want to turn him down and potentially lose the money of the wealthy philanthropist.

Ruppin was surprised to discover that he and Rosenwald hit it off instantly and, in an effort to be magnanimous and also to show Rosenwald that he wasn't the only wealthy philanthropist Ruppin dealt with, he suggested that Rosenwald meet Baron de Rothschild. He thought the two wealthy philanthropists might enjoy each other's

company and Rothschild could help convince Rosenwald to donate money to the Zionist cause. Ruppin arranged for the two of them to meet Rothschild on his yacht. This was the decadent high life and Ruppin relished his meeting with the two millionaires. He reminisced that they all got along, had a grand time on the yacht and had an invigorating conversation. The result of that meeting was that Rosenwald made several large donations, including one to Aaron Aaronsohn's agricultural station.[135] Ruppin felt that he had humbled himself appropriately by going to meet with the American millionaire.[136]

After that meeting, the Rosenwalds traveled to Jerusalem and there they were in the Grand New Hotel when the Jacobs arrived. Mrs Jacobs felt placated to be staying at the old hotel in the presence of the wealthy philanthropist.

On the first night of the Jacobs' visit, the nurses dined with them at the hotel and the conversation turned quickly to the surprise Rose Jacobs felt when their ship anchored in the sea, far from the shores of Jaffa. They commiserated in recalling the way they had to disembark from the ship, lowered into the rowboats of the Arab boatmen who crazily maneuvered their way to shore. Mrs Jacobs exclaimed that they were positive they were going to be dashed upon the rocks.

She later wrote of her astonishment at the sight of all the Arabs in Jaffa:

> The sight of large numbers of Arabs on shore came to me as an unexpected phenomenon. I recall saying to my husband: 'Are there so many Arabs here, or do they seem like a large number to me?' ...I had a fairly good background and some knowledge of Jewish history. I was well prepared for a Jewish scene, expressive of the aspirations of the modern Zionist movement, but I was not prepared for the Arab scene.[137]

The conversation then turned to the voyage from America. Mrs Jacobs described their pleasant journey to Palestine to the nurses. They had been the only Jews on the ship. 'It was hard to hide our origins, as we were the only ones on the ship to have ordered kosher food. But everyone was pleasant and the voyage itself was quite lovely.'

The Jacobs planned to spend several days in Jerusalem accompanying the nurses on their daily rounds so that Mrs Jacobs could report back to Miss Szold about their work. 'Miss Szold has given me several letters of introduction to her contacts in Jerusalem and in return

she has exacted what she calls a heavy price. I must report on all that I see of your work.'[138]

And so plans were set to meet early the next morning when Mrs Jacobs would begin her observation.

Over the next several days, Mrs Jacobs followed the two nurses on their rounds and scrupulously noted how they spent their time. The nurses led her down the crowded city streets, which were lined with continuous rows of two-story, white stone buildings. The upper floors each had a balcony, from which clean laundry flapped. Each balcony railing was festooned with red peppers or green plants, the bright colors contrasting sharply with the white Jerusalem stone. The small party soon turned off the main streets and meandered through alleyways and narrow crooked lanes. Mrs Jacobs was wide-eyed and continually uttered cries of surprise as they dodged the donkeys, camels and people. The dirty streets were navigated delicately, with the women cautioning Mrs Jacobs to stop looking up at the arched ceilings of the marketplace and to look where she stepped to avoid the pervasive animal waste.

As they walked, the nurses described the geography of the city and a little of its recent history. They explained that each ethnicity of Jews lived in its own quarter. The Old City of Jerusalem contained mostly the *Halukah* Jews, dependent on aid from abroad. Outside the Old City walls there were now about three times as many Jews living in the new neighborhoods. Meah Shearim, right next to the Old City, was like a Russian Jewish ghetto, with its families living as if they were still in Europe, the men wearing the same heavy robes and fur-lined hats as they had in Russia, despite the heat of Palestine. This is where Rae did most of her work.

The main thoroughfare was Jaffa Road, leading away from the Jaffa Gate and the Old City to the new neighborhoods. Right outside the walls of the Old City was the poorest Jewish section, the Tin Quarter, where the Yemenite and Persian Jews lived. This was where Rose did most of her work.

There was Ohel Moshe, a Sephardic neighborhood that had been established by the beloved philanthropist, Moses Montefiore, in the 1880s; beyond that was Zichron Moshe, where many secular Jews lived, including many teachers. Even Bukharan Jews from Central Asia, now numbering around 1,500 people, had their own quarter. They were among the more wealthy Jews and lived in beautiful villas.[139] About 85 per cent of the Jewish population was made up of Ashkenazic Jews from Eastern Europe. But each ethnic group, no matter where it was from, had its own synagogue, language and customs.

Mrs Jacobs noticed the poor, ragged people and the food in the bazaars all covered with swarming flies. She saw the appalling number of blind people navigating their way around with the help of sticks. Small, disheveled children approached the group with their hands held out for an offering, trying to touch them. She remarked to the nurses how shocked she was by the amount of begging that was taking place in the streets – and the dirt, the filth: it was everywhere and unavoidable.

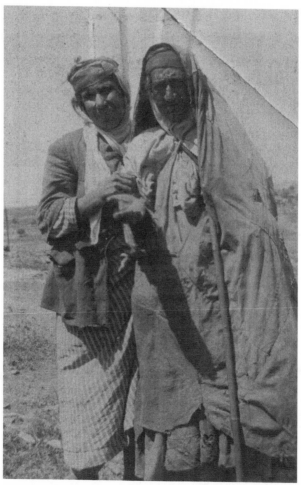

Two beggar women on their rounds, Jerusalem. Rose Kaplan – photographer, undated; Record Group 18, Group Portraits Series, Personal snapshots, Rose Kaplan-002, Photographs Series Personal Snapshots Subseries Rose Kaplan, Hadassah Archives, American Jewish Historical Society, New York, NY and Boston MA. Digital ID 262387.

Mrs Jacobs later expressed to Hadassah that 'watching [the nurses'] work of mercy was an unforgettable experience'. She tried to hold back her expressions of dismay as she entered the decrepit homes of the patients. She felt she was being led into a secret world, behind the walls and gates that was not visible from the streets. Mrs Jacobs told Miss Szold, 'The nurses were like an oasis in the desert in their clean trim uniforms. They were angels of mercy in the doing and teaching, bringing help to the needy sick and instructing the family in the home care.'

She saw that the nurses had earned the confidence and trust of the people of Jerusalem and she noted that they were so devoted to their work that they worked from early morning to late into the night. Mrs Jacobs told the nurses that Miss Szold would be thrilled by how they had set up a system with their midwives and cared for the maternity cases in such a short amount of time.[140]

The Jacobs were introduced to Drs Ticho and Segal and observed how the nurses worked with the two physicians and treated the children in the schools. She wrote to Hadassah that, 'The nurses were pictures of cleanliness and order; their unfailing help to their patients was heartening. Their understanding and sympathy were expressed in their voices, their smiles, their readiness in service.'[141]

In the evenings, as they lingered over their dessert and tea, Mrs Jacobs gave Rae and Rose an update on the development of Hadassah. She told them how Hadassah was growing and spreading to many other cities in the United States. There were now seven chapters around the country.[142] She described how the organization was actively raising money from its members to send more nurses to help them. Miss Szold was determined to accelerate the pace of the formation of a district nursing system. It was clear that, despite all the work the nurses were doing, the lack of other trained professionals who could help them was hindering them from reaching the goal that Miss Szold had envisioned. They were relieved to hear about the plan to send additional nurses to join them in their efforts. The nurses were proud that their work was inspiring American women and felt they were putting their philanthropy to good use.

After several days of joyful visiting, the Jacobs reluctantly said goodbye to the nurses to continue their tour of Palestine before heading back to complete their Mediterranean cruise.

The days were getting longer. The streets were filled with the fragrance of blooming flowers. The sweet, heavy scent of lavender and jasmine permeated Rae's senses and filled her head. That combination of smells would, for the rest of her life, bring an overwhelming sense of bittersweet happiness and longing as she would be transported back to Jerusalem instantly, recalling those days of springtime. She later wrote:

> We kept very well under the stress of hard work and exposure for we went out regardless of the heat of the day or the pouring rain... The work was so interesting and pleasant; we had the cooperation of everybody and we made many friends. We loved Jerusalem, every stone and grain of sand in it. In spite of the lack of water I know I felt cleaner in Jerusalem than anywhere else.[143]

In addition to celebrating the arrival of spring, the citizens of Jerusalem also celebrated the news that electric lights and a water system would soon be installed in the city.[144] The nurses anticipated how much easier life would be with these modern conveniences and how they would affect the health and hygiene of the people of Jerusalem.

That spring of 1914 was a record year for tourism in Palestine. The Jacobs, Rosenwalds and Rothschilds were only the beginning. The warmer weather was accompanied by shiploads of people who were streaming in to see the Holy Land. The newspapers reported an estimated eighteen to twenty thousand tourists visited Palestine that spring, the vast majority making Jerusalem one of their stops.[145]

The most prominent and distinguished visitor was the Honorable Henry Morgenthau, American Ambassador to the Ottoman Empire. Ambassador Morgenthau, who was Jewish, had been appointed to this post the previous year by his friend President Woodrow Wilson. Wilson had offered Morgenthau the position because he felt that, as a Jew, Morgenthau could help build bridges between the various religious groups of the Ottoman Empire. Now, a year into his appointment, Morgenthau had decided to tour Palestine to view the work and progress of the Zionists.

Before his anticipated visit, there was great bustle and excitement. All the talk during the usual *Shabbat* lunch at the Levys' home was about the ambassador's visit. As they passed the china serving platters loaded with savory, *Shabbat* delicacies, questions were tossed around the table. What would he want to see in Jerusalem? Who would he see? Where would Arthur Ruppin take him? This visit would be a great

opportunity to show him how the Jewish community was thriving in Palestine and how the education and health institutions were making a difference in the lives of the poor Jerusalemites. It would be important that the ambassador see the schools, soup kitchens, hospitals and, of course, the work of Hadassah.

Again, the nurses found themselves paying special attention to the cleaning of the settlement house. They urged the midwives to be paragons of health and enlisted the nurse assistants, whom they called probationers, to showcase the work they were doing in the schools.

When the big day arrived, Rose and Rae headed to the train station with the rest of the elite of Jerusalem. As the horses maneuvered the carriage down the narrow roadways, taking them through the city, they enthusiastically reviewed what they would do when the ambassador came to visit them.

At the station, a large crowd welcomed the train as it lumbered to a stop. The smoke from the train fell upon them as the brakes sighed and creaked. Turkish guards, in their sharp, clean uniforms and fezzes, were standing at attention next to the train; several were even standing on the roof of the station. A band started playing as the passengers gradually disembarked, carrying their bags and parcels. Ladies in fine dresses stepped delicately as they were helped down the steps and led to a reception area that had been set up in honor of the ambassador's arrival. Porters heaved loaded trunks into waiting carriages.

Finally, Ambassador Morgenthau appeared at the train door. Dressed in a topcoat and hat and carrying a distinguished walking cane, he waved to the waiting crowd. He was accompanied by his wife, daughter and Mr Ruppin, who was acting as his escort throughout his visit. Chief Rabbi Cohen, David Yellin and other leaders of Jerusalem welcomed the distinguished visitors and escorted them to the reception area. After a few speeches, a group of twenty-four girls from the American mission school sang for them. The ambassador then said a few words, expressing his enthusiasm about being in Palestine and his interest in seeing Jerusalem. When all the pomp and ceremony was over, the Morgenthaus ascended into a waiting carriage and drove off to Fast's Hotel.[146]

The next day, the nurses woke up especially early and made last minute arrangements in the house to welcome the ambassador and his wife. When they finally arrived, Rae felt a sense of pride as she and Rose led the Morgenthaus through the settlement house. She felt like a true ambassador of American Zionist women as she explained the goals of Hadassah and the work it had done so far in setting up a

district nursing system and providing maternal health services. She could tell the ambassador was impressed with their work as he learned about the progress they were making in the city.[147]

Later, Ambassador Morgenthau would report to the papers, 'My purpose in visiting Palestine was first, to learn for myself the actual condition of the various American institutions in Syria and Palestine... I also desired to visit the Holy Land for myself and to ascertain the conditions of the new Jewish settlement in Palestine.' He also told the reporters that he was most impressed by what he called 'the transformed Jews.' He was struck by the value of colonization and the renaissance of the Hebrew language.[148]

The rest of that month and into the early summer was non-stop activity for the nurses as they welcomed and hosted visitors from both within Palestine and abroad. They were proud to show off their work to those who came to inspect their progress in district nursing and trachoma treatment. Many of these visitors were wealthy Jews who were considering investing money in the Palestine Office of the Jewish Organization to purchase land for future Jewish agricultural colonies.

So enamored was the press with the influx of tourists to Palestine that they reported:

> It is not too much to say that Palestine is now the greatest center of Jewish interest throughout the world. Mr Julius Rosenwald has just returned from a trip of inspection immensely impressed both with what has been done and the promise of new things. Ambassador Morgenthau has visited the country and expressed himself pleased to cooperate with those working for the restoration of the country by the Jews. Baron de Rothschild has lately renewed the acquaintance with the land of his early enthusiasm.[149]

For *Pesach*, the nurses hosted Dr and Mrs Biskind from Cleveland. Mrs Biskind was the president of the Cleveland chapter of Hadassah, called the Shoshana Chapter, and Dr Biskind was an enthusiastic Zionist. Rae was thrilled to greet them as they brought plenty of news about Cleveland and Rae's family. They also brought a box filled with toothbrushes that the women of Cleveland had donated to the children of Jerusalem.

When Mrs Biskind saw the amount of work the nurses were doing and how much still needed to be done she wrote an urgent letter to the leaders of Hadassah stating, 'the work done by the two nurses in

Jerusalem, though remarkable, is wholly inadequate and should be supplemented by at least a dozen more nurses'.[150]

She was horrified at the living conditions of the patients she saw on her visits with the nurses. She was stunned to see homes that were like caves, actual holes in the ground. And on one sad day, she had the most unfortunate experience of visiting a home where a woman had died in her bed in one of the underground hovels; the other family members hadn't realized the patient was dead for several days.[151] She reassured the nurses that Miss Szold was still laboring to recruit an additional two nurses to send to Palestine and hoped to have the funds and the nurses ready to go by the end of the summer.

Despite the good work they were doing, the nurses sensed there was a bit of disappointment on the part of Miss Szold that they hadn't been able to accomplish more. In their monthly reports back to the United States, they started adding to the tallies of home visits, sick cases, maternity cases and trachoma work, the words: 'Number of nurses: 2'. It was just a reminder that the level of services being provided was the work of only two individuals. Actually, they were accomplishing an amazing amount in their trachoma work, but it was also true that it was impossible for two nurses to build the type of program Miss Szold had envisioned. Perhaps if there were more professionals or a nursing school or a maternity hospital they could do more. But for now, all they could do was train a few midwives and use the small amount of resources available to them to do their best.

The larger world and the plight of Jews in Europe continued to make itself known to the Jews in Palestine through the many newspapers that flourished at that time. One story which was followed closely by Jews throughout the world was that of Mendel Beilis. His story was published almost weekly in the world's Jewish newspapers.

Mendel was a Jew living in Russia who had, under very suspect circumstances, been accused of killing a gentile boy and using his blood in the making of *matzah*. It was a modern incarnation of the 'blood libel' – accusations that had been made against the Jews since the Middle Ages. It was hard to believe that, in this modern day, Jews were still being accused of such horrific and outlandish crimes. And yet, it was emblematic of the anti-Semitism that was lurking in Russia, ready to be unleashed in a moment.

Beilis was arrested and spent two years in prison, despite the weak evidence against him. Luckily for Mr Beilis his imprisonment set off a flurry of worldwide protests against the Russian government, demanding a fair trial and his immediate release. Individuals and

governments from around Europe and the United States petitioned the Russian government on his behalf. Finally, in the fall of 1913, there was a trial and, after hours of deliberation, the jury found him not guilty.

After his release from prison, Beilis made arrangements to leave Russia as soon as possible; he arrived in Palestine with his wife and five children in February 1914. Beilis was exhausted from his imprisonment, trial and subsequent journey, and tried hard to find peace and quiet in Tel Aviv, but everywhere he went he was besieged by people wanting his attention. Emissaries from Jerusalem came to Tel Aviv and begged him to come and live in their city. Philanthropists and leaders who came to Palestine that spring made visiting Mendel Beilis a stop on their tours.

Not only was he very worn down, he was also financially bereft despite some small financial assistance from the Jewish Committee. And yet, he reported finding peace and solace, both physical and emotional, in Tel Aviv.[152] It became a common sight to see Mr Beilis chatting with his neighbors and walking in the streets like every other citizen of Tel Aviv.

That *Pesach*, Beilis acceded to the numerous requests he had received and went to Jerusalem. He did not enjoy his time there, finding it exceedingly tedious. 'In the three days I spent in Jerusalem, I had to visit the synagogues, inspect the hospitals and charity institutions and inscribe my name in countless albums.'[153] The man was a reluctant celebrity and a personification of the redemption of the wrath and hatred that people around the world had for Jews. His survival and freedom represented hope for the Jewish people worldwide and everyone wanted to see what that looked like.

At this time, there was an influx of American engineers who came to Jerusalem. The Standard Oil Company of New York had begun oil exploration operations in the Negev Desert the previous year and was continuing to conduct geological surveys to determine whether there was oil of sufficient quantity there. The engineers often came to Jerusalem for some rest and relaxation from the harsh conditions of the desert. They could often be found in the restaurants and coffee houses along Jaffa Road.[154]

Also in April, Jerusalem welcomed its first female doctor, a young twenty-four-year-old woman named Helena Kagan. She had just graduated from university and thought she might find a more accepting environment for female physicians in Jerusalem where medical services were so greatly needed.[155]

If things weren't busy enough, Dr Ticho hosted a national conference on trachoma. It was the first professional conference ever held in Jerusalem and he was quite excited to host twenty-four Jewish doctors from around the country. The meeting was quite successful and, as a result, the physicians decided to combine their small professional societies into a larger Hebrew Medical Association.[156]

All in all, spring had been a hectic and invigorating time for Rae and Rose. They saw everyone who came to visit Jerusalem and were often busy entertaining guests and showing them around from early morning until night. They enjoyed themselves thoroughly and loved the time they spent with the visitors. They were both quite satisfied with the life they had carved out for themselves in Jerusalem.

Chapter Eight

The Challenges of Summer

Spring turned into summer and the days transitioned from warm to scorching hot. Sometimes it felt unbearable for the nurses to enter the closed airless rooms of their patients. Those who lived in basements were lucky because their rooms stayed cool beneath the unrelenting sun. The nurses sweated under their long skirts and looked forward to the cool of the evenings when they could sit in their garden and sip tea and relax. Rose wrote, 'The weather is beautiful, but it is very hot during the day and one looks forward to the evening coolness. It is a great blessing that the nights are so delightful, and one is able to sleep.'[157]

The nurses received another letter from Miss Szold questioning them about their work and progress. She was adamant in her orders that they were not supposed to be providing direct care and charity but should be setting up the district nursing program and 'little nurses' school. After fretting about it for a couple days, the women decided that they needed to write a frank letter to Miss Szold. Rose wrote:

June 7

As regards to clubs for children, I do not remember ever writing that they could not be made possible. I may have written about difficulties as to language, for one must remember that in one school there are children who speak jargon, Spanish, Arabic, Hebrew and French languages, with which we are not familiar, except jargon, and very few children speak that.

Rose finished the letter by describing the good work they were doing in the schools, knowing that she had already written many times about the progress they were making:

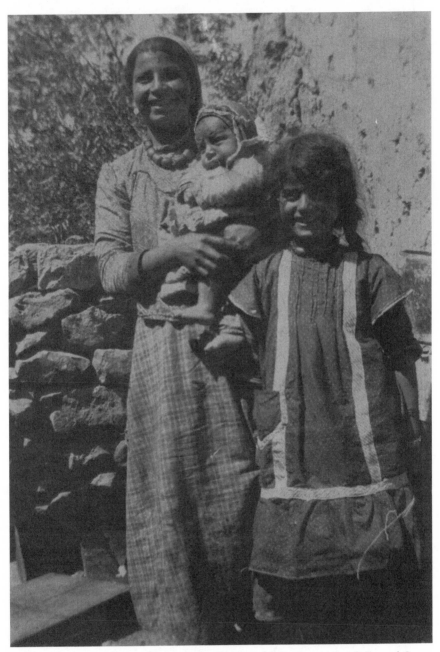

Woman with children, Jerusalem. Rose Kaplan – photographer, undated; Record Group 18, Group Portraits Series, Personal snapshots, Rose Kaplan-003 Photographs Series, Personal Snapshots Subseries Rose Kaplan, Hadassah Archives, American Jewish Historical Society, New York, NY and Boston MA. Digital ID 262389.

However, I have started with the children of the Alliance, and manage, after a fashion to get along. I find that in spite of my not knowing the different languages the children speak, and having to resort to interpretation through one of the Ashkenazi children, I still manage to make an impression on some of the children even if they do not belong to the club, but were told by their friends in the same class about the club. A number of them are Persians, Yemenites, and Sepharad. I find them more anxious to follow than Ashkenazi children. I still maintain that if one knows the language, better results might be obtained.[158]

Despite the positive reports that were sent by the nurses to New York, it was apparent that Miss Szold needed this constant reassurance. She had informed the nurses that Hadassah had identified several excellent candidates to be sent to assist in the setting up of the district nursing plan. Those candidates were now preparing to travel to Jerusalem. Miss Szold enquired about the capacity of the nurses' home in terms of accommodating two additional people. Rose wrote back that two more people could easily fit into the space if two shared one of the larger rooms; however they would need additional domestic help to maintain the household with four people.[159]

Miss Szold had decided to consult with Lillian Wald to ensure that the next nurses they hired would have the ability to move forward with the Hadassah plan. The new Hadassah nurses were carefully studying what Miss Wald was doing with New York's Henry Street Settlement in order to bring their new knowledge to Jerusalem. Miss Szold observed that Miss Wald had grown the Henry Street Settlement to employ ninety-two nurses in seven buildings and she hoped that the same development could happen in Jerusalem. The New York Settlement nurses were conducting 200,000 visits per year, Miss Szold noted.

Rae and Rose may have felt somewhat put out with Miss Szold's disappointment in them but they continued to remain upbeat and were diligent in recording the work they did and the number of patients they saw. They continued to write: 'Number of nurses: 2' on reports, just as a reminder that they did not have ninety-two nurses at their disposal.

On June 22, Dr Harry Friedenwald, an ophthalmologist and Honorary President of the Federation of American Zionists, arrived in Palestine for a six week visit. Besides the usual reasons that Zionist leaders were streaming to Palestine that year, he was anxious to observe the work that was being done in the field of eye health.[160] For the first week of his

visit, he stayed in Jerusalem and worked closely with Dr Segal, at Rothschild Hospital, and Dr Ticho and the nurses in the schools.[161]

> Rose wrote extensively about the Friedenwalds' visit:
> June 23
> While speaking to Dr Segal about a patient I came to ask him to see, he told me that Dr Harry Friedenwald had arrived last night. We have not as yet met Dr Friedenwald. We will certainly do all we can to assist Dr Friedenwald in his work in Palestine...

The next day Dr and Mrs Friedenwald and their son accompanied Dr Ticho on his school visit and met Rae there. He watched carefully as Rae checked and treated the students' eyes. That evening, Rae and Rose visited the Friedenwalds at the Hotel Kaminitz on Street of the Prophets and spent the evening with them.

The next day, the Friedenwalds came to the settlement. Rose wrote to Miss Szold:

> After signing his name in our Visitor's Book, and going through the Settlement hurriedly, Dr Friedenwald left as he had an appointment with Dr Segal. Mrs Friedenwald remained for a cup of tea. Mrs Friedenwald gave us twenty francs towards the work. I will deposit it with the rest of the funds of the 'Hadassah'.
>
> Yesterday, June 28th, Dr and Mrs Friedenwald and their son left Jerusalem for the Colonies, where they expect to remain several weeks; for the rest of their stay in Palestine they will return to Jerusalem.[162]

When Dr Friedenwald returned to America in August, he said to Miss Szold, '[The nurses] have done splendid work, and I admire the intelligence and intense devotion which they have brought to it.'[163]

In the midst of all the visiting and touring of the settlement house, the people of Jerusalem continued to need care and the nurses toiled many long hours to provide it. One day, both nurses were summoned for an unusual case. A woman was being attended in her childbirth by an older relative rather than a midwife. When the relative discovered that there was more than one baby being born, she called for the Hadassah nurses who rushed over to help. The nurses found a destitute woman living in a very roughly built shack. She was lying in a ramshackle bed and in a great deal of pain. The nurses quickly got to work and cared for the patient through the lengthy and difficult labor.

In the end, the woman delivered triplets –two boys and a girl. She was very unknowledgeable about childbirth and babies and was 'perfectly bewildered by the unexpected additions.' The nurses observed that the new mother needed a great deal of assistance and provided her with groceries, underwear and other necessities. They visited her regularly to ensure she remained healthy and kept a close eye on the babies.

Rose wrote about the case in her next letter to Miss Szold, 'When they are a little older and I am able to persuade the parents to let me photograph them, I will do so and send the pictures to you. The Urfaly, the Yemenites, and some of the Persian Jews strenuously object to being photographed, thinking it will bring them ill luck.'[164] Sadly, after a week, one of the babies died, and so the nurses continued to keep this woman and her babies in their care for many weeks.

The nurses were now seeing many cases of malaria which they had anticipated due to their experience the previous summer. There was also a great deal of typhus, typhoid fever and meningitis. These diseases, Rose wrote, 'claim at present many victims, and one is continually on the lookout for one of them to appear.'[165]

They had saved five hundred dollars specifically for the summer, in anticipation of the increase in diseases during this season. In an effort to conserve their funds, most of the patients were treated in their homes. Only the sickest were referred to the hospital, as Shaare Zedek only accepted patients who could pay. Rothschild Hospital was much more accommodating, with Dr Segal taking in as many patients as he could. Rose wrote, 'One of our patients he kept for eight weeks. It would mean for us to pay 224 francs should we have sent her to the Shaare Zedek Hospital.'[166]

Rae and Rose accepted only a few patients who were sick, again due to their limited capacity. In July they had five patients. One of them was an old lady who had a kidney disease. 'She lives all alone in a white-washed hole, without a window, the air coming in through the open door. Her bed is the floor. When in good health she works hard to support herself and keeps the little home very clean. Nourishment, medicine and physicians have to be supplied, as there is no one to help her.'[167]

Rose wrote:

> The second patient is a young man of twenty, living with his old parents in a basement. We were told about him only this morning. He had been ill of over a week and the treatment was rather an indifferent one. He has had a continual high fever. Dr Segal came

to see him and gave him a thorough examination, ordering a certain treatment. If it does not produce the desired effect, the patient may have to be taken to a hospital, for the dark and airless basement is no place for a sick person.[168]

The constant heat and daily load of sick patients were wearing the nurses down. Rose and Rae decided that they both needed to take a break from their work and see a little of the country. Rae decided to take some time to see the farming colonies of Rehovot and Petach Tikvah, and Rose decided to take a longer journey up to the north to see some of the new Jewish settlements near Lake Tiberias. They decided that Rae would travel first and Rose would start her journey when Rae returned.

The nurses had learned a great deal from Arthur Ruppin and Aaron Aaronsohn about the colonies and the work of the Zionists in Palestine outside Jerusalem. Land ownership was considered a key component in securing a homeland for the Jews. Mr Ruppin had described for them the Palestine Office's strategy of land purchase. He envisioned a swath of land, running from Jaffa by the Mediterranean Sea, moving northward and east, through the plains and the Jezreel Valley, all the way up to the Kinneret or Lake Tiberias, as the ideal land for purchase. There were very few Arabs living on this land, as most were settled in the surrounding hills, and it had the potential to be rich for agriculture. Luckily, there were many absentee land owners who were willing to sell. Even some wealthy land-owning Arab families, such as the al-Nashashibis and the al Husaynis, were happy to sell to the Jews.[169]

Arthur Ruppin had recently published a book that explained how the Zionist Organization was purchasing land for Jewish colonization. He had also given a speech about it at the Zionist Congress in Vienna the previous September.[170] At the Congress, Ruppin had said, 'Only if we create a work of our own hands in Palestine and not by the exploitation of alien labor will we earn for ourselves a moral right to the land which we have legally acquired.'[171]

Recently, a call had gone out to the Jews around the world to donate money to purchase land in Palestine. 'Buy Shares of the Jewish Colonial Trust or the Anglo-Palestine Company', read the advertisement. 'They pay regular dividends and the capital helps Palestine... Why not invest now? Buy one or two or ten shares. You get your regular dividends. At the same time, think of what you're doing for Palestine. The Jewish Colonial Trust is a credit to Zionism and the Jewish people.'[172]

Jews from around the world were responding to this call and so Mr Ruppin was spending his time traveling around the country scouting out suitable land for purchase. Once the land was owned by the Palestine Office, immigrants would be set up to 'conquer' the land, in other words, to make it suitable for farming.

At the same time, there was an ongoing concern about labor. Many early colonies and agricultural settlements that had been established in the late 1890s ultimately failed because the Jews who came to work had absolutely no knowledge or background in agriculture. This current influx of European Jews, of the New *Yishuv*, was determined not to repeat the mistakes of predecessors. These Jews were committed to learning about farming and working hard. An agricultural college had been established in 1912 in Petach Tikvah and was educating the future farmers of the land. And Aaron Aaronsohn made good use of his agricultural research station to hone in on the best way to cultivate the land of Palestine.

However, no matter how much the farmers knew about agriculture, there was still a need for laborers who would work the farms. The number of Jewish *chalutzim* who were available and willing to work in the fields was not sufficient to meet all the labor needs. In addition, many of these European immigrants were not willing to accept the low wages and seasonal work available to farm hands. Jewish laborers, used to a higher standard of living in Europe, demanded higher wages and year-round work. But the Jewish farmers could not afford to pay those higher rates and keep the workers on year-round when there was no work to be done.

As a result, many agricultural settlements hired Arab laborers. The Arabs accepted lower wages and could be hired and fired as needed. This was creating rifts amongst the Zionist political leaders and the farmers. Many people believed that the dependence on Arab labor would prevent a Jewish homeland from being self-sufficient and would also perpetuate a working class of Arabs, upon whom the Jewish farmers would be reliant for their success.

A potential solution to the labor problem was realized with the immigration in the preceding few years of Yemenite Jews. Like the Eastern European Jews, these Jews were coming to Palestine because of the persecution and poverty they faced in their country. They proved to be very hard workers and, importantly to the farmers, were quite content with lower wages.

When the Zionist leaders realized that they might have an answer to this very sticky labor problem, they decided to encourage more of

their Yemenite brethren to immigrate to Palestine. The Zionist Organization even sent a representative to Yemen to spread the word amongst the Jewish community about the opportunities that were open to them in Palestine. They were promised a place to live, along with a small patch of land on which to grow vegetables for their own self-sustenance. Funds were being collected in the United States to support the immigration of the Yemenites. *The Jewish Review and Observer* from Cleveland, Ohio wrote, 'Their cries of distress have come to us with an authentic call. They deserve the sympathy and material support of the entire house of Israel...'[173]

Thousands of Yemenites began flowing into Palestine and many of them took jobs on farms while others were settling in Jerusalem. Despite this seemingly perfect solution, there was concern amongst some that the Arabs were being displaced from their work. An assessment of the labor situation in the agricultural colonies was the subject of an article by Hadassah educator, Jessie Sampter who warned:

> The exclusion of Arab labor from Jewish economic life makes for a rift between the two groups which may have dire consequences. On the other hand, it is equally dangerous to withhold the opportunity of farm-work from Jewish immigrants... Unless pressure is exercised from without to incite the Arabs against the Jews, or vice-versa, there is no reason to suppose that they cannot live side by side in increasing good-will and confidence.[174]

Others discontent with this solution included the many Russian Jews who were also being displaced by the newly arrived Yemenites. Arthur Ruppin wrote, 'Jews wish to maintain a European standard of civilization in Palestine and must yet compete economically with a majority not accustomed to such a standard. This contains the root of all the difficulties with which our agricultural colonization has to struggle.'[175]

So while on the outside, to the casual observer, the agricultural colonies were thriving and were looked upon as the ideal of Jewish labor, the situation was a bit more complex, as Rae was about to see for herself.

To get to Petach Tikvah, Rae had to take the train to Jaffa and then continue on an omnibus, which ran a regular route from Jaffa to the colonies. It wasn't the most comfortable mode of transportation, but

until the railroad that was under construction from Jaffa to Petach Tikvah was complete, it was the only way to get there.

As the train puffed and chugged away from Jerusalem, Rae kept her face pressed against the window. It had been many months since she had left the city and it was refreshing to see the soaring wall of hills on each side of the tracks at last give way to a grand vista of expansive open plains. She felt herself breathing deeply and felt her body relaxing as the stone walls and crowded streets of Jerusalem were left behind. In the far distance, along the hillsides, she could see the smoke coming up from the Arab villages and could make out the shapes of donkeys that were carrying the Arab men as they made their way along dirt trails. The train rumbled along, and mile after mile of straw-colored grass, rocks and gently rolling terrain passed by. Everything was a monochromatic color of muted gray, yellow and brown, reflecting the lack of rain in the Palestinian summer.

As she stared out the window, Rae was lulled into a stupor by the clacking of the wheels along the tracks. It had been a long time since she had been without Rose and alone with her thoughts. She remembered the sense of longing she had had in Cleveland, and then in New York, for an adventure. She was startled to recall that feeling. Since her arrival in Jerusalem, she hadn't once felt a sense of boredom or lack of challenge. The anxiety she had often felt when confronted with routine and monotony and that tightening in her middle, the pining for more excitement, was completely gone. She realized that she felt more alive now than she ever had. She loved her work and loved Jerusalem more than she had ever imagined she would. She felt content and satisfied – and exhausted. It was a wonderful sensation. As her mind drifted and she became lost in her thoughts, she dozed off.

After a few hours, people on the train stirred and Rae started awake. She saw that they were arriving in Jaffa. She gathered her bags and disembarked, looking distastefully around her at the crowded train station. Her body tensed as she looked straight ahead, making her way through the rows of blind beggars lining the dirty walkways to the omnibus station. She winced as the putrid smells and raucous noise of the city assaulted her and she wrinkled her nose in distaste as she stepped around the waste littering her path. While Jerusalem obviously suffered from the same unsanitary conditions, Jaffa possessed none of the charm and magic of Jerusalem. It was just too much for her. Rae eagerly climbed aboard the horse-drawn omnibus and bounced along the road to Petach Tikvah.

The omnibus was what was called a 'diligence', a wagon with wooden planks laid across it which rested on the sides so that passengers could sit down. It was meant to carry eight passengers but often took many more. Riding in the diligence, passengers were subjected to sharp jostling and buffeting as the wagon hit every hole and bump along the road. Passengers even had to get out at times so the horses could better maneuver their way across patches of sand that sometimes covered the road.

Rae sat up a little straighter and held on to the side of the wagon as the distant farms of Petach Tikvah came into view. As they drew closer, she saw the changing colors of the landscape. Plantations were filled with orange and lemon groves. Then she saw vineyards, their vines heavy with grapes, ready to be made into the famous Rothschild wines. Dozens of workers labored around the vines and trees. She could tell by their clothes and the complexion of their skin that the laborers were a mixture of Jews from Eastern Europe, Jews from Yemen and Arabs.

She was excited when she saw a small village in the distance, thinking this must be Petach Tikvah. She was confused when, as they approached, she didn't see the beautiful houses and gardens she had expected but rows of long buildings next to tiny, well-kept cottages. And there were none of the trees she had heard were ever-present in Petach Tikvah.

She learned that this wasn't Petach Tikvah but the adjoining town where Yemenite families and even some Arab workers lived. Many unmarried Eastern European laborers also lived here. They all commuted the short distance to work in the fields while their children went to school in Petach Tikvah.

In the previous few years there had been such a rapid influx of Yemenite Jews into the country that there was a housing shortage. Despite the promise of a house and garden for each immigrant, many families were placed in the barracks initially until appropriate houses could be built. Funds raised abroad, including from the Hadassah chapters, were streaming in to build these new houses for the Yemenites. At the time of Rae's visit, many families lived in the modest cottages, while most of the unmarried men continued to sleep in the barracks.[176]

After a short while, the omnibus pulled off the dusty main road and onto the main street of the colony. This is what Rae had been looking out for. Impressive one-story, expansive stone houses lined each side of the street, shaded by a multitude of eucalyptus trees. The white plaster and stone of the houses contrasted magnificently with their red-

tiled roofs which shone with the reflected sunlight of the glorious day. Each house had a small garden in front, tended by women and children.

Off the main street were a series of cross streets that were also lined with houses, some of them two-story grand villas, along with other buildings necessary for a small town. There was a school building and a synagogue. They passed the new agricultural school, filled with recent immigrants who, after learning modern farming methods, would depart for more far-flung places in the north to start new agricultural colonies. The streets leading to the distant fields were lined with acacia trees, protecting the workers from the fierce summer sun as they walked back to the village at the end of each day.[177] From inside the village, Rae saw that the entire town was surrounded by groves and fields with the trees shading the houses and parks. It was a breathtaking sight.

Rae learned that Petach Tikvah, the oldest and largest colony, had been founded by Baron Edmond de Rothschild thirty-six years before.[178] After a mixed start and various levels of success, the village was now a flourishing home to 3,600 Jewish families, primarily from Eastern Europe, a mixture of both religious and non-religious people. Upon its founding, Rothschild had ordered the planting of eucalyptus trees, which were imported from Australia, to drain the malarial swamps that had covered much of the land. Now the swamps were gone and the farmers sometimes cut down a tree or two in order to build some of the necessary tools for farming and building.

Rae was greeted by her hosts and led to the guest house along with several of her fellow travelers. Petach Tikvah had become a model colony and people flocked there from all over Palestine, as well as from abroad, to see a vision of what the future held for a Jewish homeland. The idealistic views of the Jewish farmers and laborers were palpable and it was impossible to walk through the village without feeling the optimism.

As Rae observed all that was around her, she suddenly felt that her life in Jerusalem was oppressive. The crowds and dirt and disease that permeated that ancient city were nowhere to be seen here. There were vast areas of open space shaded by surrounding trees. Children ran and played all around. They had none of the haggard appearance of the children she saw in the streets and schools of Jerusalem. These children were shouting to each other in Hebrew as they played ball and ran races and she heard none of the other languages that had become part of her life. The girls, especially, were astounding to see. Rather than the long ragged robes and head scarves that most of the girls wore in Jerusalem,

many of these girls wore short dresses or even pants that allowed them to run and play like the boys. Rae looked longingly at the girls, remembering her own carefree childhood growing up in Cleveland, Ohio.

After Rae settled into her room, she was shown around the village. She saw small enclosures next to the houses where women were feeding the chickens that were running around the yard. Near the fields were men in shirtsleeves sorting through the oranges, preparing them for packaging and shipment to Europe. Once the crates of oranges were ready, they were loaded onto the backs of camels which were then led in long lines to Jaffa and the port.

The children of Petach Tikvah sometimes put on a demonstration for guests during which the girls and boys showed off their prowess at horseback riding and shooting. Rae would have been thrilled to see the confidence and skills of these young men and ladies. That evening, everyone gathered in the community building, singing and dancing to the Zionist songs that extolled the ideals of the Jewish homeland, the hearty strength of the Jewish pioneer and the sacrifices they were making together to build in this rugged land.[179] Upon hearing these new Hebrew songs, Rae felt that she also was playing a small part in building the Zionist dream.

The next day was Friday and work in the fields ended early as the workers hurried home to ready themselves for *Shabbat*. *Shabbat* in Petach Tikvah was nothing like Rae had ever experienced. While everything ground to a halt on Friday afternoon in Jerusalem, this was different. At mid-day, the workers began to stream into the town from the fields. There was an exultant feeling in the air as they quickly strode along, looking forward to their day of rest. The children raced home from school, giddy with excitement at the break from their studies during *Shabbat*.

Rae returned to her room to relax and bathe and then dress in her *Shabbat* suit and hat, emerging from her room refreshed and ready to experience a legendary *Shabbat* in the village. As she walked outside, she saw families walking down the street in their finest clothes, going to visit neighbors who were sitting on their front porches, waiting for their guests with tea and biscuits at the ready. Quiet and calm permeated the village and an almost audible sigh of contentment and relaxation could be heard. Rae enjoyed tea in the lush garden followed by a hearty, festive *Shabbat* meal.

That night, Rae had a hard time falling asleep. Unlike in Jerusalem, it remained hot even at night. Despite the open windows, there was scarcely a breeze to cool the sweat off her body. The silence of the

village, absent of all the city noises Rae had grown accustomed to, was punctuated by the buzz of crickets, the bark of distant dogs and the occasional crow of a rooster. She was not used to such utter quiet.

All day on Saturday, Rae enjoyed the quiet of *Shabbat*, the sounds of the children playing mingled with the murmur of the adults' conversations. She strolled to the surrounding fields to observe the orchards and abundant fruit. Midday lunch was served on white cloth-covered tables that were set up on the street. Each family brought out several platters laden with food, filling the tables with the sweet aromatic smells of cinnamon, garlic, cumin and pepper. People greeted each other warmly, wishing their neighbors a *Shabbat Shalom*. After they finished eating, the entire group once again sang together and some even got up to dance, forming circles around the tables and teaching each other new steps and movements.[180] The villagers valued communal life and celebration and took every opportunity they could to be together. *Shabbat* in the colonies was an experience that was highly anticipated by visitors who relished spending a day of rest in this uplifting Jewish environment.

While in Petach Tikvah, Rae also saw another strange sight. Jewish men were riding horses and carrying guns, patrolling the perimeter of the village. They were protecting it from any Arabs who tried to steal the crops, destroy the fields or otherwise harm the villagers. After seeing the studious, pale, haggard-looking men in Jerusalem and hearing stories from her parents and Rose about the subservient and persecuted nature of the Jews in Russia, Rae never would have believed that these men were Jews. They were strong and healthy with ruddy skin and an air of confidence and swagger that Rae had never seen before.

The men were part of a group called *HaShomer*, or The Guards. *HaShomer* had formed just a few years before, in 1910. Before *HaShomer*, Arabs were hired to guard the farms but, as the idea of Jewish labor grew, along with the desire for Jews to handle all aspects of the business of the colonies, Jewish men were hired and trained to ride horses and shoot guns. There were now over a hundred *HaShomer* guards who were deployed in all the Jewish villages, from these villages in the central plains all the way up north to the newest colonies near the Kinneret, or Sea of Galilee.[181] The villagers felt safe and protected by these tough men and were exceedingly proud of them.

After a couple days of visiting, Rae decided that it was time to return to Jerusalem. She was a little worried about Rose being alone with their work. She had noticed that Rose seemed to be exceptionally fatigued these days. When Rae had questioned her about it, Rose

dismissed her concern with a wave of her hand and blamed it on the summer heat. Nevertheless, Rae was anxious to get back and relieve her. Rose needed some rest.

On the way back to Jaffa, Rae stopped in Rehovot for a couple days and saw the fields and vineyards there. In Rehovot, Rae learned more about the challenges that the colonists were having with their Arab neighbors. Besides the issue of labor and the layoff of the Arab workers, an event the previous summer had sparked some tension.

Some Arabs from a neighboring village had come to Rehovot to deliver some supplies. While their goods-laden camels were passing the vineyards, a man stopped and picked some grapes. One of *HaShomer* guards had seen him and scuffled with the thief and, in the tussle, lost his gun. He shouted for help and he and his comrades ran through the fields chasing after the camel train. When they caught up with the group, which had reached the Arab town of Zarnuka, there ensued a brawl, right in the streets, as the guards attempted to retrieve the stolen weapon. The Arabs called for help from their village and the group of fighters grew even larger.

Finally, what had started as a tussle with sticks and fists escalated into an all-out fight with guns being fired. The Jewish guards of *HaShomer* suffered from the beatings with one man being shot in the stomach. Several Arabs were also badly injured and one ultimately died of his wounds. Leaders from both the Jewish community and the Arab village scurried back and forth between the two villages to make sure the conflict didn't escalate and each side made concessions until peace was restored. But, soon after, a Jewish guard was murdered by some Arabs who, it was believed, were stealing almonds.[182] This matter also was resolved, after a fashion, but lingering distrust and hard feelings remained between Rehovot and its neighbors.

The new governor of Jerusalem, Madjid Bey, attempted to ease some of the tensions between the two villages. Soon after taking office that spring of 1914, he and his family had accompanied the head of the Jewish Colonization Association, Mr Bril, on a visit to several of the colonies. He had been very impressed with the fertile fields and vineyards that had risen from the arid land and had agreed to visit the colonies again. He seemed to be very sympathetic to the Jewish pioneers. In his report back to the Ottoman government he wrote that his visit had 'pleased and interested him exceedingly'.[183] He wrote that, while he was keeping a close watch on these Zionists to ensure they remained loyal to the Ottoman Empire, he would not tolerate those who made the Zionists out to be enemies of the state.[184]

At this time, however, an Egyptian reporter from a Cairo newspaper had come to tour Palestine. During his visit he met with many officials and spent much of his time warning them about the dangers of Zionism and how Jews were trying to take over their country. He wrote about these dangers in his articles, stating that special laws were needed which applied only to the Jews, to protect the Muslims from their nefarious plot.[185]

Fortunately, Madjid Bey, who now knew about the work of the colonists because of his previous visits, chastised the reporter saying, 'You know quite well that the hopes and ambitions of the Jews are directed toward Palestine, where, in olden times their forefathers lived.' He urged the Arabs to take the example of the Zionists to heart, holding up the building of the agricultural colonies and the Zionists' industriousness as characteristics the Arabs should mimic to improve their own lot in life. 'For my part', he exclaimed, 'I do everything I possibly can to promote unity among the people of this land and to bring them together in patriotic zeal'.[186]

Upon reading about this debate in the Muslim community as it was playing out in the newspapers, the Hebrew newspaper, *Ha'Or* wailed, 'The Arabic newspapers are against us. They hate us, and what can we do about it? Don't start a big fight, and don't panic. Go to the Ottomans. It's a big question and the entire community needs to be involved to decide.'[187]

Rae reflected on all this as she returned to Jerusalem. She had learned so much on her short trip and was thrilled she had been able to see a little more of the country. As she contemplated what she had seen and heard, she realized how complex the current situation in Palestine was and how many different obstacles the Zionist colonists were facing. Nevertheless, she felt exceedingly proud of her compatriots and their accomplishments. They had made some truly amazing progress in a very short period of time. Feeling refreshed from her short journey, she now felt ready to start her work again.

When she arrived back at the settlement house, the harsh reality of her work in Jerusalem hit her quickly. She found Rose in a state of frustration. Despite the very welcome promise of running water and electricity,[188] there were still so many obstacles standing in the way of progress, both politically as well as in terms of the physical structure of the city.

She told Rae about a case she had just dealt with. 'I shall never forget the sight I witnessed last week', she said. A pregnant woman had become ill and needed to go to the hospital. Rose ordered a carriage to take her as she was too sick to walk, but the carriage was unable to get

close to the woman's home. It had to stop six or seven blocks away. 'The road was covered with stones and the streets narrow. The patient had to be carried on her husband's back and put into the carriage in an upright position... After some agony to the patient we safely got her there.'[189] Rose sighed with frustration. There was still so much work to do to bring effective health care to the people, and yet so much was out of their control. They worked tirelessly but seemingly endless barriers were standing in their way. They were both eagerly anticipating the imminent arrival of the additional Hadassah nurses.

On the bright side, the nurses knew they had succeeded in winning over the citizens of Jerusalem when they started receiving visitors at the schools. People were discovering what their school visitation schedule was and, rather than waiting for the nurses to return to the settlement house, they were tracking them down at the schools to request home visits for sick relations.[190]

The nurses received news of the momentum the Zionist movement was gaining globally. The Zionist Convention had been held in Rochester, New York in late June. There, the Zionist leader, Dr Shmarya Levin, had said, 'Those who oppose the new Jewish emancipation movement will look mighty small in the eyes of the historians of the future... It is now up to us to see that Palestine becomes littered with new Jewish colonies, with stout-hearted Jewish men and women...'[191]

Another leader, Louis Lipsky, continued, '[the idea of Zionism] is to make Palestine the center of Jewish national life by actual acquisition of the soil, colonization, the creation of cultural and educational institutions and the establishment of Jewish control, authority and government'.[192]

The nurses considered these writings and while Rose refused to ally herself to the Zionist ideas, Rae soaked in those words making them part of her own thoughts and beliefs.

Once Rae had settled back into her routine, she insisted that Rose take her planned trip to the north to see the colonies near the Kinneret. She looked worn out and Rae realized that, based on how she had felt upon returning from her trip, getting out of the city could do wonders for Rose. While she hated to leave the work solely in Rae's hands, Rose departed on her journey in late July.

The next few days, Rae spent on her own, tending to patients, visiting friends and enjoying the cool summer evenings of the city. There was no indication that circumstances were about to change drastically, almost overnight.

Chapter Nine

War comes to Jerusalem

Rae left home early, as she usually did, on the morning of 1 August 1914. As she strolled to her first school, enjoying the morning sounds and fresh scents of a new day, she was surprised to see soldiers standing on the street. When she arrived at the school, she learned that the Ottoman government was mobilizing soldiers in preparation for war. Countries in Europe had begun declaring war on one other and the Ottoman Empire had become caught up in this international morass.

Rae had kept up with the news from Europe that summer. On 10 July, in between the news that Eliezer Ben Yehuda, the father of modern Hebrew, was starting to publish his newspaper again after a short hiatus and the celebration of the growth of Hebrew throughout the country as the spoken language of the children, there was another short article: 'There was a double murder in the capital of Bosnia. The heir apparent of Austria was killed in a conflict between Germany and Slovak. We knew the archduke wanted to rule, but we didn't know he was willing to rule Germany and Slovak.' The article went on to explain that, 'The Kings of Austria-Hungary and Germany want to combine Germany and all these other countries: Czech, Poland, Serbia, Slovenia, Croatia.' Following on from the seemingly innocuous article came the exciting news, 'The first Hebrew book and art store is open. Dr Ruppin's book is on sale there.'[193]

One month after the assassination of Archduke Franz Ferdinand, on 28 July, the Austria-Hungarian Empire declared war on Serbia. And then, on 1 August, Germany, Austria's ally, declared war on Russia. The world exploded suddenly into fierce fighting. Although these events took place so far away, the effects were swiftly felt in Jerusalem.

Throughout 1 August, people were gathering on street corners and in front of shops, talking about this latest news and wondering what it

would mean for them. It felt so far away and yet the effect on Jerusalem was immediate – soldiers, newly called up, milled around and there was a general sense of apprehension, yet people carried on as usual.[194] Rae continued her routine and without Rose there for conversation, she went to bed early.

The next day, news spread that the banks had closed their doors, refusing to allow customers to withdraw money or cash checks. Rae felt a moment of panic as she quickly checked her supply of cash at the settlement house. She saw that she had enough for the time being, but it could only last a little while. Tension increased as it became apparent that something momentous was happening. All day Rae saw more soldiers tramping around the city in their black boots, posting notices on walls and doors. They mingled with the streams of people walking down Jaffa Road, their uniforms contrasting starkly with the diverse, colorful costumes of the inhabitants.

Rae joined a small cluster of people who had stopped to read one of the notices. It was a call to the men of the city, telling them to report to their municipality office to enlist in the army. All reserve soldiers were called up –men between the ages of twenty and forty-five. She noticed a sense of panic as fathers and husbands read the sign and then rushed away, glancing nervously around them.

On 3 August, there were new notices on the walls of the city declaring martial law. Citizens were warned, 'Whoever disobeys the orders of the Government or disturbs the peace will be court martialed.' And 'Whoever hides in his house deserters or animals or does not give information of their whereabouts, if it is known, will be court martialed.'[195]

Each day after that, new notices appeared, in restaurants and on street corners, from the consulates of Austria, Germany and Russia, demanding that nationals return home to join the army.[196] At the same time, the Ottoman government ordered all British, Russian and French nationals to leave the country. They were on the wrong side of the alliance that the Ottoman Empire now had with the Austro-Hungarian Empire.

In the coffee shops and in people's homes there were heated discussions about what to do. A moral crisis was brewing for the Jews of Palestine. They had grown to consider themselves new Jews of this land, not nationals of one European country or another. Russians mingled freely with Germans and British. There was no difference between them. They were all Jews, speaking Hebrew, building a new homeland together. But now they were being forced to acknowledge

that they were still citizens of their native countries, and if they did not report, as commanded, they would be considered traitors. They realized they may soon be on the battlefield, fighting and killing each other and many did not want to risk being branded as traitors. So, although they were loath to do so, some of these Zionists started closing up their affairs and businesses and packing to leave the country.

With no indication of when the banks would reopen, there was now an escalating economic crisis. Rae read an advertisement in the morning paper, on 6 August, that had been placed by several of the banks in an attempt to quell the panic that was quickly overcoming the country as people were unable to access their money. The ad read: 'Don't worry, we will wait patiently for the gold that we ordered.'[197]

Somehow, Rae did not feel consoled by this notice. She was very anxious about their cash flow. They had just received a large check from New York that was sitting in the bank and now it appeared that she would not be able to access it. She knew that without the money they would not be able to do their work.

To exacerbate the growing uneasiness, ships that were scheduled to dock in Jaffa never arrived, which meant that the import and export of goods came to a sudden and immediate halt and, overnight, the economic crisis grew. Food and other staples from Europe that would fill the shops didn't arrive, so store owners weren't able to replenish their supplies. Crates of oranges and dates and almonds that were waiting at the docks for shipment to Europe began to rot in the hot sun. Barrels of wine sat gathering dust. Revenue from the crops that would sustain the agricultural colonies disappeared with the rotting fruits.

The lack of ships also meant that people did not receive any mail. Telegrams were not received. All communication from Europe had come to a halt.

The Ottoman army continued to call its citizens to enlist and more and more troops gathered in Jerusalem and Jaffa to prepare for war. On 8 August, the Governor of Jerusalem now called for all Ottoman subjects, including Jews and Christians, up to age forty-five to enlist.[198]

Thousands of Arab and Jewish soldiers had joined up and were wandering the city streets, looking for something to do until they were called into service. These soldiers were not given the rations they needed to survive in the meantime and so they went into local businesses and took whatever they needed. They were also pressed to

find supplies for the army, as this was the only way the Ottomans could stock up for war. Stores across the country were pillaged and stripped of all their merchandise.[199]

On the day of the general mobilization, Rae joined a crowd of people lining the street just outside the Jaffa Gate, watching in astonishment as hundreds of soldiers marched along the road. They were preceded by government authorities and a military band, playing drums and trumpets and bugles. The civilians, some of them carrying parasols to shield themselves from the harsh sun, were pressing forward to see the scene that was unfolding in front of them. They were held back by other soldiers and police who waved away the little boys who kept running out on to the street to approach the soldiers. Everyone watched in awe at the spectacle.

Row after row of soldiers walked by, their faces serious and stern. More and more citizens of Jerusalem gathered to watch until one could barely move or turn a shoulder. People were shouting and clapping with excitement at the sight. There seemed to be an air of festivity as the crowd cheered its soldiers. The street was now packed with humanity,

Turk mili. [military] WWI. Street scene, Jaffa Gate. Library of Congress, Prints & Photographs Division, [LC-DIG-matpc-11594].

all wanting to display their loyalty to the Ottoman Empire. It seemed that the exuberance would overwhelm the guards who were valiantly working to separate civilians from soldiers.[200]

It was a surreal scene. Just days before, this same street had been busy with the bustle of everyday commerce. Women had walked along with baskets of fruit and breads balanced on their heads as they headed back home from the markets. Men and children, dressed in *fezzes* or *keffiyehs* or black hats with wide brims, had briskly maneuvered their way around the donkeys and camels laden with goods. The street was now unrecognizable – modern soldiers marched along the ancient road next to the stone walls of the Old City.

Rae, still alone without Rose, tried to keep her uneasiness contained as she wrote to New York:

August 11, 1914

I really don't know when you will get this letter or whether you will get it at all. There are no steamers running to or from Jaffa, although it is rumored that one is coming today, so I am hoping to get some mail and am taking the opportunity of sending some.

I promised to write last week but I was busy all day and in the evening I was only fit for bed. Then again, things were constantly changing here in Jerusalem, and what I would write to you one day I would be obliged to contradict the next. It may be the case now. We had a regular panic here last week. The horses had been called in by the Government, so as to know how many they had, should there be any need for them. The next day Turkey began mobilizing and the excitement was beyond description. Luckily, the excitement only lasted a few days, and all—that is, all the Jews—were sent back to their homes. At present things are rather quiet but no one knows whether it will last. There may be war with Russia. I sincerely hope not.[201]

Rae longed for Rose to return. She had never imagined that the city could be thrown into such pandemonium like this so quickly and she felt very ill at ease.

Despite the lack of mail service, many people, besides Rae, were writing letters to America to inform their benefactors of their plight. Boris Schatz, the founder of Bezalel, the art school and craft workroom, wrote a letter to the American Jewish newspapers.[202] He had only recently returned from a successful trip to America where he had

showcased and sold the crafts and merchandise his workers had made. His journey had been highlighted as a triumph of Jewish labor and ingenuity; the American Jewish public had welcomed him as a hero. He hoped his letter would garner sympathy and, more importantly, financial assistance from his new American supporters:

> Since the terrible European war has broken out there is... in Jerusalem a terrible crisis. The work has been stopped and no man is able to earn anything... For the Bezalel in particular the crisis has been a hard blow. All communication with Europe has been cut off, and we are unable to procure any raw material, nor are we able to export anything we have made. If we have to close Bezalel until times better themselves, without giving the workmen and the scholars as little as dry bread, these poor unfortunate people in their hunger would be compelled to leave Palestine and would become scattered all over the world, and when the war is over, we would have no workmen with whom we could again take up the work. In this case, the Bezalel would be forever closed.[203]

Rae also wrote to New York about her financial situation. The continued lack of access to her money was becoming a hardship:

> The money question is the worst. The banks are not changing checks to any great extent, and are giving only 10% of the savings accounts. The German bank was closed altogether for a day. We all thought that we were on the verge of a great hunger panic. Money began to lose its value. For instance, you could only get 14-16 metalic for one franc instead of 17 ½ or 18. Petroleum went up 5 francs a box; sugar a few metallic a pound. It was simply awful. The institutions are suffering much. The Misgab le-Dach [hospital] has closed on account of lack of funds. Even the Mission Hospital has closed. The Shaare Zedek is taking patients who can pay, and only a very few who are unable to pay. The LeMa'an Tzion will close at the end of this week, just as soon as the operative cases can be discharged. The clinic–that is, the out-patient department – will of course go on as long as Dr Ticho is here. It is quite possible that Dr Ticho will leave. He would have gone had there been a steamer.[204]

Besides the cost of food, Jerusalemites were now being forced to pay for water. Schatz wrote, 'The price of foods is very high and is still

going higher, in fact, we have even been compelled to pay for water.'[205] Rae wrote more extensively about this new hardship:

> I don't know whether you have been told what a scarcity of water there is in Jerusalem. It is the worst year that many old-timers can remember. In the city and in Montefiore the people can't get any at all. The prices are enormous and the water is filthy... Now you can just imagine – last week for a few days there was no water at all. If you could only see what the people have to drink. It is no wonder they are ill. Miss Landau has spent I don't know how many napoleon for water for her school and her home. I must say that we are very lucky. We have excellent water – everybody says it is the best in Jerusalem – and plenty of it. The people downstairs use very little water so that makes it nice for us. Some of our patients who come for injections always ask for a drink, because our water is so delicious. The LeMa'an Tzion have until now bought 4,000 tins of water. Think of the expense! They got it quite cheap – about 4 metalic each tin. Now it costs about 7–8 metalic. A tin holds about 30 quarts.[206]

Over the following few days Rae did the best she could, returning to the schools each day to check on the children and seeing patients at the settlement house. And, of course, women continued to give birth, so her supervision of the midwives continued unabated. But she went about her routine with feelings of dread. Her money was about to run out and, with the closing of the institutions that provided relief and medicine, more people were approaching her for help.

She was overwhelmed with relief to see Rose walk through the door of the settlement house on 19 August, much earlier than she had expected. It had been just impossible for Rose to complete her vacation due to the conditions around the country. She explained to Rae that she could not justify a sightseeing trip while the people in the colonies were experiencing such tumultuous times. They embraced tightly and Rose sank into a chair. If anything, she looked more exhausted than when she had left.

While she was anxious to hear what had been happening in Jerusalem, she quickly described the situation in the countryside. She related how the men of the colonies, who were either being called up to the Ottoman army or to the armies of their birth country, were leaving the women and children behind with no way for them to earn a living. The Ottoman government was sending soldiers to raid all the

colonies, taking the mules and horses and all the tools for their own use. She related how impressed she had been with the colonies in the Galilee but also how quickly everything was crumbling. Talking of the colonists, New York, 'Their crop this year was splendid, they were in fear and in trembling that each one of them will have to give one-third of it to the Government. As it was rumored, mules, horses and wagons were taken from them.' They now had no draught animals to do the farming. In addition, because of the lack of ships coming in, there was no place to sell their crops. 'Like everywhere else, the men were called to the army; some managed to buy themselves off at a great sacrifice. The worst of it is that those that had the money in the banks could not get hold of it...'[207]

When the farmers ran out of money, they had to dismiss their workers. Previously proud families who had earned a wage that supported their families were now being forced to beg for food. It was a heart-breaking sight.[208]

Rae listened to Rose's story and then shared at length what had been happening in Jerusalem. She broke the news about the many men who had either already left or were preparing to leave the country. She related how around seventy Germans had left from Jaffa for Constantinople, traveling by land, and how, later that week, Dr Bruenn and Dr Thon along with some others were expecting to make the same trip, all planning to join the German army. Even Dr Ticho would be leaving if he needed to.[209]

After they had caught up and discussed their current well-being, the nurses went to the bank to talk to Dr Levy about their financial situation. Dr Levy explained to them that they would only be able to withdraw fifty francs in gold a week and, even though a couple of weeks ago, with one of the last ships that had arrived in Jaffa, they had received that check from Hadassah for two thousand francs, they would be unable to cash it. Therefore, they were stuck with only the eight hundred francs they had in gold and would have to make do with the fifty in cash he could give them from their account.

Rose later wrote, 'the Anglo-Palestine bank has inaugurated a system of checks. A depositor, according to the sum deposited, may draw a small amount in gold and about twice as much in checks. Dr Levy allowed me to draw weekly... one hundred in checks, warning me, however, not to get too much paper.'[210]

Walking home from the bank, the nurses discussed what they would do, facing these unexpected circumstances. Rose was calm and matter-of-fact, always the problem solver. Rae was so relieved that Rose had

returned home early. Things seemed so much more manageable with her. She was always cool and unruffled under pressure. She got down to the practical details. They would start economizing that very day. They would only take on work with minimal costs, even if that meant putting some of their services on hold for a while until the 'trouble was over'. Rose also suggested that each of them should stop taking a salary at this time, as they each had money in their own personal accounts and would be allowed to draw on those accounts as long as the bank would allow. Dr Levy had told them that the bank could remain open with his plan of cash management for about two months.[211] They couldn't imagine that the situation could remain like this for any longer than that.

Over the days which followed, the nurses read in the papers how the Turkish government was continuing to order people to arms. They heard stories of how men were hiding in cellars or paying bribes in order to stay out of the army. Soldiers were going door-to-door to find the men who had not yet enlisted.[212]

The Ottoman Jews had hoped they would be exempt from the draft but it was not so. They also were required to mobilize:[213]

> Warning and announcement to all Ottoman Jews in Jaffa and settlements: We are calling on you to present yourself to the army palace. Come with your belongings. You are going to be militarized. If you don't come you will be punished very severely. Then you will yell and scream and we won't care. If you don't have clothes or documents you have to show up to your local governor so you can get your identity card. Don't be late.[214]

In the Hebrew newspapers, the editors agonized: 'Should the Jews join the Turkish army? Our sons are afraid to join the army. The important hour comes. The Ottoman government is giving orders to go into the army.'[215]

By the end of August, the economic situation was more dire and urgent than the military threat. In response to the growing shortage of food and the growing need for jobs, the Jewish community in Jaffa and the colonies had organized themselves to try to weather the worsening storm. The *Histadrut*, or workers' union, wrote about its efforts in the newspaper, their open letter placed incongruously next to an advertisement announcing that a bookstore was selling greeting cards made by Bezalel and gifts from the workshops of Nathan Straus.

The letter explained that the union had created a council that would oversee relief for unemployed workers. The *Histadrut* leaders urged all the workers to remain united and stated: 'We will do the best we can together to save our community.' They would be setting up soup kitchens and would buy wheat and flour to bake bread for the people who didn't have any food. They would also help people find jobs.[216]

Day after day, bad news was announced throughout the country. It was clear that the people of Palestine, particularly those in Jerusalem who depended on the *Halukah* system, were facing an immediate crisis.

In late August Arthur Ruppin sent an urgent assessment of the situation in Palestine to Ambassador Henry Morgenthau in Constantinople, pleading for help. He hoped Morgenthau's recent trip to Palestine and the impressions he had taken away about the work of the Jewish community would sway him to action. It did.

Morgenthau was moved by Ruppin's supplication and immediately sent a strongly worded telegram to Jacob Schiff, the great American Jewish philanthropist and a leader of the American Jewish Committee.

TO JACOB SCHIFF, NEW YORK:
PALESTINIAN JEWS FACING TERRIBLE CRISIS.
BELLIGERENT COUNTRIES STOPPING THEIR
ASSISTANCE. SERIOUS DESTRUCTION THREATENS
THRIVING COLONIES. FIFTY THOUSAND DOLLARS
NEEDED BY RESPONSIBLE COMMITTEE...CONDITIONS
CERTAINLY JUSTIFY AMERICAN HELP WILL YOU
UNDERTAKE MATTER
MORGENTHAU

This telegram was the first in a flurry of correspondence that awakened the American Jewish community to the plight of the Jews of Palestine.

Morgenthau's telegram was sent through the US Secretary of State, William Jennings Bryan, and forwarded to Jacob Schiff. Secretary Bryan forwarded the telegram to Mr Schiff with a letter indicating assistance was warranted:

Washington, D. C. August 28th, 1914.
Jacob Schiff,

The Department has received a cablegram from the American Ambassador at Constantinople, asking that you be informed that the Jewish Charities and Colonies in Palestine require immediate assistance, and whether you can raise and send funds with warship. The Department is planning to send a relief ship in the near future.
(Signed) W. J. Bryan.
Secretary of State.

Upon receiving this unusual message, Jacob Schiff forwarded the telegram to Louis Marshall, the chairman of the American Jewish Committee, asking him to rouse the Jewish community to help its brothers and sisters:

Aug. 28
Dear Mr Marshall:
I am this morning in receipt of the enclosed telegram from the Secretary of State... Since the cablegram referred to by the Secretary of State originates from Ambassador Morgenthau, who no doubt thoroughly understands the situation existing in Palestine, it appears to me we ought to give his implied suggestion prompt consideration... Meantime it might perhaps be well if you inquired from the Department of State, when it is likely that the Relief Ship, to which the Secretary refers, is going to be sent.
Faithfully yours,
Jacob Schiff[218]

That Monday, 1 September, a special executive meeting of the American Jewish Committee was convened. Of the $50,000 that was requested, Jacob Schiff offered $12,500, the Committee approved another $25,000 from its funds, and the balance was to be raised by the other Zionist organizations of America.

Louis Marshall then telegrammed Ambassador Morgenthau, assuring him that the American Jewish Committee was taking action and raising the funds. Ambassador Morgenthau responded that he had several ways he could send the money to Palestine, one of which was with the cruiser USS *North Carolina,* which was expected to arrive in Constantinople the following week. He described how he would most likely send his son-in-law, Maurice Wertheim, who was currently with him in Constantinople.

Then he continued:

> The condition of the Jews in Palestine is the very worst. Most of
> them have always depended for their support on charitable
> institutions and benevolent men in other countries, and now that
> the inflow of money has absolutely ceased, most of the societies
> will have to be abandoned, and it is almost too horrible to think
> of what will become of the poor men that will be stranded high
> and dry...[219]

On 14 September, Morgenthau wrote in his diary, 'cabled home about
N. Carolina going to Jerusalem and Maurice accompanying them'.[220]
And just a few days later, the USS *North Carolina*, with a hold full of
gold, slowly steamed across the Mediterranean Sea.

While the American leaders were hastily making arrangements for
the funds to be transferred overseas, the situation in Jerusalem was
deteriorating rapidly. On 6 September, Rose wrote:

> Conditions here are getting worse daily, and there does not seem
> to be a shadow of relief coming. Money is very scarce and
> everyday necessities, such as oil, sugar, flour, etc. have risen in
> price... We are here perfectly isolated, except for an occasional
> Italian boat. No other steamers land. The general atmosphere is
> heavy at present. Altogether the outlook for this part of the world
> is a very bad one if things are not changed soon. Kindly pardon
> this very gloomy letter but it is so hard to be cheerful.[221]

Each day more schools closed as teachers either returned to their home
countries to join their armies or were called up to the Ottoman army.
However, for the teachers that remained, they were now out of work
and their circumstances were ominous. Hospital workers and others
were told they could no longer be paid a salary but if they stayed on
they would be paid in food. Families that used to be self-sufficient were
now turning to charity. Three new soup kitchens opened to
accommodate the growing crowds of people who congregated each
afternoon, desperate to feed their families. But the new kitchens
struggled to keep their pots filled with enough soup and bread for all
who needed it.

When the nurses visited Dr Levy, they were alarmed to learn that
there was only enough flour in the city to last for one month. Mr
Ruppin was prepared to send fifty sacks of wheat to Jerusalem but was

afraid the government would confiscate them for the military. He was currently busy strategizing about how to get the provisions there safely. The nurses realized that even for those like them, who could pay for flour, there might be impending dire scarcity. They discussed how unsettling it was to think that they might also become desperate for food and they began planning how they could stretch their current supplies. No longer being able to provide their patients with even the most basic necessities to sustain them through childbirth or illness was something they hated even having to ponder.

The nurses then updated Dr Levy on the condition of their medical inventory. Medicine was scarce and prices had gone up dramatically. They had been counting on resuming their trachoma treatments when the students returned to school after *Sukkot*, but cotton, which was used extensively for the eye treatments and was critical in wiping the children's eyes in a sanitary manner that would not spread the disease, had doubled in price.[222] Most alarming of all, quinine was in short supply. Rose wrote to New York, 'This is a calamity, for it is so much used here for the treatment of malaria.'[223]

'I am afraid Jerusalem will suffer very much', she wrote. 'It depends so much upon Germany, Austria, and Russia. No one will think of Jerusalem or Palestine or Zionism. It's up to America now.'[224]

Back at Hadassah headquarters in New York, Henrietta Szold was deeply involved in the fundraising efforts for both the relief of Palestine and to support the nurses. She was frustrated about the unraveling of her plan to send additional nurses to bolster Rae and Rose's efforts to get the district nursing plan up and running. Just as they were making arrangements for the two new nurses to travel to Palestine, war had broken out. She wrote a letter to Dr Biskind, the husband of the president of the Cleveland chapter of Hadassah, who had just visited the nurses in April of that year and had spoken so highly of their work:

September 9, 1914
We do not feel that we...have the right to expose (the new nurses) to the risks incident to so widespread a war. Our contract with them, therefore, is suspended for the present.[225]

When the nurses heard that no new nurses would be coming to assist them, they were relieved. This was not the time to begin growing their work. Their nursing care had taken on a different tone and nothing new could be established with the current situation. Despite her

disappointment at having to put her plans on hold, Miss Szold was impressed with the professionalism of the nurses that was reflected in their frequent letters. Each week, the nurses updated Miss Szold on their working conditions, maintaining a level of emotional detachment that focused only on their work and their current situation:

> September 12, 1914
> The retrenching process is proving a very hard one just at this time of the year, when disease is more prevalent, aggravated by greater lack of food than usual, due to raised prices on all foodstuffs. We have never been able, since we are in Jerusalem, to take up a case of illness without rendering material assistance in one way or another. It is simply impossible not to do it now. Families who would never have thought of applying to charity are compelled to do so now or starve. Destitution at present is due to a good many causes, as a result of preparations for the war.[226]

One day, Rae and Rose were called by one of the midwives to see about a woman who was having a difficult labor. When they arrived, they found the woman in distress, weakly crying out in pain. After a few deft maneuvers, the nurses successfully helped the woman to deliver twins. They handed the babies over to the midwife and turned their attention to the mother. She was very thin and drained of all energy. Rae looked about the room and went out to the courtyard cooking area to look for food. There was not even a single scrap of bread to be found. She did find the father, though, who was pacing about outside, worried about his wife.

Rae spoke to him sharply, asking him to get some food for his wife. The husband explained to Rae that he was a leather worker, specializing in fashioning saddles and other leather goods. Because of his skills, he had been forced to work for the Turkish government making saddles for the army and had not been paid in five weeks. He had absolutely no money to buy any food and only survived from the crusts of bread given to them by their neighbors who had taken pity on them. Rae realized that if they didn't give these people food, the mother and the babies would starve to death. She quickly delivered some milk, meat and vegetables to tide the poor family over for a few days.

Throughout the weeks which followed, they encountered many cases like this –where food more than medicine was needed to cure the people. Rose wrote, 'With great difficulty will we be able to get through

this month [September]and October, and that is about all, unless there will be a change for better times.'

Even with the growing desperation that surrounded them, the good in people came out all around them. Joseph the milkman demonstrated that he was more than a scheming businessman. While, in the past, he had come to the nurses with reports of people in distress so they would pay him to deliver milk to new customers, he now agreed to supply the needy patients with milk on credit for the following six months.[227] The nurses readily agreed and kept careful records of what they owed him.

It was with great distress that the nurses learned that Dr Ticho had been called to return to Austria to join the army. He, of course, desperately wanted to remain in Jerusalem and made several appeals to the Austrian consulate but to no avail. They were unrelenting in their demand for him to return home. Their army needed as many good doctors as it could get. The women couldn't imagine life without him and met with him daily to figure out how to carry on. They were heartbroken as they helped to formulate a plan for treating the students in the schools and talked in-depth about what they could and couldn't do.

As he prepared to leave, his patients, both Arabs and Jews, became aware of his situation and, en masse, they petitioned the Austrian consulate day and night, begging them to rescind his call-up order. They argued that the medical care he provided to the citizens of Jerusalem was indispensable. The consulate remained silent.

Having heard nothing to the contrary, Dr Ticho resigned himself to the fact that he had to leave. He finally packed his bags and made everything ready to depart from the city by train on the morning of 25 September. He said tearful good-byes to his friends and colleagues at a dinner held for him a couple days before he was set to leave. The nurses were devastated at the thought of life in Jerusalem without him.

The afternoon before he was to leave he was suddenly summoned to the consulate. Keeping his emotions in check, he entered the consul's office and closed the door behind him. The consul told him that the Austrian government had taken into account his patients' words and were convinced that Dr Ticho would do much good for the war effort if he were to remain in Jerusalem. They decided that he would be allowed to stay.

With great jubilation, notices were put up around the city, posted on walls and on the stalls of the markets, notifying the citizens that their efforts had succeeded. Dr Ticho would be remaining in

Jerusalem.[228] Both Dr Ticho and the nurses took a few moments to celebrate together and then quickly settled down from the excitement to continue with their work. Privately, the women cried with relief so thankful were they that they wouldn't be operating alone.

Chapter Ten

The USS *North Carolina*

As summer rolled into autumn, the governor of Jerusalem called all the citizens of the city to gather in the public gardens of the municipal building to hear an important announcement. It was 1 October and the gardens were filled with people waiting expectantly. As the governor stood before the crowd, he announced, with an immense flourish, the immediate cancellation of 'capitulations'.[229] He proclaimed 'the great news that Turkey had cast behind her back the shame of foreign bondage, which she had been forced to endure by the European powers for centuries'.[230]

'Capitulations' referred to a status within the Ottoman Empire by which foreigners were exempt from certain Ottoman laws and were protected by the consulates of their home countries. For example, foreigners couldn't be arrested without the consent of their consulates. Capitulations were of great benefit to the Zionist colonists, as this allowed them to work freely in Palestine without too much interference from the Ottoman government. Often, the citizens of the Ottoman Empire grumbled about this dual system of justice and privilege but the foreign nationals were quite happy with the arrangement.

The pronouncement was made throughout Palestine and was framed in a very positive light so as to not create panic among the thousands of foreigners living in the country. The government reassured them that this was a wonderful benefit for them as it would mean that they would receive the protection and support of the Ottoman government.

In actuality, it was a terrible setback for the colonists and residents of the cities. All their special rights and privileges, including exemptions from paying taxes, were now erased. They could also be arrested at the whim of the government without any protection from their home

country. The Ottoman authorities rejoiced, telling the people they were now free from foreign dominance.

Every day now, the nurses stopped at the Anglo-Palestine bank to talk with Dr Levy to learn what was happening around the country and the world. The war was raging in Europe, with opposing forces fighting on the battlefields of Belgium and France, and war preparations were moving at full pace in Palestine as the Ottomans planned an attack on Egypt and the British forces there.

The nurses heard stories about the continual pillaging of the colonies and agricultural settlements. They learned that, besides the money the Ottoman government was receiving from Germany to support its war effort, it had no other source of revenue to prepare for its entrance into the war other than the confiscation of materials from farms and villages.

Soldiers were stepping up their efforts to acquire the resources they needed, taking everything that would be of value to them by force. This included not just cattle and horses but also flour, sugar, wood and even silk stockings. They were stripping iron from farming tools and machinery, and ripping out irrigation systems to confiscate pipes and engines. Tin roofs were being torn down and gates were being dismantled for the wire they were built from.[231] With all this activity and hardship, it was hard to believe that Turkey was not officially in the war.

There was some good to come out of this upheaval, however. The nurses saw both the Jewish and Arab communities of Jerusalem pull together to try to mitigate some of the effects the devastation was having on the people. Merchants were organizing and working to ensure that people could get the goods they needed, in as far as they were available. When the Anglo-Palestine bank agreed to back the merchants' efforts, they agreed to accept checks issued by the bank, backed by the gold reserves. In return, the merchants agreed to ensure the prices of goods would be affordable to the people and this arrangement included selling food to the soup kitchens at half price.

All that month, the nurses read in the newspapers about the worsening conditions around the country and the efforts that were being made to alleviate the growing suffering.

'In Mikveh Israel, they cut wages, not only for new workers, but old workers as well', one article announced.

Petach Tikvah is different. The rich don't suffer. They own real estate and have ready cash. The tradesmen are unemployed and suffering. There is no opportunity to earn money. In the settlement there is a new family from Russia. They have nothing to eat and the extra immigrants are a heavy burden. Every day fifty to sixty people don't have work...

Rehovot is very bad and depressing. Forty workers are without work. They are worried the unemployed will go up to seventy or eighty. Among the workers there is a feeling of depression. The farmers also are feeling hardships. There are no more luxuries and to save money they are laying off their Yemenite servants...[232]

It was difficult for Rae and Rose to imagine the vibrant colonies they had visited just a few months before thrown into such disarray. They must have felt a great deal of anguish thinking about the men they had seen in the fields, filled with so much pride and strength as they worked the land, now standing idle, unable to feed themselves and their families.

In the meantime, relief was slowly continuing to make its way towards Jaffa in the form of the $50,000 raised by the Jews of America. As soon as Mr Ruppin was informed that the money was on its way, he communicated the joyous news to the Jews of Palestine. Ambassador Morgenthau was sending his own son-in-law and envoy, Maurice Wertheim, on the USS *North Carolina* on this mission to deliver funds.

Mr Ruppin later reported, 'The news made a tremendous impression not only on the Jews, but also on the Arabs, among whom our prestige rose enormously.'[233] A committee made up of Ruppin, Aaron Aaronsohn and Ephraim Cohn, the infamous director of the Hilfsverein schools, was formed to distribute the funds to the Jews throughout Palestine.

It was a glorious day on 4 October when the USS *North Carolina* anchored off Jaffa. Maurice Wertheim later wrote about his arrival:

I was proud, prouder of our country and more inspired by the hymn [national anthem], than I had ever been before. For here was a United States battleship carrying to Jews who had sought refuge from all over the world, relief in their hour of need from their American brethren – a noble, stirring example of the freedom and sympathy of America.

Small wonder then, that on arrival at Jaffa, when the band ceased
playing our national anthem and I was well away toward shore
with the heavy sacks buoyed in the tender, I looked with regret
upon the receding cruiser and her American flag.[234]

He described his impressions of Jaffa, as many other visitors had, 'The
first glimpse of the quay did not encourage me much. It swarmed with
fezzes and turbans and dark, excited humanity. Turks, Arabs, and Jews
had huddled themselves into unnatural proximity, occupying every
square inch of space, so that it seemed as if another comer would surely
mean a man in the water.'[235]

Mr Ruppin was waiting for him on the docks with a line of carriages
and guards at the ready to accept the loads of gold and bring them
safely to the bank.

Mr Ruppin later wrote to the ambassador:

You will understand that it proved to be impossible to conceal the
fact that an American cruiser had arrived and had brought
subsidies for the Jews of Palestine. There was a large crowd on the
landing-station to witness the scene; neither could the transport
of the money be practised without causing a smaller or greater
sensation. However, I daresay that the fact that the son-in-law of
the American Ambassador on board an American cruiser has
brought subsidies from the United States for the Jews of this
country has deeply impressed the Palestinian population and will
no doubt have a wholesome effect on people's attitude towards
us. This was the first time that the population had an opportunity
of seeing that the cruiser of a grand power has done something
for the Jews of Palestine.[236]

Another eye-witness reported, 'The spectacle of Mr Wertheim escorted
by the leader of the Zionist Palestine Bureau and followed by sailors
carrying the sacks of money to the safe-rooms of the Anglo Palestine
Company, created a sensation among the Arabs and inspired the Jews
with fresh hope and confidence.'[237]

Fresh hope and confidence was exactly what Rae and Rose
needed. They rejoiced when they were informed that they would be
allocated some of the funds. They planned what they would do with
a replenished pool of money. In the meantime, however, while they
were waiting, they were faced with a dire situation. With each passing
day, the number of people needing their help grew. They were getting

called to patients' homes at an impossible rate. It seemed that the lack of food and nutrition was causing an increase in sickness. In addition, malaria was beginning to sweep over the city. New cases were reported daily. Yet, despite the increase in the need for their nursing services, their limited funding and lack of quinine prevented them from treating all the people in need. 'It is terrible – one is pulled to pieces, so to say, but the demands [are]made in all shapes and forms',[238] Rose wrote.

Each evening, the women conferred about their situation. They were feeling abandoned. Despite the many letters they were sending off to New York, they had not received a reply in weeks. In October, the foreign postal services stopped functioning, including the Austrian, German, French and British offices. The only one that continued operating was that of the Ottomans.

In each of the letters they sent, they asked for guidance about what they should do given the lack of money to buy supplies, the high cost of food and the general disarray in the city. Rose was frustrated with the lack of communication. Ships were trickling into the port now and it seemed that somehow Miss Szold should have found a way to get word to them. 'We reckoned that we could have had an answer to our first [letters], allowing five weeks and even a little over for a letter to reach you.'[239] But there was only silence.

In desperation, the nurses decided to spend forty-one francs to send a telegram to let Hadassah know about their dire circumstances. They agreed there was always the possibility that their many letters had not ever reached New York. They waited and waited but there was no reply to the telegram. With the little money they were permitted to withdraw from the bank, they could hardly deliver any services. They spent a great deal of their days in the settlement house, seeing patients they could barely treat. They were feeling quite useless. And there was no use going out as they had no cotton to treat the children's eyes in the schools and no other supplies.

Finally, on 6 October, they received a letter from Henrietta Szold – it had probably been brought by the USS *North Carolina*. The women celebrated and Rose replied promptly:

> To say we were happy to get it would be a very mild way to express what we felt when we read it, for we were at a loss to know what to do... As yet we did not get your answer [to the telegram], but your letter made us feel that we are not forgotten in this terrible time...[240]

The very next day, they received a telegram. They were elated at the realization that they were not so alone. Knowing that people were concerned about them buoyed their mood tremendously.

They also had news that relief funds were making their way to them and they waited impatiently. To get to Jerusalem and around the country, Mr Ruppin had arranged for Mr Wertheim to travel in the only automobile that existed in Palestine. It was described by Mr Wertheim as 'a little, two-cylindered, old-fashioned affair'. The plan was to get around the country as quickly as possible to distribute the money to the various regions. Later, Wertheim would state that he was the first person in history to travel the whole of Palestine in a car.

Once in Jerusalem, Ruppin left Wertheim with Mr Cohn for several days in order to assess the situation to report back to the ambassador. The nurses were delighted to learn that they were going to receive $2,000. They felt as though a huge burden had been lifted. Some of the tension they were feeling began to slip away. They were more than ready to start up some of the critical work that needed to be done but still they had to wait for Mr Cohn to organize and distribute the money. And so, probably with frustration but anticipation, they continued to do very little.

Mr Wertheim later described the appalling situation of the destitute people in the city and the desperate need for the nurses to alleviate it as much as possible. He explained that the poorest Jews, those from Yemen and Morocco, were feeling the effects of the war the most. He described how:

> Gaunt frames of the sick and starving were lying tier on tier on bunks or on the filthy earthen floors of little black holes that could not be called rooms. Piteously they held out their hands for food and I shuddered to think how the same misery might spread among those less accustomed to bear it.[241]

The misery was punctuated by an incident in the American Consulate. Wertheim had taken an office in the building and was seeing citizens of the city to hear about their situations. There were over a hundred people gathered and Wertheim agreed to see as many of them as possible, giving each person five minutes to tell their story. Suddenly, there was a commotion outside. Wertheim opened the door of the office to see what was happening, and saw a guard 'grasp a knife from the hand of a man for whom I evidently was the last hope and who,

when told he could not see me that day, tried to take his life'.[242] Wertheim was horrified by the desperation of the people but expressed his feelings of honor and privilege to be bringing relief from the American Jewish community to these poor people.[243]

After a few days, Ruppin returned to Jerusalem with Aaron Aaronsohn in tow, to take Wertheim north to distribute the remainder of the emergency funds to the agricultural colonies.[244]

On the way to their first stop, the colony of Zichron Yaakov, the car broke down on an isolated, desolate plain. It was an area that Mr Aaronsohn described as 'the worst place in Palestine for Bedouins and robbers'. As it was nightfall and there was no help on hand, they decided the only option was to sleep under the stars and for one of them to go for help in the morning. Being afraid for the $5,000 in gold that he was carrying, Mr Wertheim wrapped the money up in his coat and used it as a pillow, propped up against an olive tree. He was so worried about bandits, he couldn't fall asleep.

Sure enough, after several hours, four Arabs approached the small group. Rather than being robbers, however, they were saviors. They soon had their donkey tied to the car and 'After five miles of pulling, stopping and kicking – mostly the latter two – our good mule jolted us into the Arab town of Tulkarem, a metropolis of about seventy-five souls...'[245]

Over the following days, Wertheim successfully distributed the money to the Jewish colonists with the help of Aaronsohn, gathered his impressions of the land and the conditions of the people and then returned to Constantinople to deliver his report to Morgenthau.

Back in Jerusalem, it was taking a couple of weeks to get the distribution organized and sorted through the Ottoman officials who were not happy to be cut out of the deal. On 1 November the nurses finally received their funds. Rose wrote to Alice Seligsburg, a Hadassah leader in New York:

Miss Szold's letter of September 8 was the first one we received in weeks. It almost seemed as if we were entirely forgotten out here. We of course knew that the mails were very irregular but we at least hoped for an answer to our telegram. We were completely at a loss to know what to do, for we were at the end of our resources. You may well imagine our joy when we received Miss Szold's letter one day two weeks ago and the telegram the day following. To crown it all we were told in a couple of days that we were going to get $2,000 by way of the American Embassy. A

man-of-war, the *North Carolina*, was bringing it to Jaffa from Beirut. After a number of delays we finally got the money from the Anglo Bank this morning. [246]

It felt as though they had made it through a major crisis and had renewed energy for their work.

Rae also wrote a letter home to her parents telling them of the situation and giving them the good news about the *North Carolina*'s rescue mission. Rae's father, Jacob Landy, was so proud of his daughter and what she was doing that he contacted the Jewish newspaper in Cleveland and let them know what was happening. The paper later incorporated her letter into an article about Jerusalem and the work the Hadassah nurses were doing there.[247]

Even with the infusion of money, though, escalating tension and more bad news made its way to Jerusalem. The nurses learned that, while they had been idle watching for news and financial support from New York, about three hundred Jews from Russia had arrived at the Jaffa port and were forbidden to disembark. Stuck on the crowded ship, they called for help from their brethren watching them from the docks in Jaffa. They were running low on food and water and were panicked at the prospect of being shipped back to Russia without having the ship resupplied. Despite their own precarious economic situation, the local Jewish community came together and brought out supplies to the ship that would last them for their trip home. And so the ship turned back, with its forlorn passengers looking longingly at the land they had come so far to see but were destined never to set foot in.[248]

There was now a curfew in Jaffa. People were forbidden to walk without a torch after 7 p.m. and were banned from the streets after 11 p.m. Everything was being taxed now, including signs, and so shopkeepers began taking them down from their store fronts so they wouldn't have to pay taxes on them. Each week, the number of people coming to the soup kitchens and applying for aid increased. Dr Cohn reported that in Jerusalem 7,000 Jews were coming each day to the soup kitchens and at the Evelina de Rothschild school they could only give the students one meal a day.[249] People were hoarding their supplies, even hiding things in the walls, but the government confiscated everything it could find. People were moving quickly into survival mode, digging in and waiting for the next catastrophe.

Annie Landau stepped out of the small room onto the balcony and looked down. Below her stood a sea of dejected, pale faces staring up at her. With their arms outstretched, the people stood silently waiting for her. She reached into the first sack and pulled out a few loaves of bread. She leaned over the railing and gently dropped the loaves into the waiting arms below. She dug into the sack again and pulled out more loaves. When she looked back over the balcony railing, she saw that the crowd had grown larger. Passers-by, curious about what was happening had seen the first loaves fall and were determined to get some.

In November, Miss Landau had decided that she wanted to bring some bread to the residents of one of the poorest neighborhoods in Jerusalem where the need was dire. She had been advised by the Turkish guards to distribute the food from a balcony of one of the buildings, as the desperate people could potentially cause her harm during the allocation. With each piece of bread she dropped, the crowd got larger and more restless. More and more hungry citizens pushed their way into the mass of starving humanity. The small group which had been informed about the bread and had been waited patiently for its distribution now grew into a frenzied mob of starving savages, jostling and fighting over the unexpected treasure.

Suddenly, a shout was heard from someone in the crowd that people could more easily get the bread by breaking into the room where Miss Landau was standing. There was a violent rush as people moved to the building entrance and raced up the stairs. They started to push against the door, while the guards valiantly tried to keep it closed, leaning against it to prevent the crowd from breaking in. But it was to no avail. The group of hungry men was stronger than the few guards and, in the end, the soldiers had to lash out with a whip against the desperate people in order to prevent a stampede and bring Miss Landau out to safety.[250]

Such was the condition of Jerusalem in the fall of 1914. And then, on 30 October, the Ottoman Empire officially joined the Central Powers and the war. All the news that trickled into Palestine came exclusively from Turkish, German and Austrian sources. The government ordered all letters be written solely in Turkish, Arabic or German. As they engaged people to write notes for them in Arabic and German, the nurses laughed at the thought of how surprised and

confused the Hadassah leaders would be when they received letters from them in those foreign languages. They found it hilarious when they imagined their reaction upon seeing the lines of Arabic and wondered how they would ever know what they were saying.

In fact, they couldn't say much, other than to reassure them that they were doing fine. They had to be very careful about what they wrote, knowing that the letters were being heavily censored. At this time, the Hadassah office in New York despaired at the lack of communication from the nurses and, despite the Arabic and German notes they received, they worried about them and their well-being.[251]

The Zionist Organization back in the United States was encouraging the American Jews to send emergency funds through them to family and friends in Palestine which they would then send on to the ambassador's office in Constantinople, where arrangements would be made for them to be sent to Palestine. However, people were advised that they should expect a delay of four to six weeks before the money would arrive at its destination.[252]

The citizens of Jaffa had the misfortune of having two Ottoman leaders who were virulently anti-Zionist and did what they could to cause distress among the Jews of Jaffa and Tel Aviv. Hassan Bey was the commandant of Jaffa and Baha-ad-din was the *kaimakam*, or governor, of the city. These two men freely arrested many Jews of Jaffa and the colonies, accusing them of concealing weapons and belonging to secret societies. They imprisoned them, fined them and then released them. Baha-ad-din was known for being a tyrant. He became infamous for his arbitrary, seemingly impetuous decisions to wreak havoc among the Jews of Tel Aviv and Jaffa. Eyewitnesses reported:

> It would suddenly come into his head to summon respectable householders to him after midnight, and hours after they would return to their expectant families with an order to bring him some object from their homes which had caught his fancy or of which he had heard – an electric clock, a carpet, etc. Groundless arrests, insults, tortures, bastinadoes [canings on the bottom of feet] –these were things every householder had to fear.[253]

On 5 November, Hassan Bey, the commandant of Jaffa, sent his soldiers into Tel Aviv and started invading people's homes, looking for evidence of treason. Zionist leaders were arrested and sent to Jerusalem for questioning but, while nothing seditious was found, many were sent out of the country.[254]

Hassan Bey also forbade any other Jews from entering Palestine.[255] A ship with fifty Yemenite families arrived at the port of Jaffa and, although they were Ottoman citizens, they were refused entry. After much protestation, they were finally allowed ashore but were promptly arrested and placed in detention. It was only after some behind-the-scenes negotiations that the families were released.[256]

In the meantime, Jerusalem had a different situation. Zaki Bey, the military commander of Jerusalem, was well-liked by almost all the different groups of people living in that city. He often visited the foreign consuls and convened a meeting between Arabs and Jews in an attempt to maintain peace and cooperation during the economic crisis. Life under Zaki Bey was relatively quiet for a while. It was certainly difficult because of the economic conditions but the rule of Zaki Bey was bearable. The streets were still safe, at the moment, from spontaneous arrests and seizures.

Residents needed a permit to leave the city now and all foreigners had to carry their passports. There was a curfew in place and everyone had to be off the streets by 8 p.m. Cafes, pubs and restaurants had to close by 6pm. The curfew did not impact the nurses very much as they were exhausted after their long days of work and had long made it a habit to retire early. Additionally, they had no intention of leaving the city in the present circumstances.

The nurses took stock of their situation. They now had enough funds to last them awhile, at least a couple months, and then they would figure out what they would do next. Of course, they would economize as best they could to make the funds last as long as possible. Even with strict budgeting, however, and minimal use of funds, they would need to receive funds from America more regularly.

One day, as the women were sitting over their breakfast discussing what they would be doing that day, Rae suddenly noticed that Rose appeared quite fatigued. In fact, Rae realized, Rose had been inordinately exhausted over the previous few weeks and, as she looked closely at her friend, Rae saw that Rose's face seemed thinner than usual. Although they were both trim and had lost some weight due to their continuous activity, Rose appeared to have lost even more weight since her return from her trip up north.

Rae questioned Rose who finally conceded that she hadn't been feeling well and that she may need to return home for a while. Rae was filled with alarm as she carefully observed her partner's face, trying to decide how serious this might be. The stress of the war and economic conditions were certainly affecting her but, although she pressed

further, Rose didn't reveal much more. She murmured that she was only thinking about it and that Rae shouldn't worry. She promised to keep Rae informed about her decision as time went on. Although she was deeply concerned, there wasn't much else Rae could do; Rose would let her know if things got worse, she promised.

* * * * * * * *

'Miss Kaplan, Jerusalem', c. 1913; Record Group 18, Photographs Hadassah Medical Organization Series, Hadassah Archives, American Jewish Historical Society, New York, NY and Boston MA. Digital ID 251749.

On 7 November, the Ottomans declared the war to be a *jihad*, or holy war, and at the end of the month, a new military commander over Syria and Palestine arrived in Damascus. Ahmed Djemal Pasha was the commander of the Ottoman Fourth Army and the Minister of the Navy and was highly committed to the war efforts. The people of Palestine, both Arabs and Jews, quickly felt his wrath. No longer was it an option to keep one's citizenship of a foreign nation and also reside in Palestine. He particularly singled out the Russians, who were enemies of the Central Powers, and also made up the majority of the Zionist pioneers, or *chalutzim*.

Djemal Pasha had had an illustrious military career up to that point and he was anxious to continue it in his new role. It was rumored that he had overseen the persecution and murder of Armenian communities in Turkey and there was great fear that he would continue his persecution of non-Turkish peoples in Palestine. He was convinced there were conspiracies amongst the foreign Jews in Palestine and he was determined to root them out. His soldiers began going into the villages trying to find hidden weapons which he was convinced they possessed. They found nothing. He ordered 'enemy aliens' (mostly Russian Jews) to become Ottoman subjects or leave the country without delay.

Djemal Pasha commanded that no negative news about the government could be published and offenders would be put in prison. Newspapers that had struggled to remain open were now closed and the feeling of isolation grew as people had no way of learning what was happening in the rest of the world.

On 4 December, a Zionist leader named Wolf Gluskin sent several communications to Louis Brandeis, the chair of the American Jewish Committee and future Supreme Court Justice, describing the worsening conditions in Palestine. His telegram read, '...misery growing daily... Hunger with disastrous consequences will spread all over Palestine'.[257] He requested that a steamer filled with food be sent as soon as possible. He went on: 'Please do all you can to get this done. Palestine is facing a famine, a real famine in the fullest sense of the word. Is it possible that the population of an entire country will be left to starve?'[258]

Letters that the nurses sent to New York were received very sporadically and took many weeks to arrive. Hadassah leaders reported in their news bulletin in January 1915 that they received a letter dated 24 November only on 13 January. In that letter, the nurses wrote that they were well but that the conditions in Palestine were distressing.

'Our two emissaries continue their good work in spite of untoward circumstances', Hadassah reported to its members.[259] And it was true, the nurses kept up their daily routine as best they could, continuing their care-giving with decreasing resources in very trying circumstances.

The wide, shaded boulevards of Tel Aviv were bustling with their usual mid-day vibrancy on 17 December. People were going about their business; men who still had work were walking back to their shops after a long lunch break and women were making their way to the markets to search for additional supplies for their evening meals. All of a sudden, the peace was shattered by the sound of bellowing commands and the stomping boots of Turkish soldiers. Police and soldiers began pouring into the neighborhoods, rampaging along the streets and pulling anyone who had been unfortunate enough to be outside into wagons. As more and more soldiers appeared, police began going from house to house, checking lists they held and forcing people from their homes and down to the port.

News trickled into Jerusalem that Baha-ad-din, the *kaimakam* of Jaffa, had suddenly decided that the Russian Jews of Jaffa and Tel Aviv would no longer be allowed to remain in Palestine. He had written an order, which Hassan Bey had signed, giving these Jews two hours to prepare to leave on a ship to Egypt that was to arrive in the port at 4 pm that day.[260]

Eyewitnesses reported scenes of panic and terror as people were driven out of the city and onto the boats that would take them to the waiting ship. 'Policemen and soldiers posted themselves in the streets', one witness related, '[and] beat and arrested men and women, old persons and children, and dragged them to the police buildings'. Those that were taken didn't even have time to grab any belongings, and were thrown into long lines without even a change of clothes. People who were taken off the street weren't able to let their families know where they were or what had happened to them. 'Without pity they were all dragged to the Customs House, and from there transferred in the most unfeeling manner on to the ship in boats.'[261]

The loading of people into the waiting boats was so frenzied that many people fell from the boats into the water. People were threatened with death if they did not submit to the soldiers' commands and many people were beaten with sticks and whips as they were herded to the shore. In the end, so many people were rounded up that the ship didn't

have enough room for everyone and many were returned to shore. There they were forced to remain and wait for the ship to return from Alexandria to take another load. Families were separated, mothers from children, husbands from wives, all without knowledge of where their loved ones were.[262] Dr Glazebrook, the American Consul, and his wife hurried to Jaffa when they heard the news and did what they could to alleviate the plight of the refugees but they were unable to have any influence in the matter.[263] In the end, five hundred Russian Jews were rounded up that day and deported to Egypt.[264]

The next day, the Russian consulate in Alexandria received a telegram, alerting it to the impending arrival of the ship of refugees. As the Russian delegates welcomed the ship, they were greeted by bedlam. Hordes of traumatized people, some of them without even shoes on their feet, none of them with any belongings or personal items, waited to disembark. Some people had been detained in prison and had been dragged onto the ship directly from their cells. The deported included people from all walks of life: rabbis and students, lawyers, merchants and laborers, all torn from their homes and, in some cases, from their families, now left to fend for themselves. The Russian consulate worked quickly with the Egyptian government and transferred the refugees into hastily erected refugee encampments.[265]

Fear spread through the country as word was received about what was happening in Jaffa. Everyone waited anxiously to see what would happen next and who would be next on the list for deportation. A great cry of protest went out to the Ottoman government in Constantinople from the leaders of the American and German embassies. The Jewish leaders in Palestine also protested and begged for a reprieve.

In the meantime, while they had been spared a forced exodus from the city, the nurses saw other alarming signs of what the future might hold. Preparations for war continued at full force on the outskirts of Jerusalem. Soldiers were digging trenches, marching and practicing with their rifles and bayonets. Camel trains were constantly moving from the north to the south, carrying weapons and supplies for battle.[266] Where previously they had been able to take a horse-drawn carriage if they needed to travel somewhere that was too far to walk, this was no longer possible. All the horses and donkeys had been confiscated by the government, leaving people with no choice but to walk everywhere.

A few days after the Jaffa deportations, Djemal Pasha came to Jerusalem from Damascus to survey the city and its preparations for war. That evening, a new proclamation was issued. All foreigners from

non-belligerent countries had to leave the country by 28 December or stay until the war was over. This message was received with some skepticism as it was hard to keep up with all the proclamations that Djemal was making. Only recently there had been an order prohibiting foreigners from leaving the city. As the days passed, however, it became clear that this newest order would be carried out. Now foreigners were being forced to make a difficult choice. Would they stay in such unsettling times for the duration of the war or would they leave now for the relative safety of their own countries? Would it be better to stay in Jerusalem where there was no battle raging or return to Europe where war was everywhere?

The entire foreign population felt so much anxiety and uncertainty with this latest order that Arthur Ruppin decided to travel to Damascus to try to convince Djemal Pasha to cancel his new proclamation. After a three-day journey, Ruppin arrived at the palace and asked for an audience with Djemal but the military commander refused to see him. Instead, he sent a message to Ruppin conveying that the regulation for deportation would not be rescinded; however, he added that those who became Ottoman citizens could do so without paying a tax.[267] Frustrated and disappointed, Ruppin returned to Jaffa.

Rae and Rose had some serious decisions to make. Prior to this, Rae had assumed there was no question of their both remaining in Jerusalem. Their dedication to their mission had not diminished in any way because of the war but, in fact, had strengthened in the face of the growing needs of a city in despair. It had been easy to justify their continued presence when there was more work than ever needing to be done. Despite the lack of sufficient funds, they were still able to provide a basic level of care to their patients. As Americans, who were neutral in the war, they enjoyed a privilege that Russians and Britains did not. They also had a wonderful ally in Otis Glazebrook, the American Consul.

Now, however, they were being forced to make up their minds about their next steps. Would this be the right time for them to pack up and leave? As they talked about what they should do, Rose shared more about her health, telling Rae that she believed her ongoing fatigue and rapid weight loss meant she had cancer. She had even secretly seen a doctor who had advised her to go home and get more advanced medical care than she could get in Jerusalem. Rae was shattered by this revelation and couldn't find any words. But, Rose continued to explain, she was quite optimistic that with proper treatment in the US, she would be perfectly fine. She also swore Rae to secrecy about her

condition. With a heavy heart, Rae reluctantly agreed not to share the news with anyone. Though she desperately wished it were otherwise, she agreed that Rose would have to leave. She couldn't picture life in Jerusalem without her but she knew Rose couldn't stay. Rose shared her plan to return to Jerusalem to resume her work once she had received treatment in the US. Rae found it hard to believe that would happen with the war raging around the world, but she allowed herself to be comforted by Rose's words.

Knowing now that Rose would be leaving, the women sadly turned to Rae's situation. Frantically, Rae worried about what she should do. She didn't have much time to make up her mind. Should she leave with Rose? The safest thing would be for her to return to America. Everyone would understand and even be relieved to see her home safe. The future in Jerusalem did not look optimistic and things were continually worsening. Every day there were soldiers parading in the streets, marching to the outskirts of Jerusalem preparing for an anticipated battle with Egypt. Would the battle then move to Palestine and Jerusalem? What would she do if war arrived on her doorstep?

Rae, however, felt despondent about the thought of leaving. Although she knew the best thing to do would be to return home, something held her back. The people of Jerusalem needed her. And she felt needed. It was such a profound emotion to know she was making a difference in her patients' lives. If she left, she knew she would feel like she was abandoning her people. Back in the United States, what could she do to help those being torn apart by war? Raise money? It was not something she wanted to contemplate. She also considered that she would not be totally alone. Her friends Annie Landau and Vera Pinczower were still in the city and so was Helena Kagan, the doctor who had arrived earlier that year. If those women were staying on and continuing their work then why wouldn't she?

On the other hand, what would life be like alone, without Rose, her steady companion, who brought such calm and stability to every situation? As Rae walked around the city, she took it all in, imagining what it would be like to come home to an empty house and not have someone to talk to every day. How would she feel not having her close companion and confidante nearby? If she had felt isolated now, with little communication from the United States, how would she feel when her lifeline, Rose, was gone.

As she mused, she imagined herself back in the United States. Would she return to New York and take a job as an ordinary nurse in a hospital? Would she go back to Cleveland and do the same? Somehow,

she couldn't fathom picking up her life as she had left it. Thinking about going home and trying to figure out what she would do there caused her more anxiety than the thought of staying in Jerusalem alone during a war. In the end, as the deadline drew nearer, she knew what she must do. She announced to Rose that she would be staying in Jerusalem and continuing their work.

The week Rose left Jerusalem was the very last week of December, when ten thousand other Jews also left the city. Wiping away her tears, Rae resolutely helped Rose pack up her trunks. While they packed, they reminisced about the previous years and all they had experienced together. There were so many things that had happened that only the two of them would understand. While they could describe the events of the past two years to others, the joy and pain they felt and their shared experiences were something no one else could ever understand. They were bonded together for life. Rae marveled that they hadn't even known each other when they were thrown together for Hadassah's great experiment. Though Rose was almost twenty years older than Rae, they had a connection that stretched across the years. Rose had been a great example for Rae and had guided her with her organization, her knack for navigating difficult situations and her ability to stay calm in even the most stressful situations. They promised each other over and over that this was only a temporary separation and that they would see each other again very soon.

That week, thousands of people jammed the station as panicked foreign nationals jockeyed for a place on the train. Those who couldn't get a seat on the train traveled to Jaffa by carriage and wagon. Not only Jews, but Christians from the many religious orders who had made Jerusalem their home, were also leaving the city. Rose and Rae clung together in a last hug not knowing when they would see each other again. Rose vowed to return to Palestine as soon as her medical condition improved and Rae fervently believed that would happen. The train whistle blew and the two companions separated. With a last look behind her and a final wave, Rose boarded the train and was off to Jaffa.

As the fleeing evacuees arrived in Jaffa they streamed down to the port, lining up for the boats that would row them out to the waiting ship. As the travelers made their way through the queue, they had to show their passports to Baha-ad-din who was personally checking each and every one. Anticipating trouble, Consul Glazebrook had been called the previous night and now stood at the docks watching the proceedings.

All of a sudden, despite the official permission they had to leave the country, the *kaimakan* decided not to allow British men to board the ship. When Glazebrook heard the latest arbitrary order from Baha-ad-din, he approached the *kaimakan* and told him in no uncertain terms that he would remain there until all British subjects were allowed to board the ship. He then took a chair and sat on the dock. All afternoon he sat there, watching and waiting. As if an apparition, in the late afternoon, the American warship USS *Tennessee* appeared on the horizon. Baha-ad-din saw the ship with the American flag waving and guns loaded and suddenly declared that now all the Britains were permitted to leave. Once the British men were finally on board, the ship set sail for Egypt.

The USS *Tennessee* took on the next load of refugees. The captain of the ship, Benton Decker, reported seeing 'a crowd of poverty-stricken refugees, old men and women, young women and girls, and scores upon scores of little children'. One sailor reported, 'an old man with a long beard and wearing ragged clothes came alongside the *Tennessee* in a little rowboat and climbed on board. He said he was a carpenter of Jaffa, and he wanted to enlist in the American Navy. He was broken-hearted when told that only Americans could serve in the United States Navy.'[268]

The *Tennessee* left Jaffa on 27 December with 496 refugees. This was the first of its many trips from Palestine to Egypt. Rose was one of those who made it onto the *Tennessee* and sailed to Alexandria and then on to Beirut, where she boarded another ship that took her back to America.

Arthur Ruppin, having just returned to Jaffa from his fruitless trip to Damascus, saw hundreds of Jews being rowed out to the waiting ship. He recorded in his diary on 31 December, '...we are now losing within a few days more people than we gained during years of immigration, and who knows what else the immediate future may hold'.[269]

The future was something that Rae also contemplated as she made her way alone, back to the empty settlement house. As she opened the gate and stepped into the courtyard she stopped. It was hard to move forward, anticipating the loneliness that would greet her. Tears filled her eyes when she opened the door and stepped inside the silent building. The floorboards creaked loudly, echoing, as she walked through the entranceway. She wandered through the empty rooms, touching the familiar furniture, remembering the days when Eva Leon had designed it all. She walked into Rose's bedroom

and sat on the bare mattress. She took a deep breath, gathering strength for what the future would hold, and sternly told herself that she would be all right. And though Rae was now alone, she knew she would be fine.

PART III
1915

In which Rae is on her own

Chapter Eleven

Alone

On 11 January 1915 Rae wrote to Miss Szold. In this letter she told her: 'Although it is not very pleasant living here alone, especially just now, I am perfectly willing and satisfied to keep up the Hadassah work as long as I have funds, to the very best of my ability.'[270]

That was quite an understatement, Rae thought, as she laid down her pen. Ever since Rose had left, Jerusalem had been descending into greater disorder and it didn't appear it would end anytime soon. Life without Rose was quite lonely and had cast a heavy pall on Rae's daily routine. Returning home after her school visits and opening the door to absolute silence was unnerving at first. Dining alone and not being able to discuss the day's occurrences was disheartening. And the new, unsettling changes in the city were unfolding at a very rapid pace, which was incredibly nerve-wracking and kept Rae on edge.

Just a few days before, on 8 January, Djemal Pasha had arrived in Jerusalem from Damascus and established his headquarters right there in the city, on the Mount of Olives, in order to direct the upcoming assault on Egypt. To the horror of the residents of Jerusalem, he brought along with him the nefarious Baha-ad-din as his attache. The complaints about this despot's inhumane treatment of the Jews of Jaffa and Tel Aviv the previous month had reached the Central Ottoman government in Constantinople and had succeeded in having him removed as the *kaimakam* of Jaffa but in an ironic twist of fate, Djemal Pasha had simply promoted him to work directly with him. When the people of Jerusalem saw Baha-ad-din riding on his horse alongside Djemal, there were sounds of gasping as people recognized him. Immediately they began to worry about what would happen to them.

They didn't have to wait long. Just a couple days after his arrival, Djemal issued an order placing restrictions on Zionist efforts. All

Hebrew signs must be removed from stores and walls, *HaShomer* guards were outlawed and the Jewish National Fund stamps, which raised money for the colonies, were banned. Anyone found with one of these stamps would be put to death, Djemal commanded.[271]He added that Baha-ad-din's actions in Jaffa had been found to be legal.[272]

Rae spent the next day removing the Jewish star from her uniform, having learned that, in addition, all symbols of Zionism, including flags, banners and banknotes were now prohibited.

Yet, she was concerned about sharing all this bad news with the New York Hadassah office, fearing they would order her to return home. She had made up her mind she was going to stay and decided to do whatever she could to prevent them from worrying. She kept her letter light. 'I had a line from Miss Kaplan from Haifa, and am expecting one from Naples. She was very lucky to get away, because it was the last steamer so far. I am told that another will leave shortly.'[273]

Rae reviewed her finances. She had approximately 2,000 francs she was able to access. She did a bit of math, figuring out her personal account, and she decided she wouldn't take her own salary until more money was received from the US; she was confident it would be coming soon.[274] She believed that, with some frugality, her money would be sufficient for a few months.

She also determined that, to enhance the conservation of her funds, she would only do the trachoma work with Dr Ticho and maternity work with the midwives. She would no longer take on ill patients as she didn't have the capacity to treat them. There was, however, the need for physician oversight in her maternity work. Dr Segal had been exiled from the country at the outbreak of the war, since he was not an Ottoman citizen. Rae was thrilled to find a solution to that problem in Dr Helena Kagan, the physician who had arrived in Palestine the previous April. She was a rather gruff woman but exceedingly strong, both physically and emotionally, and she readily agreed to supervise Rae's maternity work.

Thankfully, Dr Ticho was still in Jerusalem, having received the exemption from the army and, upon her request, he also agreed not to take a salary. So, if Rae could just block out the events happening outside her walls, things seemed very much under control. She and Dr Ticho met over the course of several days and organized the two probationers to cover all the schools for the trachoma visits. Dr Ticho wanted to hire one more person to share in the work but Rae advised him to wait and see if they could manage the schools as it was, in order to conserve their money.

When she wrote to Hadassah in New York, she kept her words optimistic and cheerful and, to any reader, it was difficult to imagine Jerusalem was anything but peaceful and calm:

> January 12
> Everything is running smoothly... I have it all arranged now and it is working beautifully. I went to the different schools to see that everything was satisfactory. Miss Rachman is treating eight schools, Miss Drosis, working only a half day, is treating four... I am home a few hours during the day, so I keep track of the number of applicants to the settlement. The neighbors tell me that people come all day long. I have told the midwives just where I am certain hours of the day should they need me.[275]

Dr Ticho and Rae celebrated when they examined their data of the trachoma treatments from the previous year. The numbers indicated that their vigilant attention to the children had paid off with significant progress in eradicating the disease from Jerusalem. The number of children afflicted dropped to 14 percent from a high of 28 percent at the beginning of 1914. They were thrilled they could prove that consistent and vigilant care could reduce the disease.[276] As they surveyed the children, though, many of whom were suffering now from hunger and family instability since their fathers had been deported or conscripted, Dr Ticho and Rae feared they could not sustain the promising results.

As much as Rae tried to keep her mind only on her daily routine, it was impossible to keep the events that were happening right outside her gates at bay. One day, Dr Ticho greeted her with the devastating news that Djemal Pasha had ordered him to leave the country. Ticho let Rae know he had no intention of leaving and had turned to his good friend Dr Moshe Wallach, the head of the Shaare Tzedek Hospital, for help. Dr Wallach agreed to accompany Dr Ticho to Djemal's headquarters to appeal his deportation.

The next day, Rae visited the Tichos to find out what had happened. Dr Ticho said that when he and Dr Wallach had walked into Djemal's office, he greeted them with the words, 'Here comes the Devil to cancel the edicts.' But Dr Wallach persevered and made his case to the commander. He explained how important Dr Ticho's work was and described the tremendous advances he had made in healing the diseased people of the city. He emphasized that, although Dr Ticho was Jewish, he provided service to all citizens of Jerusalem, no matter their religion. Djemal was in a good mood that day and so agreed to allow Dr Ticho

to stay.[277] The two doctors left the Turkish headquarters feeling great relief and Dr Ticho felt secure that he was safe from deportation for the time being.

Djemal, however, was not finished with his mission to rid Palestine of Zionists. He believed they had formed a secret government and were plotting the defeat of the Ottomans.[278] On 15 January, news spread throughout the city that thirty-one leaders of the Jewish community from Jaffa and the Jewish colonies, including Arthur Ruppin, had been summoned to Djemal Pasha. The men were escorted to his headquarters and led into a room where they were kept waiting. An aide announced the commander would see them as soon as he had finished taking a bath. When Djemal finally entered the room, the men quickly stood at attention to greet him. He took one look at them and ordered them to be banished to Brussa, in northwest Turkey, for the duration of the war. The men realized that travel to Brussa on foot, in the winter, with the diseases that were sweeping over the country, could quite possibly result in their deaths. Once the commander left the room, the Jewish leaders appealed to one of their group, Albert Antebi, who had a history of good relations with the Ottoman government. They asked Antebi to petition Djemal and convince him to change his mind.

Antebi agreed and left the room in search of Djemal. After a couple hours, he returned, a serious look on his face. 'You know', he said, 'an order which Djemal Pasha has given remains in force forever'. The men's faces fell. Were they really going to be banished to a wasteland where they would most likely die?

Then, Antebi gave the good news that Djemal was, however, able to *modify* his order. And so, he reported, 'You will not be deported to Brussa, but to Tiberias. Not forever, but for a fortnight. And not all of you, but only half of you.' At that news, the men rejoiced. Not only were they to be spared, but a select handful of them would now be able to take a relaxing vacation at the healing waters in Tiberias. They congratulated Antebi on a job well done.[279] They were saved for now but after that incident there was a great deal of pessimism about the future for the Zionists. Ruppin questioned, 'Will we be able to hold our own in the storms now shaking the country?'[280]

In the meantime, every day as Rae went about her work, walking from school to school or visiting a maternity case, she saw lines of deportees carrying bundles in carts and on their backs, leaving the city. Children were straggling behind or sitting on top of bundles in the carts. Mothers nervously tried to keep their families together as they

traveled down the streets leading out of the city. Rae knew that most of the individuals were enemy nationals, Jews who refused to become Ottoman citizens and were now being forced to leave. Some of them were Christians, who were also feeling the wrath of Djemal, and were hurriedly evacuating. Tourists who had been stuck in the country were also now trying to get away.

These refugees were heading to the port in Jaffa where they would be evacuated by the USS *Tennessee* to Alexandria, joining the hundreds of Jews who had left in December. The US government had ordered the warship to remain in the Mediterranean to continue transporting exiles out of reach of the Ottoman military government.

Captain Decker of the *Tennessee* was quickly becoming a legend due to his kindness in receiving the refugees and welcoming them aboard. He was often seen holding small children as their parents registered with his crew. Upon witnessing the captain's compassionate actions, his men were quick to follow suit, the entire crew making sure the ragged, frightened passengers were as comfortable as they could make them. One of the officers of the ship later reported, 'The condition of those poor people was pitiful beyond description. I never saw so many sad eyes before and hope never to see as many again.'[281]

By 13 January, it was reported that two thousand exiles had crowded at the port, waiting for their turn to board the ship. The *Tennessee* could hold only five hundred passengers, so those that couldn't board waited for days before it was their turn to embark. The port was not prepared for the mass of humanity that crowded the shores; there wasn't enough food or water for the stranded exiles and everyone suffered tremendously.

Ambassador Morgenthau was using all his diplomatic power and influence to convince the Ottoman government to halt the deportations but his efforts were to no avail. Seven thousand refugees, the majority of whom were Russian Jews, were either in or waiting to get to Alexandria. The refugees were 'absolutely destitute', as they had been compelled to leave most of their belongings behind. They had no money, no clothing and nowhere to go.[282] Upon reaching Alexandria, they were processed and then crammed into hastily erected tents in the already crowded encampments.

The winter weather was often stormy and the seas were not always calm enough to take on passengers, so the *Tennessee* occasionally left without anyone on board, having to return to Alexandria for more coal to fuel the ship, so it could return to take on the additional deportees.[283]

A seaman who was on the USS *Tennessee* later wrote about his experiences: 'The sight I saw there I will never forget –Syrian refugees from the northern part of Palestine, Armenians and Jews so frightened from the treatment they received from the Turks. And the hunger... those poor people had wasted away to mere shadows. They pleaded with our officers to take them away from their tormentors...'[284] The *Tennessee* made a total of twenty trips to Alexandria, taking thousands of people away from the harsh control of the Ottomans. And still the flood of people trying to get away continued.

** * * * * * **

Rae strode along the serpentine paths through the Old City towards Jaffa Gate. When she emerged from the tight quarters into the open plaza, she was greeted by the sight of yet another parade of marching soldiers. Lifting their legs in lockstep and carrying their rifles and bayonets on their shoulders, their boots pounded as one, creating dissonant echoes on the stone walkway. As she stopped to watch and let the line pass, she was surprised to see German soldiers in the procession. She had heard rumors that Germans officers had arrived in Palestine to lead the expected attack on Egypt but this was the first time she had seen them.

The German soldiers, with their fair skin, were not used to the Mediterranean sun and looked quite miserable in the heat. Despite their newly issued sun hats, they looked quite un-soldier-like with their cheeks and noses bright red with sunburn.[285] Rae was jarred again by the juxtaposition of the military uniforms and disciplined soldiers marching along the ancient roads. It was hard to believe she was visiting school children and treating their eyes for trachoma while this military activity was going on.

Rae may have been invited to meet with Arthur Ruppin, who was still in Jerusalem after his narrow escape from deportation to Brussa. She walked up Jaffa Road towards one of the hotels. Upon entering the lobby and restaurant she was greeted with the raucous laughter and unruly behavior of German officers, who were talking loudly and drinking and generally celebrating the war. Their aggressive behavior was intimidating and Rae rapidly scanned the room until her eyes caught the profile of Arthur Ruppin. He was sitting in a corner by himself.

It was 18 January 1915 and Ruppin, now recovered from the showdown with Djemal, was focused on distributing new funds that

had just arrived from the newly formed American Jewish War Relief Committee to aid the starving people of Palestine. Ruppin had been informed that, just a few days prior, on 15 January, the Anglo-Palestine Bank had been forced to shut down. He would now be receiving funds through Otis Glazebrook, the American Consul.[286] The money was to be distributed by the same committees that had been set up the previous fall during the time of the USS *North Carolina* aid, though the infamous Ephraim Cohn of the Hilfsverein schools, who had become widely disliked by the Zionists for his role in stamping out Hebrew instruction in his schools during the language wars, would no longer have a role in the distribution. After a great deal of behind-the-scenes maneuvering, Ruppin was relieved to be able to announce that Ephraim Cohn would no longer be a member of the Jerusalem distribution committee. It was suspected that he was the one who had denounced the Zionist leaders to Djemal Pasha, which had led to their arrest. It was said that he wrote a memo to the Turkish officials criticizing the American ambassador for assisting the Zionists and accusing the *Tennessee* of carrying secret cables to the Zionist refugees in Alexandria who were plotting against the Turkish government. This letter, rumor had it, advised the Turkish officials to 'combat the Zionist movement...'[287] For these actions, it was determined by the Zionist leaders that Mr Cohn was no longer fit to serve on the Jerusalem distribution committee. Mr Cohn was now thought to be a traitor to the Zionist cause.

Rae was elated to learn that the American Jewish War Relief Committee had allocated a monthly distribution of four hundred dollars to Hadassah.[288] She felt a tremendous sense of solace, knowing this amount of money would sustain her work. She was overjoyed to receive this tacit confirmation that she would be staying in Jerusalem.

Ruppin had hoped that while he was in Jerusalem he would be able to further petition Djemal to allow the colonists to stay in Palestine. Already, four thousand Jews of Russian, French and English nationality had been forced to leave the country.[289] However, Djemal was not in the frame of mind to show any benevolence to the Zionists and rebuffed Ruppin's petition. He was in a fever of activity, making final preparations for battle. In fact, he had just left the city the previous day for Beersheva, ready to lead his troops through the desert to Egypt and the Suez Canal.[290] Ruppin was frustrated as he had learned from experience that Djemal issued arbitrary orders all the time and could sometimes be talked out of them; this time Ruppin was unsuccessful.

Rae hastily wrote a postcard for Ruppin to take to the USS *Tennessee* for posting through Alexandria. Knowing the message would be seen by the Turkish censors, she kept it brief:

> January 22. –Just a line to assure you that I am very well. I have plenty to do, and am kept busy all the time, and everything is alright. Do not worry about me. We are having beautiful weather. Everything is green and fresh. It is quite warm to-day. Greetings to everybody. RACHEL LANDY[291]

In reality, the days were getting more desperate. The local economy had crumbled, there was not enough food to eat and the poorest amongst the population were beginning to starve. Rae was tormented by the troubling scenes she was witnessing. The children in the schools were not as cheerful as usual and many of them cried easily, complaining of hunger and pains in their bellies.

After the innocuous postcard Rae sent, she realized she could no longer keep the truth from the Hadassah members. After all, there was a war going on and, although there were no battles being fought in Jerusalem, they were feeling the effects acutely. She wrote:

> January 24, 1915
> Our cashier brought me $400 a few days ago... It is very hard to telegraph nowadays or I would do so and assure you that everything is well with me here and that I received the money.
>
> Since the war began, we are not having the usual good luck with our infants. Quite a number are dying after a few weeks. Needless to say, it is all due to starvation... Dr Ticho began the full examination of the children's eyes today. I have noticed that the improvement is not so marked as heretofore. That is also due to lack of food.[292]

Rae knew that, besides the four hundred dollars she was allocated for medical care, money was desperately needed to purchase food. With an embargo on Palestine by the combatants of the Ottoman Empire, no food was able to reach the shores. And with the Ottoman soldiers having commandeered the produce and crops of the farming communities, there was a shortage of wheat and sugar and other staples. It was not even a matter of lack of money. There was just no food. Food that could sustain the population was urgently needed.

Letters and telegrams were sent overseas to the American Jewish leaders begging for help and they were now frantically engaged in fundraising to purchase some food and send it to Palestine.[293]

To further exacerbate the tension, Baha-ad-din made his ominous presence known once again with a notice he ordered to have printed in the newspaper, *HaCheruth*, on 25 January.

The editors wrote, 'We are commanded by his honor, Baha-ad-din Bey, ex Kaimakam of Jaffa, and at present attached to the Fourth Army, to publish the following in the "HaCheruth" ...'

The message from Baha-ad-din began by reiterating the ban on the Zionist flag, stamp and currency of the Anglo-Palestine bank, and announced the dissolution of all the Zionist organizations 'which have existed in secret till now'. The notice went on to say:

We are informed that some mischief-makers have intentionally misinterpreted the above, saying that it is intended against all the Jews. It is, of course, not so. It is not intended for all the Jews, who are friendly to us and who are enjoying equal rights, and who, with the help of God, will always be true to their Fatherland. The public orders were only intended against the ideas and the actions of the Zionists, but all other Jewish citizens who have no connection with destroying ideas of this kind, we always ask and hope that they will live in peace. We, the Ottomans, are as before, friends to all the Jews who are with us. Only Zionism and the Zionists, the element of slander, the revolutionists, who strive to establish a separate state in ours will always be our enemies.[294]

On reading this notice, the Zionists in the colonies and in the cities began to fear for their lives. There were stories circulating about those suspected of treason enduring torture and beatings. The Turks were not kind to those they considered traitors. People who had been arrested told horrific tales of the *bustadoes*, in which the Ottoman soldiers whipped their bare feet with canes until they were bleeding and the victim could no longer stand or walk. And Djemal and Baha-ad-din had become notorious for their erratic behavior and decision-making. Fear was now palpable on the streets as people struggled under the rule of the two tyrants.

All through January, Rae witnessed preparations for war. Camel trains made their way through the outskirts of the city carrying provisions for battle in the desert. She saw, in the distance, pyramids of Standard Oil tins that were stacked in open fields to be used for

carrying water for thousands of troops as they made their way through the arid Sinai.

Almost daily, lines of soldiers, led by fez-wearing Turkish officers and helmet-wearing German officers, made their way through the streets accompanied by military bands. They wound their way out of the city to the nearby encampments and training grounds. The soldiers, wearing white *kaffiyehs* held in place by black bands, held their rifles upright against their sides. They wore black boots coming just below their knees with their trousers tucked into the boots. Their long-sleeved white jackets were covered with the kit bags and canteens they wore slung over their shoulders. The mustachioed men all had intensely serious looks in their eyes. Some had a sense of panic about them, reflecting the urgent uncertainty about what could happen to them in battle.

Following the line of riflemen came groups of Christian and Jewish conscripts. These soldiers were not trusted to bear arms, their loyalty to the Ottoman Empire being in question. Instead, they were relegated to carrying heavy bundles on their backs as beasts of burden. One day, as the soldiers paraded past the governor, this group of transport soldiers decided to show him what they thought of their humiliating role as pack animals and began braying like donkeys.[295]

Many onlookers took pity on the soldiers and handed them cups of water as they marched past. Occasionally, an officer would ride by, cracking a whip to keep the soldiers moving quickly.[296] Then, all at once, they were gone, the city deserted. They were on their way to Beersheva and from there to launch their attack on the Suez Canal.

While the soldiers were gone, Rae tried to put her entire focus on her patients. It was hard to walk through the streets and see the number of lost souls, bellies bloated from starvation, wandering about searching for relief. Without enough food, both children and adults were now beginning to die. It was ironic, she thought, how she and Rose had been shocked when they reached Jerusalem at the horrendous living accommodations and health of the citizens of the city. Now she wished they could go back to that time – so much better than what she was facing now. She wrote:

February 2, 1915
Now what can I tell you about conditions in general? It is beyond description. I have seen pictures of the Goluth [Jewish Diaspora], and have heard people talk about it but have never lived through it. I am not personally affected, but never in my life will I forget

these last few weeks. I wish I were a better writer. You should see the people in the streets. They are perfect studies of pain, misery and starvation. I never saw such faces.[297]

The quiet in the streets of Jerusalem didn't last long. Only a couple of weeks after they left, following a humiliating defeat at Suez, the soldiers started streaming back into the city.[298] Djemal's attack, while taking the British by surprise, was easily repelled – crossing the Suez Canal had proved too much for the soldiers.

When the soldiers returned, a new economy quickly grew: prostitution. With so many men forced into the army or sent into exile, the city was filled with wives and daughters left alone to support their families. Apart from a couple of hundred women lucky enough to be hired by a lace-making factory belonging to the Christian American Colony, there was no work to be had in the city. Rae was horrified to learn that there were women who were even giving their babies away so they wouldn't have to feed them. Families were desperate and there was not enough sustenance for everyone at the Soup Kitchens. So, many women had no other choice than to turn to prostitution.

With all the soldiers in the city, there was plenty of demand for the prostitutes' services. The Turks set up a military hospital and then employed many women 'to relieve men for the front'. They reportedly treated the women in a way which was 'vile beyond description.'[299]

The German authorities set up a special house for their officers and motor truck drivers and they paid high prices to those who agreed to work as prostitutes.[300] Rae often passed these tragic, hapless women in the streets. Her heart was broken when she saw them. They averted their heads and refused to meet her eyes and she often cried at night thinking about how she was unable to provide relief for them. She didn't have the nerve to approach these miserable women and they were too ashamed to ask her for help.[301]

Many of the Soup Kitchens had run out of food and were forced to close. But the Straus Soup Kitchen was able to remain open. 'What a blessing it is',[302] Rae wrote. The superintendent of the kitchen, Rabbi Roth, wrote to the Strauses, 'It is a pathetic sight which meets my eyes when I watch the seven hundred famished, miserably unhappy men and women, who come to the Soup Kitchen for their only daily meal.'[303]

One morning, as Rae took her usual route through the Old City, she could hear in the distance some yelling and shrieking. As she rounded

the corner, she could see the gates of the Straus Soup Kitchen. A crowd had amassed around the walls of the garden and piled into the courtyard. As she drew nearer, she saw that people were scuffling and pushing each other. Women were screaming and pulling each other's hair as they vied for a place in line. Food cards, which were distributed by the Soup Kitchen, were held tightly in people's fists, as those without cards attempted to tear them from the lucky individuals who had one. Some women had even fainted and were lying on the ground unheeded as people stepped over them on the chance they could obtain a meal.

Rae stood in shock as she took in what was happening. She then hurried in through the gates, pushed her way through the suffering mass of humanity and helped the staff of the kitchen attempt to restore order. Rae wrote to Hadassah, '... I never witnessed a more pitiful sight. You can imagine the number of applicants – such screaming and pushing – women fainting, etc. It was simply awful.'[304]

The work in the schools became painful as each day she witnessed the children wasting away in front of her eyes. Yet despite their predicament, the children continued to act like children, still bringing joy to Rae.

> I was watching some children of the Sepharad Talmud Torah eat their mid-day meal yesterday. Some had a piece of bread and the green leaves and stalks which come off a head of cauliflower. I have often wondered how these children can be happy –for they really seem to be. They are very amusing – perfect little devils. I have a right jolly time with them once in awhile.[305]

A week later, as the crisis intensified, Rae's attempts at optimism completely failed. She wrote about the boys at one religious school:

> February 17, 1915
> It is all I can do to treat the Sepharad Talmud Torah. The children seem to be getting smaller and thinner every day. They are developing idiotic expressions on their faces and are such pitiful sights.[306]

Years later, Rae wrote about this time, 'I had that helpless feeling – What was the use of healing the eyes of the poor children when they needed food more than anything?'[307]

Americans were learning about the misery in Jerusalem by reading about it in the newspapers. The *New York Times* reported, 'The distress

among the 5,000 Jews and 12,000 Christians left in Jerusalem is acute, the American relief supplies being insufficient to maintain life.'[308]

To make things more dismal, there was now no oil or candles to light the homes at night and so people spent their evenings sitting in the dark. Rae's nights at home were now gloomy as well as she ate her dinner in the dim light of the setting sun and prepared for bed in the dark. She lay in her room lit only by the light of the moon, waiting for sleep and whatever the next day would bring.

Rae was thrilled to receive a cable informing her Rose had arrived safely in New York on 15 February and she rejoiced at the news that her friends and family in Cleveland had raised $300 for the emergency fund for Palestine.[309]

Knowing first-hand about the devastating crisis in Jerusalem and in the colonies, some deportees who were now in Alexandria sent a telegram to President Woodrow Wilson letting him know about the hardships they and the other Jews faced under Djemal Pasha. They asked President Wilson for protection against the Ottoman government. Soon after, Captain Decker received a message from Washington instructing him to investigate the situation during his next trip to Jaffa to better understand what was happening there.

When he next reached Jaffa, Captain Decker extended an invitation to Arthur Ruppin and Otis Glazebrook to meet with him on board the ship to report on what was happening.[310] Coincidentally, Alexander Aaronsohn, the brother of Aaron Aaronsohn, who had been compelled to join the Ottoman army, arrived in Jerusalem and snuck off to meet with Consul Glazebrook to tell him about the hardships of the Jews in the army. He told him about how Christians and Jews were not trusted to be loyal citizens of the Ottoman Empire and so were relegated to hard labor battalions, building roads and being used as beasts of burden, carrying supplies on their backs. He also told the consul about the state of the army, the low morale of the Arabs and other information about what was happening around the country.

When Glazebrook heard this important intelligence, he encouraged Aaronsohn to travel with him to Jaffa to meet with Captain Decker and give him the information directly.

Once in Jaffa, the Turkish officials gave Aaronsohn a hard time and it took a couple days of negotiation before he was permitted to get into the skiff to be rowed out to the massive warship. Once aboard, Glazebrook and Aaronsohn explained to Captain Decker what was happening around the country. Aaronsohn was asked to dictate his story for a stenographer. He later wrote, 'What became of my report I

do not know, – whether it was transmitted to the Department of State or whether Captain Decker communicated with Ambassador Morgenthau...'[311]

For his part, Ruppin implored Decker to petition President Wilson to intervene with Constantinople to stop the persecution of the Jews and Zionists in Palestine. Decker promised to send the message to Washington. This he did.

On 18 February, a cable was sent from the Secretary of State, William Jennings Bryan, to Ambassador Morgenthau:

> Decker telegraphed Department that sentiment of people in Syria and Palestine is very strong against Jews and danger at any moment of outbreak that may destroy life and property. You are instructed to attempt to secure from Turkish Government orders to civil and military officials throughout Palestine and Syria that they will be held responsible for lives and property of Jews and Christians in case of massacre or looting. Bryan[312]

Morgenthau conveyed the message to the central Ottoman government and petitioned to have Djemal and Baha-ad-din Bey removed. There was a short investigation and soon the Ministry of Interior prohibited further expulsions of Jews from Palestine and commanded the immediate cessation of house searches.[313] Alexander Aaronsohn didn't know exactly what had happened behind the scenes but he wrote, '... at all events we soon began to see certain reforms inaugurated in parts of the country, and these reforms could have been effected only through pressure from Constantinople. The presence of the two American cruisers in the Mediterranean waters has without any doubt been instrumental in the saving of many lives.'[314]

The citizens of Tel Aviv were astonished when, on 2 March, Djemal Pasha unexpectedly arrived in the town. He gathered the waiting crowd closer and made a grand speech extolling the friendship and goodwill he had towards the Jews. He passed out leaflets which promised that, if anyone bothered the Jews, that person would be severely punished. The Jews were astounded at this about-face. They asked themselves in hushed voices what had happened to cause Djemal to take on this new attitude.

A series of similar proclamations were made over the following few days. The Turkish government in Constantinople emphasized its tolerance of all religions in the Empire and blamed the recent actions against the Jews and how they were treated, including the expulsions

of thousands, as the work of 'local officials' acting without the consent of the central government. They announced, 'The Turkish Government has now taken severe measures, and has recalled the official who is chiefly to blame for the unrest among the Jewish population.'[315] Both the Arabs and Jews knew exactly who this 'local official' was and everyone was elated to see Baha-ad-din leave the country.

The government also decreed that Jews could be exempt from military service and offered them reduced taxes if they became Ottoman citizens. They also promised to organize a new police force, like *Hashomer*, but with both Jews and Arabs serving together.[316]

While all this political activity was swirling around her, Rae continued to find additional things to do to occupy her time and keep her mind on her mission. She couldn't bring food to the city, which was what people really needed, but she could provide other services that might be helpful. One initiative she was particularly proud of was the formation of a new home nursing and hygiene class in the Evelina de Rothschild School. The class met each Thursday morning and, although she was only able to recruit seven teenage girls, she wrote cheerfully, 'small classes are always better'.[317]

She taught the girls how to make beds with and without patients in them and how to lift patients who couldn't move themselves. She demonstrated how to give a sponge bath by bathing one of the girls. The students must have felt very professional when they were taught how to wrap bandages around various parts of the body and learned to use linseed poultices, mustard pastes and foot baths. In her next letter to New York, Rae wrote,'I find these classes very interesting... The girls are very clever and enjoy the classes very much.'[318]

Rae found a great deal of comfort in her friendship with her two favorite school headmistresses, Annie Landau and Vera Pinczower. The women found camaraderie in facing hardship together and found peace in each other's company. They had been good friends before but hardship drew them even closer together. Miss Pinczower asked Rae to teach the health and hygiene class in her school also but, Rae wrote in her self-deprecating manner, '... she does not approve of my Hebrew, it seems, not even of my French and German'.[319]

One day, Rae sat outside in the courtyard of the settlement house in the early afternoon, enjoying some much needed quiet time. She looked around her garden. The lemon tree was in full bloom and the flowers she had planted added brilliant color and beauty to the white and yellow stone and dirt-colored landscape. She breathed deeply to capture the fragrant scent of the plants. She listened to the echoing

voices of the mourning doves in the trees surrounding the courtyard. She loved this time of day. Her garden was so peaceful and calm, and resting like this was rejuvenating, strengthening her to face whatever might happen in the latter part of the day.

As she daydreamed, she heard a voice at the gate. She looked up and saw a young woman standing there, calling her name. Rae beckoned her into the courtyard and welcomed her. She looked a little familiar but Rae did not know her. The woman introduced herself as Therese Dreyfus, formerly a teacher in Petach Tikvah. That was why she looked familiar, Rae thought. She must have spoken to her during her visit there the previous summer.

Miss Dreyfus explained to Rae that when the war had broken out, she had been so distressed at what was happening in the colonies that she left the country and went back to her home in Switzerland. While there, she collected money from her community and, when she felt she had enough, she returned to Palestine. She had just returned about a week ago. Upon arriving back in the colonies, she discovered the colonists had started to grow vegetables to sustain themselves and could do without the extra funds. She was advised to take her money to Jerusalem where the people so desperately needed it.

When Therese arrived in Jerusalem and saw the agony in the eyes of the starving children and the inability of the existing soup kitchens to take care of all the famished people, she knew she was in the right place. She decided she would set up some additional soup kitchens around the city in order to feed as many children as possible. She estimated she had enough funds to feed one meal to a thousand children a day. Rae grew more and more excited as she continued to listen to Therese's story. If she could feed the children, then the work Rae was doing in the schools would be so much more effective. The effectiveness of the trachoma treatments had been diminishing due to the decline in the health of the students as a consequence of lack of nutrition. The thought of salvation coming to the starving children who broke her heart every day was exhilarating. Some schools were able to feed the children one meal a day and, with the new soup kitchens, Rae estimated that all the children in Jerusalem would get food.

Rae was delighted when Miss Dreyfus asked if she could come to live in the settlement house while she set up the kitchens and Rae enthusiastically agreed. She pictured the two women sitting together laughing and talking each evening. Imagining a respite from the loneliness of the empty house was glorious. The women spent some time making arrangements. Therese was staying elsewhere initially but

she would move in with Rae right after Passover, only a couple of weeks later. The two women hugged and Therese departed.

More good news came a few days later when Rae learned from Otis Glazebrook that a US Navy coal ship filled with money, food and other provisions supplied by the American Jews and the American Jewish War Relief Committee was leaving Philadelphia and steaming towards Palestine.[320]

Rae continued to rely on the American Consulate to give her the allotted 400 dollars a month as the Anglo-Palestine Bank was still closed and there were rumors it would remain closed until the end of the war. She wrote:

March 4, 1915
… I think there will be enough money for this and next month. I was told at the Consulate that more money was coming… We have heard about the ship sailing from America today with supplies for us. What would we have done without America?[321]

Over the previous couple of weeks, while Rae treated the children in the schools, she had been noticing the towels she used to administer the trachoma treatment seemed less bright than usual. After several days had passed and the towels didn't seem to be getting any cleaner, she investigated what was happening. She talked to the headmistresses and then the servants who were charged with towel washing. She discovered that, because the cost of coal and petroleum was so high, the servants had been skimping on the cleaning. Rae explained to them the importance of clean towels but it was for naught; they simply could not afford to boil the towels properly. Rae did a quick calculation of her funds and decided she would help out in this area. If the towels weren't properly cleaned and boiled then all her work would come to nothing. With her allocation of funds to purchase additional coal and petroleum, the servants resumed their thorough cleaning.

The midwives came to the settlement house each day with reports about their patients. Stories about difficult labors that ended in the deaths of newborns and mothers increased weekly. Without proper nutrition, many women were not able to successfully deliver their babies. For those infants who survived, they often died within days or weeks of birth as the mothers were unable to nurse them properly. Rae wrote, 'The maternity cases have lately been very hard ones and the midwives are certainly earning their salaries… I am wondering whether this war will ever end. Conditions here could not be much worse.'[322]

And yet, Rae continued to find pleasure in some of her daily activities. She kept an optimistic tone in her letters, filling them with words of hope and joy. She wanted to let Hadassah know that she was still determined to stay in Jerusalem. Realizing that the leaders would be receiving a great deal of news about the difficult ordeal they were facing, she was committed to doing everything she could to allow her to remain. She filled her letters with the banalities of everyday life:

> I would be so pleased if you would write more often. The mails are good, and letters are sure to reach me. These last few days I am having a little girl to help me clean the Settlement for Passover... I have had my troubles along with the cleaning this week. The water pump was out of order, and it took four days before I could get someone to repair it. Ezra, who always did the work for us left the country. It is very hard to get laborers now. The day after the pump was fixed, the boy who pumps the water pumped so hard that he broke the handle. I suppose it will take a week to get that repaired. Now haven't I the troubles of a large family?

She also wrote,'The place looks nice and fresh, and I wish you could see my plants... It is my greatest comfort now to come home. The Settlement is so bright and airy – full of sunshine – and it is such a quiet and peaceful place...'[323]

Despite her cheerful words, however, and her unflagging optimism, once again, circumstances changed for the worse.

Chapter Twelve

The Plague

There was a strange hum in the air. It didn't come from anywhere in particular but just filled the quiet spaces of midday Jerusalem. The hum gradually grew into a louder buzz. Rae, walking along the narrow cobbled streets on her way home for lunch, looked up and around but didn't see anything. People on the street were also stopping and looking around. Suddenly someone shouted and pointed up. Soon many fingers were pointing and voices were raised in surprise. Rae tilted her head up, shading her eyes with her hands to protect them from the midday sun. She couldn't understand what she was seeing. Something black and big, like a gigantic storm cloud, was moving overhead, zooming in closer with rapid speed, covering the blue, cloudless sky at a dizzying pace. The buzz grew louder and louder and crowds of people gathered to watch in astonishment.

All of a sudden, the cloud started raining down on the crowd, but, instead of wet drops, this rain was locusts. Hundreds and thousands of inch-long insects plopped onto the thunderstruck on-lookers, clinging to their clothes and their skin. As if in slow motion, as they realized what was happening, people began screaming and running in all directions, hurrying into the nearest buildings and homes or seeking shelter under the ubiquitous balconies to protect themselves from the swarms of hailing insects.

Rae pushed her way in along with the crowds of people huddling under a balcony watching in wonder as the storm of locusts continued to sweep along the street. After a few minutes, Rae decided she was close enough to get home and rushed to the safety of the settlement house. When she opened the door, however, she saw that she was not safe from the locusts even inside. She had left the windows open for

some fresh air and locusts were now pouring in through the openings, crawling and hopping on their long back legs.

Rae rushed through the rooms, slamming the windows shut, crushing the jumping, bug-eyed grasshoppers with her shoes as she ran. When all the windows were closed, she stopped to take a breath. Suddenly, she noticed locusts slithering their way in through tiny gaps between the frames and the windows. She ran to the cupboard and grabbed a handful of towels, cramming them around the window and door frames, trying to block all entryways against the creeping creatures.

Now she was sweating. Shaking her skirt and hat free of locusts that clung to them, she began stomping on the insects as they fell all around her. Soon her floors were stained with brown, crushed shells. She grabbed a broom and dustpan and dashed around the house, sweeping and scraping the locust carcasses off the stone floors and shaking them from the rugs.

For two hours that day, from noon until two o'clock, gigantic swarms of locusts flew overhead, darkening the sky with a cloud so huge it made the sun disappear, heading south towards the Dead Sea. In the wake of the swarm, millions came to land in the city and all across the country.

Rae stayed indoors the rest of the day, not knowing quite what to do at this unexpected turn of events. That night she had a hard time sleeping. She could hear the locusts outside the window. They had landed on her lemon tree and on the bushes and flowers in her garden she so cherished. She could hear them chomping and gnawing on the plants and the sound was unbearable. She shuddered at the thought of what was happening to the much-needed crops that were now growing in the fields of the colonies.

The next day she opened the door a crack and looked outside. The cloud was long gone but the locusts had come to stay. She could see thousands covering her precious lemon tree, clinging in swarms to all the branches. Tears came to her eyes as she realized they were going to kill the tree along with all the vegetation that had brought her such joy and peace of mind. She quickly pulled the door towards her, stepped into the garden and slammed it behind her. She decided that, while she was uncomfortable and squeamish, there was much work to be done. She walked through the gate and into the deserted street.

Her first stop was to visit the American Consulate and Otis Glazebrook. As she walked to the consulate, she crushed locusts with every step. Again, they swarmed onto her skirts and she had to brush

them off her arms and face continuously. The streets were oddly empty and quiet, save for the humming drone of the insects.

Before she entered the consulate, Rae shook her clothes to try to get all the locusts off. Then she quickly opened the door and rushed inside. Despite her best efforts, the insects flew in with her. It was no use. There was no getting away from these vile pests.

Mr Glazebrook told her that word had come to him that, as she suspected, the locusts had entirely destroyed the crops in the colonies overnight. Aaron Aaronsohn had been summoned to Jerusalem by Djemal Pasha to see if he could recommend some ways to rid the country of this terrible plague. The government was going to ask him to lead the effort to combat the damage the locusts were wreaking.

Taking a deep breath before she opened the door again and steeling herself for the imminent attack, Rae left the consulate and went to visit some of her patients. It was even worse than she had imagined. The homes she visited were filled with locusts, clinging to the walls and hopping across the floors. The poorest families, many of whom were starving, lacked the wherewithal to blockade their doors against the onslaught. She found the insects in the beds and among the sheets. The sick patients didn't have the strength to swipe them away and so they were resting on their bodies, chewing on their clothing and even their skin. Rae did the best she could to instruct the families to push rags into the cracks and gaps to prevent most of the locusts from streaming in. She returned home after an exhausting day.

That evening, Rae wrote to New York:

March 23, 1915
I suppose you have heard about the locusts and the damage they have done. I have been told that everything is ruined in the colonies – all the crops destroyed. The locusts visited us yesterday. They came in swarms, millions upon millions of them from noon until two o'clock. They went towards the Southeast, to the Dead Sea, I hope. It was a wonderful sight, if it were only not so terrible. It seemed as though the sky was black.[324]

For the next couple days, Rae tried to stay indoors as much as she could. She later wrote, 'We used to lie awake at night listening to the gnawing of the locusts who stripped the bark from the trees and turned the fields into blasted heaths.'[325]

When she did go out, she visited Mr Levy or Mr Glazebrook in order to learn what was happening in the rest of the country. On 26

March she reported, 'I saw Mr Aaronsohn a few days ago at the Consulate. He is on the Committee for fighting the locusts... I heard today that the damage done by the locusts is not so great as was feared.'[326]

In the days that followed, the citizens of Palestine were roused from their indolent slumber and apathy brought on by starvation and commanded to take part in this new war, the war against the locusts. Schools were closed and thousands of children were enlisted to go to the colonies to assist in the eradication of the pests. They were instructed to take sticks and dislodge the locusts from the branches and vines. Men were ordered to dig pits and canals into which locusts were driven and buried or burned. Exhausted people woke up each morning to dig up clumps of dirt that contained the locusts' newly laid eggs.

The Jews in the colonies were horrified to see that, just when they thought they were making progress, new clouds of locusts from neighboring Arab villages swarmed in. The Arabs' believed that this was God's will and that they just needed to accept it; they had made no effort to combat the invasion. The Turks again ordered all people, including the Arabs, to work together to destroy the locusts, but minimal effort was made in the Arab villages and farms.

Once the locusts laid their eggs, they disappeared. A new fear loomed, however, about what would happen once those eggs had hatched and new locusts emerged. To combat that threat, on 17 April, the government gave new orders that every person, man, woman and child between the ages of fifteen and sixty had to collect twenty kilograms of locust eggs or pay a heavy fine.[327] Once again, people were on the streets and in the nearby fields, digging up and collecting the eggs to be weighed. They were poured into deep pits where they were burned. Many years later, reflecting on this horrible time, Rae said, 'I thought I could stand most anything – the war seemed nothing to me in comparison with the Locust Army. They left a real famine in the country and the misery from starvation was acute.'[328]

* * * * * * * *

Even with the locust invasion, the war continued to rage on around them, yet Jerusalem did not feel any direct impact of battle and gunfire. On 26 March, while docked in Alexandria, the USS *Tennessee* reported seeing about ninety British and French warships and transports loading

100,000 troops and provisions for the battles in the Dardanelles at Gallipoli. The troops included soldiers from New Zealand, Australia, India and other British and French colonies. Captain Decker reported seeing thousands of injured and maimed soldiers returning from battle on hospital ships.

Word was received in Jerusalem that British ships had begun to bombard the coast of Palestine at Haifa and Gaza, terrifying the Turks, who feared an imminent invasion. It was rumored that when Djemal Pasha had returned from his failed Suez campaign, as he passed through Gaza, the British planes had flown over and strafed his camp. He cursed the traitors who had informed the enemy when he would be passing through.[329]

As the locust invasion died down, the weather became the newest discomfort. It was especially rainy and cold that miserable spring and Rae often came home from the schools completely drenched and shivering. She was grateful for her rubber tub, in which she sat quite often, after filling it with heated water, to warm her chilled body.

Over the next few weeks, as Rae made her way through the streets, she saw Turkish and German officers crowded in the taverns and places that were known to be brothels. She was horrified to learn, on 30 March, that two Arab soldiers charged with treason had been hanged at Jaffa Gate.[330]

One day, she was surprised to see small groups of old Jewish and Christian Arab men with brooms in their hands, sweeping the streets. She learned that these men, too old for regular conscription, were part of a new battalion of street cleaners, compelled by the military to gather each day and spend their days ridding the streets of the remaining locust carcasses and the usual waste that littered the city. These elderly citizens, who lacked proper nutrition and were battered from their hardscrabble lives, often stopped to rest and wipe their brows. Their commanders, riding on horseback up and down the street, would shout at them, waving their whips and sticks, demanding that they get back to work.[331]It was a difficult scene to witness and Rae felt helpless in the knowledge that there was nothing she could do for these poor men.

Dr Wallach, the head of Sha'are Zedek hospital, whom Rae knew very well, attempted to help these latest targets of the Turkish military. He appealed to Djemal to provide the Jewish members of the new battalion with kosher food, and he and Annie Landau set up a kosher kitchen in the new war hospital for the Jewish soldiers.[332]

Cholera and typhus were spreading rapidly through the city now and, again, there was nothing Rae could do to prevent it. The unsanitary streets, with sewage running through them, the lack of clean water and the prevalence of lice were contributing to the increase of cases of these diseases. When she visited sick patients, all Rae could do, without being under the supervision of a doctor, was to bathe them, offer the family a little food and refer the patient to the hospital. But even the hospitals were ill-equipped to handle the number of people falling prey to disease. So many physicians had left the country, there were not enough to take care of all the sick patients. As a result, many people were dying of these illnesses. The city was now a very different place than the one Rae knew. It was emptied of thousands of people, there were soldiers marching in the streets at all hours and now people were dying in large numbers from disease and starvation.

Rae was thrilled when Therese Dreyfus moved in. Therese spent her days working hard to establish her soup kitchens in three of the city's poorest neighborhoods. The two women spent their evenings discussing their work and the situation they were facing. Rae relished having someone to keep her company and to talk with at the end of each day.

In just a few weeks, Miss Dreyfus had set up the kitchens to her satisfaction, hired her staff and begun to serve soup and bread to hundreds of children a day. As the word got out about these new relief kitchens, the number of children she served soared to a thousand every day.

Miss Dreyfus appointed a superintendent to run the kitchens and created a supervising board of women who would oversee the distribution of the soup and even taste it each day. One of those women was Mrs Glazebrook, who added a great sense of legitimacy and authority to the kitchens since her husband was so well known. Miss Dreyfus urged Mrs Glazebrook to serve because of her reputation for compassion. Consul Glazebrook wrote to the Jewish community in America, 'I wish [you] could attend one of these distributions. It is indeed pathetic... Of course it is heartrending to see cups held up by little hands, but Mrs Glazebrook does not permit any to go away empty if she can possibly fill them in some other way.'[333]

It became clear that even with the amount of funding Therese had brought with her from Switzerland, it was insufficient to meet the needs of the starving children. Nissim Behar, the headmaster of the Alliance School, wrote a desperate letter to America: 'Our poor orphans are simply starving. All our resources are exhausted and our

income...is cut off... If our American brethren are deaf to our appeals, to whom can we apply for help? Have pity on our innocent orphans and send us relief.'[334]

In fact, the price of food was now exorbitant. The confiscation of wheat by the Turks had created a massive shortage. Flour rose to $15 a sack and the cost of potatoes was six times its ordinary price. It was impossible to get sugar, which was a staple for the sweet-tea-drinking people of Palestine. And oil and petroleum were in such short supply that people often had no way to heat their food.[335]

Faced with this never-ending sense of hopelessness, Therese confided to Rae that soon she was going to leave the country again to go to Europe and the United States to seek additional funding. In the meantime, while Therese was busy establishing the kitchens and preparing to leave, Rae enjoyed her company for the weeks she had remaining in the city.

Chapter Thirteen

The *Vulcan*

A row of Turkish soldiers lined the shore at Jaffa, rifles at the ready, looking out to sea, where a large American ship was anchored. It had been there for a few days now, refusing to unload its cargo without assurances from the Turkish government that it would be transported safely to its intended recipients. Djemal Pasha had refused, ordering 50 percent of the goods on board to be requisitioned by his army. There was now a stand-off, as the captain of the ship threatened to leave the port if Djemal insisted on this. There both sides waited, in deadlock.

A carriage pulled up at the customs house and Consul Glazebrook emerged, holding some papers in his hand. He approached the soldiers and addressed the officer. He explained to them that this cargo was under the protection of the United States government and if it were not permitted to be delivered in full to the needy populations, the nearby *Tennessee* would begin shooting at Jaffa. He then handed the officer a letter from Djemal Pasha.

The ship was called the US *Vulcan*, a collier ship, carrying coal to fuel the USS *North Carolina* and *Tennessee*. But it was also carrying a very special cargo from the Jews in America, of which the Turks were now aware and which they wanted for themselves. Ever since the *Vulcan* had arrived a few days earlier and it had become clear that the Turks were determined to take half the cargo, a flurry of telegrams had gone back and forth between Glazebrook, Morgenthau and the US Secretary of State.

All that previous winter, the American Jewish Relief Committee had been trying to secure a ship to send much-needed provisions to Palestine but had been unsuccessful in finding one fit for the journey. The *Vulcan*, in the meantime, had been scheduled to travel to the Mediterranean in early March to resupply the warships in that area

with coal. The relief committee turned to the US government for help transporting its goods and the government immediately offered room on the *Vulcan*. Space had been made for 900 tons of food and other supplies to be brought on board and shipped to Palestine. Appeals had been made to the Jewish communities throughout the US and, in just over a month, enough money had been raised to purchase flour, sugar, rice, matches and candles. In addition, $100,000 in gold was packed into sealed casks.[336]

There had been a great deal of discussion about whether *matzah* for Passover should be included with the rest of the shipment, knowing that the holiday was just around the corner. Two *matzah* companies, Manichewitz and Streit's, had donated boxes upon boxes of the Passover staple for the starving Jews. After hours of debate, and additional word from the US Navy, it was decided that the *matzah* had to be left behind. It took up a great deal of space that could be better used for food that would keep people alive; additionally, it was feared that the *matzah* would be crushed and grow soggy and rot in the humid, hot Mediterranean climate. Instead, it was decided that the *matzah* would be donated to the poor Jews in America. The newspapers reported this story, adding, 'We feel it necessary to make this statement in order to explain to the generous donors of the Matzoth why the Matzoth were left behind.'[337]

The *Vulcan* left the US on 13 March with two members of the American Jewish Relief Committee onboard: Louis Levin, Secretary of the National Conference of Jewish Charities from Baltimore, a social worker who happened to be the brother-in-law of Henrietta Szold, and Samuel Lewin-Epstein, a Jewish leader and dentist from New York. They traveled across very stormy seas and finally arrived in Alexandria on 9 April. They had intended to purchase additional food there but hadn't anticipated the frantic days of running from official to official, even traveling all the way to Cairo, to secure permission from the Egyptian and British authorities to transport the food on the *Vulcan* into Britain's enemy territory. They then had to wait additional days to purchase and load the rice, sugar, matches and candles onto the ship.[338]

After eight interminable days, the *Vulcan* finally proceeded to Beirut, arriving on 19 April.[339] While they were in Beirut, they learned that loads of flour which had been en route to the ship had been hijacked by a group of desperate women, who confiscated the flour and brought the sacks back to their own starving families and villages.

Upon hearing the story, Louis Levin sent a letter back to the United States relating how he had left one hundred dollars in gold in Beirut as

it was clearly needed. He encouraged America to raise additional funds for the area.[340] After the *Vulcan* had unloaded its coal in Beirut, it steamed on to Jaffa, arriving around 21 April. And there the ship sat, at an impasse, waiting for permission to unload the tons of cargo.

While negotiations were underway, Levin and Lewin-Epstein disembarked and made plans to tour around Jaffa and Tel Aviv. However, before they could even begin their sightseeing, Turkish officials approached them and informed them they would be detained in the city to ensure no subversive activity would take place. Djemal was convinced that the two gentlemen were spies. Since they had arrived with provisions from Egypt, an enemy country, intended for the Jews, Djemal was very suspicious of them.

Glazebrook matter-of-factly added securing the Americans' freedom to the list of his entreaties and protests he was making through Morgenthau to convey to the central government. Until Djemal was persuaded to change his mind, the two Americans were followed by Ottoman officials as they explored Jaffa and Tel Aviv.[341]

Finally, after many telegrams sent across the ocean, Glazebrook was informed that, indeed, the US Navy would protect the precious cargo and, yes, the two American emissaries could leave Jaffa. With that good news, Glazebrook strode into Djemal Pasha's office and demanded assurances that the ship would be unloaded safely. Upon hearing that the US Navy was standing firm and would fire upon Jaffa if he continued to demand part of the cargo, Djemal ordered his officials to stand down. Not only did he allow the ship to proceed with its mission but he also graciously permitted the goods to be brought in tariff-free.[342] This was a big victory for the people of Palestine.

The logistics of unloading nine hundred tons of provisions off the ship was complicated. It took several days to lower the many boxes and crates onto the small boats that plied the waters between ship and shore and row them to the docks. Once ashore, the delivery of the goods to Jerusalem proved to be another challenge. The train had long since stopped taking civilian passengers and goods from Jaffa to Jerusalem, given the control of the rails by the Ottoman military. Fortunately, Glazebrook was able to get special permission to have limited space on one of the trains for some of the provisions. The bulk of the goods, however, had to be carried by donkey and camel. And even that was a challenge. There was a shortage of these animals, since the military had requisitioned almost all beasts of burden for battle.

Arthur Ruppin later wrote in his report to the American Joint Distribution Committee, 'In transporting the victuals from Jaffa to

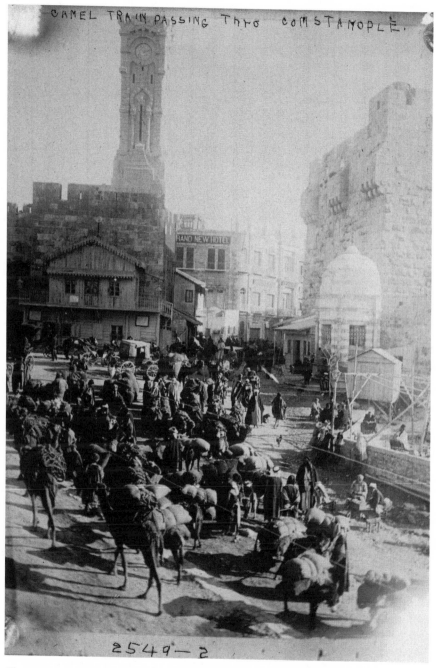

Chapter 29, p. 239: Camel train in Jerusalem near Jaffa Gate. Incorrect data provided by the Bain News Service on the negative: 'Camel train passing thru Constantinople'. Library of Congress, Prints & Photographs Division, [LC-B2- 2549-2].

Jerusalem we met with great difficulties... As there were not a sufficient number of camels the entire transportation occupied about three months...'[343]

When Levin and Lewin-Epstein got word they were finally allowed to leave Jaffa, they immediately left for Jerusalem with Glazebrook to help organize the distribution of the aid.[344] It had been decided by the American Jewish Relief Committee that, although the money for the provisions had been raised solely by the Jewish community, with the biggest contributors being Nathan Straus and Jacob Schiff, they could not allow other communities to starve. They sent word with Levin and Lewin-Epstein that 55 percent of the supplies were designated for the Jews of Jaffa, Jerusalem and the colonies, and the balance should be divided between the Muslim and Christian communities of those cities with the Muslims getting 26 percent and the Christians 19 percent. Each religious community was to choose their own committee to oversee the distribution of their allotted goods.

In Jerusalem, there was a ruckus in the Jewish community as each special interest – Sephardic, Ashkenazic, religious, non-religious and every ethnic group – fought over who would be represented on the Jewish committee.

David Yellin, chairman of the Jerusalem relief committee since the USS *North Carolina* had brought its funds, had recently received a letter from Mr Ruppin asking him to form a new committee just for the *Vulcan* supplies. Yellin had been the director of the Laemmel schools until his resignation during the language wars and was currently the head of the newly created Hebrew Teachers Seminary. He was also a member of the city government and was greatly respected throughout the community. He worked hard to form a committee; however, despite his best efforts, he was unable to gain consensus about who would serve. To complicate matters, the Ashkenazic Orthodox group, HaKollelim, had received a letter from its own benefactors in New York, instructing them about who should be on the committee. Yellin and the other leaders disagreed with this directive and, thus, they were at a stalemate.

When Levin and Lewin-Epstein arrived in Jerusalem, there was still no committee ready to receive the aid. When Glazebrook heard the update from Yellin, he knew he needed to do something to take control. He wrote a stern letter to Yellin and the rest of the members of the committee: '...It is to be remembered that the spirit and purpose of this benefaction are unlike those of the *Halukah* – that this is an emergency fund to meet the immediate needs of a present distressed

condition – that it is to be administered independent of creed, race or nationality...' He ended the letter with an ultimatum:

> The honorable Gentlemen appointed on the Jewish Committee of distribution are requested to meet at the Consulate, Thursday 4pm and it is hoped that nothing will prevent them from giving their cordial and prompt cooperation. If, however they have neither the time nor desire to serve on the Committee, it must be evident that their places should at once be filled, that there be no delay in delivering the food to the needy and starving people...
>
> Very respectfully yours, Otis A. Glazebrook[345]

The meeting took place at the consul's house on the designated day and time and almost everyone invited was in attendance. Louis Levin spoke about the unexpected letter from HaKollelim in New York, stating he knew nothing about it, it had no authority and he would proceed despite what the letter stated. He showed the group his letter of authorization from Louis Marshall and Dr Magnes, the leaders of the American Jewish Relief Committee, and said the matter was now closed.

Otis Glazebrook then appealed to the group's sense of humanity and brotherhood, saying, 'Are not all of us children of one Father?...this time a compromise is necessary...to alleviate the distress.'[346] The Kollelim representatives requested four days to consider this appeal, requesting that the group reconvene the following Monday, but they were quickly rebuffed. Instead, they were given ten minutes to consider what they wanted to do, after which time their decision would be made for them. Upon hearing this, the Kollelim representatives stood up, announced they would not serve on the committee under those circumstances and stormed out of the room. And so Levin appointed the committee based on those still present at the meeting and the group elected David Yellin as its chair.[347] They then quickly agreed on a plan for the distribution of the food and money from the *Vulcan*.

Soon after this drama, David Yellin heard that the Turkish government had found out about the $100,000 in gold that was brought on the *Vulcan*. The gold had been stored in his offices and he realized it was no longer safe there. One night, he walked across the street to his neighbor and friend, Helena Kagan, the doctor who was supervising Rae's maternity work.

Mr Yellin asked Dr Kagan if she would be willing to hide the gold at her house. They went into her yard and Yellin pointed out a little

palm tree that stood in the center of the garden. She agreed to help out and they dug up the tree and then dug a little deeper in order to bury the gold. Yellin then returned to the office and brought over bags and bags of gold. When she saw the amount of gold, Dr Kagan almost fainted. She knew that if the soldiers found it, she would be considered a traitor and would be hanged. Nevertheless, she kept her promise. They buried the gold and replaced the tree. After that, whenever the committee's supply of money grew low, they would come to Helena's garden to dig up some more.[348]

News of the American ship that brought food to save the Jews traveled quickly across the country. Muslims and Christians were impressed that the Jews had such powerful friends abroad. The food could not help everyone, though. Ruppin received a letter from the small Samaritan community in Nablus that was starving and begging for some of the provisions: '...why then should there be no pity on us to put aside a little of the good which you are doing with the inhabitants of Palestine. We are sure that with your sagacity you will know how to accept our petition.' It was signed by the leaders of that community. Ruppin responded to the entreaty that he had to follow the instructions that the Americans had laid out, which had not included provisions for Nablus nor for the Samaritan community.[349]

Rae was thrilled to host Louis Levin when he finally arrived in Jerusalem.[350] As the brother-in-law of Henrietta Szold, Rae felt a great kinship with him, as well as a great responsibility to paint a complete picture of what she was doing. She knew full well that Mr Levin would give an honest assessment of the Hadassah efforts in Jerusalem when he returned home. His report could mean the difference between her continuing her work or having to leave it abruptly. So she took extra care showing him around the settlement house and explaining what she was doing and the challenges she faced. She described the hardships that the lack of food and the locusts had brought and how they exacerbated the already appalling health conditions.

During lunch, Levin reassured Rae that her family and friends in Cleveland had not forgotten about her and had sent along cartons of food on the *Vulcan* just for her. She was overjoyed when she finally received the boxes and, with great anticipation, carefully opened each one. Inside, Rae discovered food and treats with familiar American labels and she pictured them originating in Cleveland and being carefully packed up by her loved ones' hands. The thought brought tears to Rae's eyes. She celebrated her vast treasure by inviting her

friends, the midwives and the probationers to share in the bounty. The women had a small feast, savoring the rare delicacies they hadn't seen in months and enjoying the sorely missed food.

She catalogued the relief items she received from the *Vulcan* for Hadassah: 'Sugar, rice, tea, barley, evaporated milk, absorbent cotton, sodium bicarbonate, acid, boric, quinine, sulphate, ether, chloroform'. And she wrote, 'Not all drugs have as yet come up from Jaffa; we expect more.' Rae continued, 'I wonder if you all realize how much good the *Vulcan* supplies have done.'[351] Many years later, Rae still recognized the importance of the aid brought by the *Vulcan*. 'It was a God-send', she recalled.[352]

During his stay in Jerusalem, in between organizing meetings for the distribution committee, Louis Levin made sure to stop by the settlement house to visit Rae several more times. He visited the schools with her and observed how she treated the children with trachoma. He also went into a few of the homes to see the plight of her patients. He was very impressed with the fortitude Rae exhibited and the ease with which she moved about the city, greeting people everywhere she went.

One day, Rae and the Tichos invited Levin to accompany them on a little outing to see more of the country; he accepted happily. They traveled a short distance by carriage to Bethlehem where, among other sites, they saw Rachel's Tomb. They enjoyed a picnic lunch and talked nonstop about the war and life in Jerusalem.

After a delightful day, the group returned to the city, where they were confronted by the sight of a large crowd in front of the American Consulate. People were pushing each other to get a place near the entrance, yelling at each other with short tempers caused by the excessive summer heat and hunger. Levin learned that this was a daily occurrence, in which the consulate opened its doors to distribute any money that had been received by the American Jewish Relief Committee. Each day, desperate people hoped that it would be their turn to receive a little money to buy their family some food. This chaotic scene made a deep impression on Louis and he realized the critical importance of the food from the *Vulcan*.[353]

When Louis returned home, he reported to Henrietta Szold that Rae was doing a wonderful job and 'extolled her work beyond measure'.[354] Rae's unflagging dedication to her mission, even in the worst of times, also impressed Otis Glazebrook. He wrote a letter to Eva Leon at around that time, saying, 'Miss Landy is one of the most useful people in Jerusalem. She is a splendid woman and is

accomplishing excellent work. I congratulate your society upon having such a representative.'[355]

But really, Rae couldn't imagine doing anything else. She was, of course, distraught over what was happening in Palestine, yet she felt invigorated every morning as she awoke and thought about what she would be doing that day. She had never been so challenged and so alive. She felt that her life had purpose and believed she was meant to be in Jerusalem doing this work. There was no place she would rather be and nothing else she would rather be doing.

Chapter Fourteen

Called Home

Rae received some disappointing news in the middle of May. Annie Landau had been summoned to Djemal Pasha's headquarters and given an ultimatum. His tolerance for having her, a British citizen and thus an enemy, living with impunity in the city had come to an end. Despite the reputation she had built with the Evelina de Rothschild School as an excellent educator and administrator, in addition to her efforts to alleviate hunger and hardship, she was now commanded to either become an Ottoman citizen or leave the country. Annie had no intention of disavowing her British citizenship and so, as heavy-hearted as she felt, she chose to leave.

Once again, Rae was forced to separate from a dear friend. She and Annie had become very close and often visited and shared meals together. Annie had been a role model for Rae, showing her by example what it was possible for a woman to achieve. She had forged a path of her own, not afraid of what others would think of her. She had the moral strength to stand up for what she believed in, coming to the aid of the old men who were compelled to sweep the streets and feeding the destitute people. In addition, of course, Annie had led the administration of a school that had such a wonderful reputation. By seeing all that Annie had done, Rae realized she did not have to despair when she felt pressure to follow what society thought she should do. She, too, could make her own way in life.

Despite Annie being uprooted from her life in Jerusalem, she was very resilient and was already making plans to start a school for refugees who were stuck in Alexandria. She quickly packed up her belongings and closed up the school building. Many students and friends came to see her off, wishing her the best. With her final waves, Annie boarded the waiting diligence and bounced quickly out of

Jerusalem to Jaffa. When she boarded the ship to Egypt, to her surprise, she found that Mr Levin and Mr Lewin-Epstein were also on board, finally leaving Jaffa after their long stay.[356]

As soon as Miss Landau was gone, the Turkish government took over the Evelina de Rothschild building for its own use.[357] When Ambassador Morgenthau was notified about this action, he lodged a protest with the central government, but was unsuccessful in restoring ownership to the school.[358]

Soon after Annie left, Therese Dreyfus decided it was time for her to leave also. She had set up a satisfactory administration and it appeared that the soup kitchens were running as smoothly as possible, given the daily onslaught of crowds that descended at their doors. She laid out her plans for Rae, describing how she would first brave the war in Europe to visit her friends, hoping they would be as giving as the first time, and then she would proceed to America, appealing to the generosity of the Jewish community. It had only been a few weeks since Therese had moved in with her but in that short amount of time Rae had grown used to having company again. The thought of facing an empty house each night made her feel more lonely than ever.

And then the locusts returned. Rae could not believe it. The farmers had planted new crops after the first invasion and they were just beginning to grow. All the trees that had been stripped bare by the previous swarms had started to bud and blossom, springing back to life. Now, once again, the locusts clung to the branches and the leaves, eating everything that grew, destroying the new crops and leaving a desolate landscape behind.

For a second time, the government called upon its citizens to play their part in killing the locusts.[359] Schools were closed and, as before, children were sent out to the countryside to help with the overwhelming job. People who did not take part in capturing and destroying the swarming plague of insects were, again, levied a fine.

While the people of Palestine watched hopelessly as the locusts devoured their seedlings and blossoms, there was fear of a widespread famine. Rae was distraught at their return. She wrote, 'We had them [locusts] at all stages –creeping, hopping and flying. It was difficult to walk in the street without being covered with them... Finally the locusts left for good and trees and shrubs began to bud and bloom again.'[360]

This second round of locusts stayed for less time. At the end of June, as soon as they grew wings, they flew away in giant black clouds. But the damage they left behind was acute. The vegetable fields were

obliterated and about a third of the corn crop was gone. The fruit trees, though badly battered, were not totally demolished; however, the crop for that year was greatly diminished. In Petach Tikvah, out of 6,000 *dunams* of oranges, only 1,700 remained.

Back in America, the awareness of the deprivation of the Jews in Palestine had been raised to unprecedented levels and money from Jewish communities across the country continued to pour into the offices of the American Jewish Relief Committee. Nathan Straus even decided to sell his yacht and donate the thousands of dollars in proceeds to the relief funds.[361] He felt incredibly guilty about enjoying this luxurious pleasure while people around the world were suffering so terribly in the war. The influx of donations enabled the committee to provide a steady flow of aid to Palestine.

All that spring and summer, Consul Glazebrook received the funds, passing them on to David Yellin and Arthur Ruppin with very specific instructions about how to expend them. Most of the money went towards the purchase of wheat and other staples that would relieve starvation. This aid sustained the people and prevented, at least for the moment, large-scale disaster and mass starvation. In other parts of the world where the war was raging, people were not as fortunate.

Two to three thousand Armenians lived in Palestine in 1914. Most of them lived in Jerusalem and were affiliated with the churches in the city. But in Turkey there were millions of Armenians and, from the beginning of the war, their loyalty to the Ottoman Empire was in question because they were Christian rather than Muslim. Early on, a few Armenians deserted from the Turkish army to fight on the side of the Russians. A couple of other Armenians were accused of spying for the Russians and, suddenly, all Armenians were seen to be enemies of the Turks. Entire Armenian towns and villages were forcefully evacuated and thousands of people, including women and children, were murdered. Those who survived began a long march away from the mass executions, in a frantic search for safety.

Henry Morgenthau quickly learned about these events and sent many telegrams to Secretary of State Bryan, alerting him to the horrific atrocities. Not only was he appalled at what was happening to the Armenians but he was afraid the persecution would spread to other minorities, including the Jews:

Constantinople April 27, 1915
Have received unfavorable reports about Armenians in interior provinces. Movement against Armenians forms part of concerted movement against all non-Turkish...elements and indications exist that it will be followed by action against Zionists.

The Secretary of State replied, 'Urge Turkish Government to protect both Armenian and Zionists. Bryan'[362]

The American Ambassador to France sent a telegram to Secretary Bryan on May 28 with a further warning:

> For about a month the Kurd and Turkish population of Armenia has been massacring Armenians with the connivance and often assistance of Ottoman authorities... Inhabitants of one hundred villages near Van were all murdered... In view of these new crimes of Turkey against humanity and civilization, the Allied governments announce publicly to the Sublime Porte [Turkish government] that they will hold personally responsible for these crimes all members of the Ottoman Government and those of their agents who are implicated in such massacres.[363]

As the United States was still neutral in the war, Secretary Bryan was averse to antagonizing the Turks, lest they get dragged into the conflagration and so no action was taken. Morgenthau, however, was not giving up. On 18 June, as Secretary Bryan had just resigned, he wrote to the new Secretary of State Lansing, 'Meanwhile, persecution against Armenians increasing in severity...' [364] and the next day he wrote an agonizing letter to his son.

> The ruin and devastation that is being wrought here is heart-rending. The government is using its present opportunity while all other countries are at war, to obliterate the Armenian race, and the worst of it is that it is impossible to stop it ... [A]s I receive report after report of the inhuman treatment that the Armenians are receiving, it makes me feel most sad. Their lot seems to be very much the same as that of the Jews in Russia, and belonging to a persecuted race myself, I have all the more sympathy with them.[365]

One eyewitness reported seeing columns of refugees driven from their homes, including old men and women, dressed in rags, many without shoes, walking down through pouring rain. 'The spectacle was pitiful',

he wrote.[366] And yet nothing was done as the world was engulfed in war and millions of people all over Europe were being displaced from their homes and ravaged by bloodshed.

One day in June, when Rae went to pay her daily visit to the American consulate, she was surprised to find a telegram waiting for her. She read the short message from Miss Szold. Rae's contract was expiring at the end of the month, it read, and she should feel free to come home at any time. Rae was taken aback. She felt her heart beat faster and she took a deep breath as she contemplated Miss Szold's words. She had not thought that, in the midst of this crisis, Hadassah would be concerned about the terms of a contract. As she scanned the brief words of the telegram again, she knew that it would be impossible for her to leave now, contract or no contract. She was determined to stay. She pocketed the telegram and went about her day without a second thought to the message.

A few days after that, Rae received a letter in which the abrupt message was expanded upon. Hadassah was very grateful to Rae for all she had done for the women and children of Jerusalem but, now that her contract was ending, she mustn't feel any pressure to stay. Miss Szold explained that they did not wish to influence her decision and she must evaluate and decide on her own what she would like to do.

Miss Szold went on to say that there were going to be a series of resolutions read at the upcoming Hadassah convention in Boston commending the work that she and Rose had done. They were also going to formally recognize Captain Decker and the work of his crew in bringing so many Jews safely to Alexandria on the USS *Tennessee*. The resolution about Rae read,'...resolved to express to Miss Rachel Landy, its deep appreciation of her loyal devotion, her heroic and unselfish service to the work of Hadassah in Jerusalem, and of her steadfastness and wisdom during the present crisis; and also to convey to her its fervent hope that she will long be spared to serve humanity'.[367]

Upon reading this letter, Rae reluctantly turned her attention to the message Miss Szold had conveyed and read both the letter and telegram over and over. She considered her situation and wondered what she should do. July was becoming an easier month than the previous ones. The provisions of the *Vulcan* were beginning to make a real difference to everyone's lives as the boxes and bundles continued to stream in on

the backs of camels through June and July. There was more food for immediate needs and the cost for wheat and sugar was lower than ever, thanks to the strategy of the distribution committee.[368] And with the locusts finally gone, crops had been replanted once again and started to grow.

In addition, the American Jews were attempting to develop markets for the colonies' crops and had actually made some headway in finding buyers for the few oranges and almonds that survived the locusts. The Turkish military had stopped requisitioning material and supplies, which also made life easier. Soldiers were living in the colonies, but in tents, and relations between the villagers and soldiers was said to be amicable.[369]

Other than Djemal Pasha forbidding Jews from praying at the Wailing Wall because their prayers included the hope for the Jews to return to Jerusalem, life seemed to be getting a little better in the city. People were feeling that they had made it through the worst and could manage to survive the next few months as long as things stayed the same.

Thinking about leaving Jerusalem gave Rae a pit in her stomach. She couldn't imagine giving up everything at this time. She and Rose had worked too hard and for too long to just walk away from all the progress they had made. The people of Jerusalem needed her. As long as they were giving her a choice, Rae was determined to stay. It did not take much deliberation for Rae to decide. She wrote back to Miss Szold telling her that she would remain in Jerusalem and continue the work as long as funding continued to flow. Once she posted the letter, she put the thought of leaving out of her mind and paid no further attention to the idea.

In Boston, Miss Szold stepped onto the stage of the Hadassah convention and faced a great crowd of women. She spoke fervently about her dream of establishing a nurses' training school in Jerusalem. But that dream, she cried, could only come to fruition if there was a hospital with a maternity ward that could support it. Her voice rose, deep with emotion, as she continued. Since none of the existing hospitals in Jerusalem supported a maternity ward, it would be up to the women of Hadassah to raise the money to build such a place.

Because of the nurses' letters, she revealed to the audience, she had come to realize that there was a need for a change in direction and she had refined her vision of Hadassah's work. 'We do not regret that we began with the programme of District Visiting Nursing, because never has such a fund of information about Palestine come to us as through

that bundle of letters from the two nurses, to whom this Convention owes a resolution of thanks for the work which they inaugurated and prosecuted with such skill and devotion.'[370]

Rae was heartened to learn that she and Rose had brought some benefit to Hadassah. She must have winced though, when she read of Miss Szold's words and the thought that after all these long months of hard work and efforts, their greatest worth had not been in setting up their maternity and trachoma work, at which they had labored so tirelessly, but from their letter-writing. She may have consoled herself with the thought that letter-writing and reporting were better than nothing. She knew that she and Rose were engaged in critical work and had made significant progress. She had seen every day how they had made a difference in so many people's lives. She also realized that, if it weren't for their efforts, there would be no body of knowledge about the status of health and disease in Jerusalem and nothing to build upon in the future.

In July, Rae decided the probationers needed a vacation. They had been working the entire year non-stop under the most trying of circumstances and, now that there was a little relief, this seemed as good a time as any to let them rest a little. The women were overjoyed to learn that they would not only have a month off work but would continue to get paid through their break.[371]

Rae, however, continued to work in the schools. Although it was summer vacation for the children, the schools continued to feed them. She took advantage of this by arranging examination hours at meal times and carefully checked their eyes to make sure they were keeping up with their treatments.

One day, Rae went to pay her regular visit to the consulate. She greeted Consul Glazebrook and they discussed the news of the day. Then, with a solemn look on his face, he handed Rae a telegram. She looked at his eyes and her stomach lurched as she slowly extended her hand to receive it from him. She kept her eyes on him, trying to decipher from his expression what news this telegram might bear. She saw only his kindly eyes and nothing more and so turned her attention to the slip of paper she held. She scanned it quickly and then froze. She looked up at Mr Glazebrook in disbelief, her jaw agape. Then she read it again. Dated 14 July, it said, 'Re-engage Ticho, Kagan, arrange payment and sealing Settlement through Glazebrook, pay rent six months, come home.'

She felt her heart sink and again looked up in astonishment. What was happening? She had just celebrated the news that she would be

permitted to stay if she wanted. What had caused Miss Szold to change her mind? Mr Glazebrook now gazed at her in sympathy but there was nothing he could do to change things this time. After a short conversation, Rae rushed home without stopping to talk to anyone and shoved the telegram into a drawer. All the rest of that day she felt ill and lethargic. She was distracted in her work and couldn't concentrate on the children in her usual manner.

When she awoke the next morning, she felt even worse than the previous day. She could barely move from her bed. She took her temperature and found it had shot up to a102 degrees. She threw herself back into bed and fell asleep. When she awoke several hours later, she was still sick. Was this malaria? Or was she sick about being ordered to leave? Whatever the cause, Rae was confined to her bed for several days, tossing and turning with fever and stewing over the abrupt message.

After a few days of misery, she started feeling a little better and she realized she needed to respond to the telegram. She sat down to write a lengthy letter. In it, she outlined the work she was doing and how important it was to the people of Jerusalem. She explained how life was much improved since the *Vulcan* had come and how she was quite content to continue on with the Hadassah mission until additional nurses could be sent.

She pulled herself together, leaving the house for the first time in many days, and walked to post the letter at the consulate. Once she delivered the letter, she began to feel better, her fever disappeared and she decided to carry on as usual, in the hope that the letter would persuade Hadassah to allow her to stay. But in the back of her mind she was, for the first time, mentally preparing herself for the eventuality that she may be leaving.

After that letter, Rae stopped writing to New York. She wasn't sure what she should say and was hoping that, with no additional news, Miss Szold and Hadassah would change their minds about making her return home. She couldn't understand what had happened to make them have this sudden change of heart about her being in Jerusalem and, honestly, she didn't really care.

For the next few weeks, Rae doubled down on her work, though she often found herself lost in thought as she tried to imagine not being in Jerusalem. She meandered through the familiar neighborhoods, greeting people on the streets, and noticed the details of her surroundings in a way she hadn't for many months. Nothing was taken for granted. She paid attention to every sound and smell that had long

seeped into her subconscious. Even amidst the devastation of the people and the countless number of Turkish and German soldiers in the city, the beauty of Jerusalem burst through. The walls of the buildings and the rough cobbled streets sang to her as they hadn't in a long time. She grasped at everything she could, pushing it all into her memory, desperate to hold onto every piece of the city. She scribbled in her journal each night, recalling details and writing about events she never wanted to forget.

In the meantime, life for the Armenians in Turkey was getting worse. Morgenthau reported, 'Persecution of Armenians assuming unprecedented proportions'.[372] He went on to explain how most of the people caught up in this persecution were old men and women. He described scenes of people crowding the roads, leaving their villages on foot without any food or clothing and no place to sleep. He wrote of how he tried to offer assistance to these poor refugees but his help was refused. He wrote, '…There seems to be a systematic plan to crush the Armenian race… I have repeatedly spoken to the Grand Vizier and pleaded earnestly with Minister of the Interior and Minister of War to stop this persecution. My arguments were unavailing…'[373]

Back in Palestine, however, the Zionists celebrated some great news. The USS *Tennessee* had been called home and, in its preparation to travel back to the United States, Captain Decker had agreed to take all the oranges his ship could carry for the American buying public. There was tremendous joy when those crates of oranges were loaded onto the ship bound for a brand new market. Finally now, maybe the colonies would see some much needed income. Everyone was sorry to see Captain Decker and his crew leave as they had provided so much support to the Jewish community over these past months, but they were thrilled to sell their produce to new buyers across the ocean.

Around this time, Rae received word that Therese Dreyfus had arrived in New York after a fruitful trip to Europe. She was now going to do her fundraising in America and had many speaking engagements lined up.[374]

As the weeks went by, Rae received no reply from New York and began to feel hopeful that her letter had convinced Hadassah they should let her stay. She began to relax and breathe a little more easily, thinking they must have had a moment of panic that had dissipated when they received her letter in which she begged them to let her stay.

Then, on 15 August, a month after the first shocking telegram, Rae received a second one. This one had two words on it. 'COME HOME' it screamed at her. When she read this, Rae sank into a nearby chair

and rested her head in her hands. It was over, she thought. They really meant it. She later wrote, 'When your second message...came..., it nearly took my breath away'.[375] She spent the next few hours quietly reflecting. She did not want to go back to the United States and had never intended to leave like this. She felt as if she were being ripped away before she was ready, snatched up against her will, leaving work unfinished. This ancient city was now her home and, although she knew it was intended that she return to America after two and a half years, the order to leave seemed unreasonable. Deep down, she had assumed that, as long as she was doing good work, Hadassah would allow her to stay indefinitely. This place had grabbed hold of her and wouldn't let her go. She contemplated what would happen if she refused to leave, imagining the consternation the Hadassah leaders would feel. Could they force her to return if she didn't want to?

She didn't understand what was happening and tried desperately to analyze why they were so adamant about her leaving now. In the end, though, like it or not, she gradually became reconciled to the idea of leaving and began settling her affairs. In a shorter amount of time than she could imagine, she organized with Dr Ticho to supervise the three probationers who were working with her in the schools and arranged for Dr Kagan to fully take over supervision of the three midwives.

She still had a great deal of food and provisions from the *Vulcan* so she invited her friends and neighbors to come over and take everything. 'Can you imagine what exciting times I had? The Settlement was full of people day and night ...and in 48 hours, with the help of my friends I was packed, out of the Settlement, and all my business arranged.'[376]

The thought of sitting in Jaffa, alongside the mobs of people who were also waiting to leave, was repugnant. She really despised that city. So she made arrangements with Consul Glazebrook to notify her when a ship was ready to take on passengers. As she waited, she wrote a long letter to Hadassah, stating, '...I still wish I would be obliged to stay until you could send nurses. I don't know whether it is Jerusalem or these trying times, but I have become so attached to everything and everybody that it gives me a sinking feeling when I think of leaving it all at this stage, especially since I have been through the worst...It upset me very much to break up the Settlement. I had looked forward to leaving it in a different fashion.'[377]

She had to wait in Jerusalem longer than she had anticipated. 'After all that rush I sat about for several days all packed, afraid to open my trunk for fear I might have to leave at a moment's notice...'[378] While

she waited she remembered about her diary. She had kept a meticulous journal through all her time in Jerusalem and her stomach dropped as she realized that there were many things written in it she would never want the Ottoman censors to read. She realized that there were thoughts and ideas she had recorded that could even get her arrested and she panicked at the thought of being locked up in a Turkish cell, waiting for someone to save her. She had heard enough stories of the beatings many Zionists had suffered to know this was not something she would want to endure.

After thinking it over, she took the diary out of her bag and began ripping out all the pages. Before she ripped, she read what she had written. Crying and laughing as leafed through the pages, she re-lived all that had happened over the previous few years. As she recalled the events that she had written about, she realized how much she had changed since her arrival in this city. She had been so naive and idealistic at the beginning. It had been so hard for her and Rose to reconcile all their grand plans with the harsh reality of what they had faced. But they had finally adjusted and had made the best of their situation. She became teary once again as she thought about how much she still missed Rose. She wished they were going through this together.

She was morose as she realized all her thoughts and reflections were now going to have to remain in her head in order for her to remember this time of her life. Placing all the ripped pages together in a pile, she lit a match and put it to the paper. She watched the little pyre burn all her words and she prayed that she would always remember this time. Later, Rae reflected, 'I kept a diary while in Jerusalem which I was not allowed to take with me and which I very foolishly destroyed before I left.'[379] In retrospect, she realized she could have left the diary with Consul Glazebrook but, in the moment, she didn't think of it.

Her departure was actually delayed due to a new directive from Alexandria. The officials there had recently announced their decision to deny entry to any more Jews due to the number of refugees already there. To complicate matters, the Turkish government declared that no 'Christian neutral' could leave Turkey unless three times as many Jews left also.

Ambassador Morgenthau was in a quandary as he was desperately trying to get the Armenians away to safety. Without a place to send the Jews, the Armenians were stuck waiting to escape. Morgenthau informed the Secretary of State that he was negotiating to get the Egyptian government to change its mind so both Jews and Armenians could leave.[380]

Rae had been planning to travel on the USS *Chester* but, due to the latest pronouncement, the ship left Jaffa without taking on any passengers. Rae wrote, 'I am glad now that I did not go to Jaffa. Most of the people have come back to Jerusalem again.'[381]

Hadassah in New York hadn't heard from Rae since their second telegram ordering her home, so Miss Szold sent a frantic telegram to Otis Glazebrook via Morgenthau,'Why does Landy not come home?'[382]

As part of his efforts to rescue the Armenians, Morgenthau proposed an audacious plan to have the refugees shipped to America and resettled in California, Oregon and Washington. He wrote, 'Minister of War has promised to permit departure of such Armenians to the United States whose emigration I vouch for as bona fide. Destruction of Armenian race in Turkey is progressing rapidly.'[383] This idea was promptly rebuffed, the Secretary of State replying, 'Difficulties in way, wholesale emigration Armenians insurmountable.' And, showing a complete lack of understanding of the dire situation of the Armenians, and to the consternation of Morgenthau, he added, 'could you use from fifty to one hundred thousand dollars for immediate relief suffering [of] non-moslems by way of food, clothing, repatriation, or assisting emigration.'[384]

Finally, on 4 September, the American ambassador in Great Britain reported that the Egyptian government had finally relented and agreed to allow additional Jews to enter its country.[385] The ambassador advised Morgenthau to make arrangement for their immediate transfer. With this news, Morgenthau was now able to negotiate with the Ottoman government to allow both Jews and Armenians to leave their shores.

It was now almost time for Rae to leave. During her last weeks in Jerusalem, before she departed for Jaffa, she concluded a final letter to Hadassah with some recommendations:

> May I suggest that when you are making out the budget for 1916 you think about raising the salary of the two probationers. They have proved to be very accommodating and conscientious. No matter what or how much I asked them to do, they alway did it cheerfully...I think the midwives are underpaid. I hope this letter will not be too much for the censor. In four days we have Rosh Hashanah. May the New Year bring all that is good for us all.[386]

On 8 September, Rae spent one last bittersweet *Erev Rosh Hashanah* in Jerusalem with her friends. As she savored the sweet apples and honey and pomegranates, she realized she might never return to this

place. And certainly, if she ever did return, things would be different. A feeling of great sorrow overwhelmed her. She looked around the table. Dr and Mrs Ticho, Helena Kagan, Vera Pinczower, Dr and Mrs Levy and the midwives and probationers had all grown so dear to her. This small community had helped her grow so much over these past few years.

Finding a small group of women who had put their careers before anything else had solidified Rae's ideas that what she envisioned for her life could be possible. The deep friendships she had developed sustained her through even the most challenging times, despite the hardships they all faced. She could barely eat the festival meal thinking about what the future might hold for these people and for herself. They spent the evening reminiscing, trying to keep the conversation cheerful and light.

For the next several days, Rae wandered around the city visiting patients and students and saying goodbye. She stopped to see her neighbors and they hugged through their tears as they said their final farewells. Finally, Rae got word that the *Chester* was back and ready to take on passengers. On 12 September, she and her colleagues loaded her trunks onto a waiting carriage. She embraced Dr Kagan and Dr Ticho one last time and then climbed onto the diligence and departed for Jaffa.

It took the entire day to reach the city by diligence since the horses had to be relieved several times. During the rough ride, Rae looked longingly at the desolate landscape. She reflected how dramatically things had changed since the previous summer when she had made this trip to Petach Tikvah and Rehovot. She contemplated both what her future would be as well as what the future held for this land and the Jewish people.

When she finally arrived at the port, she found it teeming with mobs of people waiting to leave. There were people from the cities and the colonies, Jews and Christians, waiting to get away from the harsh rule of the Turks. She recognized some Jewish leaders who had been expelled from the country and passed many others she had never seen before. To her great disappointment, the ship was, in fact, not ready to take on passengers and she was forced to continue to wait, this time remaining in Jaffa. Her bag and trunks were checked by the Turkish officials and then sealed, leaving her without access to her belongings. She was fortunate in that she had enough money to check into a hotel and there she sat, waiting. It was a most maddening time. Now that her trunks had gone and her friends were far away in Jerusalem, she

was very eager to get on the ship and get on with her journey. The interminable waiting, anticipation of a departure and then further delay was emotionally draining and exasperating.

Finally, an entire week later, during which time Rae brooded and barely tolerated Jaffa, passengers were permitted to embark on the waiting warship. She silently smiled to herself as she climbed into the small boat and watched the oarsmen row her out to the ship. She wished Rose could have been here with her to laugh at this full circle she had come. It was a smooth crossing to the massive ship, especially since she now knew what to expect.

As Rae reached the top of the stairs and climbed onto the deck of the *Chester*, she was not prepared for what she saw. Hundreds of Armenian refugees gazed at her as she made her way to the check-in point where the American officials were waiting.[387] She had heard many rumors about the Armenians and what they were facing in Turkey but she had never seen, with her own eyes, the effects of their persecution. Ragged, traumatized women and children filled the decks and crowded the passageways throughout the ship. They huddled together, silently watching the Jews climb aboard. They had haunted looks on their faces and they were as gaunt from starvation as the poorest in Jerusalem. They cringed in fear if anyone in uniform approached them and many lay about, unmoving, weak from hunger and disease. Rae learned there were four hundred Armenians on this ship and many more were waiting to leave in Constantinople and Beirut.[388] Two hundred Jews were crammed onto the ship, joining the Armenians.

Rae put down her bag and looked around. After the initial shock at what she saw, she realized she needed to pull herself together. Her nursing instincts had started to kick in but she realized these poor people were being taken care of by the American sailors and she had other things on her mind right now. She quickly found a place standing alongside her fellow Zionists at the rail of the deck. At long last, the ship's horn blared, the anchor was slowly lifted and the ship started moving. Rae leaned against the rail, staring fixedly at the receding shoreline. She wiped tears away as she watched the distant people at the docks growing smaller. Very soon, she could see only the minarets of the mosques. And finally there was only water.

Her unexpected journey, which she had embarked on so quickly almost three years before, had come to an abrupt end. As she continued to stand there, listening to the shrill cries of the Armenian children and the subdued voices of the deportees as they expressed sorrow and disappointment in leaving this land, she realized how important this

experience had been to her. In later years, Rae wrote, 'I feel my part was just a mere drop in the ocean, for I gave so little in comparison to what I received while living and working in Jerusalem.'[389]

She thought back to that distant time when she boarded the *Franconia*, how excited she had been about her impending adventure. She had been filled with nervous trepidation about what she would encounter in Jerusalem but had been so idealistic and optimistic. She reflected on how naive and innocent she had been back then. She now felt years older and wiser and a very different person. While still filled with love of *Eretz Yisrael* and believing in the Zionist dream, she knew there was a long way to go before those ideals could ever become a reality. Slowly, filled with sorrow, she turned away from the rail and faced south. She wondered about the next chapter in her life and what it would bring her but she knew that whatever it was, she was ready for the adventure.

Epilogue

The USS *Chester* landed in Alexandria on 21 September 1915.[390] The ship's arrival was reported in the *New York Times*, which stated that nearly four hundred British, French and Russians nationals, including two hundred Jews who had been expelled by Djemal Pasha, were on board. The article did not report any Armenians, though Rae described them in her notes, but it is most certain that Rae was on this particular voyage because she applied for an emergency passport in Alexandria on 23 September.

On 8 October, Rae sent a cable from Naples informing Hadassah she was sailing to Boston on the *Cretic*.[391] Henrietta Szold traveled to Boston to meet her and accompanied her back to New York by train. They arrived in the city on 22 October.[392]

Upon her arrival in the US, Rae learned the reason for the abrupt command to return home. Miss Szold broke the news that both of Rae's parents were very ill and were desperate to see her before they died. Shocked at this information, Rae no longer felt distraught about leaving Jerusalem. After a very short stay in New York, where she addressed the Hadassah central committee and gave thorough reports on what was happening in Palestine, she boarded a train to Cleveland.

She remained in Cleveland for about a year, nursing her parents until their deaths in 1916. Soon after, Rae moved back to New York, taking a job at Fordham Hospital. Restless as always and seeing the war continue, she joined the Army Nurse Corps on 3 July 1918.

It is not difficult to guess at what motivated Rae to join the military, although the exact reason for her enlistment is not known. Certainly she had a very profound love for her country; as an immigrant she was grateful for the opportunities and life her family had had since their arrival from Lithuania. She also had a great sense of adventure that was

even more enhanced by her experience in Palestine. Her ability to endure hardship was also well proven by her experiences. It must have been very difficult for her to settle down to an ordinary life.

In May 1918 there was a national nursing convention in Cleveland, Ohio. It is not known whether Rae attended this convention but it is possible, since it would have given her the opportunity to see her family. At the convention, the leaders elected to accept only trained, graduate nurses into the Army Nurse Corps.[393] There was also a great national recruiting effort being made to encourage women to join the Army Nurse Corps. Recruitment posters displayed prominently throughout the country may also have influenced Rae's decision to join the Corps.

When the US entered the First World War it was estimated that the army would require 10,000 nurses. This was a huge increase from the only 403 nurses on active duty in March 1917.[394] This figure was quickly revised upwards several times until, at its peak at Armistice, the Army Nurse Corps consisted of 21,480 women. Because of the shortage of nurses, requirements for enlistment were loosened and any nurse, single or married, from the age of twenty-one to forty-five was eligible to join the corps.[395] These new measures enabled Rae, at age thirty-two, to enlist.

There is no official documentation of what Rae did in her first year of service. The army records that are available do not include her assignments from her enlistment in July 1918 until September 1919. Rae left no personal diaries or letters about her life and any other official records were destroyed in a fire at the National Personnel Records Center in St Louis, Missouri in 1973.

All that is known of her early service is from Ida Dennis, an educator from Cleveland who wrote a book to teach students about American history. In *The Way of Democracy*, published in 1940, Miss Dennis took basic facts and created stories around them to illustrate the importance of democracy and American values. She decided to use Rae as the subject of one of her chapters to illustrate how a woman could succeed in America. According to Rae's niece, Evelyn Rosenblum, Dennis considered herself an honorary Landy. She was very close to the family and knew many of their stories, so was able to incorporate a great deal about Rae's life into the chapter.

Miss Dennis wrote that Rae's first assignment was to help prepare other nurses to travel overseas. Rae was quite disappointed with her assignment, restless and anxious to go abroad. Finally, in November 1918, Rae was assigned to lead a nurses' unit to France. Miss Dennis

reported that while Rae was in transit across the ocean the armistice was signed and the First World War ended.[396]

Detailed military records, which document where Rae was stationed for the rest of her military career, begin in September 1919. She was in Staten Island, New York from September 1919 until 5 February 1920, when she was sent to Coblenz, Germany with the American Forces in Germany. The largest concentration of US troops in Germany was in Coblenz where there was a very large base hospital that was made up of thirteen two-story concrete buildings and had a bed capacity of 460.

Rae was at the base hospital for about a week and then moved to the Office of the Attending Surgeon of the American Forces in Germany as chief nurse. She was in that office for about two months before she was sent to Antwerp, Belgium in May of 1920 to serve as chief nurse for the Port Surgeon.

After the First World War, Antwerp was used as a supply base for the American forces in Germany as well as the evacuation port from which US soldiers were sent home. This port hospital contained seventy-five beds and was used to care for sick or injured soldiers until their ultimate evacuation back to the United States.[397] Rae served with the Port Surgeon until she was sent back to the States sometime in 1921.

While numerous documents list Rae as having served in Coblenz and Antwerp, she left nothing that describes her personal experiences. However, among her papers is a letter of condolence from Colonel Miner Felch, written to her family upon her death. In his letter Colonel Felch explained that Rae was chief nurse in 1920 while he was attending surgeon of the American Forces in Germany at Coblenz. Colonel Felch described Rae as having had 'a pleasing personality' and all of the fine qualities required by an outstanding nurse: '[Miss Landy] was a most wonderful woman who always gave her all to the task at hand.' According to Colonel Felch, Rae was with Mrs Felch when their daughter was born and remained a close friend to the Felches throughout her life.[398]

BETWEEN THE WARS

For the Army Nurse Corps, the years between the two world wars were quite uneventful and the number of nurses who were serving in the

corps decreased dramatically. By June 1921, demobilization had reduced the Army Nurse Corps to 851 nurses with only seventy-four first lieutenants.[399] Rae was one of these seventy-four.

On 13 September 1921, Rae reported for duty as Chief Nurse at Walter Reed General Hospital and, on 28 September, she left there to go to the Attending Surgeon's Office, serving at the White House. Rae would have been discharged from the army at this point but, in April of 1922, she requested permission to stay in the army; her request was approved.

* * * * * * * *

CALVIN COOLIDGE, JR

What we know of the next chapter of Rae's life comes from both her obituaries and Ida Dennis, who made this the center piece of her chapter about Rae. That Rae was the nurse who took care of Calvin Coolidge, Jr was a story that was related often in the Landy family, but I have not been able to verify it independently. White House and Walter Reed historians were unable to confirm the name of the nurse.[400]

In June 1924, President Coolidge's son, Calvin, Jr, was playing tennis in sneakers without wearing socks. He got a blister which developed into blood poisoning. He became very ill and died soon after. As part of her duties at the Attending Surgeon's Office, Rae would have stayed with him until he was taken to Walter Reed Hospital, where he remained until his death several days later.

Rae's military records indicate that she was in the Attending Surgeon's Office in Washington, DC from June 1923 until November 1924, and Calvin Jr died in July 1924. Her records also indicate that she took a thirty day leave of absence in September of 1924, perhaps needing to recover from the tragic events but, again, Rae left no personal memories of these events.

After Calvin Jr died, Rae continued a relationship with Mrs Coolidge. According to Ida Dennis' account, several years later, as Rae was walking in the streets of Washington, a limousine stopped and the window of the back seat opened. It was Mrs Coolidge, who beckoned to Rae and invited her to have lunch at the White House. Rae got into the car and had lunch with the President and First Lady.

For the next six years, Rae's posts included San Francisco, Kansas and then back to Washington. By November 1929 she was back at

Walter Reed, just in time to meet Mrs Coolidge. She then moved on to Fort Totten, New York and, finally, Fort Hayes in Columbus, Ohio in 1935.

It was at Fort Hayes that Rae's niece, Evelyn Rosenblum, has her first story about her Aunt Rae. I was able to interview Evelyn about Rae several times in 2004 and 2005 and was able to capture not only the memories that Evelyn had of Rae but also information about Rae's character and personality. Evelyn had a very close relationship with her aunt, one that was nurtured throughout her childhood and into her young adult life. Evelyn was the keeper of Rae's legacy, donating many of her personal effects to the Western Reserve Historical Society Archives and the Hadassah Archives.

That summer of 1935, seven-year-old Evelyn traveled to Columbus from Cleveland to spend the summer with her aunt on the military base. One night, Evelyn didn't want to go to sleep so she hid under the bed. Rae couldn't find her so she enlisted several nurses to help look for her. They searched everywhere and were about to call the police when they finally looked under the bed and discovered her. Evelyn doesn't actually remember this happening but was often told the story by Aunt Rae when she got older.[401]

THE PHILIPPINES

In July 1936, Rae left Columbus to go to the Philippines. She was Chief Nurse at Fort Stotsenburg and then at Sternberg General Hospital in Manila. The Philippines was said to be a luxurious, restful, tropical duty during the 1930s. Military personnel in the Philippines had Filipino houseboys, maids, chefs, gardeners and tailors looking after their every need.[402]

It seems to have been a welcome duty for Rae, as it is at this point in her career that we have photographs of her and her living quarters in the Philippines. In her pictures she appears very happy and relaxed. The Philippines was described as looking and smelling like paradise, with palm trees and beautiful flowers such as gardenias, bougainvillea and orchids. At the army posts the soldiers participated in activities such as badminton, tennis, bowling and ball games. At Fort Stotsenburg, officers held weekly polo matches and took weekend rides into the forests to see the monkeys, toucans and parrots.

For the nurses, life was not difficult:

Every morning a houseboy would appear with a newspaper, then over fresh-squeezed papaya juice with a twist of lime, the women would sit and chat about the day ahead, particularly what they planned to do after work: visit a Chinese tailor, perhaps, or take a Spanish class with a private tutor; maybe go for a swim in the phosphorescent waters of the beach club.[403]

Rae wrote that the social life was magnificent, with nurses allowed to participate in all the officers' affairs. Evening socials included cocktails and bridge, with the party-goers 'dressed in white jackets and long gowns at dinner, good gin and Gershwin under the stars.'[404]

When nurses arrived at the docks in the Philippines throughout the 1930s, a crowd was usually gathered. A band played to welcome them and then the new nurses were taken to the Army and Navy Club, 'where a soft lounge chair and a restorative tumbler of gin was waiting'.[405]

The nurses' work day was not very stressful or complicated. Most of their work was routine surgery and taking care of sick patients, with few emergencies. Most of the nurses in the Far East Command were in the army and the majority of these worked at Sternberg Hospital. The nurses' quarters were behind the hospital and were very comfortable, 'with shell-filled windowpanes, bamboo and wicker furniture with plush cushions and mahogany ceiling fans gently turning the tropical air.'[406]

Unfortunately, along with the excellent working conditions and recreational activities, there was also the threat of tropical diseases. It was to one of these that Rae succumbed. First, she had a reaction to a vaccine when she first arrived, which landed her in the hospital for a week. Then, in 1938, she contracted dengue fever – a tropical mosquito-borne disease. She was sick in the hospital for the better part of August through October. Soon after she was released from the hospital, she was transferred back to the States.

Because Rae was so weakened by the dengue fever, she was not able to take a long-anticipated trip back to Palestine. She did, however, have another adventure traveling across the Pacific Ocean. While Rae was on board the ship *The Republic*, the captain received an SOS call from a merchant vessel called the *California Express*. There was a very sick woman on board that ship who needed medical attention immediately. A rescue team, which included Rae, was quickly assembled and placed in a lifeboat. The lifeboat approached the *California Express* and the team went on board. It was determined that the woman, Mrs Daniels from Canada, was in need of more intensive medical help and she was

brought back to *The Republic*. For three days the medical team attempted to save Mrs Daniels but, in the end, she died.

Mr Daniels, along with Mrs Daniels' body, was brought back to the *California Express* and then proceeded on to London. Mr Daniels was so moved by the effort that had been made to save his wife that he wired the Headquarters of the Second Battalion in Surrey, England to tell his story. Mr Daniels praised the American medical crew who attempted to save his wife and suggested that the War Department of the United States be notified and the crew be commended. The Canadian government notified the US government, which notified the US Army. On 14 April 1939, Rae received a letter of commendation from the US War Department. [407]

When Rae returned to the States from the Philippines, she was first based at Fort Monroe, Virginia and then went to Mitchel Field, Long Island. It was from this time that Evelyn had many memories of her Aunt Rae. She recalled being at the army air base during the summer and having a ball. The nurses tried so hard to be nice to her because she was the chief nurse's niece. Evelyn remembered riding her bicycle all around the base and swimming in the pool. It was a wonderful time for a young girl.

In 1940, Rae became one of four assistant superintendents of the Army Nurse Corps, in charge of the nurses on the entire eastern seaboard. She was promoted to Lieutenant Colonel and was stationed on Governors Island in New York Harbor. Governors Island is a 172-acre island located half a mile from the southern tip of Manhattan. It was the headquarters of the United States First Army and, during the Second World War, it was a major administration and chief reception center for army inductees.

Rae requested to retire in 1940. She was getting tired and older and wanted to spend her remaining years with her family in Cleveland. She was also hospitalized several times for lumbago. However, because of the outbreak of the Second World War and the US's impending involvement, her request was denied. She remained assistant superintendent at Governors Island.

When the US began preparing for war, there was an immediate need for more nurses and Rae became involved in recruiting. On 24 April 1941 she was on the radio show 'The Major Explains', a bi-weekly discussion in which Major Ray Perkins of the recruiting service of the 2nd Corps spoke. Major Perkins introduced Rae, who said, 'Nurses are urgently needed now, even though we are not actually at war.' This radio broadcast was heard all over the country.

In 1941, Rae learned that there was going to be an army hospital built in her hometown of Cleveland, Ohio and she immediately requested to be transferred there. Her request was granted and she moved to Cleveland in 1943 to work as the chief of nurses at Crile Army Hospital. People were surprised at her desire to leave her post because she had a fantastic job as assistant superintendent of nurses, but she wanted to be close to her family. Rae noted that she had come full circle. Her first nursing position had been with Dr George Crile and her final one was at a hospital named for Dr Crile. When Rae returned, she was greeted by the Jewish press as a hero. Multiple articles were written about her and her accomplishments.

Rae was now ready to retire. She was very tired and had to push herself to work. On 4 May 1945, a retirement hearing took place. She reported that she had pain in her legs and back and had been back in the hospital in February 1945. After a brief hearing, her retirement was granted. During her military career, Rae was awarded a Bronze Victory Button, a World War I Victory Medal, a World War II Victory Medal, a Good Conduct Medal and a World War II Lapel Button. Rae spent the remaining years of her life living peacefully, surrounded by her large extended family and she spent a great deal of time with her many nieces and nephews. On 5 March 1952, Rae called a neighbor, complaining of chest pains. The neighbor wanted to take her immediately to the closest hospital, Mt Sinai, but Rae insisted on being transported to the Veterans Administration Hospital, as Mt Sinai would cost too much money. She died of a heart attack at age sixty-six, waiting to be transported to the hospital. Evelyn related that, on that day, her mother returned home from shopping and heard the phone ringing. By the time she got to the phone, it had stopped ringing. She learned later that day that her sister had died. Evelyn's mother was haunted the rest of her life thinking that Rae had reached out to her and she wasn't there for her. With great sorrow and mourning, Rae's family buried her in Arlington Cemetery, where you can see her grave today. Rae is listed on 'Prominent Jewish Figures' on the Arlington National Cemetery website.[408]

Upon learning of her passing, Hadassah sent Rae's family a telegram, saying,

'Her Heroic Action on Behalf of Hadassah in 1913 in Palestine will forever remain deeply enshrined in our minds and hearts. Her persevering spirit and great professional attainments, her pioneering zeal and dedicated effort did much to make Hadassah's great health program in Israel an enduring monument to the Jewish women of America. We mourn her passing.'

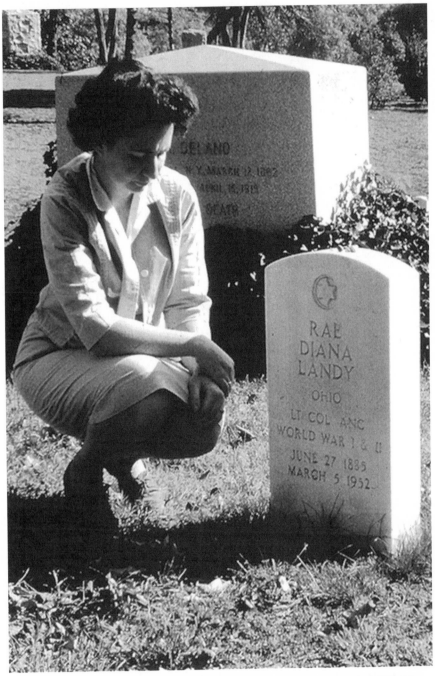

Evelyn Rosenblum visiting Rae Landy's grave at Arlington Cemetery in 1965. Photo courtesy Louis Rosenblum.

Hadassah remembered Rae by naming several chapters of Hadassah after her and Rose Kaplan. In addition, Hadassah established a Kaplan/ Landy Award that was presented to 'an American Jewish/Zionist nurse who exemplifies the spirit of Rose Kaplan and Rachel Landy'.

Evelyn Rosenblum remembered, 'Everyone in the family was in awe of her or loved her or both. They knew she had accomplished great things. She did everything gracefully, without seeking recognition. She did a great job at everything she attempted. She never talked about herself in all the years I knew her. She never talked about her adventures. She talked about you.'[409]

There's so much we don't know about Rae. Evelyn regretted that she did not ask more questions about her experiences but believed that Rae would not have said very much, as she was very modest. She said, 'The idea of probing never entered my mind. But I bet she never would have told me much. She just wasn't like that.'[410]

In Rae's later years, as she prepared notes for a speech to present to Hadassah, she reminisced:

> ...we crept into the black alleyways of Jerusalem, literally holding aloft the small, but penetrating light of modern science, and of American determination to rid Eretz Yisrael of disease and ignorance... [We] dared to arm ourselves not only with practical instruments, but with that deep love and abiding faith in the future of the Jewish people which have been the essence of Zionism since its beginning...[411]

* * * * * * *

A TRIBUTE TO ROSE KAPLAN 1867–1917

Rose Kaplan returned to the United States in January 1915 to undergo treatment for cancer. After she recuperated from surgery, she insisted on going back to Palestine. She reassured everyone that she was completely healthy. But the war raged on and Henrietta Szold knew it was impossible for her to get back into the country. However, she got word that there was a great need for nurses in the refugee camps in Alexandria and so gave permission for Rose to go to Egypt and set up nursing services there.

How apt that this adventurer would board a ship that ended up catching fire – just one more adventure in a lifetime of them.

Remarkably, while on the burning ship, Rose wrote in her diary, which she later gave to Miss Szold. Her entries speak volumes about the kind of person she was: a personality that never came out in the letters that had been published in the Hadassah news bulletins.

> Sept. 18. When I settled down in my corner today, I noticed smoke, but paid no attention to it and sat still until I saw the passengers running toward the hold. Bales of cotton, smoldering and on fire, pieces of wood, and our trunks were being pulled out of the hold... I went to my cabin and got my bag with the papers from my steamer trunk, and put on my high shoes instead of the Oxford ties I had on. It was not much of a precaution, but I thought that a few preparations would not harm in case I should have to swim for my life. I was not a bit excited, though I cannot deny that the prospect of an enforced sea bath was not pleasant.[412]

After a distress signal was sent out, the passengers were rescued by a nearby ship and brought safely back to New York.

Despite her adventure, Rose was determined to go to Alexandria and she convinced Miss Szold to keep her word and allow her to resume her journey. Miss Szold relented and Rose finally arrived safely in Alexandria in October 1915, just as Rae was returning to the US. Never breathing a word to anyone in New York about how sick she was, Rose worked tirelessly up to her death from cancer on 3 August 1917. She was buried in Egypt but her remains were later brought to Israel and buried on the Mount of Olives in Jerusalem.

Rose left behind only her elderly father in Russia and a sister in America. She had no worldly possessions and left only her tremendous legacy of dedicated nursing to her people. It is for this reason that I include the following tributes to Rose from the Hadassah women who loved her.

Miss Szold wrote a moving eulogy that was published in the *Maccabaean* magazine:

> There was but one rule of life for her: service must be rendered by Rose Kaplan whatever the cost, however exacting the circumstances... Nothing would do but completely and absolutely to surrender to its demands... If the Hadassah work in Jerusalem lives, and so long as it lives, it will somewhere bear the impress of Rose Kaplan's personality, and testify to her civic public service standards.

...it is well that we should keep in mind the great lesson in these days of turmoil. We may forget that exaltation of the spirit need not come to the accompaniment of drums and fifes. Rose Kaplan teaches us that one can be a soldier of peace and can do one's work amid peaceful surroundings and yet with an exaltation of the spirit that raises one above the crowd. Human life is fragmentary. What is it that we have of Rose Kaplan's life? She left no great possessions... That is the supreme lesson of Rose Kaplan's life. She submerged her ego for the good of the community. She did not do it because she happened temperamentally to be unselfish. No, she did it because it was a principle with her, because she had espoused that philosophy of life which places the community above the individual. That is what always encouraged me to believe that in the end Rose Kaplan would have become a champion of Zionism because fundamentally that is what Zionism also asks.[413]

Eva Leon wrote in August 1917:

It is not only the soldier bearing arms that falls on the battlefield. Our faithful Hadassah Kaplan has also fallen upon the battlefield. She did not kill nor did she shed any blood. She healed and she comforted. This was her great mission as a true daughter in Israel; and her last message to us was to continue the work of Hadassah.[414]

In 1937, on the occasion of Hadassah's twenty-fifth anniversary, Rae wrote of Rose:

I have thought about her so much these last years and I feel more than ever that it was a privilege to have known and worked with her. She was about twenty years older than I when we started out together and when I think back now, I wonder whether I appreciated her enough at the time. I was too young and inexperienced in those days... Rose and I got along so well and when you consider that we never had met before, and had to go off together in a strange land, I think it was rather swell, don't you?[415]

HADASSAH AND HENRIETTA SZOLD

Hadassah has had a long, illustrious, 104-year history. There are many great books that have been written about the organization and Henrietta Szold, and the Hadassah Archives are under the thoughtful and dedicated care of the American Jewish Historical Society. Henrietta Szold remained an active Zionist leader until her death at age eighty-four in 1945.

Early in Hadassah's history, Miss Szold shepherded the organization through several political situations the women's organization had with the larger American Zionist movement. She was adamant that her organization was not a charity, an accusation she heard often from the men who led other organizations. When she sent Rae and Rose to Jerusalem in 1913, she sent with them an American style of community nursing and social work that was becoming prevalent in the larger American cities that were teeming with new immigrants. As the nurses reported through their letters on the conditions of the poor people in Jerusalem and the state of the existing hospitals, she realized that the Jerusalem hospitals could not support the needs of the women and children. Because no hospital had, or was willing to build, a maternity ward, women would continue to be compelled to give birth at home in the most primitive conditions unless Hadassah did something about it. As recorded in this book, she made a statement in 1915 to that effect. However, with the war raging on and her two nurses gone from Jerusalem, there was very little Hadassah could implement immediately. Dr Helena Kagan was able to maintain some of the work and expand it to include the polyclinic she had opened but then she also had to leave the city.

In the meantime, the World Zionist Organization continued to receive reports about the devastation of the people remaining in Palestine and realized that American Jews needed to do something to alleviate the suffering, starvation and disease. They decided to fund a medical unit to deploy to Palestine as soon as possible and asked Hadassah to contribute to the funding and also to lead the unit. The executive committee of Hadassah, still under the leadership of Szold, agreed immediately and the organization and administration of the American Zionist Medical Unit shaped the next chapter of Hadassah's work in Palestine.

Henrietta Szold stayed firm and true to the Hadassah mission throughout the war and inter-war period, taking on projects and initiatives that would promote health and hygiene to women and

children in Palestine. In many ways the world events and the impact they had on women and children shaped the projects she and the executive committee agreed to take on, yet she never deviated from the core mission. Under her leadership, Hadassah's initiatives included the American Zionist Medical Unit, which became known as the Hadassah Medical Organization, the formation of Young Judaea, a Zionist youth organization, the Youth Aliyah, bringing Jewish children to Palestine to escape from emerging Nazi Germany and, finally, the establishment of a medical school and Hadassah Hospital in Jerusalem.

Today, Hadassah remains a vibrant women's Zionist organization, still true to its mission of supporting Hadassah Hospital and educating American Jewish women about Zionism and Israel.

FINAL WORD

The twenty-fifth anniversary of Hadassah occurred while Rae was stationed in the Philippines. Rose Jacobs had reached out to Rae to deliver some remarks over the radio to commemorate the event and to honor the contribution she and Rose had made to the organization. Here is Rae's response.

Fort Stotsenburg, Pampanga, Philippines, 1937
My dear Mrs Jacobs:
There was only one way to answer your cable, for I see that Hadassah will not take 'no' for an answer. I was afraid you would continue to send cables, so for the sake of Palestine I consented... Were I able to put into words just how I feel in my heart it would be a different story, but that is a gift which I do not possess.

Although it is 24 years this [February] that I arrived in Palestine, my memories of everything concerned with it are just as vivid as if it happened only yesterday. Still I feel that it was my experience and I was the one benefited by it and the only one interested. People as a rule do not care to hear about experiences one had a quarter of a century ago...

So much has happened in Palestine in recent years, Hadassah has made such strides in leaps and bounds that the work Miss Kaplan and I did fades in the background. It sifts down to what I maintain, that the experience was really our own, and the

contribution we made was so very small, and we were the sole beneficiaries...[416]

Rae did deliver a speech over the radio, and many of the words she spoke are included in this book. Her humility and modesty are reflected in both her letter to Mrs Jacobs, as well as in her speech, belying the impact and legacy she and Rose left on the people during their time in Jerusalem. And despite her protestations to the contrary, it is a legacy that is still felt today through the work of the Hadassah women's organization and Hadassah hospital

Notes

1 *The Maccabaean: A Magazine of Jewish Life and Letters*, 23, 2 (New York: Federation of American Zionists, February 1913), p. 35.

2 *Vintage Brochure – Cunard Line –RMS Franconia and Laconia (1912)*, Undated, but believed to be 1912, Gjenvick-Gjønvik Archives.

3 'Nurses Sent to Holyland', *New York Times*, 27 January 1913.

4 R.D. Landy, 'Landy's reminiscences of her 1913–1915 experiences in Palestine', 1937, Lt Col. Rachel Diane (Rae) Landy Papers; P-785; box 1; folder 4; American Jewish Historical Society, New York, NY and Boston, MA.

5 G. Wigoder (ed.), *American Jewish Memoirs: Oral Documentation* (Jerusalem: Hebrew University of Jerusalem, 1980).

6 M. Levin, *It takes a Dream: The Story of Hadassah* (Jerusalem: Gefen Publishing, 2002), pp. 32–54.

7 *Ibid.*

8 There is no documentation about how Rae found out about the opportunity, but it is likely that it was publicized in the NY hospitals as they had large numbers of Jewish nurses. While there is no documentation that Rae was part of one of these study groups, based on where she lived, her Zionist idealism and what was happening in Harlem, she most likely was part of one.

9 'Harlem Hospital History', http://www.si.umich.edu/CHICO/Harlem/text/hospital.html. Last accessed 2007.

10 Author interview with Evelyn Rosenblum, February 2005.

11 L.J. Sussman, 'New York Jewish History' (New York: New York State Archives).

12 J.S. Gurock, *When Harlem was Jewish* (New York: Columbia University Press, 1979).

13 Author interview with Evelyn Rosenblum, February 2005.

14 D.H. Miller, 'History of Hadassah: 1912–1935', Unpublished Doctoral Thesis, 1968.

15 'The Healing of the Daughter of My People', *The Maccabaean: A Magazine of Jewish Life and Letters*, 23, 2 (February 1913), p.137.

16 E.R. Benson, *As We See Ourselves* (Indianapolis: Center Nursing Publishing, 2001), p. 45.

17 Author interview with Evelyn Rosenblum, February 2005.

18 See Landy, 'Landy's reminiscences of her 1913–1915 experiences in Palestine'.

19 See 'Harlem Hospital History', http://www.si.umich.edu/CHICO/Harlem/text/
 hospital.html.
20 See Gurock, *When Harlem was Jewish*.
21 See 'The Healing of the Daughter of My People', p.137.
22 Author interview with Evelyn Rosenblum, December 2004.
23 See Landy, 'Landy's reminiscences of her 1913–1915 experiences in Palestine'.
24 *Ibid*.
25 'Miss Gottheil Back From the Holy Land', *New York Times*, 28 September 1913,
 p. 7.
26 See Landy, 'Landy's reminiscences of her 1913–1915 experiences in Palestine'.
27 Author interview with Evelyn Rosenblum, February 2005.
28 See 'Nurses Sent to Holyland', *New York Times*, 27 January 1913.
29 See *The Maccabaean*, 23, 2, p.35. The traveling party would not have seen this
 article but it is included here to show the scope of press coverage which their
 departure to Palestine garnered.
30 See Landy, 'Landy's reminiscences of her 1913–1915 experiences in Palestine'.
31 '*Franconia*', http://www.thegreatoceanliners.com/franconia1.html. Last accessed
 November 2016..
32 'Dinner Menu Card, Cunard Line, R M.S. Laconia, Tuesday, 8 September 1914',
 Gjenvick-Gjønvik Archives.
33 H. Szold, 'Rose Kaplan', *The Maccabæan: A Magazine of Jewish Life and Letters*,
 31, (1918) p. 37–8.
34 'Straus to Dedicate His Life to Charity', *Cleveland Jewish Chronicle*, 28
 November 1913, p.1.
35 'Will Go To Jerusalem', *The Jewish Review and Observer*, 7 February 1913,
 p. 8.
36 'A Hadassah Scrapbook', *Hadassah Magazine*, 1987, p.14, Container 1, Papers
 of Rachel Diane Landy, Western Reserve Historical Society, Cleveland, Ohio.
37 L. G. Straus, *Disease in the Remedy:The Life Work of Nathan Straus* (New York:
 E.P. Dutton & Company, 1917), p.155.
38 See Landy, 'Landy's reminiscences of her 1913–1915 experiences in Palestine'.
39 A. Dockser Marcus, *Jerusalem 1913: The Origins of the Arab-Israeli Conflict*
 (New York: Penguin, 2007) p. 4; see also Landy, 'Landy's reminiscences of her
 1913–1915 experiences in Palestine'.
40 While the nurses met Mr Ruppin and the Thons, their dinner together is not
 documented, but it is easy to imagine this took place.
41 Rae Landy, Handwritten notes on the event of the 25th anniversary of Hadassah,
 1937.
42 M. Shilo, 'Second Aliyah: Women's Experience and Their Role in the
 Yishuv', *Jewish Women: A Comprehensive Historical Encyclopedia*, 1 March
 2009. Jewish Women's Archive. <http://jwa.org/encyclopedia/article/second-
 aliyah-womens-experience-and-their-role-in-yishuv>. Last accessed 23 October
 2016.
43 A. Ruppin and A. Bein (ed.) *Arthur Ruppin: Memoirs, Diaries, Letters* (Jerusalem:
 Weidenfeld and Nicolson, 1971), p. 90.
44 See Landy, 'Landy's reminiscences of her 1913–1915 experiences in Palestine';
 see also Dockser Marcus, *Jerusalem 1913: The Origins of the Arab-Israeli
 Conflict*.

45 'Interesting Experiences of American Jewish Nurses in Jerusalem', *The Jewish Independent*, 31 October 1913, p. 4.

46 R. Thon (ed.), 'Sarah Thon' in *Jewish Women: A Comprehensive Historical Encyclopedia*, Jewish Women's Archive, March 2009. http://jwa.org/encyclopedia/article/thon-sarah. Last accessed October 2016.

47 'Life of the Jews of Eretz Yisrael 1913', film, 1913.

48 H. Szold, 'Recent Jewish Progress in Palestine' in J. Jacobs (ed.), *The American Jewish Yearbook*, 17 (Philadelphia: The Jewish Publication Society of America, 1915), p. 112.

49 See 'Interesting Experiences of American Jewish Nurses In Jerusalem' *The Jewish Independent*.

50 See Szold, 'Recent Jewish Progress in Palestine'.

51 See 'Interesting Experiences of American Jewish Nurses In Jerusalem' *The Jewish Independent*.

52 See 'Life of the Jews in Eretz Yisrael'.

53 See Landy, 'Landy's reminiscences of her 1913–1915 experiences in Palestine'.

54 E. Leon, 'Rose Kaplan: An Appreciation', 2 August 1917, Box 1, Folder 4, Rachel Diane Landy Papers, 1913–99, Western Reserve Historical Society Archives, Cleveland, Ohio.

55 The school put on concerts quite often but there is no documentation that the nurses attended a concert that day.

56 'History of Shulamit Conservatory (1910)' Ron Shulamit Conservatory website: ronshulamit.org. Last accessed October 2016.

57 R. Jacobs, '1st visit to Palestine' (New York and Boston: Hadassah, the Women's Zionist Organization of America Newsletters), RG 19—Microforms, 1914, Hadassah Archives, American Jewish Historical Society.

58 See Landy, 'Landy's reminiscences of her 1913–1915 experiences in Palestine'.

59 S. Wise, *Challenging Years: The Autobiography of Stephen Wise* (New York: G.P. Putnam's Sons, 1949) p. 42.

60 See Landy, 'Landy's reminiscences of her 1913–1915 experiences in Palestine'.

61 J. Abrams, 'The Hadassah', *The Canadian Jewish Chronicle*, 9 July 1920, p. 14.

62 Contemporary analysis concludes actual figures are undetermined, but see for example, C. Emmerson, '1913: In Search of the World Before the Great War', *Public Affairs*, 2013; H. Szold, 'Recent Jewish Progress in Palestine'; L.S. Schor, *The Best School in Jerusalem: Annie Landau's School for Girls, 1900–1960* (Waltham, Massachusetts: Brandeis, 2013), p. 73.

63 Seligsberg, Alice, 'Our Own Interpretation', RG19-Microforms 1914-, Hadassah Archives, American Jewish Historical Society, New York, NY and Boston MA., p.6.

64 'Jews Raise Funds to Aid the Yemenites', *The Jewish Review and Observer*, Cleveland, Ohio, 7 March 1913, p. 5.

65 See Landy, 'Landy's reminiscences of her 1913–1915 experiences in Palestine'.

66 *Ibid.*

67 See Jacobs, '1st visit to Palestine'.
 While this passage was written by Rose Jacobs a year later, it is placed here to illustrate how visitors felt upon seeing Jerusalem.

68 See Szold, 'Recent Jewish Progress in Palestine'.

69 See Levin and Kustanowitz, *It Takes a Dream: The Story of Hadassah*, p. 43.

70 JDC Archives, Records of the New York Office of the American Jewish Joint Distribution Committee, 1914–18, AC2132, file 322, 'Summarized Report of Nathan Straus Soup Kitchen', pp. 30–1.

71 'Extracts From The Nurses' Letters', *Hadassah Bulletin*, 1, 3, 30 October 1914 (New York, NY and Boston, MA: Hadassah, the Women's Zionist Organization of America Newsletters), RG17, Hadassah Archives, American Jewish Historical Society.

72 See 'Miss Gottheil Back From the Holy Land'.

73 See Jacobs, '1st visit to Palestine'.

74 See 'Miss Gottheil Back From the Holy Land'.

75 *Ibid.*

76 *Ibid.*

77 'Charity at Home', *Jewish Philanthropist*, 7, 1907 (15 November 1913), p. 11.

78 See Jacobs, '1st visit to Palestine'.

79 'News Notes', *Public Health Nurse Quarterly*, 5, 3 (National Organization for Public Health Nursing), July 1913, p. 124.

80 E. Simmons, *Hadassah and the Zionist Project* (Lanham, Maryland: Rowman & Littlefield, 2006), p. 16.

81 See 'Miss Gottheil Back From the Holy Land'.

82 See Landy, 'Landy's reminiscences of her 1913–1915 experiences in Palestine'.

83 *Ibid.*

84 *Ibid.*

85 *Ibid.*

86 Letter from Rose Kaplan to Mount Sinai Alumnae Association, 30 October 1913, *Mount Sinai Alumnae News*, January 1914, pp.1–3.

87 See Landy, 'Landy's reminiscences of her 1913–1915 experiences in Palestine'.

88 See 'Miss Gottheil Back From the Holy Land'.

89 See Jacobs, '1st visit to Palestine'.

90 See 'Extracts From The Nurses' Letters', *Hadassah Bulletin*, 1, 3, 30 October 1914.

91 See Landy, 'Landy's reminiscences of her 1913–1915 experiences in Palestine'.

92 See Abrams, 'The Hadassah'.

93 See Landy, 'Landy's reminiscences of her 1913–1915 experiences in Palestine'.

94 Invitation to lunch, written on Evelina de Rothschild School letterhead, signed, 'Love, Us', Box 1, Folder 4, Papers of Rae Landy, Western Reserve Historical Society, Cleveland, Ohio.

95 See Landy, 'Landy's reminiscences of her 1913–1915 experiences in Palestine'.

96 H. Friedenwald, 'The Ophthalmias of Palestine', *Transactions of the American Ophthalmological Society Fifty-First Annual Meeting* (New London, Connecticut: American Ophthalmological Society, 1915), pp. 272–3.

97 *Ibid.*

98 See Abrams, 'The Hadassah'.

99 *Ibid.*

100 See Landy, 'Landy's reminiscences of her 1913–1915 experiences in Palestine'.

101 *Ibid.*

102 *Ibid.*

103 *Ibid.*

104 See Wise, *Challenging Years: The Autobiography of Stephen Wise*, p. 49.

105 See Benson, *As We See Ourselves*, p.43.

106 *HaTzvi*, Jerusalem, 2 May 1913.

107 See 'Miss Gottheil Back From the Holy Land'.

108 See 'Extracts From Nurses' Letters', *Hadassah Bulletin*, 1, 3, 30 October1914.

109 See Friedenwald, 'The Ophthalmias of Palestine', p.275.

110 'Dr Helena Kagan interview', Hadassah, the Women's Zionist Organization of America, RG18-Audio RTR-B8-1, Hadassah Archives, American Jewish Historical Society, New York, 6 August 1961.

111 H. Friedenwald, 'The Sanitary Problems of Palestine', *Kadimah*, 1 (1918), p.61.

112 See 'Extracts From The Nurses' Letters', *Hadassah Bulletin*, 1, 3, 30 October 1914.

113 M. Rosenthal (ed.) *A Tapestry of Hadassah Memories* (North Carolina: Town House Press, 1994), p.11–12.

114 See Jacobs, '1st visit to Palestine'.

115 'Report of the Sixteenth Annual Convention of the Federation of American Zionists, Cincinnati, Ohio', *The Maccabaean: A Magazine of Jewish Life and Letters*, 23, 7 (July 1913), p. 204.

116 'Much Misery In Jerusalem Found By The Nurses Of the Daughters of Zion', *Jewish Independent*, Cleveland, OH, 25 December 1913, p.6.

117 *Ibid.*

118 See 'Miss Gottheil Back From the Holy Land'.

119 See Straus, *Disease in the Remedy: The Life Work of Nathan Straus*.

120 *Ibid.*

121 See 'Miss Gotthiel Back From the Holy Land'.

122 'Letter to Alice Seligsberg from Henrietta Szold, August 17 and 21, 1914', The Alice L. Seligsberg and Rose G. Jacobs Papers in the Hadassah Archives 1918–57, RG19-Microforms 1914-, Hadassah Archives, American Jewish Historical Society, New York, NY and Boston MA;see also H. Szold, 'Rose Kaplan', *The Maccabæan: A Magazine of Jewish Life and Letters*, 31 (1918), pp. 37–8.

123 See 'Miss Gottheil Back From the Holy Land'.

124 See Jacobs, '1st visit to Palestine'.

125 J. Sampter, *Guide to Zionism* (New York: Zionist Organization of America, 1920), p.175.

126 *The Struggle for the Hebrew Language in Palestine* (Actions Committee of the Zionist Organization, 1914), pp.40–2.

127 See '*The Struggle for the Hebrew Language in Palestine*', pp.40–2.

128 A. Ruppin, *Arthur Ruppin: Memoirs, Diaries, Letters* (London and Jerusalem: Weidenfeld and Nicolson, 1971), p.131.

129 'Ottoman Government Says "Turkish, Arabic, or Hebrew"', *Jewish Independent*, Cleveland, Ohio, 16 January 1914, p.1.

130 'The first airplane lands in the Holy Land (Turkish Palestine)', 27December 1913.http://www.iaf.org.il/2962-20686-en/IAF.aspx.Last accessed October 2016.

131 'The Jewish Nation', *The Jewish Review and Observer*, Cleveland, Ohio, 1 August 1913, p.6.

132 'Proceedings of the Seventeenth Annual Convention of the American Nurses Association Held at the Planters Hotel St. Louis, Missouri April 23–29, 1914',

The American Journal of Nursing, 14, 10 (Lippincott Williams and Wilkins), July 1914, pp.870–2.

133 See Jacobs, '1st visit to Palestine'.
134 *Ibid.*
135 'In Jerusalem', *The Jewish Independent*, Cleveland, Ohio, 27 March 1914, p.1.
136 See Ruppin, '*Arthur Ruppin: Memoirs, Diaries, Letters*', pp. 116–18.
137 See Jacobs, '1st visit to Palestine'.
138 *Ibid.*
139 See Sampter, *Guide to Zionism*', pp. 178–9.
140 See Jacobs, '1st visit to Palestine'.
141 *Ibid.*
142 'Daughters of Zion of America', *The Maccabaean: A Magazine of Jewish Life and Letters*, 25, 1 (July 1914) pp.9–14.
143 See Landy, 'Landy's reminiscences of her 1913–1915 experiences in Palestine'.
144 'Jerusalem's Ancient Walls to be Pulled Down', *Jewish Review and Observer*, 24 July 1914, p.5.
145 H. Szold, 'Recent Jewish Progress in Palestine' in J. Jacobs (ed.), *The American Jewish Yearbook*, 17 (Philadelphia: The Jewish Publication Society of America, 1915), p.76.
146 Henry Morgenthau Diary, 2 April 1914, Henry Morgenthau Sr, MSS, Library of Congress.
147 Henry Morgenthau Diary, 4 April 1914, Henry Morgenthau Sr, MSS, Library of Congress.
148 'U. S. Ambassador to Turkey Tells of Recent Interesting Visit to the Holy Land', *Jewish Criterion*, 38, 24 (17 July 1914), p.7.
149 'Jerusalem to Be Thoroughly Modernized', *The Jewish Review and Observer*, Cleveland, Ohio, Friday 24 July 1914, p.5.
150 'Cleveland Daughters of Zion to Increase Activity; Ruth Chapter Progressing' *The Maccabaean: A Magazine of Jewish Life and Letters*, 24, 5, New York (May 1914), p.158.
151 'Hadassah Lifts Up the Wretched', *The Jewish Independent*, Cleveland, Ohio, 8 January 1915, p.1.
152 M. Beilis and S. Schwartz (eds), *Scapegoat on Trial: The Story of Mendel Beilis* (New York: CIS Publishers, 1992).
153 *Ibid.*
154 J.A. DeNovo, *American Interests and Policies in the Middle East: 1900–1939* (Minneapolis: University of Minnesota Press, 1963), p.169.
155 'Dr Helena Kagan interview', Hadassah, the Women's Zionist Organization of America, RG18-Audio RTR-B8-1, Hadassah Archives, American Jewish Historical Society, New York, 6 August 1961.
156 See Friedenwald, 'The Sanitary Problems of Palestine', p.65.
157 See 'Extracts From The Nurses' Letters', *Hadassah Bulletin,* 1, 3, 30 October 1914.
158 See 'Extracts From The Nurses' Letters', *Hadassah Bulletin,* 1, 1, 10 September 1914 (New York, NY and Boston, MA: Hadassah, the Women's Zionist Organization of America Newsletters), RG17, Hadassah Archives, American Jewish Historical Society.
159 See 'Extracts From The Nurses' Letters', *Hadassah Bulletin,* 1, 3, 30 October 1914.

160 H.H. Cohen, 'Our Palestine Letter', *The Maccabæan: A Magazine of Jewish Life and Letters*, 25, 2 (August 1914), p. 71.

161 H. Friedenwald, 'The Ophthalmias of Palestine', p. 264.

162 See 'Extracts From The Nurses' Letters', *Hadassah Bulletin*, 1, 1, 10 September 1914. 163 See 'Extracts From The Nurses' Letters', *Hadassah Bulletin*, 1, 3, 30 October 1914.

164 See 'Extracts From The Nurses' Letters', *Hadassah Bulletin*, 1, 1, 10 September 1914.

165 *Ibid.*

166 *Ibid.*

167 *Ibid.*

168 *Ibid.*

169 G. Shafir, *Land, Labor and the origins of the Israeli-Palestinian conflict 1882–1914* (Cambridge:Cambridge University Press, 1989), pp. 42–3.

170 'The Methods of Zionist Colonisation', *The Maccabæan: A Magazine of Jewish Life and Letters,* 24, 5 (May 1914), p.155.

171 See Ruppin, '*Arthur Ruppin: Memoirs, Diaries, Letters*', p.147.

172 See 'The Palestine Land Development Company'.

173 'Jews Raise Funds to Aid the Yemenites', *The Jewish Review and Observer*, Cleveland, Ohio, 7 March 1913, p.5.

174 See Sampter, *Guide to Zionism*, p.175.

175 See Shafir, *Land, Labor and the origins of the Israeli-Palestinian conflict 1882–1914*, p.45.

176 See Sampter, *Guide to Zionism*', pp. 166–7.

177 *Ibid.*

178 H. Szold, 'Recent Jewish Progress in Palestine' in J. Jacobs (ed.), *The American Jewish Yearbook*, 17, (Philadelphia: The Jewish Publication Society of America, 1915), p. 29.

179 'Dr Steinback Enthusiastic About Palestine', *The Maccabæan: A Magazine of Jewish Life and Letters,* 22, 2 (August 1912), pp 43–4.

180 See Szold, 'Recent Jewish Progress in Palestine', p. 93.

181 See Sampter, *Guide to Zionism*', p.170.

182 A. Dockser Marcus, *Jerusalem 1913: The Origins of the Arab-Israeli Conflict* (New York: Penguin, 2007).

183 'Turkish Officials and Jewish Colonization in Palestine', *The Maccabaean: A Magazine of Jewish Life and Letters*, 24, 5, New York (May 1914), p.154.

184 R. Mazza, *Jerusalem from the Ottomans to the British* (London, New York: I.B. Tauris, 2009) p. 28.

185 See 'Turkish Officials and Jewish Colonization in Palestine' p.155.

186 'Governor of Jerusalem Defends Jews', *The Jewish Independent*, Cleveland, Ohio, 26 June 1914, p. 6.

187 *Ha'Or*, 24 July 1914.

188 See 'Jerusalem to Be Thoroughly Modernized'.

189 See 'Extracts from the nurses' letters', *Hadassah Bulletin*, 1, 3, 30 October 1914.

190 *Ibid.*

191 'Zionist Convention', *Jewish Criterion*, 38, 2, 3 July 1914, p.11.

192 'Seventeenth Annual Convention of the Federation of American Zionists', *The Maccabaean: A Magazine of Jewish Life and Letters*, 25, 1 (July 1914), p.24.

193 *Ha'Or*, 14 July 1914.
194 'The Effects of the European War on Palestine', *The Maccabaean: A Magazine of Jewish Life and Letters*, 25, 3 (September 1914), pp.111–12.
195 See Mazza, *Jerusalem from the Ottomans to the British*, p.116.
196 See 'The Effects of the European War on Palestine'.
197 A. Jacobson, 'A City Living through Crisis: Jerusalem during World War I', *British Journal of Middle Eastern Studies*, 36, 1 (2009), pp.73–92.
198 See Mazza, *Jerusalem from the Ottomans to the British*, p.23.
199 'Extracts From Nurses' Letters', *Hadassah Bulletin*, 1, 4, 23 November 1914 (New York, NY and Boston MA: Hadassah, the Women's Zionist Organization of America Newsletters), RG17, Hadassah Archives, American Jewish Historical Society.
200 'Turkish forces mobilizing in Palestine to engage British forces at the Suez Canal in Egypt during World War I', film, Palestine 1914.
201 See 'Extracts From The Nurses' Letters', *Hadassah Bulletin*, 1, 4, 23 November 1914.
202 'Bezalel Closed By War', *The Jewish World*, 28 September 1914, p.6.
203 *Ibid.*
204 See 'Extracts From The Nurses' Letters', *Hadassah Bulletin*, 1, 4, 23 November 1914.
205 See 'Bezalel Closed By War'.
206 See 'Extracts From The Nurses' Letters', *Hadassah Bulletin*, 1, 4, 23 November 1914.
207 *Ibid.*
208 See 'The Effects of the European War on Palestine', p.112.
209 See 'Extracts From The Nurses' Letters', *Hadassah Bulletin*, 1, 4, 23 November 1914.
210 *Ibid.*
211 *Ibid.*
212 *Ibid.*
213 See 'The Effects of the European War on Palestine', p. 112.
214 *Ha'Or*, 18 September 1914.
215 *Ibid.*
216 *HaPoel HaTzair*, 27 August 1914.
217 'Telegram correspondence between Jacob Schiff, AJC Executive Committee, and U.S. Ambassador to Turkey Henry Morgenthau, August 31, 1914', F-15, American Jewish Committee Archives, New York.http://www.ajcarchives.org/AJC_DATA/Files/F-15.PDF.
218 'Jacob Schiff, AJC Executive Committee, to AJC President Louis Marshall. Attached is telegram correspondence between Jacob Schiff and U.S. Secretary of State W.J. Bryan', 28 August1914, American Jewish Committee Archives, New York.
219 'Letter to Louis Marshall from Henry Morgenthau, 4 September 1914. http://www.ajcarchives.org/AJC_DATA/Files/F-16.PDF.
220 Morgenthau Diary, 14 September 1914, Henry Morgenthau Sr, MSS, Library of Congress.
221 See 'Extracts From Nurses' Letters', *Hadassah Bulletin*, 1, 4, 23 November 1914.

222 *Ibid.*
223 *Ibid.*
224 *Ibid.*
225 'Henrietta Szold letter to Dr. I.J. Biskind', 9September 1914, Papers of Rachel Diane Landy, Box 1, Folder 4, Western Reserve Historical Society, Cleveland, Ohio.
226 See 'Extracts From Nurses' Letters', *Hadassah Bulletin*, 1, 4, 23 November 1914.
227 *Ibid.*
228 *Ibid.*
229 Conde de Ballobar, E.M. Moreno and R. Mazza (eds), *Jerusalem in World War I: The Palestine Diary of a European Diplomat* (London, New York: I.B. Tauris, 2011), p.8.
230 H. Ben-Yehuda, 'When the War Came to Palestine', in H. Ben Yehuda, K. Fullerton, E. Banks, J. Wardlaw-Milne, G. Robinson, J. Finley, T. Waters (eds) *Jerusalem, Its Redemption and Future; The Great Drama of Deliverance Described By Eyewitnesses* (Christian Herald, 1918), p.22.
231 See Sampter, *Guide to Zionism'*, pp. 218–9.
232 *Ha'Poel HaTzair*, 18 September 1914.
233 See Ruppin, *'Arthur Ruppin: Memoirs, Diaries, Letters'*, p. 149.
234 M. Wertheim, 'Palestine and the War: Impressions on a relief trip to the Holy Land', *The Survey*, January 1915, pp.353–60.
235 *Ibid.*
236 'D.A. Ruppin to U.S. Ambassador Henry Morgenthau', 1 October 1914, F-17, American Jewish Committee Archives, New York. http://www.ajcarchives.org/AJC_DATA/Files/F-17.PDF. Last accessed October 2016.
237 H. H. Cohn, 'Palestine and the War', *Maccabaean: A Magazine of Jewish Life and Letters*, 25, 5(November–December 1914), p.191.
238 'Extracts From The Nurses' Letters', *Hadassah Bulletin*, 1, 5, December 1914 (New York, NY and Boston MA: Hadassah, the Women's Zionist Organization of America Newsletters), RG17, Hadassah Archives, American Jewish Historical Society.
239 *Ibid.*
240 See 'Extracts From The Nurses' Letters', *Hadassah Bulletin*, 1, 5, December 1914.
241 See Wertheim, 'Palestine and the War: Impressions on a relief trip to the Holy Land'.
242 *Ibid.*
243 F. M. Warburg, Joint Distribution Committee of the American Funds for Jewish War Sufferers, 'Reports Received by the Joint Distribution Committee of Funds for Jewish War Sufferers' (New York: C. S. Nathan, Inc., 1916); also J. Jacobs (ed.), *The American Jewish Year Book 9 September 1915 to 27 September 1916*, pp. 360–4.
244 'Letter from Ruppin to Morgenthau October 1, 1914', F-17, American Jewish Committee Archives. http://www.ajcarchives.org/AJC_DATA/Files/F-17.PDF. http://www.ajcarchives.org/AJC_DATA/Files/F-17.PDF
245 See Wertheim, 'Palestine and the War: Impressions on a relief trip to the Holy Land'.

246 See 'Extracts From The Nurses' Letters', *Hadassah Bulletin*, 1, 5, December 1914.

247 'First Installment of Relief Funds Reaches Palestine', *The Jewish World*, 23 October 1914, p.8.

248 'Jewish Travellers Stopped at Jaffa', *Pittsburgh Criterion*, 9 October 1914.

249 *HaPoel HaTzair*, 20 October 1914; also 'Palestine and the War', *The Maccabaean Magazine*, 25, 5 (November–December 1914), pp.189–92.

250 See H. Ben-Yehuda, 'When the War Came to Palestine', p. 86.

251 See 'Extracts From The Nurses' Letters', *Hadassah Bulletin*, 1, 5, December 1914.

252 'Within the Ranks', *The Maccabaean Magazine*, 25, 5 (November–December 1914), p. 193.

253 *Palestine during the War: being a record of the preservation of the Jewish settlements in Palestine* (London: Zionist Organisation, 1921), p.20.

254 *Ibid.*, p.21.

255 See Sampter, *Guide to Zionism'*, pp. 220–1.

256 See *Palestine during the War: being a record of the preservation of the Jewish settlements in Palestine*, p. 20.

257 See 'Extracts From The Nurses' Letters', *Hadassah Bulletin*, 1, 5, December 1914.

258 'Palestine Faces Famine: Appeal Made to General Zionist Affairs Committee', *New York Times*, 12 January 1915.

259 *Hadassah Bulletin*, 1, 6, January 1915 (New York, NY and Boston MA: Hadassah, the Women's Zionist Organization of America Newsletters), RG17, Hadassah Archives, American Jewish Historical Society.

260 See *Palestine during the War: being a record of the preservation of the Jewish settlements in Palestine*, p.23.

261 *Ibid.*

262 *Ibid.*

263 See H. Ben-Yehuda, 'When the War Came to Palestine', p.31.

264 See Ruppin, *Arthur Ruppin: Memoirs, Diaries, Letters*, p.153.

265 See 'Reports Received by the Joint Distribution Committee of Funds for Jewish War Sufferers', pp.14–2.

266 See H. Ben-Yehuda, 'When the War Came to Palestine', p.85.

267 See Ruppin, *Arthur Ruppin: Memoirs, Diaries, Letters*, p.152.

268 '*Tennessee* Back From War Zone; Adventures of Armored Cruiser That Has Been in Troubled Waters of Turkey for Eight Months', *New York Times*, 8 August 1915.

269 See Ruppin, *Arthur Ruppin: Memoirs, Diaries, Letters*, p. 4.

270 'Extracts From The Nurses' Letters', *Hadassah Bulletin*, 1, 8, March 1915 (New York, NY and Boston MA:Hadassah, the Women's Zionist Organization of America Newsletters), RG17, Hadassah Archives, American Jewish Historical Society.

271 'Turks and Germans Expelling Zionists: Systematic Destruction of Jewish Colonies in Palestine is Alleged. 7,000 Refugees in Egypt, Eighty Thousand Expected –All Colonists Deeds Must Be Destroyed on Pain of Death', *New York Times*, 22 January 1915; see also Ruppin, *Arthur Ruppin: Memoirs, Diaries, Letters*, p.155.

272 *Ibid.*, p.154.

273 See 'Extracts From The Nurses' Letters', *Hadassah Bulletin,* March 1915.
274 *Ibid.*
275 *Ibid.*
276 See Friedenwald, 'The Ophthalmias of Palestine', p.264.
277 E. Porush (D. Cook – translator), 'Early Memories: Recollections Concerning the Settlement of Jerusalem The Old City and Its Environs During the Last Century (*Zikhronot rishonim: zikhronot al haye ha-yishuv haYerushalmi ba-ir ha-atikah umi-hutsah lah bameah ha-aharonah)*
278 See Ruppin, *Arthur Ruppin: Memoirs, Diaries, Letters,* p.154.
279 *Ibid.,* p.153.
280 *Ibid.,* p.155.
281 '*Tennessee* Back From War Zone; Adventures of Armored Cruiser That Has Been in Troubled Waters of Turkey for Eight Months', *New York Times,* 8 August 1915.
282 'Refugees on Our Warship; The *Tennessee* Lands 1, 500 from Palestine at Alexandria', *New York Times,* 22 January 1915.
283 'Refugees Left at Jaffa; *Tennessee* to Return for Them – Jason Starts Homeward', *New York Times,* 12 January 1915; also 'Jews in Flight From Palestine; Cruiser *Tennessee* Carries Refugees from Turkish Persecution to Egypt', *New York Times,* 19 January 1915.
284 A.P. Mosier, 'Service Aboard the USS *Tennessee* and *Memphis*' [related *c.* 1965–70], http://www.lookbackward.com/mosier/mosier-profiles/mosier-a/mosier-a1/. Last accessed October 2016.
285 A. Aaronsohn, *With the Turks in Palestine* (Boston, New York: Houghton Mifflin Company, 1916), p.37.
286 'Zionist Notes', *The Jewish Review and Observer,* Cleveland, Ohio, 26 March 1915, p.5.
287 'An Informer and His Principals', *TheMaccabaean: a Magazine of Jewish Life and Letters,* 27, 3 (September 1915), pp.66–7.
288 See 'Zionist Notes', 26 March 1915.
289 See Ruppin, *Arthur Ruppin: Memoirs, Diaries, Letters,* p.155.
290 *Ibid.,* p.154.
291 'Postcard From Jerusalem', *Hadassah Bulletin,* 1, 9, April 1915 (New York, NY and Boston MA: Hadassah, the Women's Zionist Organization of America Newsletters), RG17, Hadassah Archives, American Jewish Historical Society.
292 'Extracts From Miss Landy's Letters', *Hadassah Bulletin,* 1, 11, June 1915 (New York, NY and Boston MA: Hadassah, the Women's Zionist Organization of America Newsletters), RG17, Hadassah Archives, American Jewish Historical Society.
293 'Jews Send $200,000 To War Sufferers; Telegram from Secretary Bryan Tells of Destitution Among the Refugees', *New York Times,* 24 January 1915; see also 'Misery in Holy Land as a Result of War; Great Suffering Among Populace – Quarrels Between the Turks and the Germans', *New York Times,* 1 February 1915.
294 'Political Conditions in Palestine', *The Maccabæan: A Magazine of Jewish Life and Letters,* 26, 3 (March 1915), p.50.
295 B. Spafford Vester, *Our Jerusalem: An American Family in the Holy City, 1881–1949* (Garden City, NY: Doubleday and Company, 1950), p.234.
296 *Ibid.,* p.235.

297 See 'Extracts From Miss Landy's Letters', *Hadassah Bulletin*, 1, 11, June 1915.

298 Actions on the Suez Canal took place 26 January, first attack on 2 February and by 4 February it was over.

299 'War-Time Prostitution on Wane in Jerusalem', *The Social Hygiene Bulletin*, 7, 8 (August 1920), p.8.

300 *Ibid.*

301 See 'Extracts From Miss Landy's Letters', *Hadassah Bulletin*, 1, 11, June 1915.

302 *Ibid.*

303 N. Straus, *Disease in Milk: The Remedy, Pasteurization; The Life Work of Nathan Straus* (London: Dalton, 1917), pp.156–7.

304 See 'Extracts From Miss Landy's Letters', *Hadassah Bulletin*, 1, 11, June 1915.

305 *Ibid.*

306 *Ibid.*

307 See Landy, 'Landy's reminiscences of her 1913–1915 experiences in Palestine'.

308 'Zionists in Peril of Turkish Attack: Constantinople Doing its Utmost to Stir Up Feelings Against the Colonists. Arab Outrages Incited, Use of Zionist Stamps Punishable by Death–Zionism Declared Anti-Turkish Movement', *New York Times*, 2 February 1915.

309 'Reports From Individual Chapters', *Hadassah Bulletin*, 1, 7, February 1915 (New York, NY and Boston MA: Hadassah, the Women's Zionist Organization of America Newsletters), RG17, Hadassah Archives, American Jewish Historical Society, February 1915.

310 See Ruppin, *Arthur Ruppin: Memoirs, Diaries, Letters*, p.155.

311 See Aaronsohn, *With the Turks in Palestine*, p.48.

312 Papers Relating to the Foreign Relations of the United States, 1915, Supplement, the World War, Office of the Historian, U.S. Department of State, Special efforts on behalf of British, French, and Italian nationals, and of foreigners generally, in Turkey, Secretary of State to Ambassador in Turkey, File no. 367.116/309a Washington, 18 February 1915.

313 *The American Jewish Chronicle* 3, 1(11 May 1917), pp. 3, 11.

314 See Aaronsohn, *With the Turks in Palestine*, p.48.

315 'Bernstorff Defends Turks: Trouble Among Jews in Palestine Due to Overzealous Officials', *New York Times*, 9 March 1915.

316 American Jewish Yearbook colonies, 274.

317 'Extracts From Miss Landy's Letters', *Hadassah Bulletin*, 1, 8, March 1915 (New York, NY and Boston MA: Hadassah, the Women's Zionist Organization of America Newsletters), RG17, Hadassah Archives, American Jewish Historical Society.

318 *Ibid.*

319 *Ibid.*

320 'To Take Aid to Palestine; *Vulcan* will Carry Provisions and Medicine–Sails March 4 is also bringing coal to the *North Carolina* and *Tennessee*', *New York Times*, 14 February 1915; 'Relief Cargo for Jews: U.S. Collier *Vulcan* Sails from Philadelphia for Palestine Loaded with Food and clothing and flour and also supplies for USS *North Carolina* and *Tennessee*. L.H. Levine and E.W. L. Epstein were on the vessel and will direct the distribution of food', *New York Times*, 15 March 1915.

321 See 'Extracts From Miss Landy's Letters', June 1915.

322 *Ibid.*

323 *Ibid.*

324 *Ibid.*

325 See Landy, 'Landy's reminiscences of her 1913–1915 experiences in Palestine'.

326 See 'Extracts From Miss Landy's Letters', *Hadassah Bulletin*, 1, 11, June 1915.

327 Tamari, Salim, *Year of the Locust: A Soldier's Diary and the Erasure of Palestine's Ottoman Past* (Berkeley and Los Angeles: University of California Press, 2011), p.103.

328 See 'Landy's reminiscences of her 1913–1915 experiences in Palestine'.

329 See Tamari, *Year of the Locust*, p.104.

330 *Ibid.*, pp.91, 94.

331 *Ibid.*, p.97.

332 See Porush, 'Early Memories: Recollections Concerning the Settlement of Jerusalem The Old City and Its Environs During the Last Century' p.28.

333 O.A. Glazebrook, 'More Palestine Reports; Use of *Vulcan* Supplies', *Bulletin of the Joint Distribution Committee*, 1 (New York: American Jewish Joint Distribution Committee, September 1916–August 1917), p.197.

334 *The Jewish Independent*, 9 April 1915, p.6; also *The Advocate: America's Jewish Journal*, 49 (10 April 1915), p. 272.

335 'Distress in Jerusalem', *New York Times*, 23 April 1915.

336 *The Advocate: America's Jewish Journal*, 49 (29 May 1915), p.568.

337 'Matzos to be Distributed to Poor of This Country', *The Jewish Review and Observer*, 19 March 1915; also 'American Jewish Relief', *The Reform Advocate*, 27 March 1915, p. 194.

338 *The Advocate: America's Jewish Journal*, 49 (29 May 1915), p.568.

339 *The Advocate: America's Jewish Journal*, 49 (26 June 1915), p.705.

340 *Ibid.*

341 A.L. Levin, *Dare to Be Different* (New York: Bloch Publishing, 1972), pp. 165–6.

342 See Tamari, *Year of the Locust*, pp.106–8.

343 Warburg, Felix M., *Reports Received by the Joint Distribution Committee of Funds for Jewish War Sufferers* (New York: Press of C.S. Nathan, Inc., 1916), p.140.

344 Henry Morgenthau Diary, 12 May 1915, Henry Morgenthau Sr, MSS, Library of Congress.

345 'More Palestine Reports: Use of *Vulcan* Supplies', *The Bulletin of the Joint Distribution Committee*, 1, 12 (August 1917), p.196.

346 See Levin, *Dare to Be Different*, pp. 170–1.

347 Title Unknown, 'Palestine, Relief Supplies, *Vulcan* Committee, 1915–1917', item id 9041, December 31, 1918, http://search.archives.jdc.org/multimedia/Documents/NY_AR1418/00004/NY_AR1418_00908.pdf

348 'Dr Helena Kagan interview', Hadassah, the Women's Zionist Organization of America, RG18-Audio RTR-B8-1, Hadassah Archives, American Jewish Historical Society, New York, 6 August 1961.

349 American Jewish Joint Distribution Committee archives, Palestine, General, 1915.

350 See Levin, *Dare to Be Different*, p.175.
351 'Extracts From Miss Landy's Letters', *Hadassah Bulletin*, 2, 15, November 1915.
352 See Landy, 'Landy's reminiscences of her 1913–1915 experiences in Palestine'.
353 See Levin, *Dare to Be Different*, p.182.
354 *Hadassah Bulletin*, 2, 14, October 1915 (New York, NY and Boston MA: Hadassah, the Women's Zionist Organization of America Newsletters), RG17, Hadassah Archives, American Jewish Historical Society.
355 *Ibid.*
356 See Levin, *Dare to Be Different*, p.185.
357 'Across the Seas', *The Jewish Independent*, 23 July 1915, p.1.
358 'Palestine', *The Jewish Review and Observer*, 20 August 1915, p.6.
359 See Tamari, *Year of the Locust*, p.125.
360 See Landy, 'Landy's reminiscences of her 1913–1915 experiences in Palestine'.
361 'Nathan Straus donated his yacht, and will sell it and donate the proceeds to the relief of the Jews in Palestine', *New York Times*, 30 June 1915.
362 Papers Relating to the Foreign Relations of the United States, 1915, Supplement, the World War, Office of the Historian, U.S. Department of State, Special efforts on behalf of British, French, and Italian nationals, and of foreigners generally, in Turkey, Telegram from Ambassador in Great Britain (Page) to Secretary of State File No. 867.4016/115, LONDON, 4 September 1915.
363 See Papers Relating to the Foreign Relations of the United States, 1915, The Ambassador in France (Sharp) to the Secretary of State, File No. 867.4016/67, Paris, 28 May 1915.
364 See Papers Relating to the Foreign Relations of the United States, 1915, Telegram The Ambassador in Turkey to the Secretary of State, File No. 867.4016/70, Constantinople, 18 June 1915.
365 *Ibid.*
366 G.A. Schreiner, *From Berlin to Bagdad: Behind the Scenes in the Near East* (New York: Harper and Brothers, 1918), pp.200–4.
367 *Hadassah Bulletin*, 1, 12, July 1915, (New York, NY and Boston MA: Hadassah, the Women's Zionist Organization of America Newsletters), RG17, Hadassah Archives, American Jewish Historical Society.
368 'The Situation in Palestine', *The Maccabaean: A Magazine of Jewish Life and Letters*, 27, 3 (September 1915), p.78.
369 'War's Effects on Jewish Population in Jerusalem', *The Jewish Review and Observer*, 16 July 1915, p.2.
370 See *Hadassah Bulletin*, 1, 12, July 1915.
371 'Extracts From Miss Landy's Letters', *Hadassah Bulletin*, 2, 15, November 1915.
372 See Papers Relating to the Foreign Relations of the United States, File No. 867.4016/74 Ambassador in Turkey to Secretary of State, 10 July 1915.
373 *Ibid.*
374 'Miss Theresa Dreyfus of New York recently returned from Jerusalem', *New York Times*, 16 August 1915.
375 See *Hadassah Bulletin*, 2, 15, November 1915.
376 See 'Extracts From Miss Landy's Letters', *Hadassah Bulletin*, 2, 15, November 1915.
377 See *Hadassah Bulletin*, 2, 15, November 1915.
378 *Ibid.*

379 See Landy, 'Landy's reminiscences of her 1913–1915 experiences in Palestine'.
380 See Papers Relating to the Foreign Relations of the United States, 1915, 'The Ambassador in Turkey to the Secretary of State', File No. 867.4016/96 Constantinople, 16 August 1915.
381 See *Hadassah Bulletin*, 2, 15, November 1915.
382 M. Levin, *Balm in Gilead: The Story of Hadassah* (New York: Schocken Books, 1973), p. 31.
383 See Papers Relating to the Foreign Relations of the United States, 1915, 'The Ambassador in Turkey (Morgenthau) to the Secretary of State', File No. 867.4016/117, 3 September 1915.
384 See Papers Relating to the Foreign Relations of the United States, 1915, 'Acting Secretary of State to Ambassador in Turkey' (No File Number), 22 September 1915.
385 Papers Relating to the Foreign Relations of the United States, 1915, Supplement, the World War, Office of the Historian, U.S. Department of State, Special efforts on behalf of British, French, and Italian nationals, and of foreigners generally, in Turkey, Telegram from Ambassador in Great Britain to Secretary of State File No. 867.4016/115, London, 4 September 1915.
386 See *Hadassah Bulletin*, 2, 15, November 1915.
387 'Says Turks Desire to Destroy Zionism', *New York Times*, 8 October 1915.
388 See Landy, 'Landy's reminiscences of her 1913–1915 experiences in Palestine'.
389 *Ibid.*
390 'Says Turks Desire to Destroy Zionism', *New York Times*, 8 October 1915.
391 *Hadassah Bulletin*, 2, 14, October 1915 (New York, NY and Boston, MA: Hadassah, the Women's Zionist Organization of America Newsletters), RG17, Hadassah Archives, American Jewish Historical Society.
392 See *Hadassah Bulletin*, 2, 15, November 1915.
393 World War I: Nurses, *History of the U.S. Army Nurse Corps*, http://www.womensmemorial.org/H&C/History/wwi(nurses).html.Last accessed November 2016.
394 *Ibid.*, p.92.
395 *Ibid.*, p. 98.
396 Dennis, Ida *The Way of Democracy* (New York: MacMillan Company, 1940).
397 'Between World Wars', *American Military History* (Washington, DC: Center of Military History, United States Army, 1989), http://www.army.mil/cmh-pg/books/AMH/amh-19.htm page updated 27 April 2001. Last accessed November 2016.
398 Letter from Colonel Miner F. Felch, Box 1, Folder 4, Rachel Diane Landy Papers, 1913–99, Western Reserve Historical Society Archives, Cleveland, Ohio.
399 M.T. Sarnecky, *A History of the U.S. Army Nurse Corps* (Philadelphia: University of Pennsylvania Press, 1999).
400 Personal correspondence from Walter Reed Hospital historian, January 2005; Judy Bellafaire, Ph.D., Chief Historian, Women's Memorial, via personal email correspondence, December 2004.
401 Author's conversation with Evelyn Rosenblum, 2004.
402 E.M. Norman, *We Band Of Angels: The Untold Story of American Nurses Trapped on Bataan by the Japanese* (New York: Pocket Books, A Division of

Simon and Schuster, 1999). Digital version: http://www.worldwar2history.info/Army/nurses/Philippines.html. Last accessed October 2016.

403 *Ibid.*
404 *Ibid.*
405 *Ibid.*
406 *Ibid.*
407 Commendation letter from U.S. Army, Rae Landy Box 1, Folder, Western Reserve Historical Society.
408 Arlington National Cemetery, 'Prominent Jewish Figures', http://www.arlingtoncemetery.mil/Explore/Notable-Graves/Minorities/Prominent-Jewish-Members. Last accessed November 2016.
409 Personal interview with the author.
410 Personal interview with the author.
411 See Landy, 'Landy's reminiscences of her 1913–1915 experiences in Palestine'.
412 See *Hadassah Bullet in*, 2, 14, October 1915.
413 H. Szold, 'Rose Kaplan', *The Maccabæan: A Magazine of Jewish Life and Letters*, 31 (1918) p. 37–8.
414 E. Leon, 'Rose Kaplan: An Appreciation', 2 August 1917, Box 1, Folder 4, Rachel Diane Landy Papers, 1913–99, Western Reserve Historical Society Archives, Cleveland, Ohio.
415 See Landy, 'Landy's reminiscences of her 1913–1915 experiences in Palestine'.
416 See Landy, 'Landy's reminiscences of her 1913–1915 experiences in Palestine'.

Bibliography

Books and Journals

Aaronsohn, Alexander, *With the Turks in Palestine* (Boston, New York: Houghton Mifflin, 1916).

Adams, Rebecca, 'Origins of Public Health Nursing in Israel', *Curationis*, 1, 1 (September 1978).

American Social Health Association, 'War-Time Prostitution on Wane in Jerusalem', *The Social Hygiene Bulletin*, 7, 8 (August 1920), p.8.

Benson, Evelyn R., *As We See Ourselves* (Indianapolis: Center Nursing Publishing, 2001).

Beilis, Mendel, *Scapegoat on Trial: The Story of Mendel Beilis*, S. Schwartz (ed.) (New York: CIS Publishers,1992).

Ben-Yehuda, H.,'When the War Came to Palestine' in H. Ben Yehuda, K. Fullerton, E. Banks, J. Wardlaw-Milne, G. Robinson, J. Finley, T. Waters (eds), *Jerusalem, Its Redemption and Future; The Great Drama of Deliverance Described By Eyewitnesses* (New York: Christian Herald, 1918).

Bryce, James (Viscount) and Arnold Toynbee, *The Treatment of Armenians in the Ottoman Empire, 1915–1916: Documents Presented to Viscount Grey of Falloden by Viscount Bryce*, (Reading, England: Taderon Press, Gomidas Institute, 2000).

Çiçek, M. Talha, *War and State Formation in Syria: Cemal Pasha's Governorate During World War I, 1914–1917* (New York: Routledge, 2014).

Conde de Ballobar, E.M. Moreno and R. Mazza (eds), *Jerusalem in World War I: The Palestine Diary of a European Diplomat* (London, New York: I.B. Tauris, 2011).

Dennis, Ida, *The Way of Democracy* (New York: MacMillan Company, 1940).

DeNovo, J.A., *American Interests and Policies in the Middle East: 1900–1939* (Minneapolis: University of Minnesota Press,1963).

Djemal Pasha, *Memories of a Turkish Statesman, 1913–1919* (New York: George H. Doran Company, 1922).

Federation of American Zionists, 'Dr. Steinback Enthusiastic About Palestine', *The Maccabæan: A Magazine of Jewish Life and Letters*, 22, 2 (August 1912), pp.43–4.

—*The Maccabaean: A Magazine of Jewish Life and Letters*, 23, 2 (February 1913), p.35.

—'The Healing of the Daughter of My People', *The Maccabaean: A Magazine of Jewish Life and Letters*, 23, 2 (February 1913), p.137.

—'Report of the Sixteenth Annual Convention of the Federation of American Zionists, Cincinnati, Ohio', *The Maccabaean: A Magazine of Jewish Life and Letters*, 23, 7 (July 1913), p. 204.

—'The Methods of Zionist Colonisation',*The Maccabæan: A Magazine of Jewish Life and Letters*, 24, 5 (May 1914), p.155–8.

—'Turkish Officials and Jewish Colonization in Palestine', *The Maccabaean: A Magazine of Jewish Life and Letters*, 24, 5 (May 1914), p.154.

—'Daughters of Zion of America', *The Maccabaean: A Magazine of Jewish Life and Letters*, 25, 1 (July 1914) pp.9–14.

—'Seventeenth Annual Convention of the Federation of American Zionists', *The Maccabaean: A Magazine of Jewish Life and Letters*, 25, 1 (July 1914), p. 24.

— Cohen, Helene Hanna, 'Our Palestine Letter', *The Maccabæan: A Magazine of Jewish Life and Letters*, 25, 2 (August 1914), p. 71.

—The Effects of the European War on Palestine', *The Maccabaean: A Magazine of Jewish Life and Letters*, 25, 3 (September 1914), pp.111–12.

—Cohen, Helene Hanna, 'Palestine and the War', *The Maccabæan: A Magazine of Jewish Life and Letters*, 25, 4(November–December 1914), p.191.

—'Within the Ranks', *The Maccabæan: A Magazine of Jewish Life and Letters*, 25,5 November–December 1914, p. 193.

—Political Conditions in Palestine', *The Maccabæan: A Magazine of Jewish Life and Letters*, 26, 3 (March 1915), p.50.

—'An Informer and His Principals', *The Maccabaean: a Magazine of Jewish Life and Letters*, 27, 3 (September 1915), p. 65.

—'The Situation in Palestine', *The Maccabaean: a Magazine of Jewish Life and Letters*, 27, 3 (September 1915), p.78.

—'Reports From Zionist Centers', *The Maccabaean*, 27, 6 (December 1915), p. 159.

—'News From Palestine', *The Maccabaean*, 27, 6 (December 1915), p. 157.

—Szold, Henrietta, 'Rose Kaplan', *The Maccabæan: A Magazine of Jewish Life and Letters*, 31 (February 1918), pp. 37–8.

Friedenwald, Dr Harry, 'The Ophthalmias of Palestine', *Transactions of the American Ophthalmological Society Fifty-First Annual Meeting* (New London, Connecticut: American Ophthalmological Society, 1915).

Friedenwald, Dr Harry, 'The Sanitary Problems of Palestine', *Kadimah* (1918), p.65.

Friedman, Isaiah, *Germany, Turkey, and Zionism 1897–1918* (New Brunswick NJ and London: Transaction Publishers, 1997).

Gilbert, Martin, *Jerusalem in the 20ᵗʰ century* (New York: John Wiley and Sons, 1996).

Glazebrook, O.A., 'More Palestine Reports; Use of Vulcan Supplies', *Bulletin of the Joint Distribution Committee*, 1 (New York: American Jewish Joint Distribution Committee, September 1916–August 1917), p.197.

Gurock, Jeffrey S., *When Harlem was Jewish* (New York: Columbia University Press, 1979).

Jacobson, Abigail, 'A City Living through Crisis: Jerusalem during World War I', *British Journal of Middle Eastern Studies*, 36, 1 (2009), pp.73–92.

Jacobson, Abigail, *From Empire to Empire: Jerusalem Between Ottoman and British Rule* (Syracuse NY: Syracuse University Press, 2011).

Jacobson, Abigail, 'American "Welfare Politics": American Involvement in Jerusalem During World War I', *Israel Studies*, 18, 1 (Spring 2013), pp.56–75.

Kaiser, Hilmark, 'The Ottoman government and the Zionist movement during the first months of World War I' in Çiçek, M. Talha (ed.) *Syria in World War I: Politics, Economy, and Society* (New York: Routledge, 2015).

Kaplan, Rose, 'Letter from Rose Kaplan to Mount Sinai Alumnae Association 30 October, 1913', *Mount Sinai Alumnae News* (January 1914).

Levin, Alexandra Lee, *Dare to Be Different* (New York: Bloch Publishing, 1972).

Levin, Marlin, *Balm in Gilead: The Story of Hadassah* (New York: Schocken Books, 1973).

Levin, Marlin, *It Takes a Dream: The Story of Hadassah* (Jerusalem: Gefen, 2002).

Lippincott, Williams and Wilkins, 'Proceedings of the Seventeenth Annual Convention of the American Nurses Association Held at the Planters Hotel St. Louis, Missouri April 23–29, 1914', *The American Journal of Nursing*, 14, 10 (July, 1914), pp.870–2.

Ludke, Tilman, 'Loyalty, Indifference, Treason: The Ottoman-German Experience in Palestine during World War I' in Haim Goren, Eran Dolev and Yigal Sheffy (eds) *Palestine and World War I: Grand Strategy, Military Tactics and Culture in War* (London: I.B.Tauris, 2014).

Marcus, Amy Dockser, *Jerusalem 1913: The Origins of the Arab-Israeli Conflict* (New York: Viking, 2007).

Matossian, Bedross Der, 'The Armenians of Palestine 1918–48', *Journal of Palestine Studies* 41,1 (Autumn 2011), pp. 24–44.

Mazza, Roberto, *Jerusalem: From the Ottomans to the British* (London, New York: I.B. Tauris, 2009).

Miller, D. H., *History of Hadassah: 1912–1935* (Unpublished Doctoral Thesis, 1968).

Morgenthau, Henry, *Ambassador Morgenthau's Story* (New York: Doubleday, 1918).

Morgenthau, Henry, *All in a Lifetime* (New York: Doubleday, 1922).

Mosier, Alvin P., 'Service Aboard the USS *Tennessee* and *Memphis*', Personal narrative, related *c.* 1965–70. http://www.lookbackward. com/mosier/mosier-profiles/mosier-a/mosier-a1/. Last accessed October 2016.

Norman, Elizabeth M., *We Band Of Angels: The Untold Story of American Nurses Trapped on Bataan by the Japanese* (New York: Pocket Books, A Division of Simon and Schuster,1999).

Porush, Eliyahu, D. Cook (translator), *Early Memories: Recollections Concerning the Settlement of Jerusalem The Old City and Its Environs During the Last Century (Zikhronot rishonim : zikhronot al haye ha-yishuv haYerushalmi ba- ir ha- atikah umi-hutsah lah bame ah ha-aharonah)* (Jerusalem: Solomon Press, 1963).

Powers, Tom, 'Jerusalem's American Colony and Its Photographic Legacy' (self-published: 2009). http://israelpalestineguide.files.word press.com/2009/12/jerusalems_american_colony-_its_photographic_legacy.pdf. Last accessed July 2016.

Rosenthal, Miriam (ed.), *A Tapestry of Hadassah Memories* (North Carolina: Town House Press, 1994).

Rubinstein, Judah, *Merging Traditions: Jewish Life in Cleveland* (Kent, Ohio: The Kent State University Press, 2004).

Ruppin, Arthur , *'Arthur Ruppin: Memoirs, Diaries, Letters'* (London and Jerusalem: Weidenfeld and Nicolson, 1971).

Sampter, Jessie Ethel, *A Guide to Zionism* (London: Forgotten Books, 2013). Original work published pre-1945, year unknown.

Sarnecky, Mary T., *A History of the U.S. Army Nurse Corps* (Philadelphia: University of Pennsylvania Press, 1999).

Schor, Laura S., *The Best School in Jerusalem: Annie Landau's School for Girls, 1900–1960*, (Waltham, MA: Brandeis University Press, 2013).

Schreiner, George Abel, *From Berlin to Bagdad: Behind the Scenes in the Near East* (New York: Harper and Brothers, 1918).

Shafir, Gideon, *Land, Labor and the origins of the Israeli-Palestinian conflict 1882–1914* (Cambridge: Cambridge University Press, 1989).

Shandler, Jeffrey and Beth S. Wenger (eds) *Encounters with the Holy Land: Place, Past and Future in American Jewish Culture* (Philadelphia: National Museum of American Jewish History, University of Pennsylvania, 1997).

Simmons, Erica, *Hadassah and the Zionist Project* (Lanham, MD: Roman and Littlefield Publishers, 2006).

Straus, Lina Gutherz, *Disease in the Remedy: The Life Work of Nathan Straus*, Second Edition (New York: E.P. Dutton and Company, 1917).

Sussman, Lance J. *New York Jewish History* (Binghamton, NY: Department of History, Binghamton University State University of New York, or the New York State Archives, A Division of the State Education Department, Albany, New York).

Szold, Henrietta, 'Recent Jewish Progress in Palestine' in J. Jacobs (ed.),*The American Jewish Yearbook*, 17 (Philadelphia: The Jewish Publication Society of America,1915).

Tamari, Salim, *Year of the Locust: A Soldier's Diary and the Erasure of Palestine's Ottoman Past* (Berkeley and Los Angeles: University of California Press, 2011).

Vester, Bertha Spafford, *Our Jerusalem: An American Family in the Holy City, 1881–1949* (Garden City, NY: Doubleday and Company, 1950).

Warburg, Felix M., *Reports Received by the Joint Distribution Committee of Funds for Jewish War Sufferers* (New York: Press of C.S. Nathan, Inc., 1916).

Warburg, Felix M., *The Bulletin of the Joint Distribution Committee Representing American Jewish Relief Committee of the American Funds for Jewish War Sufferers*, 1 (September 1916–August 1917).

Wertheim, Maurice, 'Palestine and the War: Impressions on a relief trip to the Holy Land', *The Survey* (January 1915), pp.353–60.

Wigoder, Geoffrey (ed.) *American Jewish Memoirs: Oral Documentation* (Jerusalem: Hebrew University of Jerusalem, 1980).

Wilner, Joseph A., *Why! Woodrow Wilson Should Receive the Undivided Support of Every Jew in America* (London: Forgotten Books, 2003). (Original work published 1916).

Wise, Stephen, *Challenging Years: The Autobiography of Stephen Wise* (New York: G.P. Putnam's Sons, 1949).

Zionist Organization, *The Struggle for the Hebrew Language in Palestine* (London, 1914).

Zionist Organization, *Palestine during the war: being a record of the preservation of the Jewish settlements in Palestine* (London,1921).

Archival Sources

American Jewish Historical Society

R.D. Landy, 'Landy's reminiscences of her 1913–1915 experiences in Palestine', 1937, Lt. Col. Rachel Diane (Rae) Landy Papers; P-785; box 1; folder 4; American Jewish Historical Society, New York, NY, and Boston, MA.

'Accounting of Mrs Jacobs First Voyage to Palestine – 1914' The Alice L. Seligsberg and Rose G. Jacobs Papers in the Hadassah Archives 1918–1957. RG19-Microforms 1914-, Hadassah Archives, American Jewish Historical Society, New York, NY and Boston MA.

'Letter to Alice Seligsberg from Henrietta Szold, August 21, 1914', The Alice L. Seligsberg and Rose G. Jacobs Papers in the Hadassah Archives 1918 –1957, RG19-Microforms 1914-, Hadassah Archives, American Jewish Historical Society, New York, NY and Boston MA.

'Letter to Alice Seligsberg from Henrietta Szold, August 17, 1914', The Alice L. Seligsberg and Rose G. Jacobs Papers in the Hadassah Archives 1918 –1957, RG19-Microforms 1914-, Hadassah Archives, American Jewish Historical Society, New York, NY and Boston MA.

Seligsberg, Alice, 'Our Own Interpretation', RG19-Microforms 1914-, Hadassah Archives, American Jewish Historical Society, New York, NY and Boston MA.

'Dr. Helena Kagan interview', 6 August 1961, Hadassah, the Women's Zionist Organization of America, RG18-Audio RTR-B8-1, Hadassah Archives, American Jewish Historical Society, New York.

Hadassah, the Women's Zionist Organization of America Newsletters, RG17, Printed Material, Hadassah Archives, American Jewish Historical Society, New York, NY and Boston MA.

—Hadassah Bulletin, 1, 1 (September 10 1914).
—Hadassah Bulletin, 1, 2 (September 28 1914).
—Hadassah Bulletin, 1, 3 (October 30 1914).
—Hadassah Bulletin, 1, 4 (November 23 1914).
—Hadassah Bulletin, 1, 5 (December 1914).
—Hadassah Bulletin, 1, 6 (January 1915).
—Hadassah Bulletin, 1, 7 (February 1915).
—Hadassah Bulletin, 1, 8 (March 1915).
—Hadassah Bulletin, 1, 9 (April 1915).
—Hadassah Bulletin, 1, 10 (May 1915).
—Hadassah Bulletin, 1, 11 (June 1915).
—Hadassah Bulletin, 1, 12 (July 1915).
—Hadassah Bulletin, 2, 14 (October 1915).
—Hadassah Bulletin, 2, 15 (November 1915).

Joint Distribution Committee Archives

Accessed online
RG-4-12, Series 1, File 120.1 Palestine, Relief Supplies Reports, 1914.
—File 120.2 Palestine, General, 1914.
—File 120.3 Palestine, General, 1915.
—File 125 Palestine, Relief Supplies, Vulcan Committee, 1915–17.

Library of Congress

Henry Morgenthau Diary, April 2, 1914, Henry Morgenthau Sr, MSS, Library of Congress.

Henry Morgenthau Diary, April 4, 1914, Henry Morgenthau Sr, MSS, Library of Congress.

Henry Morgenthau Diary, May 12, 1915, Henry Morgenthau Sr, MSS, Library of Congress.

Henry Morgenthau Diary, September 14, 1914, Henry Morgenthau Sr, MSS, Library of Congress.

Western Reserve Historical Society Archives, Cleveland, Ohio

Leon, Eva, 'Rose Kaplan: An Appreciation', 2 August 1917, Box 1 Folder 4, Rachel Diane Landy Papers, 1913–99.

'Letter from Colonel Miner F. Felch', Box 1, Folder 4, Rachel Diane Landy Papers, 1913–99, Western Reserve Historical Society Archives, Cleveland, Ohio.

Gjenvick-Gjønvik Archives

Accessed online:http://www.gjenvick.com
—'Dinner Menu Card, Cunard Line, R M.S. Laconia, Tuesday, 8 September 1914'.
—'Vintage Brochure – Cunard Line – RMS Franconia and Laconia (1912)', Undated, but believed to be 1912.

Film

Accessed online:
'Turkish forces mobilizing in Palestine to engage British forces at the Suez Canal in Egypt during World War I'(Palestine 1914), film. www.criticalpast.com. Last accessed July 2016.

Sokolovshy, Noah, 'Life of the Jews of Eretz Yisrael 1913' (1913), film.https://www.youtube.com/watch?v=EFD_o0-1QbQ. Last accessed July 2016.

Index

Aaronsohn, Aaron, 82, 83, 98, 99, 127, 131, 167, 168
Aaronsohn, Alexander, 159-160
Abraham and Straus, 11
Addams, Jane, xii, 59, 60
Alexandria, Egypt, 3, 22, 23, 139, 143, 151, 152, 153, 154, 159, 168, 173, 181, 185, 191, 196, 205, 206
Alliance Israelite Universelle, 31, 52, 95, 170
American Jewish (War) Relief Committee, 153, 163, 172, 173, 176, 177, 179, 183
American Jewish Committee, 118, 119, 137
American Joint Distribution Committee, 174
Anglo-Palestine Bank, 32, 35, 37, 98, 116, 126, 153, 155, 163
Antwerp, Belgium, 198
Armenians, 137, 152, 183-185, 189, 191, 192, 194, 196
Attending Surgeon's Office White House, 199
Auguste Victoria, 68
Austria-Hungary Empire, 109

Barnier, Joseph, 76
Baha-ad-Din, kaimakam of Jaffa, 134, 138, 142-143, 147-148, 155, 160-161
Behar, Nissim, 170
Beilis, Mendel, 90-91
Ben Yehuda, Eliezer, 109
Bezalel, 34, 49, 113-114, 117
Biskind, Dr. Isidore and Kate, 89, 121
Blood libel, 90
Bonnier, Marc, 76
Brandeis, Louis, 137
Bruenn, Dr. Wilhelm, 37, 44, 116
Bryan, William Jennings, 118, 119, 160, 183, 184
Bukharan Jews, 84

California Express, 201-202
Capitulations, 125
Chalutzim, 78, 99, 137
Chester, USS, 192, 193, 194, 196
Chicago, Jews raising money for nurses, 12, 20
Cisterns, 39, 61
Cleveland Clinic, 13

Cleveland College of Physicians and Surgeons, 13
Cleveland, Ohio, xi, xiii, xiv, 9, 13-17, 20, 42, 71, 77, 78, 89, 100, 101, 104, 121, 132, 141, 159, 178
Coblenz, Germany, 198
Cohn, Ephraim, 73-74, 127, 130, 132, 153
Constantinople, 3, 116, 118, 119, 131, 134, 139, 147, 160, 184, 194
Coolidge, Calvin, Jr., 199
Coolidge, President Calvin, 199
Crile Army Hospital, 203
Crile, Dr. George, 13, 203

Daughters of Zion, xiv, 1, 7, 10, 11, 15, 35, 43, 49, 79
Decker, Captain, 143, 151, 159-160, 169, 185, 189
Diligence, 102, 181, 193
Djemal Pasha, Ahmed, 137, 139, 140, 147, 149-150, 153, 159, 160, 167, 169, 172, 174, 181, 186, 196
Dreyfus, Therese, 162, 170, 182, 189

Egypt, 22-23, 182, 205, 206
 Expulsion of Jews to, 138-139, 143, 191, 192
 Battle at Suez Canal, 141, 147, 152, 153
 And the *Vulcan*, 173, 174
Evelina de Rothschild School, 52, 56, 57, 77, 132, 161, 181, 182

Fast's Hotel, 88

Federation of American Zionists, 10, 21, 62, 95
Feigenbaum, DrArieh, 60
Felch, Colonel Miner, 198
Fort Stotsenburg, 200
Franconia, 3, 5, 18, 19, 23, 68, 195
Franz Ferdinand, Archduke, 109
Free Synagogue, 58
Friedenwald, Harry, 95-96

German soldiers in Jerusalem, 152, 156, 157, 159, 169, 189
Giza, 23
Glazebrook, Otis, 140, 153, 159, 163
 And expulsion of Jews, 139,142-143, 166-167, 170
 And The *Vulcan*, 172-174, 176-177, 183
 Impressions of Rae Landy, 179-180
 And Rae leaving Jerusalem, 187-188, 190, 191, 192
Gordon, A.D., 6, 34, 78
Governors Island, New York, 202
Grand New Hotel, 81, 82, 83

Ha'Or newspaper, 107
HaKollelim, 176, 177
Halukah, 33-34, 52, 66, 84, 118, 176
Harlem Hospital, 3, 7, 9, 14, 18
Harlem, xiv, 6, 9
HaShomer, 105, 106, 148, 161
Hassan Bey, 134-135, 138
Hebrew Medical Association, 92
Henry Street Settlement, 95
Herzl, Theodor, 6, 25, 27

Herzliya Gymnasia, 28-29
Hilfsverein Schools, 52, 73-74, 127, 153
Histadrut, 117, 118
Husaini, Hassan Al, 66

Jacobs, Rose, 72, 81-86, 209, 210
Jaffa, xiii, 3, 32, 54, 66, 68, 75, 81, 98, 155, 159, 172, 174, 176, 179, 182,
 Rae's first visit, 23-28
 Rae's second visit, 100-101, 104, 106
 Rae's last visit,190, 192-94
 Rosenwald's visit, 82-83
 During the war, 110-113, 116-117, 134-135, 138-140, 147, 150
 And the USS *North Carolina*, 127-128, 132
 Deportations from, 142-143, 148, 151
Jaffa Gate, 36, 63, 81, 84, 112, 152, 169, 175
Jaffa Road, 33, 34, 84, 91, 110, 147, 148, 150-152
Jewish Colonial Trust, 98
Jewish Publication Society, 10
Jewish Women's Hospital in Cleveland, xiv, 13

Kagan, Helena, 91, 141, 148, 177-178, 187, 190, 193, 208
Kinneret, 98, 105, 108

Labor, Arab, 99-100, 102, 106
Labor, Jewish, 27, 30, 34, 78, 99-100, 102, 103, 105, 114
Laemmel School, 63, 73, 74, 176

Landau, Annie, 52, 56, 77, 115, 133, 141, 161, 169, 181-182
Landy, Jacob, 16, 132,
Language war, 73-74, 153, 176
Lansing, Robert, 184
LeMa'an Zion, 53, 54, 114, 115
Leon, Eva, 4, 12, 19, 22, 23, 24, 29, 32, 33, 43, 49, 52, 55, 58, 64, 65, 66, 68, 179, 207
Levin, Dr. Shmarya, 108
Levin, Louis, 173, 174, 176-179, 182
Levy, Isaac, 32, 33, 34, 35, 37, 47, 53, 66, 87, 116, 117, 120-121, 126, 167, 193
Lewin-Epstein, Samuel, 173, 174, 176, 182
Lipsky, Louis, 108
Lithuania, xiv, 4, 17, 20, 196
Little mothers classes, 47, 50, 51, 62

Macy's, 11
Madjid Bey, 106, 107
Malaria, 11, 19, 61, 97, 103, 121, 129, 188
Manhattan, 3, 9, 14, 202
Marshall, Louis, 119, 177
Mea Shearim, 37, 44
Menorah Park, Cleveland, 17
Mikveh Israel, 31, 126
 And landing of first airplane, 74-75
Missionaries, 40, 43, 45
Montefiore, Moses, 84
Morgenthau, Henry, 172, 182, 192
 Visits Palestine, 87-89,
 And the USS *North Carolina*, 118-120, 127, 131

And deportation of Jews, 151, 160

And Armenians, 183-184, 189, 191-192

Mount of Olives, 17, 147, 206

Mt. Sinai Hospital, Cleveland, 13, 203

Mt. Sinai Hospital, New York, 19

Negev, 91

Neveh Shalom, 26

Neveh Tzedek, 26

New York City, 6, 12, 14, 17, 19

New York Times, 4, 21, 158, 196

North Carolina, USS, 119, 120, 125, 127, 129, 132, 153, 172, 176

Office of Attending Surgeon, 198, 199

Ohel Moshe, 84

Old City, Jerusalem, 33, 37, 40, 44, 61, 63, 81, 84, 113, 152, 157,

Ottoman Empire, 24, 87, 106, 109, 110, 113, 125, 133, 154, 156, 159, 183

Ottoman Jews, 117, 135, 140, 151, 161

Palestine Office (of Jewish Organization), 25, 89, 98-99

Persian Jews, 63, 84, 95, 97

Petach Tikvah, xiii, 98, 99, 127, 162, 183, 193
 Rae's trip to, 100-105

Philippines
 Rae's army service, 200-201, 209
 Rose's service, 19

Pinczower, Vera, 73, 74, 77, 141, 161, 193

Pinsker, Leon, 6

Polytechnic University, 73, 74

Port Surgeon, Antwerp, 198

Rehovot, xiv, 98, 106, 127, 193

Rishon L'Zion, 31, 59

Rosenblum, Evelyn, vii, xi, 197, 200, 204, 205

Rosenwald, Julius, 82-83, 87, 89

Rothschild Hospital, 44, 96, 97

Rothschild, Baron Edmond de, 59, 87, 89, 103
 Meeting with Ruppin and Rosenwald, 82-83

Ruppin, Arthur, xiii, 25-27, 74, 78, 88, 98, 99, 100, 109, 152
 Meeting with Rothschild and Rosenwald, 82-83
 And the USS *North Carolina*, 118, 120, 127-128, 130-131, 153
 Travels to Damascus, 140, 143
 Summoned to Djemal Pasha, 150
 And Captain Decker, 159, 160
 And the US *Vulcan*, 174, 176, 178, 183

Ruppin, Shulamit, 26, 30

Sampter, Jessie, 100

Schatz, Boris, 34, 113, 114

Schiff, Jacob, 118-119, 176

Sears, Roebuck and Company, 82

Segal, Dr. Jacob, 44, 45, 47, 86, 96, 97, 148
Seligsburg, Alice, 131
Sepharad Talmud Torah, 158
Serbia, 109
ShaareTzedek Hospital, 39, 61, 97, 114, 149
Spanish-American War, 19
Standard Oil cans, 33, 63, 79, 155
Standard Oil Company and oil, 91
Sternberg General Hospital, 200, 201
Straus Health Bureau, 37, 44, 60
Straus Soup Kitchen, 20, 37, 66, 157, 158
Straus, Isidore, 22
Straus, Lina, 4, 10, 14, 16
Straus, Nathan, 4, 11, 12, 15, 16, 21, 22, 32, 37, 65-66, 117, 176, 183
Suez Canal, 153, 156, 157, 169
Szold, Henrietta, 1, 7, 19, 37, 39, 62, 65, 67, 68, 83, 86, 90, 95, 121, 173, 178, 179
And Rae's meeting, 10-15, 18
Letters to and from the nurses, 93, 96, 97, 122, 129, 131, 147
Telling Rae to return home, 185, 186, 187, 188, 192
Meeting Rae when she returns to America, 190
Tribute to Rose Kaplan, 205, 206
And Hadassah, 208-209

Tel Aviv, 78, 91, 174, 134, 147, 160, 174
Nurses' first visit, 27-30

Expulsion of Jews from, 138-139
Tennessee, USS, 143, 151-152, 153, 154, 168-169, 172, 185, 189
The Republic, 201-202
Thon, Sarah, 26, 27, 34
Thon, Ya'akov, xiii, 25, 116
Ticho, Anna, 53, 54, 193
Ticho, Dr. Avraham, 60, 92, 179, 187, 190, 193
And learning about trachoma, 53, 54, 55
Treating trachoma, 56, 86, 96, 148, 149, 154
Almost deported, 114, 116, 123, 124, 149-150
Tin Quarter, 63-64, 71, 84
Titanic, 22
Trachoma, 26, 60, 64, 89, 90, 121, 148, 149, 152, 187
Conditions in Jerusalem, 53-54
Nurses' treatment of, 56-58, 62, 179
Dr. Ticho's conference, 92
Diminished effects of treatment, 162, 163

U.S. Army Nurse Corps, Rae's service in, 196-202

Vedrines, Jules, 74-75
Vulcan, US, 172-180, 188, 190

Wailing Wall, 37, 66, 186
Wald, Lillian, xii, 12, 59, 95
Wallach, Dr. Moshe, 149, 169
Walter Reed Hospital, 199, 200

Water
 In Jaffa, 25, 26
 In Jerusalem, 38, 39, 46, 53, 61, 63, 75, 87, 107, 114-115, 164, 170
Wertheim, Maurice, 119, 127-131
Wilson, President Woodrow, 87, 159, 160
Wise, Rabbi Stephen, 32, 58, 59, 82
Woodland Avenue, Cleveland, 16, 20

Yellin, David, 88
 And distribution of funds from US *Vulcan*, 176-178, 183

Yemenite Jews, 62, 79, 84, 95, 97, 135
 And labor, 34, 99-100, 102, 127
Yishuv, Old, New, 77, 79, 99

Zaki Bey, 135
Zarnuka, incident at, 106
Zichron Moshe, 84
Zionist Convention, Rochester New York 1914, 108
Zionist societies in New York, 6